THE ENCYCLOPEDIA OF
ART
TECHNIQUES

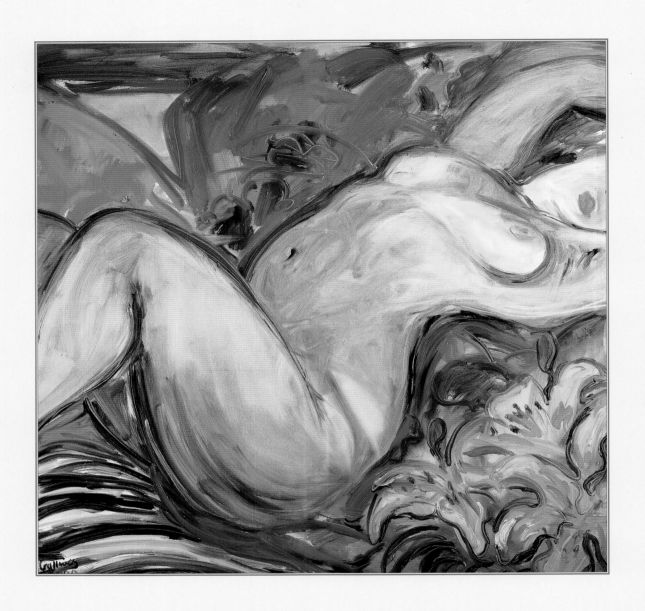

THE ENCYCLOPEDIA OF
ART
TECHNIQUES

EDITED BY TESSA CLARK

A QUINTET BOOK

Published by A&C Black (Publishers) Limited
37 Soho Square
London W1D 3DZ

ISBN 0 7136 6629 3 X

This book was designed and produced by
Quintet Publishing Limited
6 Blundell Steet
London N7 9BH

Designer: James Lawrence
Editor: Tessa Clark
Assistant Editor: Catherine Osborne

Managing Editor: Diana Steedman
Creative Director: Richard Dewing
Publisher: Oliver Salzmann

Manufactured in Singapore by Universal Graphics Pte Ltd
Printed in China by Leefung-Asco Printers Limited

CONTENTS

FLOWERS
AND STILL LIFE

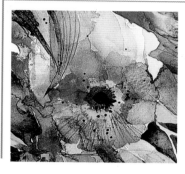 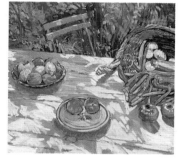 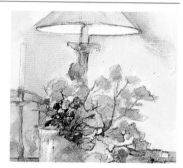

THE NUDE
AND PORTRAITS

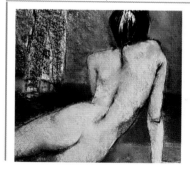 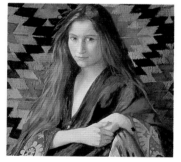

LANDSCAPES

INTRODUCTION

FLOWERS AND STILL LIFE, THE HUMAN
FIGURE AND LANDSCAPES ARE THREE
OF THE MOST POPULAR SUBJECTS FOR
ARTISTS. ALL THREE HAVE LONG
HISTORIES – IN PARTICULAR, THE
PORTRAYAL OF FLOWERS DATES BACK
TO EGYPTIAN TOMB PAINTINGS AND
IN PREHISTORIC TIMES RUNNING
AND HUNTING FIGURES WERE
DEPICTED WITH GREAT ELOQUENCE.
OVER THE CENTURIES THE WAY
ARTISTS HAVE APPROACHED THESE
SUBJECTS HAS CHANGED AND
DEVELOPED, BUT THEIR AIM HAS
REMAINED CONSTANT: TO RECREATE
THE WORLD AROUND THEM ON
PAPER, CANVAS OR BOARD.

right *Harriet.* Oil by Jane Bond. In this
delightful painting a burnt sienna
underpainting warms the dark values of the
hair. The golden highlights are painted wet
into wet to achieve this soft, silky appearance.

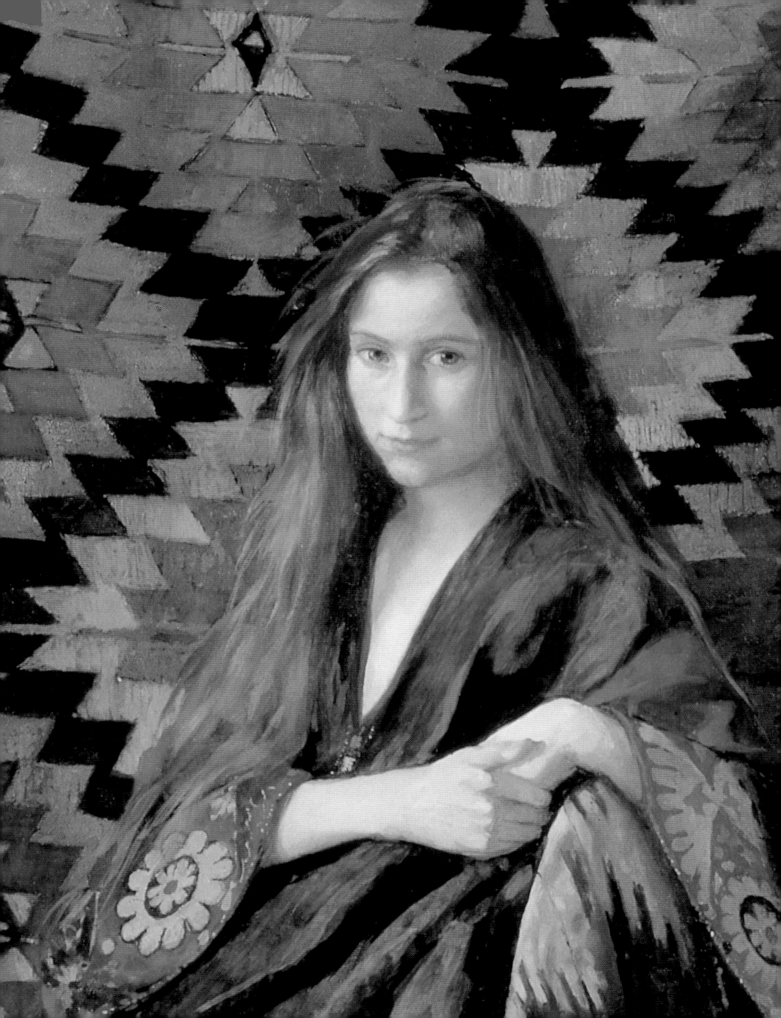

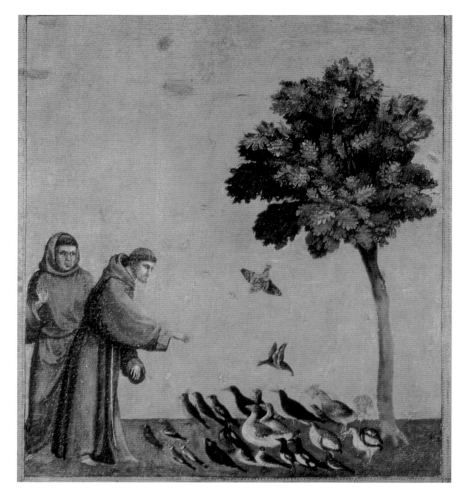

left A fresco by Giotto in the Upper Church of St Francis, Assisi. St Francis' teachings encouraged Renaissance artists to include flowers and plants in their paintings.

FLOWERS AND STILL LIFE

FROM EGYPTIAN TOMB PAINTINGS AND JEWELLERY TO GREEK POTTERY, THE VALUE PLACED ON FLOWERS IN EARLY DECORATIVE ART IS APPARENT.

It is, however, the herbals which provide our strongest link with the botanical artists of the past. Frequently compiled by medical men as works of reference, they provide an insight into the native wild plants of many regions. One such herbal, the *De Materia Medica*, compiled in the 1st century AD by Dioscorides, a physician with the Roman Army, was still being used by a herbalist monk in Greece during the 1930s.

Over the centuries, the quality of drawings became poor and stylised, largely due to copying. What Chinese whispers do for the sense of the spoken word, so repeated copying altered the accuracy of the plant portraits. To identify medicinal herbs from these drawings must have been extremely hazardous, with the possibility of kill rather than cure.

Small wonder that botanical gardens grew up around universities with medical schools and better herbals were demanded by the students. From hand-drawn and coloured illustrations, to crude woodcuts in early printed editions, improvement continued as these gave way to finer engravings and etchings.

Some of the more realistic portrayals of flowers occur on the illuminated manuscripts of the 15th century. Common flowers such as daisies, violas, camomile and dianthus, not to mention strawberries and ivy, are often shown against a background of gold leaf. In the early 16th century the Book of Hours of Anne of Brittany, richly adorned with around 300 plants, is part herbal, part devotional aid.

The teachings of St Francis of Assisi, with the emphasis on love for everything in the natural world, encouraged artists to include flowers in major paintings.

Another change in the tide of floral art came with increasing world exploration. From the mid-16th century onwards each expedition which set out was likely to include an artist in its number. The job sometimes entailed map-making as well as providing a pictorial record of the new land and its flora.

From this time, building to a peak in the 18th and 19th centuries, the true botanical artist was born, as all the splendour of these new varieties was captured in accurate drawings. Bound and reproduced as catalogues or florilegia, or executed for wealthy

patrons, the works of the great names of those days live on – Bauer, Ehret, Redouté and many others set the standard for future generations.

With the Impressionists of the 19th century came change, and a looser, freer style of flower painting developed. This, together with Abstract Art to a lesser degree, continues to run alongside the more traditional realism of true botanical illustration.

In the field of still life, the vibrant tradition in Spain, with its origins in the late 16th century, produced such painters as Diego Velazquez (1599–1660) and Goya (1746–1828), who approached the still life in a truly independent way. Their influence has been far-reaching through history. It is evident in the works of artists spanning the centuries, through to Paul Cézanne (1839–1906) and Pablo Picasso (1881–1973).

In the early 17th century, the reformed churches of northern Europe rejected the grandiose religious painting and decoration of the past. Artists had to find new ways of making a living. In Holland they turned to painting still life, and the great Dutch tradition was born.

The Dutch painter Vincent Van Gogh (1853–90), born some two centuries later, has captured the imagination of our generation. His violent yet harmonious compositions give the eye a new sensation.

And the still lifes of the 19th-century French artists Henri Matisse (1869–1954) and Cézanne are now acclaimed and revered. Cézanne, the father of Impressionism, employed a system of short, tightly grouped brush strokes that is a technique employed today by many still life artists.

In the 20th century, Picasso redefined volume while containing the integrity of the canvas. Tables tipped forward to reveal more of the objects, challenging the rules of perspective and taking the genre of still life further than any painter had dared to take it in the past.

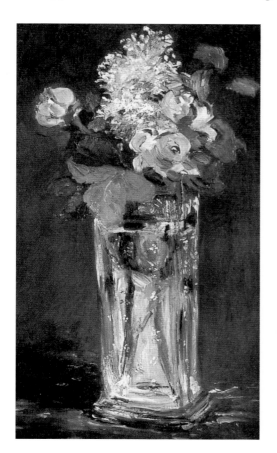

above *Fleurs dans un Vase.* Oil by Edouard Manet. Expressive brushstrokes.

right *Still Life: a Vase of Flowers.* By Jan van Huysum. Elaborate detail.

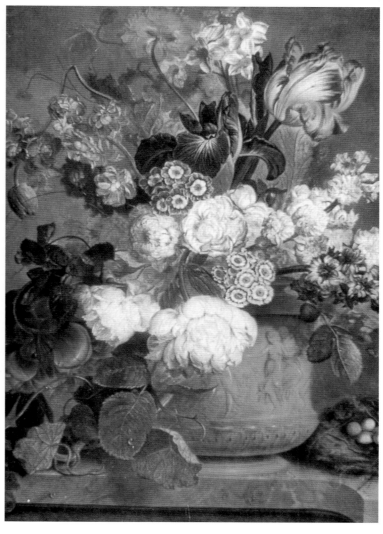

THE HUMAN FIGURE

THE ANCIENT GREEKS SAW THE NUDE AS THE SUM OF
HUMAN BEAUTY AND ENDEAVOUR, AS REFLECTED IN THE BELVEDERE APOLLO.

However, with the passing of the pagan world, there began the Christian concept of man, son of Adam, who was conceived and born in sin. This was reflected in the artistic representation of the human figure by a new degree of shame and self-consciousness.

The climb out of that abyss of self-abasement began with the rediscovery of the Greco-Roman literature and art, which signalled the Renaissance.

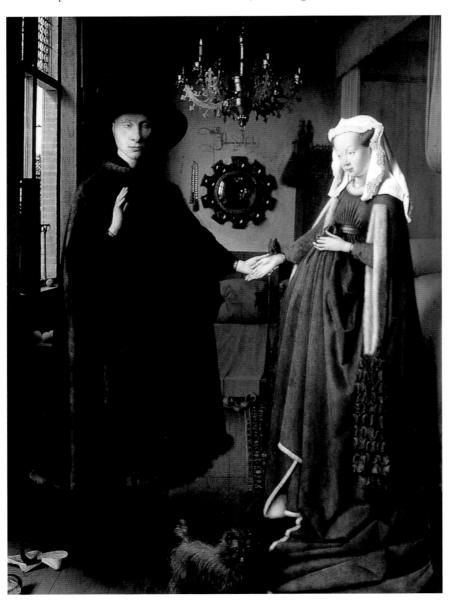

The nude once again became the touchstone of art, an example being Botticelli's *Venus*, exulting in her own beauty. Tragically, the reaction to this new liberalism was fear and religious fanaticism and many artists, including Sandra Botticelli (1445–1510), threw their own work into the bonfire of the vanities in Florence in 1497. The top-most tiers of the pyre were reserved for artworks of beautiful women.

The repression, however, was short-lived and the cultured Venetians were willing patrons for the young Titian, whose images of voluptuous nudes were enthusiastically copied in the courts north of the Alps, where the semi-pagan allegories of Rubens (1557–1640) reflected the fruits of earthly power. Today we perhaps identify more with the ordinary women of Rembrandt's canvases.

In France, for about a century and a half, the nude became the frivolous plaything of the French aristocracy, only to emerge after the Revolution in the new image of *La Madelaine*, with the sturdy republican virtues of David (1748–1825). Then, with the collapse of the hopes and ideals of the republic

left *The Arnolfini Marriage* (1434). By Jan Van Eyck. *Reproduced by courtesy of the Trustees of the National Gallery, London.* Popularly thought to be a marriage ceremony, although this is by no means certain, this painting seems surprisingly modern in its portrayal of light, which subtly unifies all the objects and figures in the room.

and the empire, the female nude became a hapless victim of romantic fantasy in the historical paintings of Eugene Delacroix and his contemporaries. With a curious piquancy, one of the minor figures in *The Crusaders Entering Constantinople*, by Delacroix (1798–1863), was transformed into the primary inspiration for Degas' (1834–1917) series of paintings of women at their *toilettes*.

The nude in Manet's *Déjeuner sur l'herbe* scandalised society. This stir had less to do with the figure itself than with the context in which she was seen – sharing a picnic with a group of fully clothed painters.

The last decade of the 19th century saw the creations of Edgar Degas, Gauguin, Toulouse-Lautrec and Rodin some of the finest works of art to have been inspired by the nude. At the beginning of the 21st century, interest in figurative art is returning and with it comes the need to study the nude.

The history of portraiture dates back to the 14th century and a fresco by Giotto, in a chapel in Florence, which is bordered almost certainly by members of the Peruzzi family.

In many early Renaissance religious paintings, portraits of the donors appear as onlookers, perhaps kneeling before the Virgin or standing at the edge of the scene. To begin with they were smaller in scale than the religious figures, denoting their spiritual inferiority, but later, as the donors became more wealthy and influential, their portraits grew to the same scale as the Biblical characters.

Both Italian and Flemish artists of the 15th and 16th centuries painted bankers and merchants and, from this time onwards, portrait painters were employed by kings, popes and aristocratic families who wanted to celebrate their achievements.

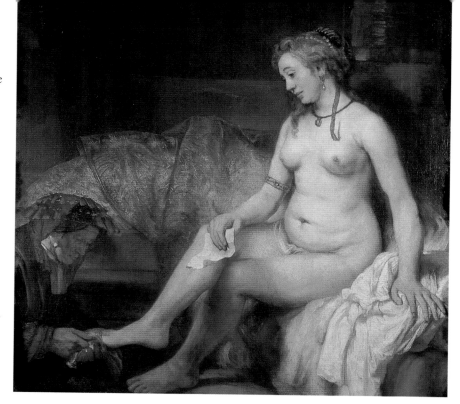

The setting for a portrait and the objects chosen to accompany the sitter have long been a means for the painter to say something more about his subject. From time to time, objects are chosen for their symbolic significance as in the "vanitas" paintings fashionable in the 16th and 17th centuries, in which objects like a lighted candle, a skull, a book and money, prompt the viewer to a melancholy contemplation of the impermanence of life and pleasure.

Jan Van Eyck (1390–1441), the great 15th-century Dutch painter, filled his religious pictures and his portraits with objects carrying a symbolic interpretation.

Most, if not all, society portraiture celebrates wealth, charm and power. Official portraiture celebrates power and achievement. These forms are usually commissioned and almost always closely follow traditional lines.

There is of course another type of portraiture, the informal portrait. These are often intimate insights into the psychology of a friend, relative or lover: Goya's *Maja* paintings, Stanley

above The model for Rembrandt's *Bathsheba with King David's Letter* (1654) was his common-law wife, Hendrickje Stoffels. He created a whole world in his studio where models and sitters re-enacted life.

Spencer's portraits of Hilda, Claude Monet's portrait of his dying wife and Paula Modersohn-Becker's portraits of old women and children, to name a small handful in a wealth of portraits of this type. Portraits like these are usually uncommissioned and in recent art history it is more this kind of portrait that we know and love. The portraits of Gwen John, Van Gogh, Cézanne and Picasso are just a few very familiar names.

Some portraiture is highly imaginative, stylised or distorted, and artists such as Francis Bacon wrest a likeness from the sitter by a tortuous painterly process, producing great art as well as great portraiture.

Bacon is an unusual example of a portrait painter who never worked to commission. Amazingly, his paintings are recognisable likenesses, a necessary condition of a portrait.

LANDSCAPES

AS TOWNS AND CITIES GREW AND THE WILD FORESTS WERE TAMED AND CUT, SO THE INTEREST IN THE WILD ENVIRONMENT GREW.

Albrecht Dürer (1471–1528) and Albrecht Altdorfer (c1485–1538) were two German artists who produced drawings and paintings where figures were reduced to a minor role in a highly detailed study of nature. Dürer himself is credited with painting the first townscape.

But Dutch 17th-century painting was the first European movement to establish the art of landscape in its own right. Dramatic chiaroscuro effects of light and dark were combined with the depiction of commonplace domestic scenes as Dutch society celebrated the rise of bourgeois living.

Landscape became an accepted subject to paint. The architectural arrangement of shapes in space, the balance of horizontal against vertical and the overall stillness of paintings by Nicolas Poussin (1593–1664) embody the principles of the classical tradition in landscape. This line proceeds down through Cézanne and into the abstractionists of the mid-20th century, such as Mondrian.

During the 19th century, the Romantic movement developed. The Romantic artists were concerned with mood, emotion, movement and effect rather than the purely formal aspects of balance and symmetry in landscape. Nevertheless, the best paintings usually contained elements of all these qualities.

J.W Turner and John Constable continued the naturalistic tradition, albeit in their own individual ways. Turner (1775–1851) produced grandiose subjects like *The Fighting Téméraire*, while Constable (1776–1837) painted pastoral, almost parochial subjects such as *The Hay Wain*.

The work of Constable and Turner had a profound influence in France, particularly on Gustave Courbet (1819–77), a realist who painted nature directly as he saw it.

Courbet's example led directly to Impressionism. The approach of these artists was not only realistic; their concern was to capture the effect experienced on first seeing a view – in its totality and without any undue attention to detail. It was the first movement to be expressly concerned with light. The principal artists were Monet, Renoir, Pissarro, Sisley, Seurat and Morisot. These painters worked largely outdoors and on location. To seize the precise effects of light and atmosphere on colour meant spending long hours enduring the elements. They had to be hardy individuals!

Cézanne (1839–1906) was dissatisfied with the lack of formal considerations in the work of his Impressionist contemporaries. His theory that all forms in nature are based on the cone, the sphere and the cylinder gained him the reputation of being "the father of modern painting". He saw and interpreted the scene in front of him in these terms. He worked on location in the hills around Aix-en-Provence in southern France, using Impressionist colour, but he was also influenced by Poussin and the classical tradition in art.

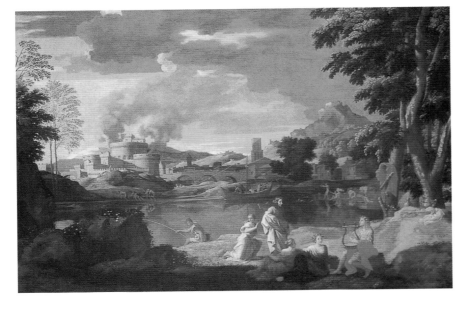

left *Orpheus and Eurydice* (1650). Nicholas Poussin uses a landscape formula of dark idealised landscape receding in parallel planes which structure the depth of the painting, while clear vertical and horizontal accents give increased stability to the work. This underlying geometry gives the scene its elegant serenity.

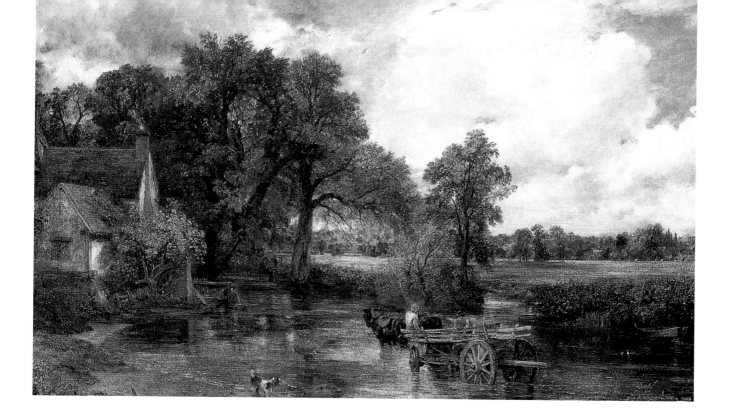

Van Gogh (1853–90) is credited as being the precursor of the entire Expressionist tradition in modern art. To him, the subject was a starting point for his personal response through colour to that subject. He has been quoted as saying he was more concerned with the colours on his palette than those in front of him. Gauguin (1848–93), who started as an Impressionist, developed the principles of symbolism. His colour and shapes were simplified to produce a more "primitive" effect. He constructed his paintings largely in the studio. Both artists drew their inspiration directly from nature and human experience, rather than from the preconceptions about art held by petit-bourgeois society.

Along with many other artists in the latter part of the 19th century,

right *Autumn at Argenteuil* (1873). By Claude Monet. This Impressionist painting superbly captures the effect of the sun, low in the sky, on the gold-coloured tree foliage at the left of the picture.

Van Gogh and Gauguin were influenced by Japanese prints. Flatter, purer colour enclosed by a black outline was the manifestation of this influence in European art.

The research into the nature of colour by the French scientist Eugene Chevreul was to have a major impact on European art. The principle of simultaneous contrast caused artists to substitute the colours they saw

above In works like *The Hay Wain* (1821), Constable struggled against the academic tradition with its Italianate landscapes. He worked extensively directly from nature, before the subject, painting rapidly, with separate strokes and blobs of paint.

before them for colours which make harmonious contrasts. This led directly to the brilliant primary colours used by the Fauvists.

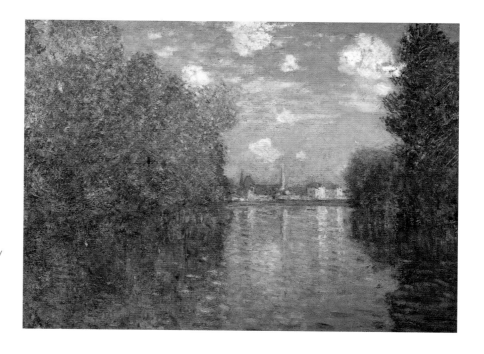

MATERIALS AND EQUIPMENT

FINDING INVENTIVE WAYS OF
APPLYING PAINT TO PAPER, BOARD OR
CANVAS WILL TURN A PICTURE INTO A
PAINTING. VIGOROUSLY BRUSHED
TEXTURES, IMPRESSIONIST STIPPLING
AND RHYTHMIC BRUSHWORK CAN
BRING YOUR PAINTING TO LIFE.
DEVELOPING A FLUENT SHORTHAND
WITH PAINTING AND DRAWING
TAKES TIME AND EXPERIMENTING
WITH THE VARIOUS TOOLS AND
MEDIA AVAILABLE IS THE BEST WAY TO
PROCEED. BUYING PAINTING AND
DRAWING MEDIA CAN BE CONFUSING
WHEN YOU ARE UNSURE ABOUT WHAT
WILL SUIT YOUR PURPOSES. IT IS EASY
TO MAKE EXPENSIVE MISTAKES, SO IT
IS WORTHWHILE TO THINK
CAREFULLY BEFORE BUYING.

PAINTING MEDIA

Watercolour

The great British tradition of watercolour has paved the way for the abundance of superior paints and pigments available throughout the world. This huge range of tints, tones and hues gives the newcomer a bewildering array of choices. Artist's watercolour paint can yield superb results, even for the beginner, if handled properly. The subtlety of luminous washes and strong tinting qualities bring to the medium a vitality that lends itself to still life and flower work.

The high-quality sets of water-colours you can buy often include colours that you personally may not use, so buy an empty paintbox and make your own choice of colours. This will focus your mind on exactly what it is you are looking for.

Gouache

Gouache paints are opaque watercolour paints that come in tube form. They are opaque because of opaque extenders such as barium sulphate or chalk. The pigments are combined with gum and wetting agents to produce beautifully flowing colours.

Gouache, or "body colour", can be used with watercolour to make excellent combinations of washes and opaque colour, perfectly suited to flower still life work. This medium is also known as "designer's gouache", due to its ability to produce flat areas of matte colour without brushmarks, which endears it to graphic designers.

below A selection of watercolour and gouache materials including a box of half pan watercolour paints, some tubes of gouache, a fine sable and a medium flat brush. Also shown are gum arabic, which can be used to thicken paint and produce a slight sheen and masking fluid, which will reserve white or pale-coloured areas when washes are applied.

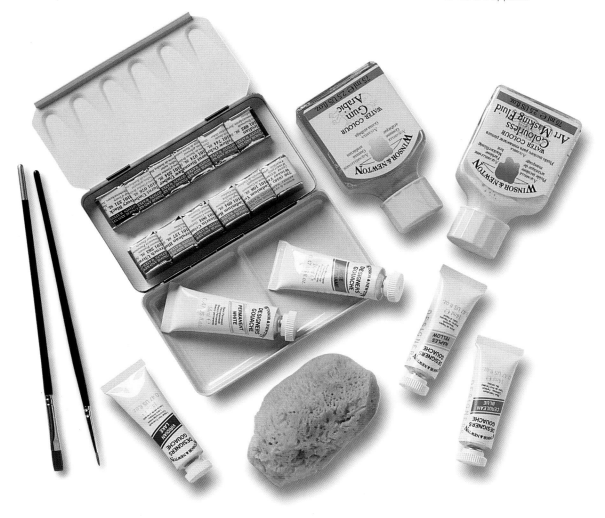

Acrylic

Acrylic paints are water-based, non-yellowing permanent paints that dry to a waterproof finish. The acrylic medium is actually a plastic, made from petroleum products. The paints are user friendly and there is a good choice of colours and hues.

This flexible and fast-drying medium lends itself to layering techniques such as scumbling and transparent glazes. The fast-drying property also means that palettes and brushes must be carefully cleaned; if not, they can be easily ruined. There are superb media, such as gloss medium, matte medium and gel medium, that can be used with the acrylic paint. Flow improvers, retarders and impasto gels also give the artist a greater control over the nature and consistency of the paint. It is worth trying them all out.

Oil

The luminous quality of oil paint and its ability to create glazes, thick impasto and high contrasts, put this medium in a class of its own.

The huge range of colours and brands of oil paint available make the choice of a personal palette somewhat overwhelming. You may find that you prefer the consistency and handling of one brand, or certain colours of another, so leave your options open. Manufacturers usually give a choice of artist's or student's grades of paints, in both oil and watercolour. The "student" colours are slightly cheaper, but the pigments may be less concentrated or even substituted with alternatives, so that they do not achieve the brilliance of "artist" colours. That does not mean these paints are not worth using; in fact, they are excellent as a starter palette, when you are not sure of your commitment to the medium.

Refined linseed oil and English distilled turpentine are the only basic drying oil and diluent, respectively, that the artist in oils needs. A standard mixture of one-third linseed and two-thirds turpentine will serve the artist well. There are, however, many other media worth experimenting with. Synthetic media such as liquin will speed up drying time and improve the flow of oil colours. It also increases translucency, making it suitable for glazes. Opal medium gives a matte appearance to colours and dries slowly.

An impasto medium such as Oleopasto will give the brushstrokes more weight and the texture of the mark will be more exaggerated. This can also be used as an extender to make colour go further. In this way it is possible to build up thick layers using minimal amounts of expensive paints. Artist's Retouching Varnish can be used to liven up dull, flat areas of a painting at the end of each day.

below A selection of acrylic colours and one of a range of media available for diluting the paint.

DRAWING MEDIA

Pencils

Artists' pencils are graded from H (hard) to B (soft). A 2H pencil will give you a very sharp, light line, while an 8B will give a heavier, darker line. When you choose a medium, try to match the appropriate size and weight of line to the right size of paper. Pencils are suitable for sketchbook drawing and medium-sized sketch pads. The line is, however, too light and thin to sustain a strong image on a large format. There are, of course, exceptions to this rule: you can use a soft pencil to crosshatch; if you apply strong pressure, it is possible to build up very satisfactory dark shading over a large area of paper.

Graphite sticks

These sticks are made of the same material that forms the "lead" of a pencil – graphite. It is produced in stick form so that you can work either with the side, to produce a grey pencil tone, or with the point, when it is like a soft, wide pencil. Graphite sticks can be sharpened with a mat knife to form a wedge-shaped point, which will enable you to go from a thin line to a broad line simply by turning the stick slightly.

Drawings done with a graphite stick do not have to be sprayed with a fixative. Erase any errors with a kneaded eraser, a plastic eraser or with fresh bread.

Coloured pencils

There are several different types of coloured pencils available and they vary in brilliance and softness. Try them out before you buy, because they are quite expensive and fragile.

Take care not to drop them, as the lead inside will shatter.

Coloured pencils are suitable for small drawings and they can be erased with a kneaded eraser or a plastic eraser.

Charcoal

Avoid using any type of charcoal on smooth papers, such as newsprint, because the stick slides over the surface too quickly, giving an insipid line. It is a good idea to use lining paper and cut it to the length you need for quick, disposable sketches. For better drawings, use drawing or sketch pads, or charcoal paper.

Willow pencils are ideal for quick sketches. Compressed charcoal sticks are available in different grades; they are heavier and darker than charcoal pencils and can give you a rich, dark tone quickly. A good drawing done with charcoal sticks can resemble a lithograph.

All charcoal can be erased with a kneaded eraser or fresh bread. Bread should be your first choice with charcoal sticks to avoid "rubbing in" the heavy charcoal. With bread you can gently lift it off without damaging the surface of the paper. Completed drawings should be sprayed with fixative. To avoid smudging a drawing, keep it covered with an overlay of thin tracing paper.

Soluble pencils and crayons

When buying crayons you may consider purchasing the newer soluble varieties, which give you the best of both worlds. Used dry they work as a traditional crayon and for effect and convenience the application of water, preferably distilled, to all or part of the drawing, softens it in a pleasing

below A selection of drawing materials, including lead pencils, coloured pencils, water-soluble pencils and charcoal.

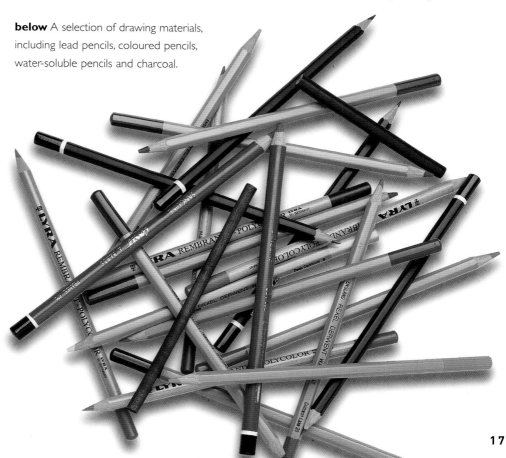

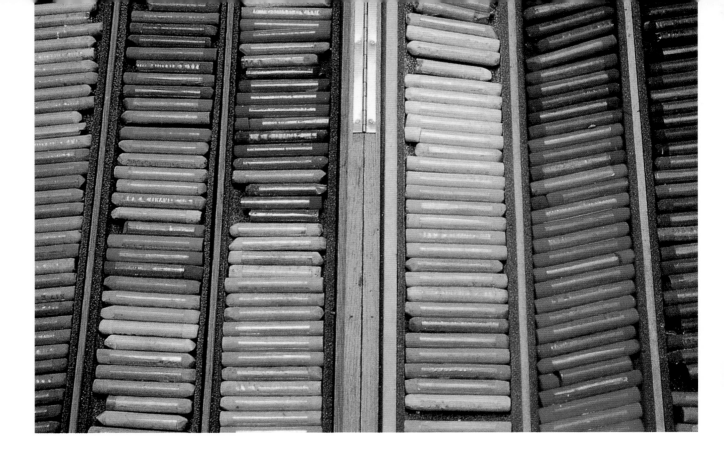

above Pastels come in an amazing array of colours.

way. Some types require turpentine to be used instead of water. They are most useful for the artist working outdoors as they are easily carried and enable quick sketches and approximate colour notes to be made on the spot. They are equally useful for producing quick colour roughs where only a suggestion of the final colour is required.

Made with pigment rather than dye, these pencils are variably lightfast and you should bear this in mind if you are working with a long-term objective.

Conté crayons

These are rather hard sticks of pigment, bound with gum arabic. They can be sharpened with a sandpaper block and used on the point or on the side. Alternatively, they can be broken to make a sharp edge. The original colours used by the Renaissance masters were sienna, umber and black. White conté crayon or softer white pastel can be used for highlighting.

A lightly textured paper is the best support for conté crayons, but heavier grades of paper can be used.

Erase conté crayon with a kneaded eraser or fresh bread.

Pastels

There are three types of pastel. Soft pastel is a round stick and, as its name suggests, is very soft and easily blended or layered.

Neopastel (or Nupastel) is a square-edged, thin stick. It is much harder than soft pastel and although it can be blended, the hardness makes layering very difficult. It can be used to make a sharp line or for small-scale work.

Oil pastel, which is based on an oil and wax binder, is totally different from the other kinds of pastel, which are all bonded together with water and gum.

Coloured inks and pens

Inks can be lightfast variable, though inks with acrylic, rather than shellac resin binders, tend to be less colour fugitive. Likewise pigment rather than dye-coloured inks are preferable. The old favourite Indian ink is, of course, invaluable and, like the coloured inks, may be thinned with distilled water. Do not be afraid to mix coloured inks as some interesting shades are

below A selection of coloured inks, with two nibs of different sizes.

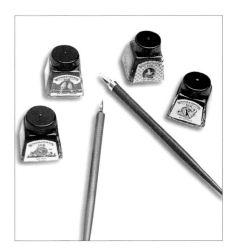

above A full colour range of felt-tip pens.

possible. The black pigment ink is waterproof and lightfast. It goes without saying that any ink has to be waterproof if it is to be used in a line and wash drawing.

Traditionally, metal pen nibs, from the finest mapping pens to those with a wider nib, are fitted into a holder and a metal reservoir is attached, which contains the ink. This allows for a wide choice of nib as, apart from a variety of widths, they are available with round tips and flat tips, all of which can create a

confusion of choice. A sketching pen can be the answer, allowing you to build up confidence before trying other nibs. Like a fountain pen, it can be filled with coloured ink and is comfortable to use, but remember that Indian ink is unsuitable because it dries out and clogs up the flow. Technical pens which use ink cartridges are easy and clean to use.

Felt-tip pens

The introduction of felt-tip pens gave us a marvellously adaptable, fluid line to work with. Beware, however, of pens with fugitive inks – your drawings will begin to fade in a year. Permanent colours, although in a limited choice, are available and new ones are being developed so that we should soon have a full range of permanent colours from which to choose. Some felt-tip pens have flexible tips, which give a fluid, attractive brush line.

Felt-tip pen cannot be erased.

EQUIPMENT

Palettes and accessories

PALETTES The purpose of the palette is to display and mix the colours. The main palette for the studio-based artist can be a simple sheet of formica or heavy-duty glass, about 60cm (2ft) square, which sits on a table top next to the easel. Give yourself room to manoeuvre and get full use from your colours.

Disposable peel-off palettes are a fast and efficient way to mix lighter

colours and try out experimental mixtures without taking up valuable space on the main palette. Washable plastic and enamel palettes, available in many shapes and sizes, are perfect for the studio-based watercolour or acrylic artist.

It should be noted, however, that when you are using acrylic, it is very important to clean all the palettes meticulously before the paint starts to harden.

DIPPERS These are conveniently sized small metal containers for media such as the turpentine/linseed mixture that is used by oil painters. Keeping four dippers going at once, with two for the light colour brushes and two for the dark colour brushes, minimises the chance of colour contamination.

To clean brushes, use a small jug of artist's white spirit, which should be changed regularly.

MAHLSTICKS Painters use mahlsticks to keep the hand steady when working on awkward parts of the canvas or paper and when executing precision or detail. The traditional mahlstick has one padded end, which gently rests on the painting surface, while the stick supports your arm.

MOPS AND SPONGES There are many ways of applying paint. Especially useful for the water-colourist is an ox-ear-hair or squirrel-hair mop, used for flat washes, as is the goat mop. The natural sponge is also useful with water-based paints for creating special effects as well as moving the paint around.

PALETTE KNIVES AND PAINTING KNIVES Palette knives are useful for mixing large quantities of paint and so avoiding damage to brushes. The various palette and painting knives available give the painter another versatile range of tools. The palette knife can be used in both acrylic and oil painting for laying on paint like spreading butter, or for scraping off paint, creating textures as well as making corrections.

Artist's painting knives come in various shapes and sizes. The standard painting knife comes with a cranked wooden handle and a flexible steel trowel head. This shape is important as it allows the artist to work close to the surface of the canvas without leaning against it for support. The tip of the blade can be used to scrape back or draw into the paint. This sgraffito technique allows you to create different textures and also crosshatching.

Brushes

Brushes can create the mood of a painting, as shown by the swirling strokes of Vincent Van Gogh or Edouard Munch (1863–1944), where raw emotions are expressed through vivid, energetic brushwork. Keep your brushwork free and lively and you will see the benefits. Choosing the right brush for the right job means looking carefully at the selections in the art store. Know what kind of marks you want from your brush before trying some of them out.

You will need bristle brushes of various shapes and sizes, along with some sable brushes for precise detail and linework. Synthetic bristle-type brushes are also worth considering. They are hard-wearing and less expensive and the range of shapes and sizes they come in gives the artist excellent choice and the chance to experiment. There are also less expensive alternatives to pure sable brushes, such as the synthetic mixtures that contain nylon or polyester. These brushes perform well and are especially suitable for beginners.

The important thing to remember is to be confident with your brushwork, since this is the key to successful painting. A hesitant hand leads to caution and a reserved approach, which can stifle the creative process. Practise strokes with a dry brush to help the flow of thought to the hands, and allow rhythm and spontaneity to build up when you are handling the brush.

It is worth spending as much as you can afford on brushes, since these are the tools of the trade. The better the quality of the brush, the better it handles the paint!

BRISTLE BRUSHES The hog-hair bristle brush itself is the ideal tool for mixing colours on your palette. The spring in the bristle is stiff enough for

below A variety of watercolour brushes. From left to right: large mop brush useful for washes, long thin rigger brush for fine lines, synthetic round hair, mixed fibre round, ox-hair round, squirrel-hair round, sable fan bright, long-handled square sable, sable round and sable rigger.

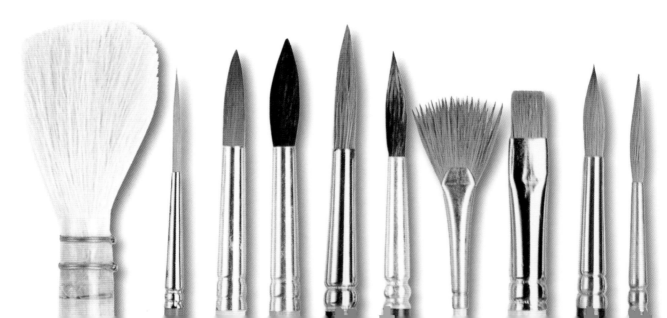

the paint to gradually work its way into the belly of the bristle. Always mix paint on the palette gradually, so that the bristles fill evenly with paint. There is nothing worse than an overloaded brush.

Filberts and flats are the most commonly used types of hog-hair bristle brush. Filberts are the all-round brush. The shape is flat with an oval head. A variety of textures, swirls and tapered lines can be produced with filberts. This type of brush will deliver a good, even stroke of colour and is suitable for blocking in large areas of colour in the early stages of a painting.

With their chisel heads, flat brushes, with long or short bristles, make very distinctive diamond or square-shaped marks, producing well-defined edges to your brushmark. The dappling effect produced with flat brushes was favoured by the Impressionists. Their paintings clearly show deft brushstrokes flying across the canvas in an ordered chaos!

The round is ideal for outlines and for drawing out your composition. It is also good for stippling effects when held vertically. The larger rounds can also deliver wonderfully hefty brushstrokes, while still keeping a crisp edge, allowing a consistent flow of paint.

Bright brushes are short, flat brushes, chisel-ended with a square head. They are useful for "scrubbing" paint into large areas of canvas and they are durable enough to cope with vigorous, energetic handling.

The complete sets that have a "round", a "filbert" and a long and short "flat" selection are good to start with. A brush good for blending colour is the fan brush. This comes in both bristle and soft hair. A rigger is useful for fine lines.

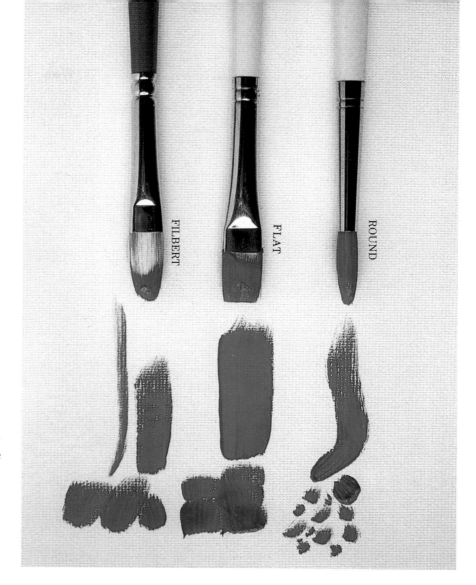

FILBERT

FLAT

ROUND

SABLE BRUSHES Sables are soft hair brushes, especially suited to watercolours, although they are also extremely useful to the oil painter. The finest quality sable, and the most expensive, is the Kolinsky, taken from the tail of the Siberian mink!

The sable tapers to a fine point, giving the artist precise control over the tip of the brush. It can be used for fine line as well as for precision painting and colouring. The responsiveness and colour-carrying capacity of the sable are the main qualities that endear it to the artist. Watercolour is thin in consistency, so soft hair and sable brushes are the most suitable for it. Take care to avoid bending the hairs backwards on

above The three basic shapes of brush used for painting in oils, and the marks they make.

these brushes, because this will shorten their life, and sables are not cheap! Good-quality sables do not shed their hair easily and if cared for, they will keep their shape.

Some manufacturers produce excellent ranges of sable brushes at reasonable prices, so shop around. In many ways, your choice of brush is personal to the way you paint, so experiment with less-expensive brushes to find what type suits you.

The step-by-step sequence overleaf is an exercise to demonstrate the marks made by different brushes.

BRUSHMARKS

THIS SKETCH OF TULIPS SHOWS HOW DIFFERENT BRUSHES CAN
BE USED TO MAKE PARTICULAR MARKS. IT IS PURELY AN EXERCISE.

BY ELISABETH HARDEN

I The body of the petal is formed
with a size 8 sable, laying a flood of
colour in the bowl and using the
point for the fine petal tips.

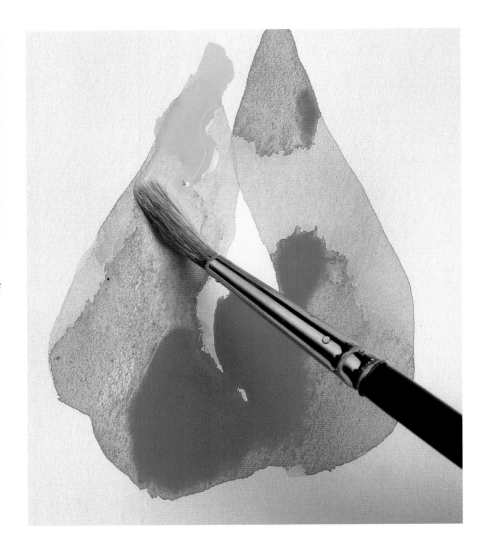

2 A thinner sable, size 4, drops
yellow paint into the point of the
petal and coaxes it into the drying
wash.

3 Flat brushes make fine lines when
used along their narrow edge, can be
twisted to make very wide marks
and then trailed to a point. This is a
25mm (1in) synthetic brush making
these marks in one stroke.

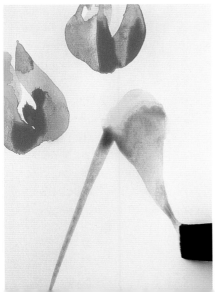

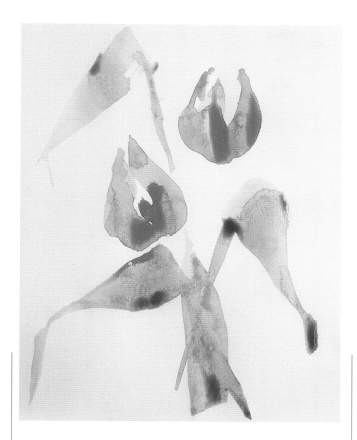

4 Other leaves have been formed with the wide brush, sometimes using different colours on each angle of the brush tip.

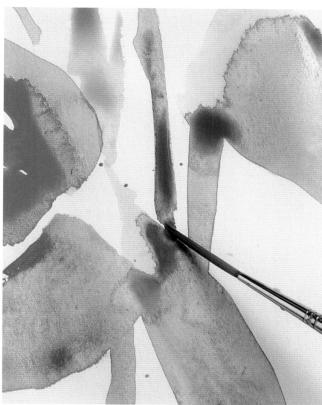

5 A well-loaded rigger brush forms the stems. Riggers hold more paint than the equivalent short-bristled brush and are useful for fine lines and trailing shapes.

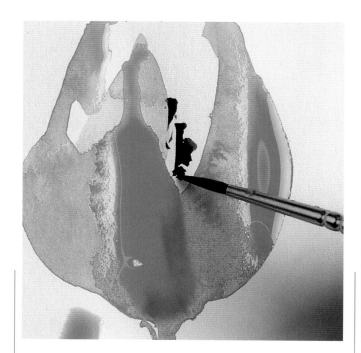

6 For detailed work the delicate point of a fine size 2 sable can accurately pinpoint paint into specific areas.

7 Fairly dry paint is stroked onto the leaf with a dryish flat brush.

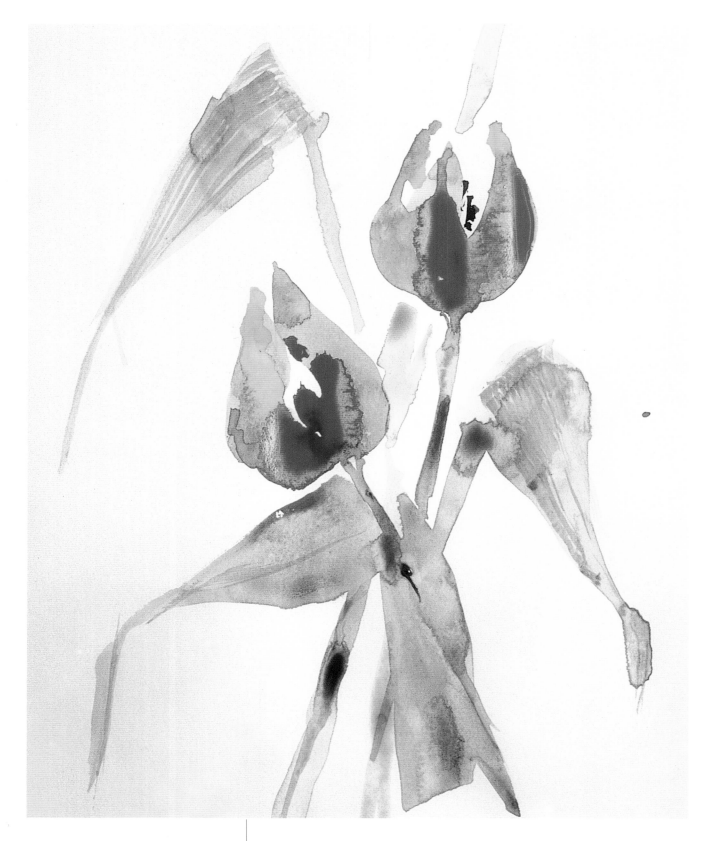

8 The completed picture – a simple
demonstration exercise that succeeds
in producing an effective image.

Papers

There is an abundant choice of excellent artist's papers for watercolour work, ranging from the "Ingres" tinted papers to Chinese handmade papers. Some top-quality papers are coated with a gelatine layer, which helps to prevent staining and increases the brilliance of washes. A good watercolour paper should not yellow over time and should be acid-free. Paper thickness is measured in pounds or grams: the higher the number, the thicker the paper, and therefore the more durable (and the more expensive!).

Artist's watercolour blocks, and the heavier weights of paper, do not necessarily require stretching.

A paper to be used for a watercolour painting must have a highly absorbent quality and be able to stand up to soaking, layering and scraping techniques. The higher-quality papers are carefully treated in order to prevent them from rotting over a period of time and to stop the watercolour from soaking through the paper.

Traditionally, the highest-quality papers are made from cotton fibres, which give the sheet strength and durability. The term "100% rag" is used to denote paper made of pure cotton fibre.

Papers come in three main categories. Hot pressed (HP) is smooth to the touch. Cold pressed (NOT) has a slight textural feel to it and is the ideal all-round paper to work on. The less experienced artist often finds this paper easier to work with than the very smooth satin finish of Hot pressed. Rough paper has a distinct tooth, which can produce magnificent results when used to full effect. A coat of size over stretched paper allows the artist to work with oil paints.

For practice drawing and sketching, any good cartridge paper, either in pad or sheet form, is adequate. For more finished pieces of work in pencil, ink or watercolour, you will find Hot pressed (HP) watercolour paper, of a 140lb (300gsm) weight, is satisfactory.

below Some of the many different types of watercolour paper available.

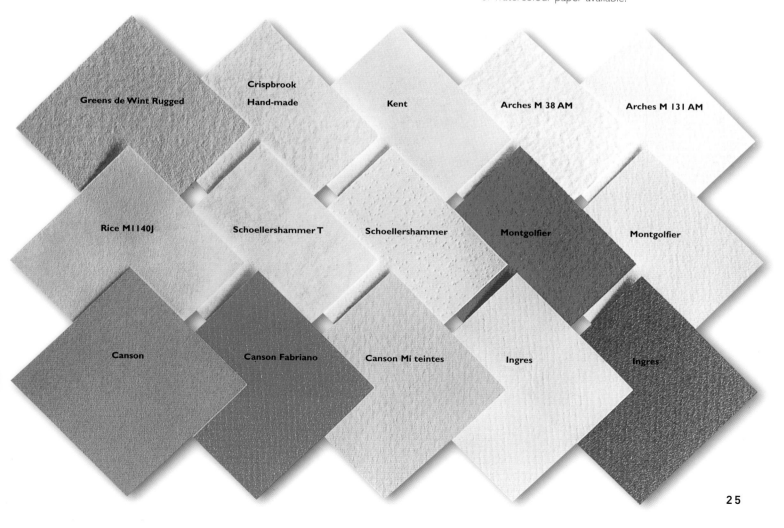

Greens de Wint Rugged

Crispbrook Hand-made

Kent

Arches M 38 AM

Arches M 131 AM

Rice M1140J

Schoellershammer T

Schoellershammer

Montgolfier

Montgolfier

Canson

Canson Fabriano

Canson Mi teintes

Ingres

Ingres

STRETCHING PAPER

Light- or medium-weight papers tend to buckle when wet paint is applied, but they won't do this if they are stretched.

Stretching paper may seem a chore, but there are two excellent reasons for doing it. One is that you can save a good deal of money, because light papers are less expensive than heavy ones and the other is that stretched paper is more pleasant to work on – it is frustrating to paint over ridges caused by buckling.

Stretching isn't difficult, but you need to do it well in advance of painting. The paper has to be soaked and will take at least two hours to dry thoroughly.

1 First check which is the right side of the paper. Hold it to the light so the watermark appears the right way round.

2 Trim the paper to size for the drawing board, leaving a good margin of board so that gummed tape will adhere.

3 Soak the paper in a tray or sink full of clean water. The amount of time needed to soak varies with the type of paper.

4 Measure out lengths of gummed paper tape to match each side of the drawing board.

5 Take the paper out of the water and drain it off. Lay it on the board and stick dampened, gummed tape along one side.

6 Stick gum strip along the opposite side of the paper. Tape the other two sides. Keep the paper flat throughout.

7 To secure the paper, push a drawing pin into the board at each corner. Let the paper dry naturally or it may split.

Easels

An easel is essential for any painter working directly from observation. Having the support vertical enables the artist to make instant comparisons with the subject and the painted image. There are a number of different types and sizes of easels. Small portable metal easels are lightweight, but tend to be unstable in windy conditions. Wooden fold-up easels with telescopic legs are ideal for location work. The ultimate for portability is probably the combination sketch-box easel. When unfolded and set up, this device consists of a paintbox with drawer and a small vertical easel with adjustable legs. For studio work involving larger paintings, there are the radial easel and the studio easel.

Supports

Wood was one of the earliest painting supports. Wood panels are a luxury item and nowadays wood composition is a satisfactory alternative, with hardboard the best in terms of weight, surface and cost. The smooth side should be sanded and primed.

Painting on linen dates from Ancient Egyptian times but was widely used in the Renaissance as a lighter support for massive paintings.

Canvas is a wonderful support, providing a subtle "tooth" for paint and a sensitive resistance to the brush, but it is expensive to buy ready-made. A good-quality art shop will provide you with the canvas and the stretchers. Raw canvas needs to be sealed with glue size and primed.

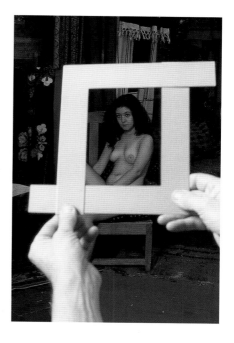

above This shows how a flexible viewfinder can be used to vary the proportions of a rectangle.

Viewfinders

A viewfinder can be invaluable. In the case of a landscape it will allow you to choose a view that fulfils all your needs for a composition.

If you are working on a flower painting or still life it will help you to make decisions about its colour balance and composition – it can be difficult to visualise what the three-dimensional set-up will look like when it is portrayed two-dimensionally on canvas or paper.

Making a viewfinder yourself is not difficult – it is basically a small window mount cut in the shape of your painting support. Use matte board, black on one side and make sure the window is exactly the same proportion as the support you are using. For more flexibility, use two L-shaped pieces of card, which can be moved to make a "window" of varying proportions.

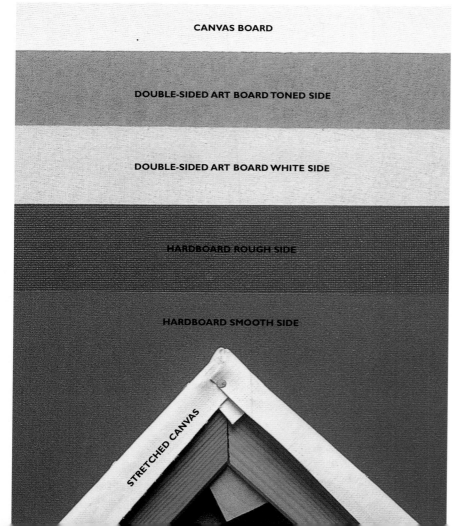

CANVAS BOARD

DOUBLE-SIDED ART BOARD TONED SIDE

DOUBLE-SIDED ART BOARD WHITE SIDE

HARDBOARD ROUGH SIDE

HARDBOARD SMOOTH SIDE

STRETCHED CANVAS

left A variety of painting surfaces for oils.

STRETCHING A CANVAS

Canvas is normally sold by the yard or metre in large widths. Its thickness is defined by weight, so that 510gsm (15oz) canvas is thicker than 410gsm (12oz). To stretch the canvas you require stretcher bars, which can be purchased in various sizes or ordered to your own requirements from specialised woodworkers.

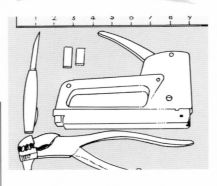

1 The tools required are a ruler, a knife, a staple gun and staples (or tacks if you prefer) and a pair of canvas pliers.

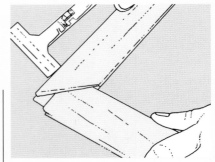

2 Fit the corners of the stretcher firmly together. Give each a sharp tap to be certain it is secure.

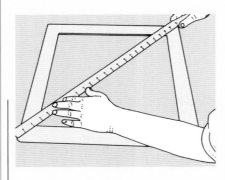

3 Check that the stretcher is square by measuring the diagonals.

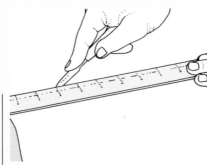

4 Cut the canvas to size using a ruler and a knife. Allow a 3.75cm (1.5in) overlap all round.

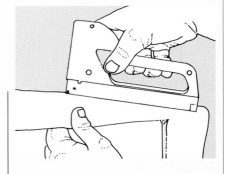

5 Lay the stretcher on the canvas. Fold the canvas over at one end and insert a staple in the outer edge of the stretcher.

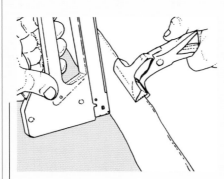

6 Use the pliers to pull the canvas tight at the opposite end and insert a staple. Pull the other sides tight and staple.

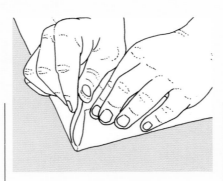

7 Insert staples at 7.5cm (3in) intervals all round, to within 5cm (2in) of the corners. Fold in the first corner tightly.

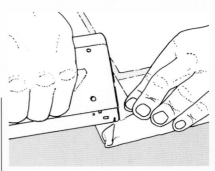

8 Secure the corner with two staples and repeat the process for the three other corners.

PRIMING

BOARDS AND CANVASES MUST BE PRIMED BEFORE

WORKING IN OILS.

This is especially true in the case of canvas, because oil in contact with bare canvas will rot it. Acrylic primers are available that do not require any prior sizing. They are adequate for boards or even paper (a good-quality matte white latex paint is also adequate). To produce the best surface, however, you should first size the board or canvas and then prime it with an oil-based or tempera primer.

Glue size should be purchased from good art shops. Rabbit-skin glue is the best type available. Take approximately 25g (1oz) dry weight and add it to 600ml (1pt) of cold water. Leave it to soak overnight. Using a double-boiler or one saucepan inside another, warm up the mixture until the glue is thoroughly dispersed. Never apply direct heat or allow the glue to boil. When the size has reached blood temperature, apply it to the board or canvas with gentle, even strokes. Do not over-brush and create bubbles. In the case of canvas, the moisture will further stretch the canvas on drying and this is why it is important that the canvas is not too tight in the first place. Wedges should never initially be inserted into the stretcher corners, but should be used to take up slack when the picture is finished.

Allow this coat of size to dry, ideally overnight. and the board or canvas is ready for priming.

CLEANING UP

WHEN PAINTING IS FINISHED. BRUSHES AND PALETTES SHOULD

BE CLEANED TO KEEP THEM IN GOOD ORDER.

Oil palettes need to be covered if they are to be re-used. Brushes should be wiped on a rag, rinsed in mineral spirit or turpentine and thoroughly washed under a running tap. The sediment in mineral spirit or turpentine can be allowed to settle and the liquid poured into a clean jar for re-use. The sediment can be absorbed in kitchen paper or newspaper.

Brushes used for acrylics dry like leather, so they should be kept wet and cleaned immediately after use. Palettes and board should be speedily washed, or peeled and scraped if they have been allowed to dry. The necks of tubes need to be wiped to ensure that they will close tightly.

Watercolour brushes need to be well washed in running water after use and the bristles gently coaxed to a fine point. Many artists store them upright in a jar, but if you intend keeping them in a roll or container, they should be completely dry. Watercolour paints are expensive and can be reactivated – even by performing a little basic surgery on dried-up tubes. A palette can be selectively cleaned by carefully running water into areas you do not want and skirting round paint that is worth keeping. Clingfilm will keep the palette damp.

STUDIO OR WORKING PLACE

EVERY ARTIST DREAMS OF HAVING THE PERFECT STUDIO WITH CLEAR NORTH LIGHT, YARDS OF WORK SURFACE AND AMPLE STORAGE SPACE. FOR MOST ARTISTS THIS REMAINS A DREAM AND WE LEARN TO ADAPT AND MAKE THE BEST OF WHAT WE HAVE. THE FOLLOWING MAY BE OF PRACTICAL HELP TO YOU IN PLANNING YOUR WORK AREA.

Basic requirements

LIGHT If you have a north light you are truly blessed. If you have a mixture of light sources it can sometimes be difficult. Probably the flower painter can cope with this better than most artists as the subject is generally portable and blinds or curtains can exclude the direct sunlight at certain times of the day. Only for a few weeks of the year is it really troublesome and a large sheet of corrugated cardboard can serve as a temporary blind, allowing work to continue. Another solution is a screen placed to shield the working area, thus taking the glare off the paper while not cutting down on light.

It is always preferable not to work in artificial light, although, of course, it is sometimes necessary. A 100 watt daylight bulb is very useful, giving a good clear light which enables you to judge colour well. Placed in a desk lamp it does generate a lot of heat, however and this is something to beware of.

WORK SURFACE It is essential that the height of your work surface – whether it is a desk, table or easel – is correct for you and that applies equally if you use a chair. If you are to spend long hours sitting in one position a comfortable chair is essential. Back and neck ache, even tennis elbow, are possible problems, so it is wise to get up and move around from time to time. You might be surprised to discover how tiring drawing or painting can be.

ARRANGING EQUIPMENT It is important to lay out your equipment in an organised fashion. Assuming you are right-handed, the subject you want to draw or paint is best placed either directly in front of you or towards the left, at a comfortable distance so that you can see it clearly. If you are working at a desk or table the board or block should be propped up slightly in front of you, although you may prefer to work flat. If you are using water the pot should be stood on several folded sheets of kitchen paper. This is important as it enables surplus water to be dabbed off the brush quickly and in the case of spills provides a first line of defence in mopping up. Paints should be on the left-hand side. Brushes and pencils to the right. Of course, this does not apply when using crayons, pastels and so on, but only when water is involved.

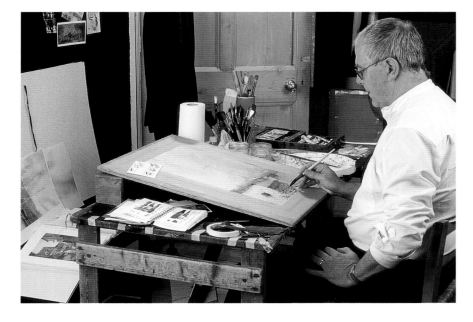

left Creating a productive environment with all the materials and equipment to hand makes working much easier.

right *Lamp and Winter Plant.* By Norma Stephenson. This makes good use of an artificial light source as the glow of the lamplight intensifies the green ivy leaves. The study is drawn in ink, pastel and watercolour.

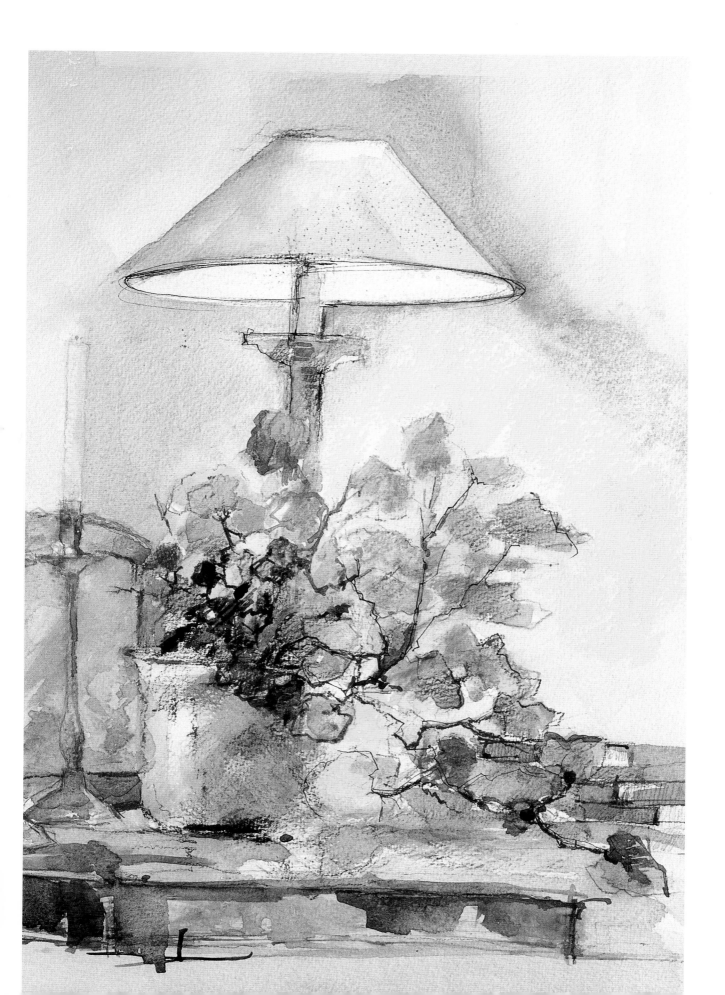

TECHNIQUES

DISCOVERING THE UNIQUE
PROPERTIES OF DIFFERENT MEDIA IS
AN EXCITING PART OF CREATING ART.
FORM IS SIMPLIFIED AS SOON AS THE
BRUSH TOUCHES THE CANVAS,
CONVEYING SUBTLE SHIFTS IN LIGHT
AND CREATING REFLECTIONS AND
TEXTURE. THE ECONOMICAL
APPLICATION OF PAINT, OF WHICH
MANET WAS MASTER, CAN LEAD TO
EXTRAORDINARILY FLUENT PAINTING.
DRAWING AND PAINTING, USING
WHATEVER MEDIUM, IS ABOUT SHORT
CUTS OF VISUAL IMAGERY THAT
PERSUADE THE VIEWER TO SEE MORE
THAN IS ACTUALLY THERE.

PAINTING TECHNIQUES

WATERCOLOUR

WATERCOLOUR HAS A TRANSLUCENCY AND SPONTANEITY THAT
LENDS ITSELF TO A VARIETY OF TECHNIQUES.

Additives

Gum arabic added to the water used
for mixing paint will give a denser
colour and a firmer texture. Ox gall
(literally the gall of an ox – now
happily available in prepared form)
reduces surface tension and allows
the paint to spread freely.

Back runs

Slightly wetter paint, worked into
a wash before it is dry, will spread
into random shapes with hard,
serrated edges. It is a distinct
characteristic of watercolour. Back
runs can also be created and
manipulated with a hairdrier by
blowing the paint in various
directions, and also by tipping the
painting board and then allowing
the paint to flow back over itself.

Dry brush

A bristly texture or lined effect can be
obtained by splaying a fairly dry
brush, loading it with a minimum
amount of paint and dragging it over
the paper at an upright angle.
Experiment on rough paper to gauge
the exact degree of dryness, amount
of paint and the type of bristle to use.
Stiff, longer hog hair generally works
well, as does a flat brush with the
bristles spread between finger and
thumb. Use this effect sparingly.

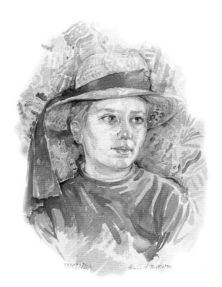

top Back runs created by dropping slightly
wetter paint into a wash and manipulating
it by tipping the board or blowing with
a hairdrier.

above Paint lightly brushed over paper with
a dry brush will produce this lined effect.

left *Lucinda.* Watercolour by Pat Hares.

Hard edges

When a puddle of paint is dropped onto dry paper, the pigment tends to collect toward the edges causing a hard line. The strength of this colour can be increased by pushing or blowing the paint into this edge. This hard-edged effect can sometimes be frustrating when unwanted lines of paint appear because the paper has dried too quickly, but it can be remedied by gently nudging the paint lines with a damp brush or sponge. More often, however, it is a wonderful technique.

Wash over wash, leaving different areas dry, will create a web of flowing lines, which can be used to suggest shapes and add depth to a painting.

right Several layers of wash have been applied here, leaving different areas dry in each case, the result being this mesh of flowing lines.

Lifting out

Removing paint to bare the light paper beneath is another possibility. A sponge, crumpled tissue paper or blotting paper, cotton bud or stiff brushes can be used to lift wet paint from the surface and make a soft-edged shape. Paint can also be lifted out when dry.

Water dropped or stroked into strong colour pushes edges back and can be mopped out. Obviously a lightweight paper will cope less well with vigorous "lifting out".

left A stiff brush has been used to remove areas of paint, leaving soft edges and paler tones beneath.

Masking

For some people masking fluid is the greatest innovation, removing the need for careful painting and adding sparkle to a painting. For others it is an instantly recognizable painting trick and they avoid using it.

It is available as a colourless fluid or with a yellow tint, which is easier to see as the painting builds up and it is applied by spattering or stippling with a toothbrush or painting it in with a brush. However, this can be a disaster for bristles unless the brush is thoroughly and instantly washed in warm, soapy water.

When the masking fluid is dry it can be painted over. Paint settling round masked areas tends to create sharp edges and more paint can be dropped in to heighten the sharpness of contrast. When the painting is finished the masking fluid can be removed easily with a finger or soft eraser.

above Masking fluid has been used to reserve white areas under a wash and, when this has dried, more areas have been masked and further layers of paint applied.

USING MASKING FLUID

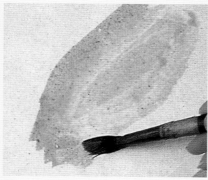

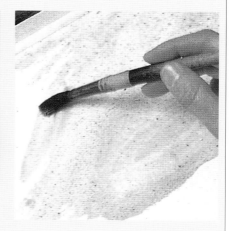

I A small quantity of masking fluid is lifted from the tinting saucer with an old toothbrush. The loaded brush is dragged against the edge of a palette knife so that flecks of masking fluid are spattered onto the surface of the paper and allowed to dry before overpainting.

2 After dampening the paper, the artist mixes a wash of raw and burnt sienna and uses a broad brush to create an irregular shape.

3 The paint is broken by the now-dry droplets of masking fluid.

Wash

The wash is the principal technique of watercolour painting and its luminous character is created by laying thin veils of colour on top of each other.

Wet-on-wet

Heavy or stretched paper, dampened but not soaked, is the best surface for the random and unpredictable technique of wet-on-wet. As a liberating exercise, it is unsurpassed; as a component of a painting, it needs to be controlled. It can establish an atmospheric background or mass of colour but requires the sharpening effect of strong brushwork to add form and substance. The basic wash should be damp but not wet. Paint dropped or painted in will spread. As the paper dries slightly, more paint can be fed in and then manipulated into a planned pattern.

Variegated colour

Bi-coloured shapes can be made by filling the brush with one colour, drying the tip, dipping it in a strong concentration of another colour and applying the two colours to the paper simultaneously. A firmer two-colour stroke can be made by dipping each corner of the bristles of a flat brush in a different colour.

right A wide, flat brush with different coloured paint on each edge of the tip has been articulated to produce these two-colour bamboo leaves. On its edge the brush will produce fine lines but when pressed and turned it will splay out into flowing shapes.

Glazing

This is the classic watercolour technique, which is more precise than wet-on-wet. A light sketch drawing is made onto white paper. Successive washes are applied, starting with the palest overall colour, leaving the bright highlights white. The washes progressively darken and enrich the surface until the final wash is applied only on the areas of deep shadow.

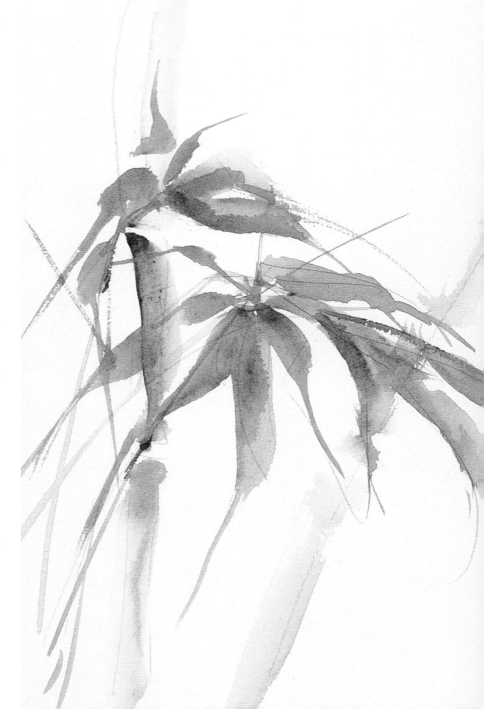

WATERCOLOUR STUDIES

Watercolour is an immediate medium that does not improve with overworking. Confidence and a sure touch, which can only come from practice, are needed.

A very useful way to train the eye and hand, and to experiment with watercolour at the same time, is to take numerous small pieces of paper cut or torn from a larger sheet and force yourself to work rapidly and simply.

left and below These small watercolour studies by David Carr probably took less than 10 minutes. First a light wash of warm colour was laid down, with the side of the brush following the main direction of the torso, head and limbs. While the paint was still damp, and using drier paint and the point of the brush, ultramarine and crimson mixed was drawn into this. Thin washes of cooler paint were glazed over the warm areas where the figure is in shadow, giving a sense of form and movement.

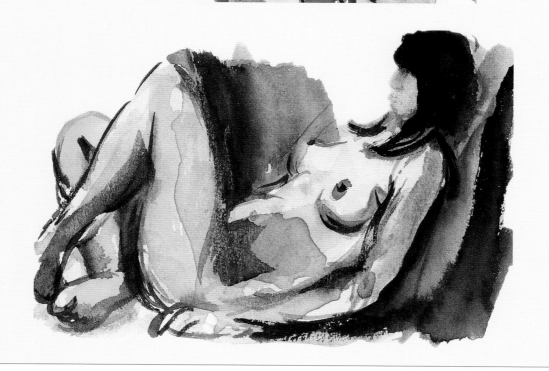

Sponging

Paint can be sponged on or sponged off. Natural sponge produces a less regular effect. Squeezed almost dry, dipped into paint and dabbed lightly onto paper, a sponge will create its own texture. A saturated sponge will spread a wash quickly and smoothly. A dry sponge pressed onto paper will suck in paint and leave cloud-like blanks. A sponge is an essential tool for softening edges and mopping up overwetted areas.

Texture and pattern

Texture and pattern can be achieved by many methods. Fabric or crushed foil, pressed into paint and lifted when dry, can form interesting textures. Spread paint on a surface, press paper into it and then peel it off. Coarse salt sprinkled onto a fairly dense wash will absorb the wet paint and leave a speckled effect. Painting over wax or oil pastels produces interesting results.

above Candle wax rubbed over paper and colour painted over will produce interesting effects.

below These small watercolour studies are examples of the same model painted in different ways, sometimes with a light glaze technique, other times with more wet into wet and with body colour.

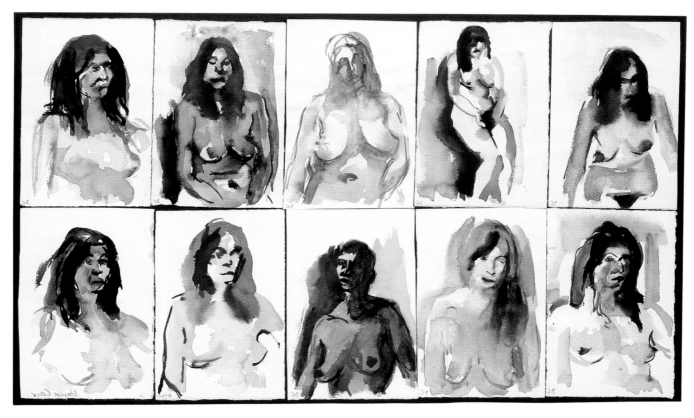

Spattering

Speckles of paint can be sprayed onto a surface by scraping the thumb or knife across the bristles of a paint-loaded toothbrush. Masking will restrict the spattering to particular areas and by partially dampening the paper with a brush or by spraying with water, interesting textures can be created. This is an effective method for breaking up flat areas. The Impressionists' technique of making a sparkling surface can be imitated by flicking complementary colours over each other. In acrylic and gouache, the paint's opacity allows pale colours to be speckled over darker ones.

Line and wash

This is a good technique for sketching on location because you can make a study quickly. Only a minimum of colour is needed, with line added to define forms.

There are two methods:

1 Make a preliminary line drawing on the support, then apply washes of colour up to the boundary lines, still retaining the line beneath.

2 Apply colour washes first, then when the paint is dry, draw the lines on top to accentuate the forms and indicate shadow areas.

Pencil, ink, conté pencil or charcoal are all suitable for applying the line work.

GOUACHE

Since gouache is watercolour with added body, most watercolour techniques can be used easily. The thicker consistency of gouache also lends itself to other techniques.

Additives

Gum arabic added to gouache gives it a sheen. Adding paste makes a thick, malleable paint that lends itself to interesting textures.

Gradating tone

Ribbons of colour placed close to each other and differing slightly in tone can produce a rippling rhythm.

Washing out

This method of using ink and gouache is an unusual one that lends itself well to floral images. It is best described by demonstration, so look at the following step-by-step sequence overleaf.

left Fine ribbons of gouache paint, each varying slightly in tone, have been painted next to each other to give a sense of flowing movement to plant shapes.

WASHING OUT USING GOUACHE AND PERMANENT INKS

THIS TECHNIQUE EXPLOITS THE PROPERTIES OF PERMANENT INK AND GOUACHE. THE BLACK INK INTENSIFIES THE COLOUR, AND THE FINAL RESULT LOOKS RATHER LIKE A COLOUR LITHOGRAPH OR ETCHING WITHOUT RECOURSE TO EXPENSIVE EQUIPMENT.

BY FAITH O'REILLY

1 Poinsettias are chosen as the subject for this because of their brilliance of colour and distinctive form, and they are set against a dark background. The artist concentrates on a small area of the flowers.

2 Using paper with a rough surface to absorb the colour and of sufficient strength to withstand scrubbing under a tap, the artist applies thick gouache using little or no water. The design can be drawn lightly on the paper as here, but pencil marks may show through so it is better to use unaccompanied brushstrokes. Experience will give you the confidence to do this.

3 The quality of the paint is important – try to use only artist's quality or poster paint in pots and look for permanence marks. This is because the colour will bleach out as the ink washes off. Any areas left without paint will be black in the final image. White gouache can be used in any areas that are to remain white. At this stage greens have been added to the background behind the red flowers.

4 When all the colours have been applied, make sure that all areas you do not want to be black are covered in coloured or white gouache.

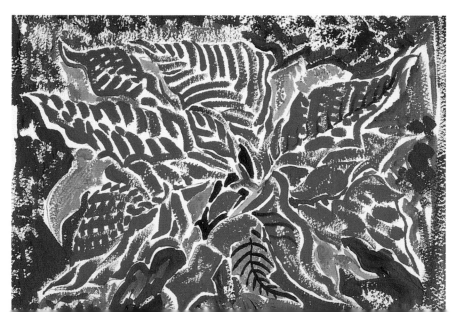

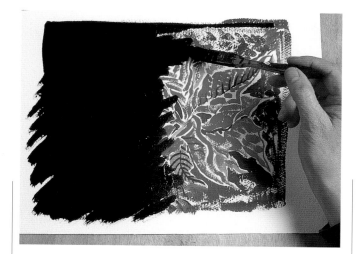 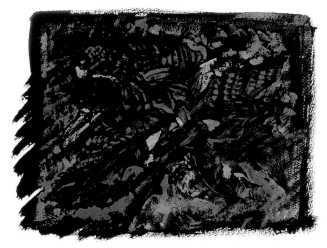

5 After allowing the paint to dry, preferably overnight, apply black Indian ink over the whole surface – other dark-coloured inks can be used as long as they are permanent. The ink is applied quickly using a large brush so that the underlying paint is not disturbed too much.

6 The work is left to dry for half an hour. Then it is gently washed under a tap until the ink begins to lift off. A shower can be used to give more control to the lift-off process. Various results will ensue, and a nailbrush or washing-up pad can be used with a light scrubbing action to make textured marks on the image.

7 The wet paper is then stretched on a flat board, stuck down with gummed paper and cut off the board when dry.

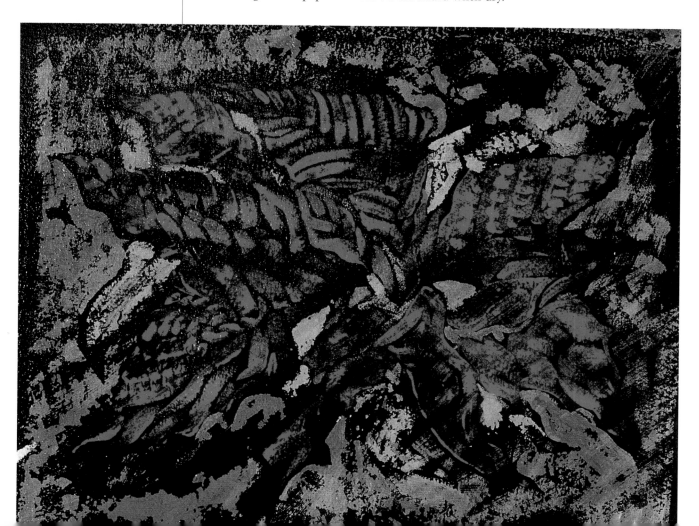

OIL

OIL PAINT IS A MOST VERSATILE, EASILY MANIPULATED AND
LONG-LASTING MEDIUM. THERE ARE TWO BASIC METHODS OF
APPLYING PAINT.

Alla Prima

Alla prima is a simple and direct method of applying paint, in which no preliminary studies are done other than a lightly sketched drawing in charcoal or thinned paint applied directly to the painting support. The support is usually white with no base colour. The paint is applied right across the picture, either in small brushstrokes or in broad areas of colours, followed by blending and joining tones, with a few touches to finish the work. As the painter is working quickly with this method the viscosity (liquidness) of the paint is important. It has to be rather like thick cream – supple, yet at its full brilliance. To achieve this, the paint should be diluted with a little oil and turpentine on the palette *before* starting the painting. The second method is the "traditional" one by which layers or strokes of paint are built up slowly, "lean to fat", starting with very thin layers of paint and gradually applying it more thickly, either adding more oil or using paint straight from the tube.

Glazing

Glazing involves working with successive transparent layers of diluted

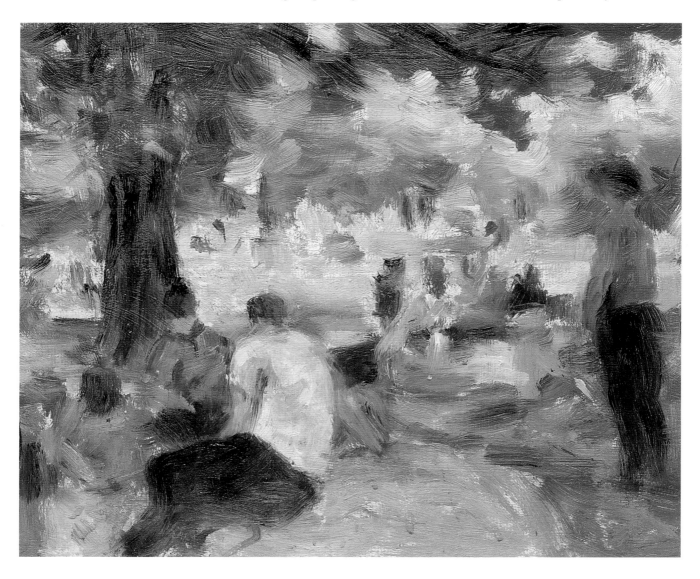

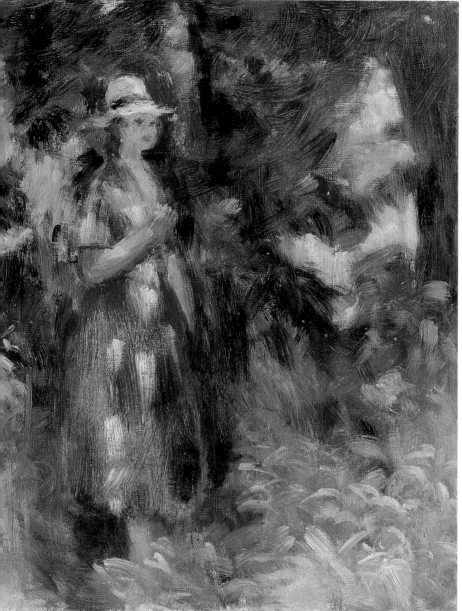

The traditional technique of egg tempera was used until the end of the 15th century and it is experiencing a revival today.

This water-based medium uses the binding properties of egg yolk to complete the mixture of pigment. The traditional ground to work on is wooden board, primed with several coats of gesso. The white of the gesso shines through the tempera to enhance the reflected light.

Egg tempera has the ability to produce luminous, transparent glazes, and due to its fast-drying properties, it allows tones and shades to be built up very subtly. With its sticky and fast-drying nature, tempera has to be applied using short brushstrokes and it resists blending.

left *Girl by the Edge of a Wood*. By Ted Gould. The artist used successive glazes of thinned oil colour to achieve richness and tonal depth. Finally, bright patches of thick colour create the effect of dappled light.

paint, so that each layer allows the colour beneath to remain visible. For those who prefer to build up their picture by stages, glazing is the classic method. It may involve scaling up a sketch or study for transfer to the full-size painting support. The drawing is then made using charcoal or diluted paint. This is followed by a layer of paint, which has been thinned, indicating areas of light and dark. When this is dry, the entire painting is covered by successive layers of paint, except for the very lightest areas. It is important to allow each layer to dry sufficiently before adding the next; this prevents the underpainting from being disturbed and "muddied". Finally, highlights and definition lines are applied using thicker, impasto paint. White is usually absent from the glazes in order to retain their transparency.

Glazing is also suitable for acrylic and watercolour painting.

Scratching

This is simply scraping off paint to reveal the underpainting and leave a textured effect. The point of a palette knife or the tip of a brush handle was frequently used by the Cubists to draw into wet paint.

left *Picnic in the Park*. By Ted Gould. Painted in oil *alla prima*, the band of shadow under the trees, broken with dappled light, contrasts with the sunlit background.

Impasto

Thickening oil paint by mixing with impasto media can produce very satisfying textures and can add great weight to brushstrokes and energy to textures (see right). The buttery consistency of oil paint lends itself to this approach. The use of a fast-drying alkyd medium helps reduce the cracking tendency of thick paint. Thick mixtures of colour tend to dull and muddy if you work them too long on the canvas, so keep the painting fresh and plan your marks if you possibly can.

A stout bristle brush such as a filbert can get the best response from a thickened paint. Palette and painting knives are suitable tools for mixing and applying paint and creating ridges and textures. Combs and even pieces of cardboard add to the variety of impasto textures that can be produced. Plaster or decorator's filler give a fine-grained consistency to undiluted oil paint.

above Oil paint mixed with oleopasto allows the artist to develop impasto textures.

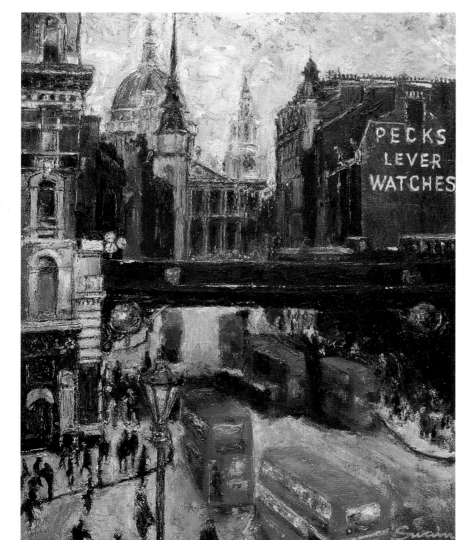

right Scumbling with a flat bristle brush to create texture.

left *St. Paul's from Ludgate Hill*. Oil by Kenneth Swain. This splendid picture has been produced almost exclusively with the palette knife.

Adding sand will give a grainy texture to a painting. Experiment with adding sawdust for a texture of brown sugar, or wood chips for a flaky appearance.

Palette knife

A version of impasto painting, but applied with a knife, this technique is generally used as an overpainting to increase surface texture. Large amounts of paint are first mixed on the palette, then applied to the support using an angled, pointed palette knife.

Sand or sawdust is sometimes mixed into the paint to increase its bulk and texture. The result usually has the appearance of a spontaneous, expressionistic style.

This is also suitable for acrylic.

Scumbling

The dry-brush technique known as scumbling can achieve both depth and texture in a painting at the same time. This involves working over a dry colour with a dry brush and just a little colour, allowing the base

colour to show through in parts. It is advisable to use a durable brush like a hog bristle to scrub one colour on top of another. Scumbling techniques help produce rich textures and luminous colours and tones in the painting.

ACRYLICS

BECAUSE ACRYLICS ARE QUICK-DRYING YOU CAN USE BRIGHT OR
DARK COLOURS FOR THE UNDERPAINTING AND BUILD UP LAYERS
OF PAINT QUICKLY.

Whatever the medium, some pigments are naturally opaque and others are transparent, so it is not strictly true to say that acrylic is an opaque medium and watercolour a transparent one. Oxide of chromium, for example, is opaque whether it is bound with gum arabic for water-colour or with acrylic medium for acrylic paint and likewise golden ochre is transparent. One property of acrylic is its versatility. It can be used in very thin washes, like watercolour, when even the opaque pigments are used thinly enough to make them seem transparent, or at least translucent. It can also be built up thickly and, with the addition of impasto medium, can be worked in impasto techniques.

Glazing

Acrylic paint is ideally suited to glazing. Because it dries rapidly, thin washes of colour can be laid over each other in rapid succession, producing a subtle translucency. It is particularly effective in the initial stages of a painting, and a combination of glazes and thicker opaque areas will produce a lively surface that has depth and body.

Hard edges

Because of its body and speed of drying, acrylic paint makes crisp edges, either butting up against other colour or by using tape or paper mask. It is ideal for fine lines.

Below *Leslie.* Acrylic by Steve McQueen.

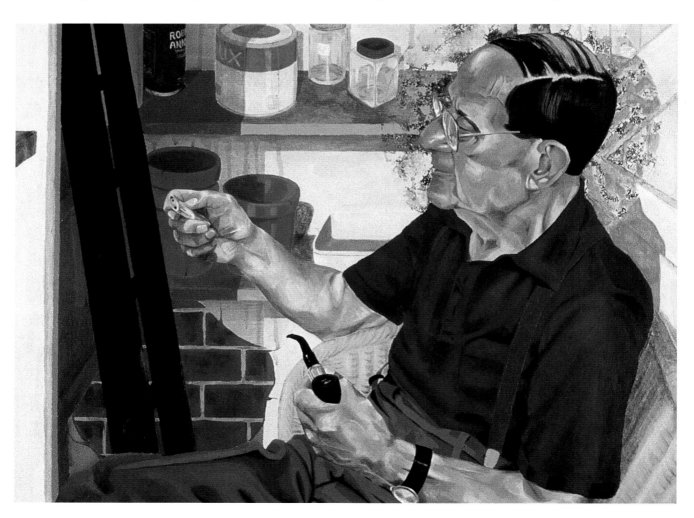

ACRYLIC GLAZE

1 The ground colour of Azo yellow light is painted and left to dry. Then an initial thin coat of French ultramarine is applied.

2 Another transparent glaze of ultramarine is applied. After each stage, the work is left to dry. You can see the original layers reflecting through.

3 Areas of shadow are given a glaze using naphthol crimson, enhancing the three-dimensional aspect of the fruit.

4 The finished study shows the veils of colour, giving depth and gloss to the surface of the fruit.

PASTELS

PASTELS CANNOT BE MIXED BEFORE USING SO IT IS ESSENTIAL BEFORE STARTING TO SELECT ALL THE COLOURS YOU WILL NEED TO COMPLETE A PAINTING. THEY SHOULD BE LAID OUT ACCORDING TO COLOUR AND TONE.

The strokes made by a pastel vary enormously, depending on the angle at which they are held and the manner in which they are used. Held lengthwise and flat against the support, they produce a wide band of colour. Held upright, they can be used for medium-width strokes of colour and for "stubbing in" more brilliant dots of colour. If broken in half, very fine lines can be drawn with the edge onto the support. Pressing down on the pastel will result in larger amounts of colour filling the paper grain and giving a more "solid" look to the mark. Conversely, light pressure results in a smaller deposit of pastel, with more texture and background showing through.

Pieces of pastel can be ground down to make a powder. This can be done with a piece of wood or a metal spoon and then applied to the support with a soft tissue or brush; the technique is useful for obtaining background tints.

Most artists adopt either of two methods of painting:

1 Layering. Broad strokes of pastel are laid one over the other, building up to a rich, dense finish. It is usually necessary to fix each layer before the next is applied, although this can be avoided with soft pastels.

2 Linear. Strokes of pastel are placed all around the picture with little or no attempt to blend. Additional strokes are then applied using different colours until the entire picture is

below *Flower Still Life with Peaches.* Pastel by David Napp. Bold use of pastel.

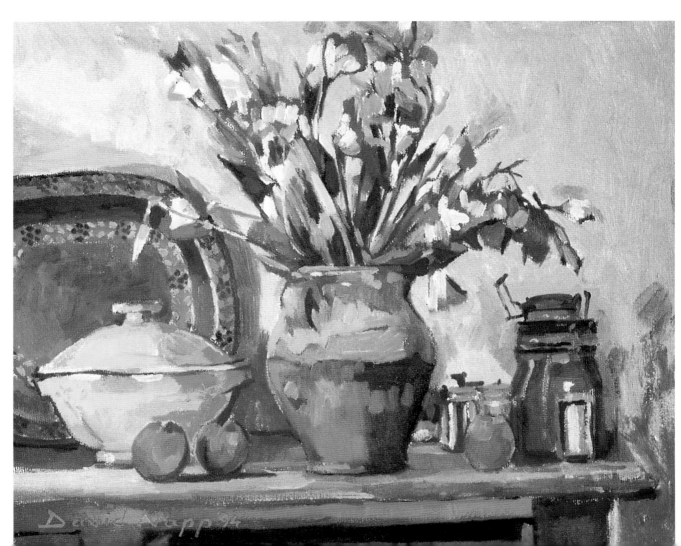

densely covered with long and short strokes. This method is usually adopted for work on a tinted background support, where the intention of the artist is to retain the neutral colour in the final painting.

Protecting a pastel painting

Pastel is the most vulnerable of the painting media. A picture is easily spoiled if the surface is accidentally touched or if it is placed uncovered in a portfolio. Spray lightly with a fast-drying fixative, before covering the work with a sheet of tissue paper.

The paper should be anchored to the support, or wrapped around it to prevent rubbing when the painting is being transported.

Note Be sparing with the fixative, because too much can cause some colours to darken and some, notably white, may disappear altogether.

below Shirley Williams has made excellent use of dark and cooler tones between the groups of flowers to give depth to the picture. Added brightness is achieved by using some complementary colours in this portrayal of a summer bed. Pastel on 00 Flour paper.

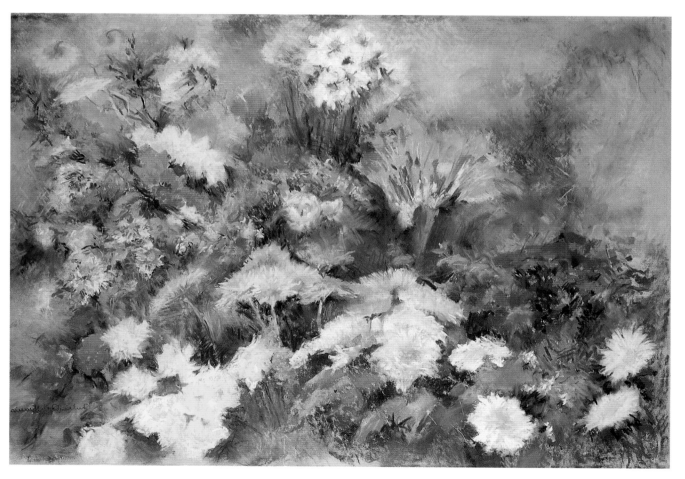

DRAWING TECHNIQUES

PENCILS

Pencils are held in different ways in order to achieve different results.

A fine pencil held upright in the writing position will give a clear, clean line. Held towards the horizontal between forefinger and thumb thus bringing the side of the pencil, or crayon, into contact with the paper gives a broad stroke which will shade and soften the image.

Varying degrees of hardness (H) will produce a paler line or shade. Running down the scale of Bs towards 6B will give darker, softer lines or shade.

This basic technique applies just as well when using conté drawing pencils or any non-soluble coloured pencil. Whatever you use make sure that you keep a good point as a worn-down stub will give poor results. The pencil sharpener and ideally a piece of fine glass paper should be on hand whenever possible.

Remember that a "toothed" paper is best for crayons and coloured pencils so that the pigment can bite on its surface.

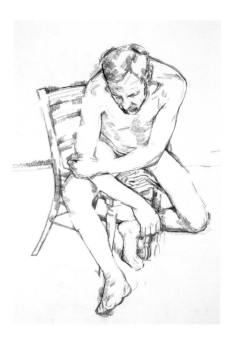

right This very subtle pencil drawing of a man seated on a chair is a perfectly created three-dimensional form with the minimum of pencil modelling.

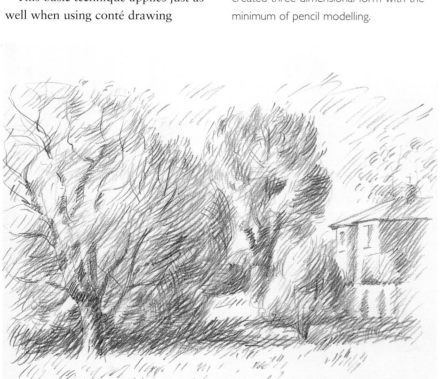

above The spherical shape of these trees make a suitable subject for pencil crosshatching.

Crosshatching

The drawing is made by a build-up of short lines placed at a regular angle across the paper. The angle of the pencil is then changed and the lines crossed again. This process continues until the drawing is "complete". Alternatively, the initial sketch can be made with a very soft pencil, after which the lines are "smudged" with the finger to move the tone around and create areas of light and dark.

The same technique may be used with charcoal.

Pencil and brush

The combination of pencil and brush is probably the technique that is most frequently used by flower portraitists. At the simplest level the pencil substitutes for the pen in a line and wash study, while at the peak of achievement the brush produces the finest lines, turning each silken curve

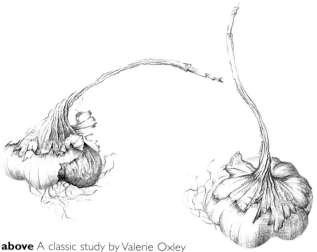

above A classic study by Valerie Oxley captures the texture of the garlic skins to perfection. 2H, F and B pencils were used.

of a petal into a separate work of art.

Start by drawing the outline, keeping the point of the pencil down to make a smooth, even line rather than a feathered one. Keeping the heel of your hand on a piece of paper will act as a pivot.

When the outline is complete apply a wash in the palest shade of your watercolours. Blend in the deeper hues, using a small-scale wet-on-wet technique. Once the flower is stained the brush comes into play. Using the finest possible point, lay on small amounts of the required pigment in delicate hatched lines to model the curves in the flower.

PENS

Unlike a pencil line, which can be changed, once a pen line is on paper, it seems to be immovable and unchangeable – a daunting prospect for beginners.

To overcome this, either make a rough drawing in pencil before applying the pen, or start by using the pen to make an outline of dots which will allow you to disguise any mistakes more easily when you add shading at a later stage.

Contour shading is a technique that involves following the contours of the plant either by going along the line of the plant or across it. In a straight-line shading the juxtaposition of lines can give a wonderful texture. Stippling (see overleaf) uses dots instead of lines (and is also a painting technique).

You can also add ink or watercolour washes – the line and wash technique.

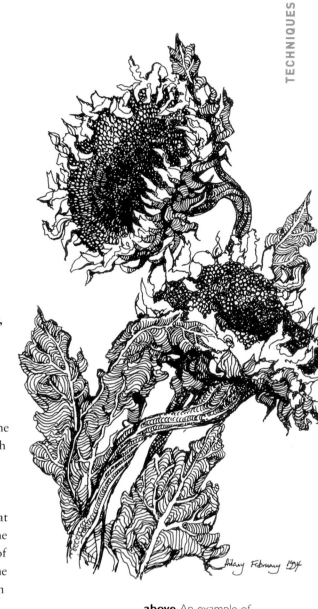

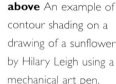

above An example of contour shading on a drawing of a sunflower by Hilary Leigh using a mechanical art pen.

right This study of the encrusted saxifrage "Dr Clay" by Joy Luckas demonstrates the skill required by the artist in portraying a small plant. Not only are the leaves tiny but each one is intricately marked. An initial pencil drawing is followed by pale watercolour washes over each leaf, taking care to allow for the finely marked edges. No white paint is used and the silvery sheen is achieved by "washing away" small areas of paint in some places.

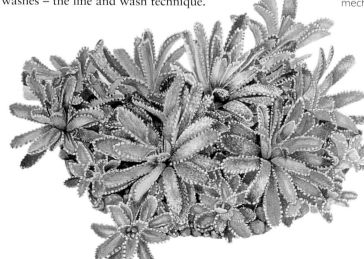

BRUSH AND INK

Use either a sable or a cheaper Chinese brush for brush drawings; you will find that they give very different types of line.

The sable has such great resilience that a line can change from fine to thick and back again. The Chinese brush will not "snap back" in the same way and you have to dip it frequently to re-point it. Nevertheless, it gives a very characterful line with angular movements and abrupt marks. The Chinese brush should be held so that it is almost vertical to the paper.

There is no need to use black ink only. Sepia and sienna are suitable warm shades for a figure study.

below left and right How to hold and use a brush and ink. A variety of thicknesses of stroke can be created with this medium.

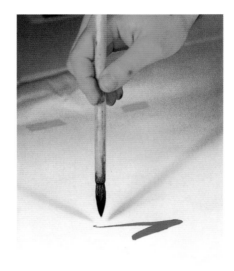
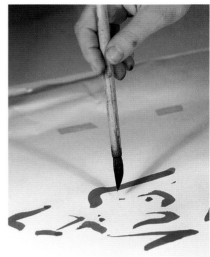

CHARCOAL

Charcoal is useful for very quick compositional studies and can be used to provide the darkest element in a drawing.

It is also ideal for "smudging", where large areas of tone can be created very quickly.

Modelling with charcoal always begins with a simple sketch in charcoal pencil, then tone is built up using either the side of a charcoal stick or small crosshatch lines. It is usually best to leave blending until last. Papers with a smooth surface are not suitable for charcoal.

right You can rub the charcoal with the flat side of the hand to blend it, then lift out any areas with a kneaded eraser. The eraser can also be used on the edge to draw lines into the charcoal.

above A charcoal sketch by Enid Fairhead of a harvest, near Datchworth, Hertfordshire.

MIXED MEDIA

THE TERM "MIXED MEDIA" REFERS TO ALL WORKS THAT USE
MORE THAN ONE MEDIUM.

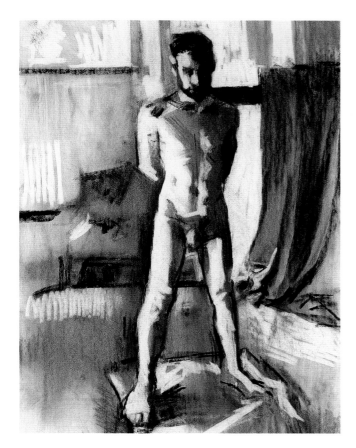

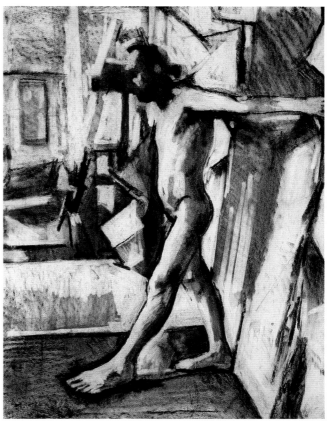

Artists can combine ink, gouache, acrylic and pastel, employing the best qualities of each medium. This method of working can be very expressive, getting around the limitations of one medium by exploiting the qualities of another! Mixed media gives the artist great freedom of expression and can produce tremendous results.

above Charcoal drawings of a male nude.

FINGER PAINTING

Although this may appear clumsy, there are times when fingers (see below) do the best job. The fingers are sensitive "tools". They can soften line and smooth the change of tone, and can rub paint into the grain of the canvas. To achieve a similar sensitivity while keeping the paint off the fingers, wrap a piece of cotton rag tightly around the finger and then treat the surface of the painting as if you were polishing silver.

COLOUR, LIGHT AND SHADE

"LIGHT CANNOT BE REPRODUCED, BUT MUST BE REPRESENTED BY SOMETHING ELSE, COLOUR. I WAS VERY PLEASED WITH MYSELF WHEN I FOUND THIS OUT." THIS SIMPLE BUT CRUCIAL STATEMENT WAS MADE BY ONE OF THE PIVOTAL FIGURES OF LATE 19TH- AND EARLY 20TH-CENTURY PAINTING, PAUL CÉZANNE (1839–1906). ALTHOUGH PAINTERS OF THE 19TH CENTURY WERE INCREASINGLY INTERESTED IN THE GROWING SCIENTIFIC RESEARCH INTO THE FIELD OF COLOUR, ARTISTS HAVE ALWAYS KNOWN THAT A SENSE OF LIGHT IS CREATED BY A JUXTAPOSITION OF COLOURS. THERE ARE POMPEIIAN WALL-PAINTINGS FULL OF GOLDEN LIGHT AND LAVENDER SHADOW; GREEN SHADOWS COMPLEMENT THE WARM CARNATION OF FLESH IN EARLY ITALIAN PAINTING; YELLOW AND VIOLET ARE PRIMARY COMPONENTS OF COLOUR CHORDS IN MEDIEVAL GLASS.

Cézanne's theory was that the more the colours sit in harmony, the more the outline stands out, so when colour is at its peak, form reveals itself to us. Colour can also be harnessed to evoke periods of time, for example using earth colours to evoke the Victorian era. The contrasts of a Greek façade, with multicoloured architraves and balconies of turquoise and red, may seem like a riotous explosion, but in fact to use these hot colours in a composition can create a sense of harmony, serenity and calm.

Colour has an inherent ability to transform its surroundings. Our personal response to colour lies deep within the psyche and defies explanation. Colour can relate to personal experiences within us all. An artist must search for a colour that fits the sensation he or she experiences when viewing an object. It is not just a case of a green pitcher being the one shade of colour, or even the one colour. The eye is extremely sensitive and capable of millions of decisions about colour. Deciding on

colour is essentially selective observation and this power of colour appreciation can be harnessed in the world of paint.

In the Dutch school, the use of similar tonal features was very deliberate. Artists would choose

below This group is composed in colours from within a limited range. Soft and bright shades of blue, highlighted with white, are set in a warm surround of ochres and yellows.

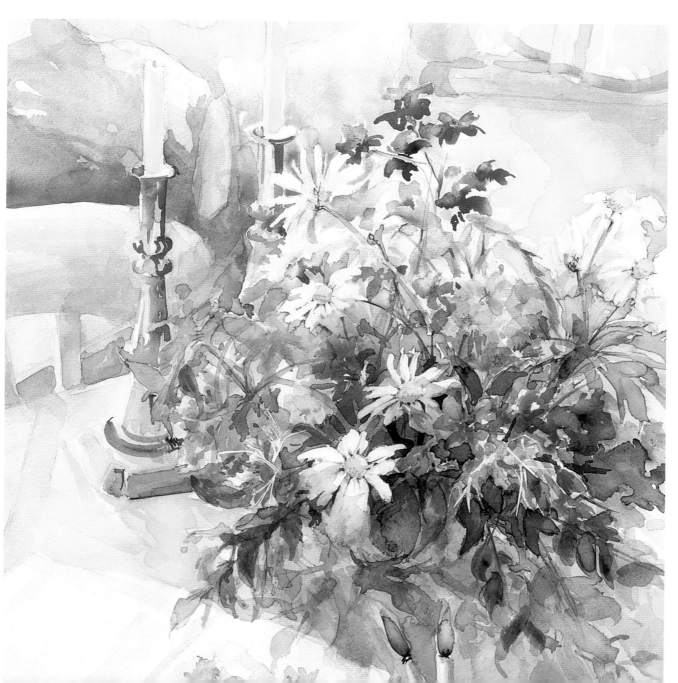

subjects of similar tones and colour, for example a fish on a silver plate and a pewter mug with bread. Soft velvet light caressed the objects. All the tones run into each other to evoke a created landscape of related colour.

Chiaroscuro is the dynamic use of light and shade. This method of elegant lighting, was used by Rembrandt (1606–69), with objects, as if under a spotlight, looking almost solid. This strong contrast of lights and darks can bring to a painting a quality of melodrama, where highlighting is used to lead the viewer from one focal point to the next and where shadows cast in a certain way emphasise the shape of fruit or drapery, picking out surface texture.

Sfumato, from the Italian word meaning delicate shading, is the blurring of images for effect.

Leonardo da Vinci's (1452–1519) masterly use of paint, making soft transitions from light to dark, from shade to shade, creates this smoky, ambiguous effect. A softening of the edges of objects, and a reduction of contrast as you travel further into the picture, can help create the illusion of depth and movement within the picture frame.

The colour wheel (see below), and the separation of colours from warm to cool, is a useful tool in learning to understand the value of colour. The warm colours, namely the yellows, reds and oranges, are balanced by the cool range of greens, blues and violets. You can use the colour wheel to help create balance and harmony in placing colours. Try out a colour combination that is two or three colours apart on the wheel.

COLOUR IN SCIENTIFIC TERMS

In scientific terms colour is the break-up of light into the visible spectrum. A beam of white light passed through a glass prism separates into the bands of colour familiar to us as the rainbow and described by Sir Isaac Newton in the 17th century as violet, indigo, blue, green, yellow, orange and red. Since that time many light-wave frequencies outside that rainbow spectrum have been investigated, notably infrared at the yellow end of the range and ultraviolet at the other. Ultraviolet is the light that enables insects to home in on plants but is impossible for humans to see.

An object has no colour until it is illuminated by light. White light comprises all colours. Most materials and substances consist of pigment that will absorb certain ranges of the light spectrum and reflect others. For example, a yellow sunflower is yellow because it contains pigment that will reflect yellow light wavelengths and absorb all others. An extremely dark object contains very little reflective pigment so most of the light rays are absorbed. Anything that is black absorbs all light.

below A colour wheel showing that paint pigments may not correspond exactly to theoretical colours.

cadmium red
cadmium orange
alizarin crimson
yellow ochre
violet
cadmium yellow
ultramarine
lemon yellow
cobalt blue
yellow-green
Prussian blue
sap green
viridian

HOW COLOURS WORK

above The complementary of any primary colour is the result of mixing the other two primaries. So, in the column of colours, the complementary of primary red is green (primaries blue and yellow mixed), the complementary of the primary yellow is violet (red and blue) and the complementary of primary blue is orange (red and yellow). They are diagonally opposite each other in the colour wheel.

right In proximity, complementary colours enhance and enliven each other. The "twisted thread' illustrates an experiment by Eugene Chevreul, a director of the Gobelins tapestry works. He took several strands of blue (all slightly varied) and introduced a strand of orange – the complementary. The yarn produced had specks of orange. The eye perceives the blue to be more intense than it is because of the presence of the orange.

right The small diagram shows why certain colours, when mixed, give another colour. Coloured dyes and pigments appear the colours they are because they absorb all colour wavelengths except one, which they reflect. The reflected wavelength is perceived as the pigment's colour. This is a simplification. In the example, blue and yellow each contain a little green, not normally noticeable because it is not the dominant colour or wavelength. When they are mixed, however, blue absorbs the yellow light, and yellow absorbs the blue, and their common denominator, green, now doubled, is given off and picked up by the eye.

USES OF COLOUR

THE OVERRIDING ABILITY OF COLOUR IS TO TRANSFORM A PICTURE INTO A PAINTING,
TO EXCITE A MULTITUDE OF EMOTIONS, TO INSPIRE AND INVIGORATE. WHEN COLOUR
HARMONIES ARE ACHIEVED, THE EFFECTS CAN BE EXTRAORDINARY.

Yellow is the colour of spring; orange has reflections of autumn. Limes or apples, with their acid greens, are excellent for vibrant contrasts with red. Look for the greens and shapes of foliage that can enhance colour composition. A bright colour appears stronger when placed next to a neutral colour such as a grey. Use colour for mood: blue to denote sadness or despair, yellows for celebration. Many artists have been known for their obsession with colour, notably Van Gogh, who spent a whole summer in search of a specific yellow, or Picasso with his emotive "Blue Period".

Setting off forceful colours against each other, like the use of yellow and blue that Van Gogh favoured, shows the power of colour at its best. The intensity of the contrast may be tempered by the surface texture of the paint. Short, sharp, isolated brush-strokes of complementary colour can optically mix in the eye of the viewer to suggest a pure colour; the strength of the combined colour will be much more intense than if it had been mixed. This almost pointillist technique can be used to liven up small areas of the composition or to create dynamic contrasts over the whole surface. Henri Matisse said:

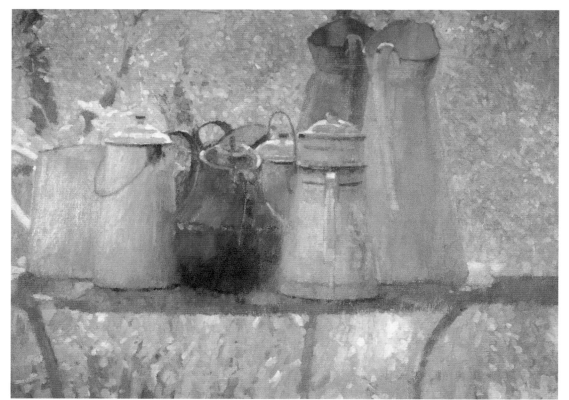

above left *Poplars*. Acrylic by Gerry Baptist. This brilliantly exploits the complementaries pink, blue and yellow to produce a vibrant painting full of light. The neutral black is cleverly used as a unifying factor.

left *Still Life with Enamel Pitchers*. Oil by Nicholas Verrall. Subtle shifts in tone create a lively surface.

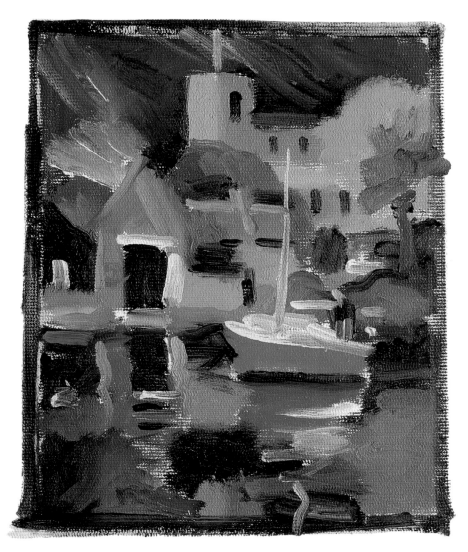

right The inspiration for this picture was the backdrop of the dark, ominous sky set against the warm sandstone church tower. The red boat anchored in front of the church provides a strong focal point.

"When you find three colour tones near to each other… let's say green, a violet and a turquoise, their conjunction calls to mind a different colour, and that is what we might call *the* colour."

Colour, pattern and texture are important elements in any painting. Paint can be applied in clear, precise brushstrokes and built up with planes of colour, giving objects a rugged, hefty form. The use of strong line competing with flat perspective can bring defined form to a composition. And using a complementary colour in contrast to the general colour scheme will bring out a point of particular interest in the picture.

BLACKS AND WHITES

THERE ARE THREE WHITES COMMONLY USED IN OIL PAINTING.

Titanium white contains the dense pigment titanium dioxide, and it creates a good opaque base for mixing colours. It is fairly slow drying and remains workable for a couple of days. Small amounts of titanium white will whiten any other colour.

Zinc white, which has a slight blue tint to it, is more of a buttery texture and is the least opaque of the whites, with the slowest drying time. The transparent quality of zinc white

makes it perfect for glazing paintings. It dries to a brittle, hard film.

Flake white, made of basic lead carbonate, is a very flexible paint to use. It is fast drying and suitable for underpainting.

Note that white does not appear on the watercolour palette. However, Chinese white, a form of zinc white, is often used for highlights and for adding body to colour. With acrylic painting, titanium is again a good

white to use. When using gouache, there is permanent white, an opaque, versatile liquid capable of washes and solid highlights.

There are good blacks and greys available, but in many ways it is preferable to create your own by mixing other colours, such as indigo and alizarin crimson. The depth of colour that is created in this way can add an extra dimension to what might be a dull part of a painting.

COLOUR AND LINE

These four studies use areas of strong colour with clear linear definition of the figure.

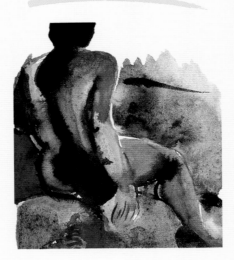

left and below These three small watercolours by David Carr, painted rapidly at one sitting, have a calligraphic quality about them. Strong blocks of pure colour have been laid down for the figure and space, and allowed to bleed a little. There is some glazing, but the form is fully defined by dark, sweeping lines of deep violet (alizarin crimson and French ultramarine) or a near black (cadmium red and French ultramarine).

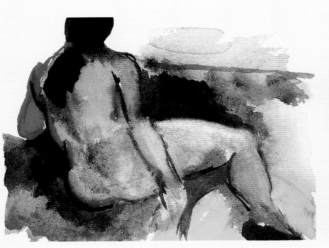

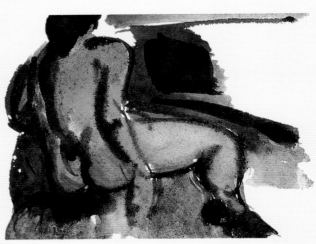

left Similarly, in the small reclining figure by David Carr, broken washes and glazes of clear, warm and cold colours gain their definition by drawing in the form.

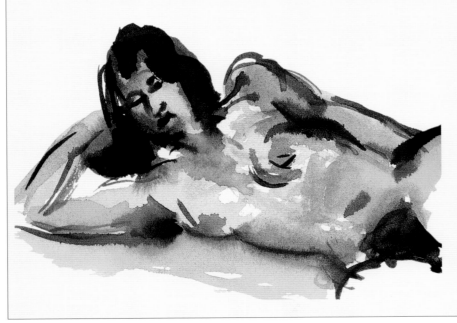

HUE AND TONE

COLOUR IS ALSO DEFINED IN TERMS OF SATURATION, HUE AND TONE.

Saturation means using colour at full strength to obtain maximum intensity; desaturation means diluting the colour and reducing the intensity.

The term hue indicates the tint or shade of colour and its variations, how much white or black the colour contains. The top illustration on this page shows a study in gouache using only hues of cadmium yellow.

Tone is the quality of light and dark. When a coloured picture is reduced to shades of grey on a photocopier we can see the tonal values clearly.

Yellow tends to be light in tone, violet dark, but other colours on the colour wheel that lie between them – orange, red, green and blue in its lighter hue – are fairly similar in tone. Assessing tone is one way of obtaining balance in a picture.

Balance can also be achieved with colour by utilising the affinity of two related colours, say red and orange and balancing them with a complementary colour, like blue, which is darker in tone and which is the complementary of orange.

left This tonal painting of nettles uses only the shades from black to white. Brilliant white catches the rather cruel, jagged-edged leaves and the luminosity of a glowering sky. Various shades of grey and black and textures of paint and ink, explore the intricacies of the dense undergrowth.

above Gouache colours can be mixed with white and black to make a whole range of hues. Here cadmium yellow has been used in its pure form and mixed in various proportions with black and white to make this wide variety of colours, from pale primrose to dark olive.

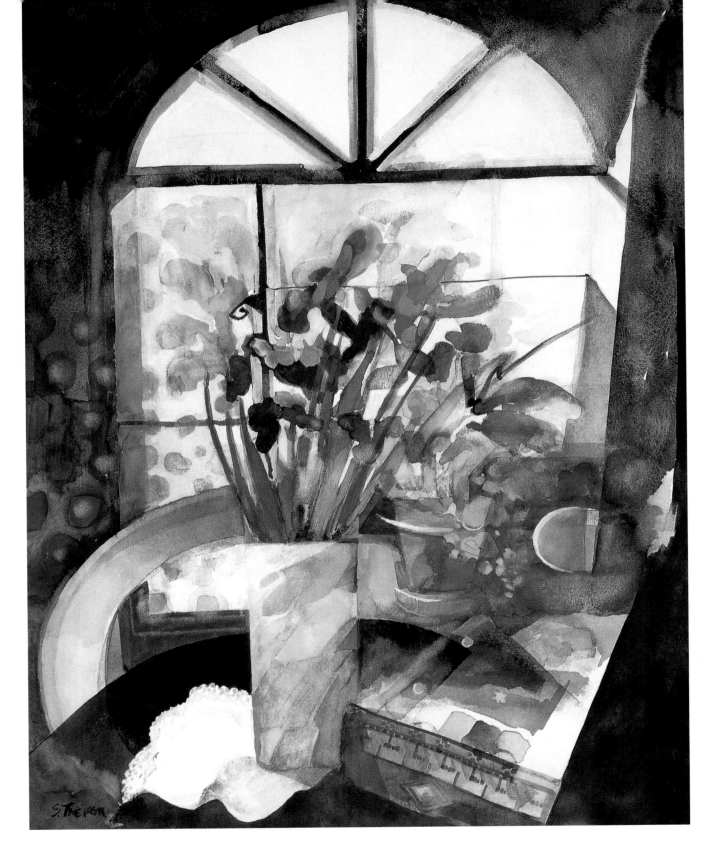

above *Iris and Sewing Box.* By Shirley Trevena. This captures the brilliance and intensity of a back-lit scene. The outer petals of the flowers are hazy and indistinct, soft forms in subtle colours that contrast with the stark shapes of the unlit flowers. Light catches various surfaces throughout the composition and creates luminous areas of shape and pattern. The colour scheme adds to the drama of the composition, a surround of subtle purple and brown linked by a gentle patterning of red to the concentration of colour in the centre of the still life. Yellow detail enhances the brilliance of the lilacs and purples.

THE EFFECTS OF LIGHT

THE INTERPLAY BETWEEN LIGHT AND SHADE GIVES A PAINTING ITS LIFE, A PATTERN TO ITS SURFACE AND A WEIGHT AND DIMENSION TO THE SUBJECT.

It is a means of expressing a three-dimensional subject within the two-dimensional limits of a painting. Light can add excitement and, by contrast, give dark passages a rich density and an air of mystery.

Consider the effect of a different light direction on a subject. It will be uniformly lit and there will be a lack of dimension.

The same subject obliquely side-lit will look totally different. This is the traditional method of lighting a group, used by painters for centuries, either from a window or by candlelight and is the most effective way of establishing form and bulk. Parts facing the light source will be pale with white highlights, merging round the form to very dark areas where the subject receives no light. Shadows are cast, adding weight to the composition and the pattern they make is often as exciting as the original subject.

Lit from the back the subject becomes even more dramatic. Deep colours and tones, barely indicative of their normal colour, will contrast strongly with a surrounding aura of light and a pale hazy background. The mood is theatrical and the effect dramatic. Inky shadows are cast in the foreground, leading the eye into the intensity of the picture. Colour and tone change in an unexpected way when seen against the light.

Light is one of the elements over which an artist can have great control in the creation of a picture, with the power to direct and readjust the source of light until exactly the right effect is achieved. By utilising an interesting source of light, the pattern made by light and dark can become a principal feature of the painting, bathing an area in lamplight while pushing the background into murky shadow, or using a chink of light to create a brilliant spot of colour, or stripes of brightness that ripple over the form, giving it a different identity.

right *Temptations 10/12*. Oil by James McDonald. Dramatic use of contrast, light and shade.

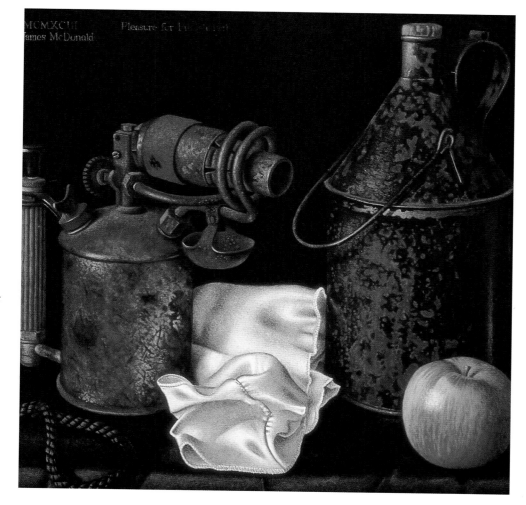

SHADOWS

FOR EACH SOURCE OF LIGHT THERE IS AN APPROPRIATE

SHADOW AND EACH SHADOW HAS AN IDENTITY OF ITS OWN.

S hadow is not, as might appear at first glance, a uniform dark area on the opposite side of light. It is made up of umbra (total shadow) and penumbra (partial shadow), and in each part there can be great variety of tone and colour. Look at the shadow to find where the darkest part is and see how it is coloured, look at the subtleties and pattern in the palest part and see how the whole merges with the light, sometimes creating a stark line, sometimes a gentle fusion.

Building up colour in shadow helps bring to life dull areas of a painting. Complementary colours can be played off each other for effect. The juxtaposition of tiny amounts of these opposite colours can create vibrant contrasts that can transform a painting; for example yellow and violet could be the right contrast to lift an area (see right).

above left and right Two versions of the same pose. On the left, dark pastel in the shadow area creates a solid form. On the right, the bright orange in the shadows makes the figure seem translucent.

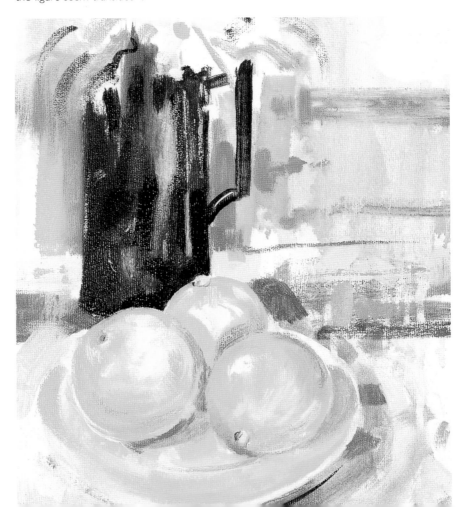

right The yellow plate and lemons contrast with the shadow area of violet.

DIRECTION OF LIGHT

An important factor in landscape painting is the direction of light. There are four directions from which light can illuminate a scene: front, side, back and top. On cloudy, overcast days, the direction is usually from above. The tops of objects are the lightest, casting a pool of soft shadow beneath. The absence of sunlight reduces contrast both in colour and tone, producing a generally muted effect.

above Back lighting occurs at the extreme ends of the day, at dawn and at sunset. In this case, the light is coming directly towards the painter from low in the sky. The sky itself is the brightest area in the scene, reducing all the objects between the sky and the artist to silhouettes, with long vertical shadows in front. In this study the girl carrying the basket has fine highlights on her head, the side of her basket and the edge of her blouse.

left Side lighting. This study assumes that the light is coming from the left and fairly low down. The sun is bright in a cloudless sky, causing the trees, figure and building to be seen three-dimensionally and in sharp relief. Shadows are cast diagonally from the right side of the objects. Strong side lighting illustrates Cézanne's thesis that all nature is based on the sphere, cone and cylinder.

left Front lighting. The position of the sun is directly behind the artist in this study. The effect is to increase the colour temperature to its warmest and flatten the shapes of everything. The angle of the light source is high, so that the shadows are underneath the forms.

FLOWERS AND STILL LIFE

FLOWERS ARE A SYMBOL OF LOVE AND LIFE, FRESHNESS AND VIGOUR. TO PAINT OR DRAW THEM IS THE ULTIMATE PLEASURE. FLOWERS OFFER A SUBJECT OF THE UTMOST VARIETY IN A FORM THAT IS PART OF OUR EVERYDAY LIVES. CERAMICS, TEXTILES AND ADVERTISING ALL MAKE USE OF THIS SIMPLE IMAGE AND FOR CENTURIES FLOWERS HAVE BEEN AN ESSENTIAL ELEMENT IN MANY STILL LIFE PAINTINGS.

LOOKING AT PLANTS

IF YOU LOOK AT THE WAY A PLANT HOLDS ITSELF, THE MANNER IN WHICH IT
STANDS, CLIMBS OR SPREADS, A PERSONALITY WILL BE REVEALED, VIGOROUS
AND ERECT, SOFT AND INCLINING, UNDULATING AND INVASIVE.

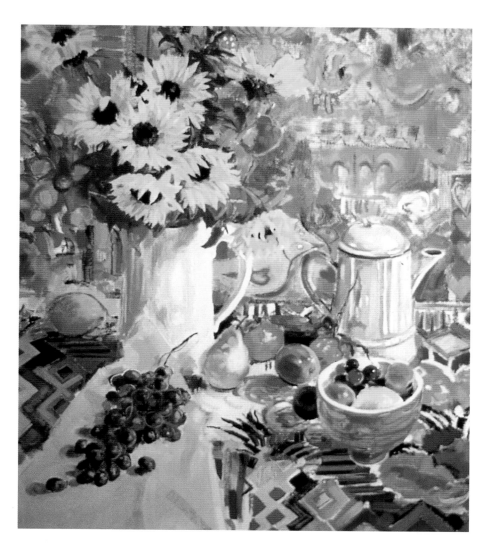

right *Still Life of Sunflower*. Oil by
Peter Graham. A highly coloured
still life.

The manner of a plant's growth
will give you the skeleton. Closer
analysis will unravel the structure of
the components – the composition of
the flower head, the shape and
texture of petals, the way the leaves
join the stem, the roots and fruits –
and the way they all fit together. A
picture will emerge from this
investigation of a singular identity
with pronounced characteristics.

There is another equally important
way of looking at plants. It is the
exploration of what you actually see
before you, the jigsaw of shapes made
by plants facing you at odd angles
with petals overlapping and leaves
and stems twisting, bending and
crossing. You will see colours and
patterns made by shadows, and by
leaves set against the light. Analysing
the plant in this way will reveal a

group of shapes, some of which bear
no resemblance to the conventional
flower shape you think you know,
but which are the reality of what
you actually see.

It is very easy to look at a plant
and see it in terms of flowers and
leaves, to draw the most distinct
features and then haphazardly join
them. The structure of a plant is in
some ways like that of the human

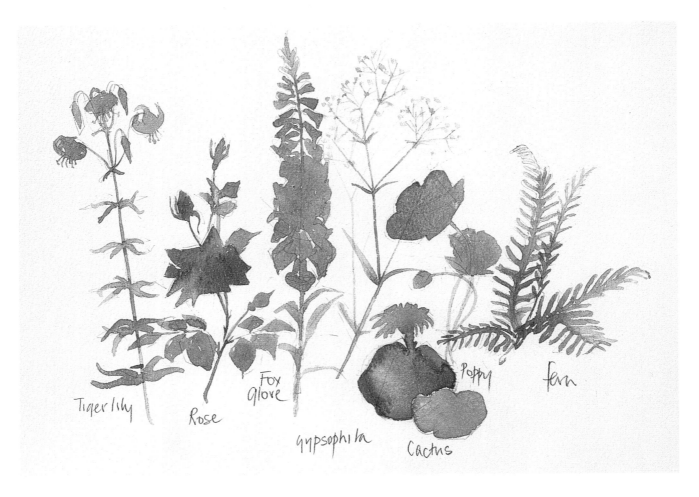

Tiger lily

Rose

Fox glove

gypsophila

Cactus

Poppy

Fern

skeleton, so it makes much more sense to draw the plant's basic skeleton along what might be called its spinal cord and move outward via the all-important joints and angles toward the flowers and leaves. Head, hands and fingers move in all manner of ways, but they are dependent upon the extension of the joints – shoulders and hips – and they have little identity when drawn unless this join is convincing. The equivalent of head, hands and fingers are petals and leaves; the hips and shoulders are the junctions.

Junctions

One of the key areas in a plant is the junction. Branches, flowers and leaves and stem are joined to each other in distinctive ways, and these junctions hold the key to the structure and posture of the plant.

Sometimes this attachment is simple, leaf stalks springing from a simple bump. At other times, the junction is a complicated knot of twisting foliage.

Points to notice when constructing junctions are how the collection of leaves and stems fit together, what goes over what, the angle of the join and whether the leaves or flowers spring from the stem or unwind from a wrapping. All this will alter at various stages in the life cycle. The colour at a junction may be different from the rest of the plant, and the texture and width of the stem may vary above and below this point.

Notice also the junction at the base of the plant, the way the plant grows from the root – as a single

above The shape and structure of some plants is so distinctive that they are instantly recognisable even without the clues of colour and detail. A silhouette highlights the features that give rise to this recognition.

column or as a mass of stems – and the way the flower is attached to the stem. Once you are familiar with the junction, the rest will follow easily.

Stems

When looking at the junctions keep an eye open for different types of stem – angular, sinuous, woody – and the marks on them – leaf scars, speckles, peeling tissue, thorns. Look at the texture – fleshy, flaky, hairy, smooth – and the colour, which in

many cases may be totally different from the leaves and stem. Look also at the way light defines a stem and how the gradation from pale to dark can emphasise the roundness or squareness of the stem and how the repetition of dark and light shadows on the curves creates movement as they thicken and taper. The stem is a very useful element in a loose flower painting; colour dropped into wet paper, creating hazy shapes, can be given a structure by simply painting in a few stems.

Leaves

The basic shape of the leaf may vary enormously. The important point to look for in a leaf is the central spine.

The leaf growing along this spine may be a simple oval shape or more complex and divided into fingers. The edges may be smooth or frilly, serrated or prickly; the texture may be hairy or shiny and glossy.

Many leaves are complex, with leaflets placed on either side of a central stem. Look at the way these are arranged, opposite each other or alternating, and the way they join the central stem. Look at the angle at which leaves grow, unwinding from a central stem, like the iris, stabbing upwards like a sword or inclining with age. Establish the line of growth and the rest will follow.

Leaf veining is often responsible for the pattern on the surface. Even a

small area of veining can identify the whole. Notice the texture of the leaf surface and its underside – bristly, waxy, hairy – and the colouring, which may vary in different parts of the leaf. Young leaves are frequently pale; stalks and leaf edges are often a different colour. Variety of leaf shape can add pattern to a painting.

Observation and an understanding of the makeup of plants should be used as a backup to the emotional response that must be at the heart of the picture. This knowledge will give a sense of familiarity with the flowers you intend to paint and, thus, a confidence in capturing the particular qualities that have inspired you to paint them.

below A group of ivy leaves collected to examine the considerable variety of colour in one genus of plant. The veins are an important part of the pattern of this plant and help define the line of growth.

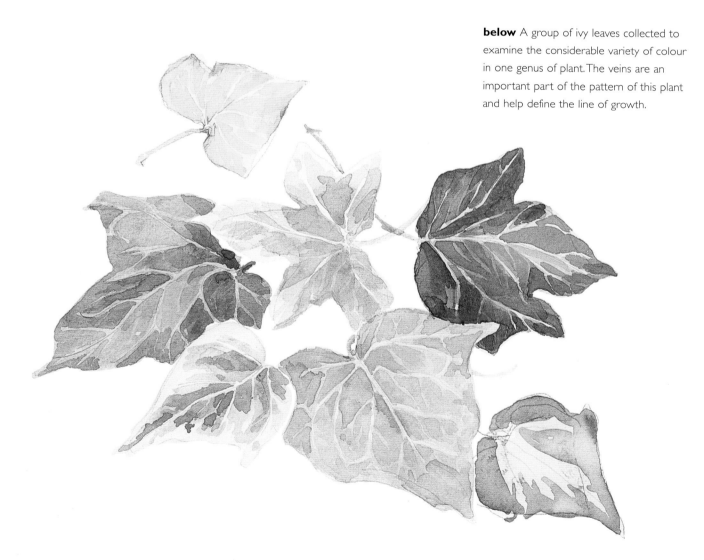

DEALING WITH DETAIL

THE ARTIST NEEDS TO STUDY THE NATURAL FORM OF THE PLANT IN DETAIL TO SEE HOW ITS
COMPONENTS APPEAR TO ALTER WHEN THEY ARE VIEWED FROM DIFFERENT ANGLES.

Without this awareness any artwork will look flat and lifeless, as well as botanically incorrect, instead of lively and three-dimensional. The first detail to concentrate on is the leaves of the plant and the effect that foreshortening has on them.

Foreshortening leaves

To the beginner it often seems that the very word "foreshortening" is the gateway to difficulties, but that need not be so. Remembering certain elementary facts will help to make it easier, as the following simple exercise will demonstrate.

In your left hand hold an object such as an audio cassette level with your eyes and totally vertical. In your right hand hold a ruler against it.

You will see that the cassette measures approximately 7cm (3in). While keeping the ruler in position, tip the cassette away from you. As it tips back the reading on the ruler decreases. Stop when the top edge reaches 5.5cm (2.25in). You have foreshortened the cassette. You will also see that the top corner of the cassette has apparently moved away from the vertical ruler and that the back edge appears to be narrower than the leading edge. This is perspective. If you continue to tip the cassette back the surface area gradually disappears from view until you are looking at the edge of the cassette, which measures approximately 1.5cm (0.5in).

Now substitute a simple leaf shape for the cassette, and tip that

above left Cow parsley has the most complex junctions, both ridged and bulbous, and the feathery leaves spring out in all directions.

above One of the features of stems is that they are often seen bunched together, crossing and twining, losing their singular identity, but forming a distinctive mesh.

in the same fashion until you are holding it on the horizontal. You will be looking at the edge of the leaf, with the least amount of surface area exposed.

With practice, drawing in such a way will come naturally and you will begin to realise that you can trust your eyes.

Drawing stems

It is a fact that if you draw towards a given point rather than away from it you are more likely to produce a sweeping, accurate line. This is more useful when drawing stems. Picture the long sweep of a tulip stem. Instead of starting at the bloom start the line at the required distance away from it and, keeping your eye on the point where you wish to make contact, bring your pencil towards it. You are more likely to score a direct hit with this method. So, on some scrap paper mark a cross, keep your eye on it and from about 35cm (14in) away, sweep your pencil toward it. Repeat this until you feel confident.

While on the subject of stems it is worth mentioning that often there is a variation in thickness between leaf joints, often seen on roses. These are the times when drawing a long stem becomes easier to cope with as one works between the leaf joints rather than along the whole length.

Hirsute or hairy stems should be looked at carefully before drawing. The hairs are never regularly positioned. Neither do they all emerge from the stem at a 45 degree angle, or indeed from the "edge" of the stem. Some will protrude from the stem surface with only the tip of the hair silhouetted against the light. In some ways the hairs look finer when drawn towards the stem rather than away from it, but whichever way you choose to draw, delicacy of touch is essential.

Foreshortening flowers

Foreshortening flowers never seems to pose the same mental block as foreshortening leaves. Perhaps this is because we tend to think of flowers in more human terms, either full face, semi-profile, or full profile. For whatever reason, a composition of all full-face flowers would be very boring and it is necessary to include other profiles to give depth and interest.

A flower seen in profile, either from front or back, has more pegs on which to hang the drawing. In the former the configuration of petals around the bud provides focus, whereas in the latter sepals and calyx add a different dimension.

When tackling any flower, it is helpful to decide on its overall shape first. Take rough measurements with the pencil, literally against the flower, at strategic points and mark these lightly on your paper. Then link these marks with straight lines to give you a grid on which to place your drawing.

In the projects that follow, line and wash, ink and dry-brush techniques are used to depict the delicacy of flowers and the curves of stems.

below This botanical drawing of a tulip shows how the brush is used to line the petal, conveying both curve and texture.

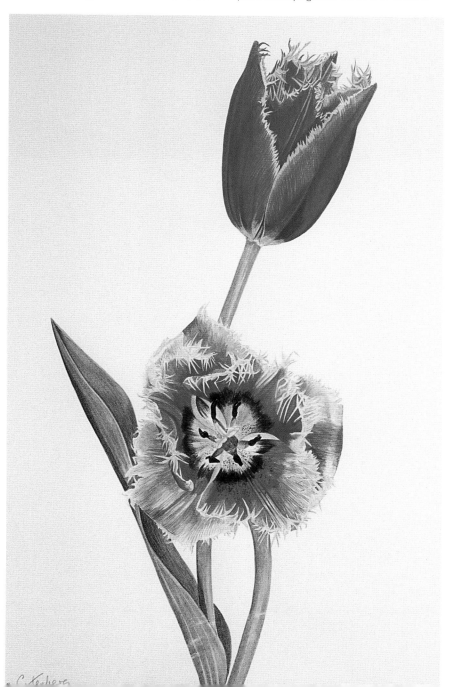

BROOM

A SIMPLE LINE AND WASH DRAWING, WITH LATER ADDITIONS
USING COLOURED AND WATER-SOLUBLE PENCILS.

BY MARGARET STEVENS

1 A pot of broom suggests summer on a February day.

2 A single flowering spray is very quickly drawn using a 0.3mm technical pen.

3 As it is not intended to portray the entire plant, a second spray most suited to its position is added.

4 The desired shape of the composition is gradually achieved.

5 The artist adds a pale wash of blue watercolour behind the blooms.

6 Soft kitchen paper is used to dab out a cloud effect.

7 A wash of pale aureolin yellow is applied to the flowers with a little Indian yellow to provide simple shading.

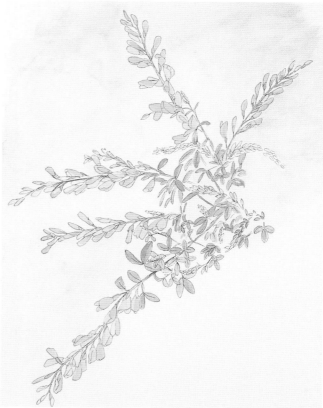

8 The tiny leaves are washed over with a pale bluish-green.

9 You can now see the overall effect.

10 The artist uses a watercolour pencil in night green to give depth at the base of the plant.

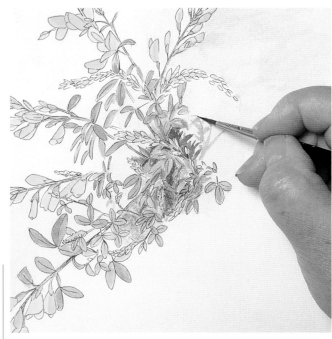

11 This deep colour is blended in with water using a fine sable brush.

12 Later the picture is finished by the addition of a rocky outcrop executed in watercolour and coloured pencils. Further sprays of broom extend the plant and additional crosshatching in ink intensifies the shadows.

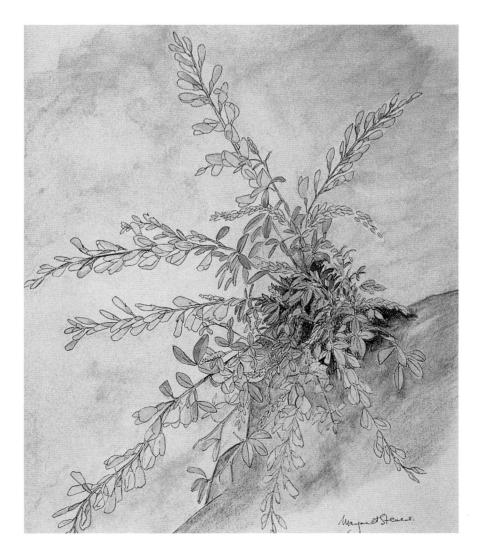

SEEDHEADS

THIS DRAWING ILLUSTRATES WHAT CAN BE ACHIEVED BY
USING COLOURED INKS WITH A SIMPLE MAPPING PEN, TO
PORTRAY VERY SIMPLE PLANT MATERIAL.

BY HILARY LEIGH

1 The seedheads were collected in summer and left to dry naturally.

2 Two stems of dock are drawn, using burnt sienna ink, to establish the upper limits of the picture.

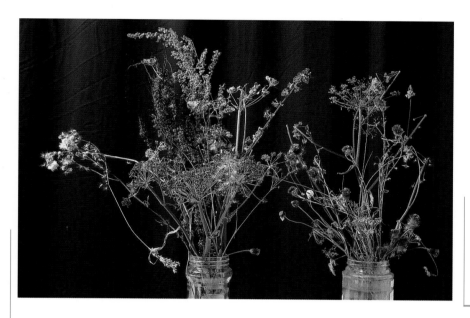

3 The artist uses purple to draw a head of cow parsley, partly in front of the dock.

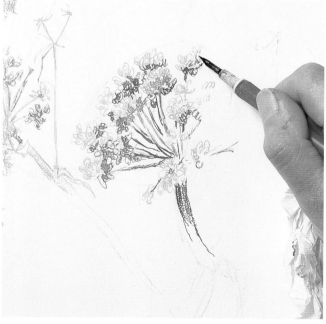

4 Purple is used again to add detail to a yellow umbelliferous seedhead.

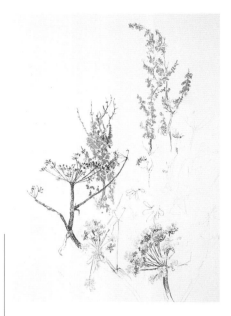

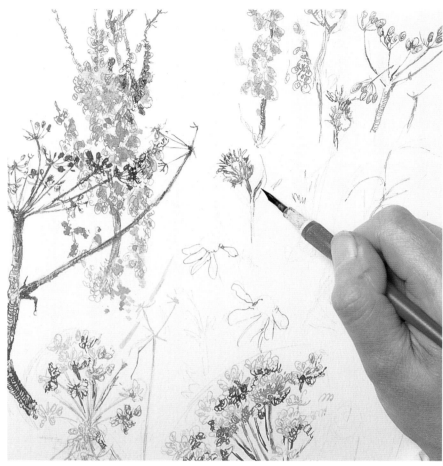

5 The basic structure of the picture is now established.

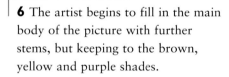

6 The artist begins to fill in the main body of the picture with further stems, but keeping to the brown, yellow and purple shades.

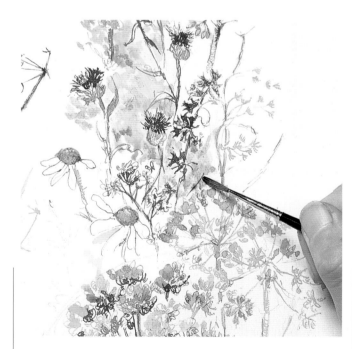

7 A brush is used to run in a well-diluted mix of yellow and Prussian blue, which makes an attractive green and gives an impression of hazy depth.

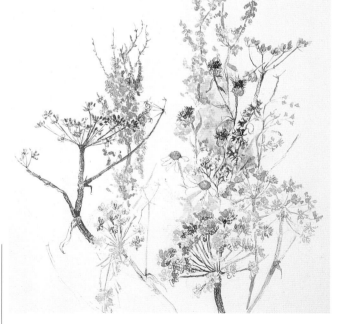

8 You can see how the body of the composition has started to fill out.

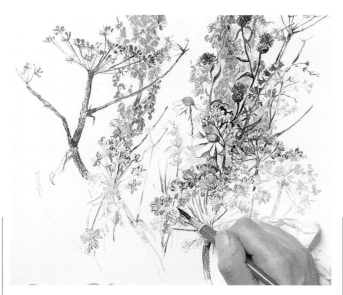

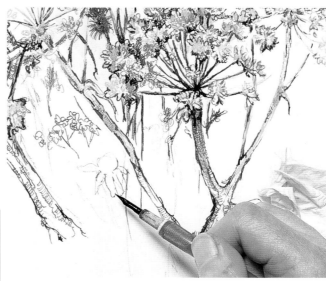

9 The artist has called on her memory of summer by including the moon daisies and now the centre of the drawing is being worked on to give a more intense tone.

10 Stems are being finished and an additional daisy gives interest at the bottom of the picture.

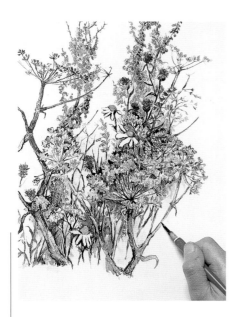

11 A final touch of detail is added to a woody stem.

12 The finished drawing is an harmonious blend of very few colours, inspired by a basic collection of what would commonly be called weeds.

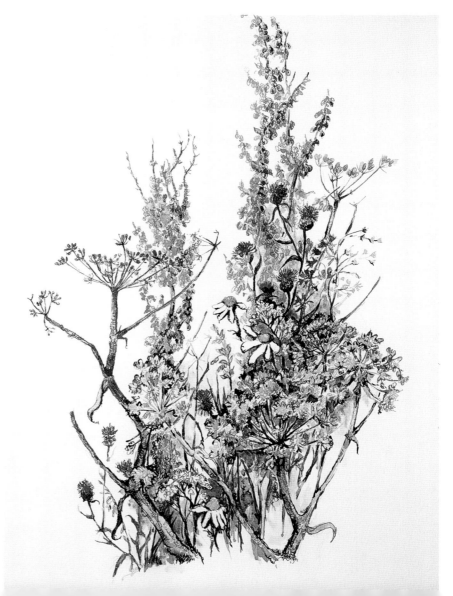

IRIS

THIS STUDY IN INK ON HOT PRESSED WATERCOLOUR PAPER
DEMONSTRATES THE STIPPLING TECHNIQUE.

BY MARGARET STEVENS

1 A perfect iris is the ideal specimen for an exercise of this type.

2 The artist makes an initial drawing using a 0.3mm technical pen. Every effort is made to achieve accuracy in positioning the petals.

3 The first lines of dots, which model the curves of the flower, are drawn.

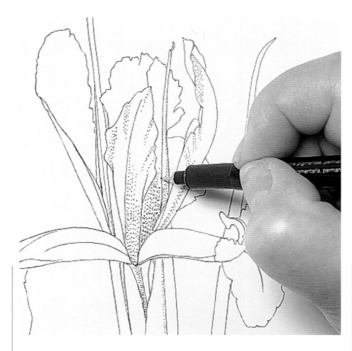

4 Further dots are added to mould the curve to the right shape.

5 The artist stipples the fall of a petal, showing its crinkly edge.

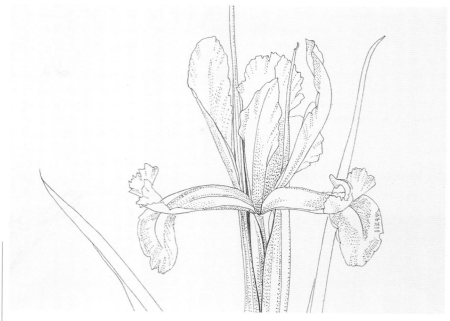

6 You can now see the overall appearance of the iris at around the halfway point.

7 This close-up of the actual flower shows you the amount of stippling necessary to indicate the form of the bloom – *not* its colour!

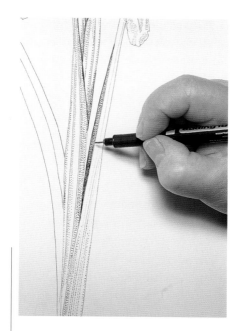

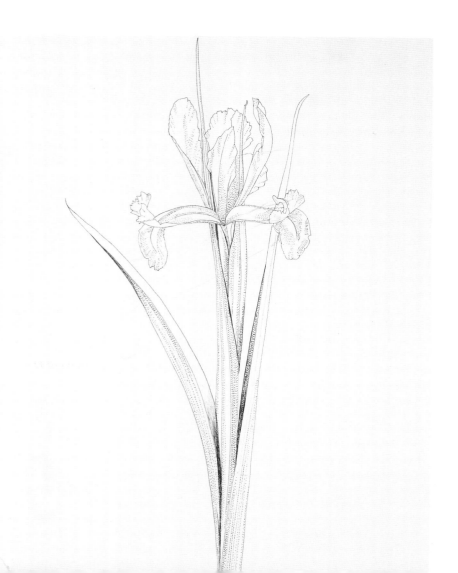

8 The artist works long rows of dots following the straight line of the leaf. These are overlaid as necessary with other rows of dots, to build up a degree of depth.

9 The finished flower study should be clean, simple and accurate.

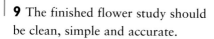

MIXED FLOWERS

THIS STUDY, USING ARTIST'S WATERCOLOUR PAINTS ON ARCHES 300GSM (140LB) PAPER, DEMONSTRATES DRY-BRUSH TECHNIQUE, IN WHICH MUCH OF THE DETAIL DEPENDS ON BRUSH DRAWING. IT AIMS FOR BOTANICAL REALISM AND CANNOT BE QUICKLY ACHIEVED.

BY MARGARET STEVENS

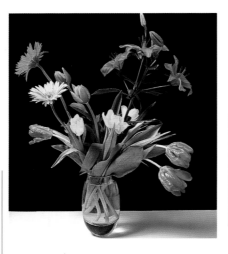

1 The vase of lilies, gerbera and tulips shows the raw material from which this picture evolved.

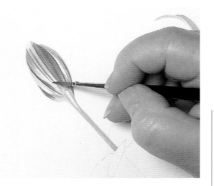

2 A pencil drawing of a lily was followed by work on the bud, before it opened and spoilt the composition. Washes of colour are built up from palest yellow to deepest brick red.

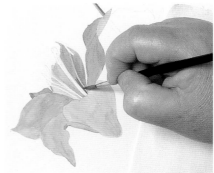

3 The open lily shows the artist applying colour, using a size 2 brush, around the stamens. Already you can see how the different elements of the composition are beginning to relate to each other.

DRAWING IN STAGES

The impressionist artist who works quickly has a much easier time than the artist working in the traditional naturalistic style. The former has a reasonable chance that the picture will be completed before the flowers have died. Not so the more botanically minded artist whose work can take days if not weeks. However, there is an approach that will solve the problem.

Let us assume that you go into the garden and find the perfect flower. Far better than picking a huge bunch, which will surely die too soon, take your perfect flower indoors and put it into water quickly. Choose your favourite paper, look at your flower and use your imagination. Try to visualise the sort of picture you want to create. Use scrap paper if it helps and note down some rough ideas based on your one perfect flower. With care

you will choose the right position, then draw it in, making sure that when you come to paint it you will not block your options. While you are working in pencil you can erase and place one flower, or leaf, *in front* of another one. Once watercolour is added that option is removed. For that reason it is wise only to indicate the position of stems in pencil until you are certain they will not, for example, cut your composition in half. It may be possible to paint from bloom to first leaf joint but no further. Having completed the first flower you will be able to select the next one and decide where that is best placed. So the composition builds up, the position of each flower based on its colour and shape, and following, but not *too* rigidly, the rule that triangles and curves, and odd numbers of flowers should be used.

4 More detail is being added in this tricky central area of the flower.

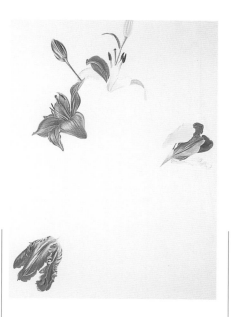

5 Two tulips are added to give the outline triangular composition.

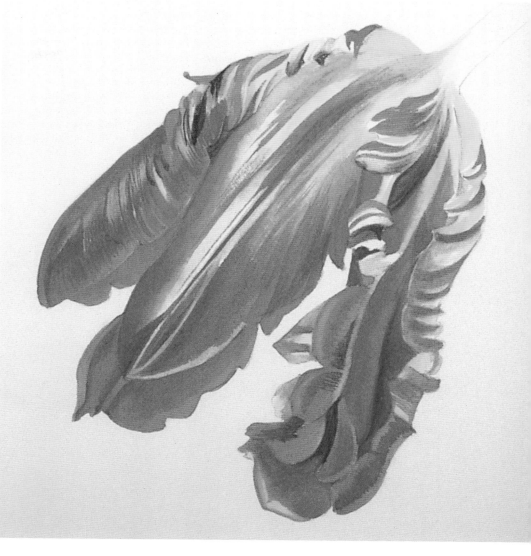

6 A close-up of one tulip, worked up as always from palest yellow and green to richest "feathers" of crimson, doing full justice to the texture of the petals.

7 A golden gerbera is added in the top half of the picture and the petals are moulded with the brush using a mix of yellows and brown madder on a base of Naples yellow.

8 The complicated centre is worked up with the brush, using dark brown with a hint of purple to give intensity.

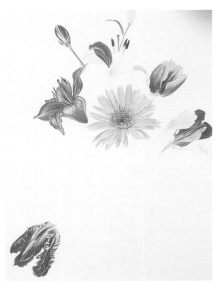

9 This shows the composition so far. The next stage will involve adding stems to add structure to the whole.

10 The artist now adds leaves and stems at the top of the picture.

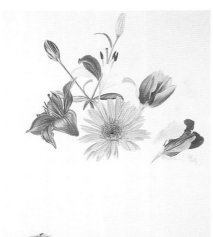

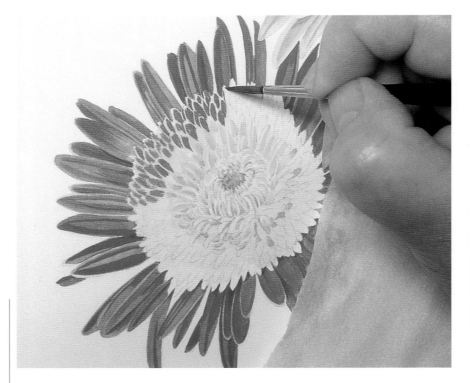

11 It is important to see that no stems have been carried into the lower half of the picture, thereby enabling the artist to leave her options open.

12 A red gerbera is painted, slightly to the back of the golden one. An all-over yellow wash at the centre is built up with the brush to show the many tiny petals.

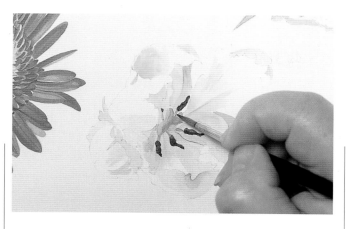

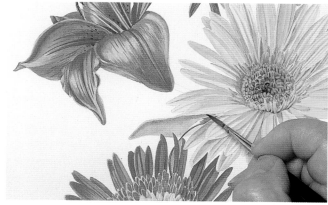

13 A full-blown tulip enables the artist to portray the stamens, using a brown/purple mix for the very dark tone.

14 More leaves are added to give a sense of depth.

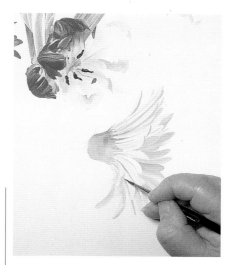

15 Another golden gerbera, this time in semi-profile, balances the composition.

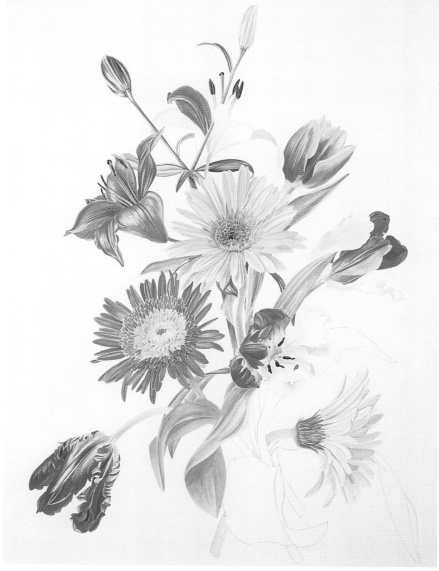

16 Almost finished, the study gives an idea of the artist's ultimate intention regarding composition and blend of strong colours.

CREATING A COMPOSITION

COMPOSITION IS THE KEY DIFFERENCE BETWEEN A DRAWING THAT IS A VISUAL DELIGHT AND A PIECE OF WORK THAT WILL NOT ENCOURAGE A SECOND GLANCE.

In the words of Henri Matisse: "The whole arrangement of my picture is expressive. The place occupied by objects, the empty spaces around them, the proportions, everything plays a part. Composition is the art of arranging in a decorative manner the various elements at the painter's disposal for the expression of his feelings." In order to build vocabularies of images, many artists will keep piles of drawings and sketchbooks in their studios. Keeping notes and sketches is very important for the nurturing of thoughts. One of the most interesting parts of creating a piece of work is the way you follow through an idea that develops in your head. A pattern in a cloth, or an interesting colour contrast in nature, can set off ideas. You may find it difficult to visualise how the set-up will look once it is on your canvas. To imagine the three-dimensional set-up on a two-dimensional plane, a "viewfinder" comes in handy. This will allow you to visualise the composition on the canvas and set your parameters.

Some artists prefer to block in all the component parts of the composition and complete the final work on the background after all other objects have been painted: others work with the whole composition at the same time.

Central verticals, similarity of shapes and sizes, high contrasts and strong diagonals like the edge of a table or drape can lead the eye to where you want it to go. Crowded groupings of flowers against a dark background can lead to an excellent composition. Always think about the balance of the group and the

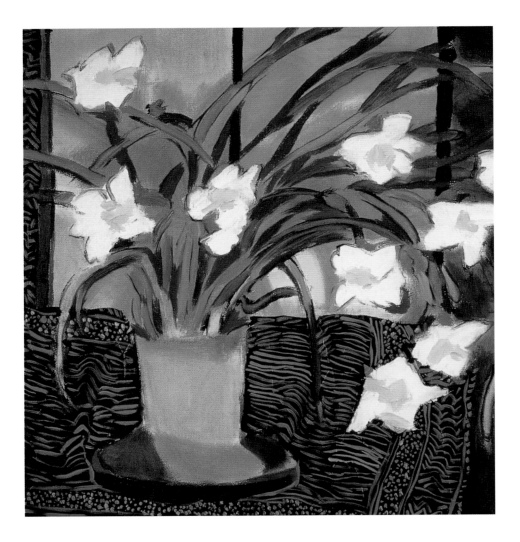

left *Flowers from Battersea.* Oil by Philip Sutton. A bright still life.

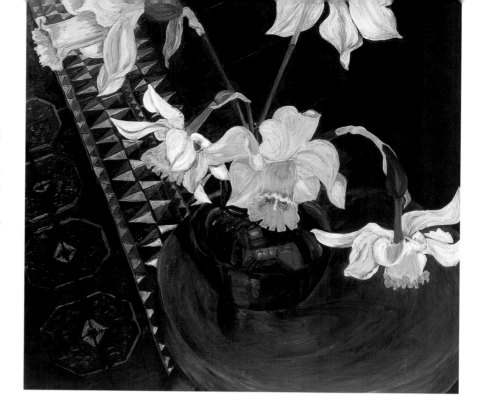

arrangement of colour. If there are only a few flowers, or if particular flowers become the centre of attention of the group, then choosing an odd number rather than an even one tends to make for better balance. Try using more than one container in the composition or adding objects that enhance by their shape or colour – perhaps some fruit or vegetables. Another option is to see how the group looks when you lay some of the flowers beside the container.

right Jeni Sharpstone's oil painting of daffodils contrasts the delicacy and haphazard petal growth against the dark, formal patterning of an Oriental carpet.

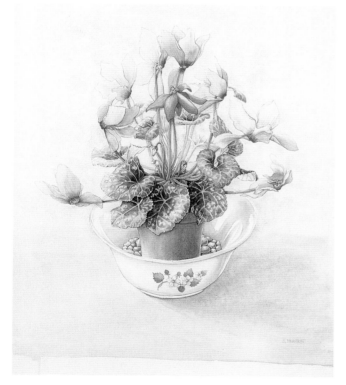

left This bowl of cyclamen, painted by Sue Merrikin, captures the vigour of the growing plant – the thrust of the stems and the inclination of the flowers.

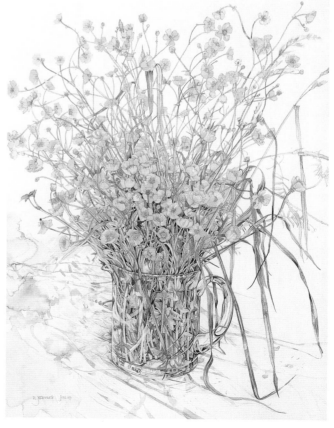

right Rosemary Jeanneret painted this remarkable study of buttercups. The group loses nothing of its freshness by being described in such detail. The delicacy of the tiny flowers and their particular manner of straggling, haphazard growth is accentuated by their mass. There are definite lines of composition; the wilting grass leaves on the right lead the eye down to shadows and through these into the bulk of the flowers.

Nature is a great source of ideas for colour and shape. For flower arrangements, the simple selection of country flowers is often the answer to a composition. A simple random element will lift the painting out of the ordinary. Look at the way flowers sit in nature. Take notes of the colour contrasts in summer and fall and combine these with the wonderful natural colours available in fabric to transform your ideas into an exciting composition. The sheer precision of colour in anemones, or the exquisite blue of a cornflower can lead the artist into wonderful contrasting juxtapositions of colour while keeping a naturally balanced palette.

Think of all the other elements that the flowers will be sitting beside, and the backdrop of colour. The mood of a painting is set with the flowers.

Successful paintings have a visual balance. This can be achieved by careful use of shapes, colour, perspective, lines and textures. The use of a strong vertical in the painting will act as an anchor for the composition, giving stability, weight and structure. Also, the "art of leaving out" becomes an essential ingredient in selecting, designing and composing your painting.

The projects here make use of a variety of techniques: masking, scumbling, stippling, scraping and the use of a palette knife.

below *Art Deco Table.* Oil by Peter Graham. Bold colours combined with careful attention to detail.

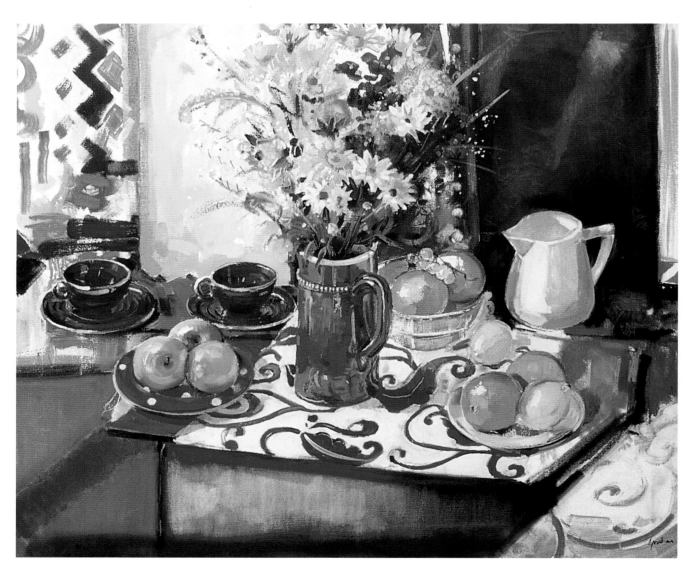

CHRISTMAS ROSES

THE PURPOSE OF THIS EXERCISE IS THREEFOLD: TO COMPOSE THE GROUP SO THAT ITS ARRANGEMENT WITHIN BOUNDARIES MADE A PATTERN IN ITSELF; TO EXPLORE THE SUBTLETIES OF WHITE FLOWERS; AND TO PAINT USING ONLY A LIMITED COLOUR RANGE. CHRISTMAS ROSES ARE FLOWERS OF GREAT DELICACY OF SHAPE AND SUBTLETY OF COLOUR, RANGING FROM INTENSE PLUMMY PURPLE TO THE ALMOST WHITE. THERE IS ALWAYS A GREEN TINGE TO THEIR COMPLEXION.

Stretched Saunders NOT 300gsm (140lb) paper is the painting surface and the palette is cadmium yellow, May green, Hooker's green, cobalt green and olive green.

BY ELISABETH HARDEN

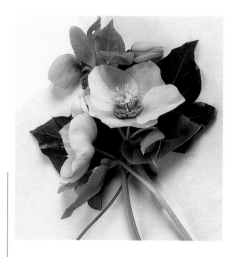

1 The flowers are arranged on a white surface. They languish out of water so the painting needs to be completed quickly.

2 A viewfinder is a useful aid. A rectangular shape approximating to the proportions of the composition is used to help fit the image into the space. Masking tape is stuck gently round the edge of the composition to create a border and enables the paint to be freely washed against the edge.

3 Delicately coloured flowers painted in watercolour depend on the subtle application of thin layers of paint. Building up these layers gradually reveals the roundness of the form and here this process is shown at an early stage. Masking fluid has been used to reserve white details.

4 Cobalt green is a curiously oily colour, but it has a wonderful fresh tone and precipitates into the hollows of textured paper in an intriguing way. Here it is painted loosely with a medium sable brush to define the petals of the flowers and add a contrasting background.

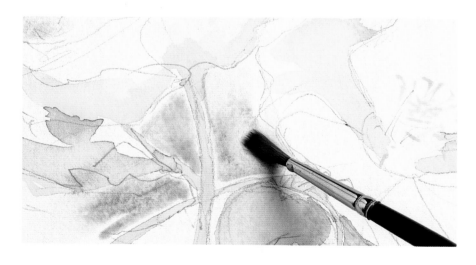

5 Cobalt green has also been lightly brushed over petals to give them some shadow. The main shape of the composition is becoming clearer, but it seems pallid overall and the tonal values need adjustment.

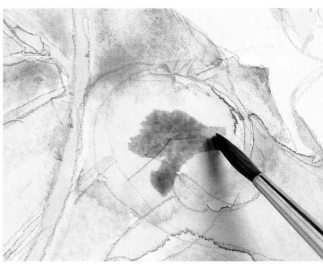

6 A denser green is painted and dropped in, emphasising the areas of shadow and so giving the whole painting more substance.

7 With each application of darker paint the artist needs to look at the whole pattern and adjust accordingly. Here you can see how the form is emerging.

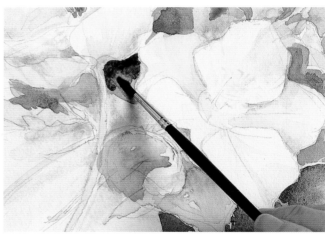

8 The artist looks at the subject carefully and tries to discover the areas of darkest tone. These will both throw the pale flowers into relief and create depth. It is interesting to see that in this case the area with the most paint recedes and the part with no paint jumps forward.

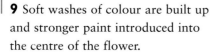

9 Soft washes of colour are built up and stronger paint introduced into the centre of the flower.

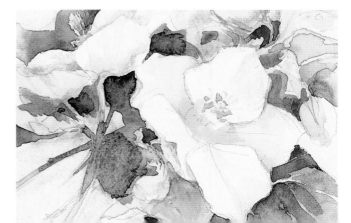

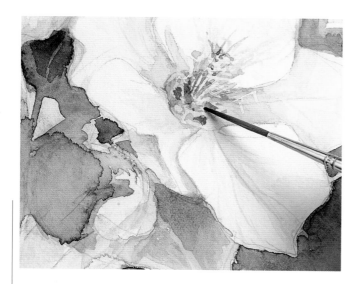

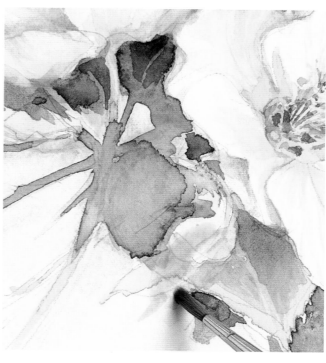

10 A very fine brush is used to pick out the dark parts of each flower centre, the masking fluid is rubbed off and the details are readjusted. The flower centres are now the point of focus for the whole painting.

11 The whole image seems intensely green, so a few touches of a warm toning colour are added.

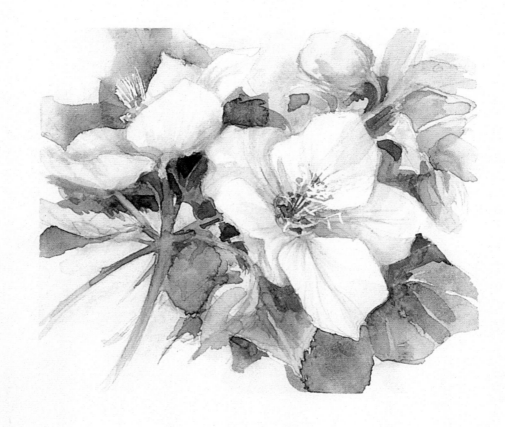

12 The masking tape is removed when the painting is complete. The resulting white surround tends to concentrate the eye more closely on the subject and makes interesting shapes round the edge.

A GROUP OF ANEMONES: 1

OIL PAINT IS AN EXCELLENT MEDIUM FOR CAPTURING THE BRILLIANT COLOURS OF ANEMONES.

BY FAITH O'REILLY

Faith O'Reilly chooses a specific palette of titanium white, chrome lemon, Naples yellow, aureolin yellow, cobalt blue, sap green, oxide of chromium green, Mars violet, cobalt violet, alizarin crimson, scarlet lake, Italian pink and rose madder. The paints are mixed with distilled turpentine or used straight from the tube.

1 The anemones are arranged in a white jar to relieve the heaviness of a dark-toned surface and set against a yellow background to complement the predominantly purple colouring of the flowers. Sometimes it helps to do a quick watercolour sketch at this stage, to help establish the range of colours needed for the desired effect.

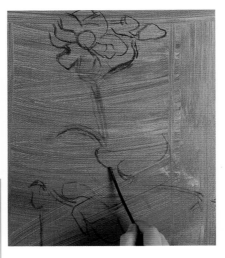

2 The stretched canvas is prepared with an undercoat suitable for oil or acrylic and on top of this is painted a thin layer of alizarin crimson and ultramarine to create a tonal background for the group. The composition is sketched with charcoal, starting with the basic structural lines.

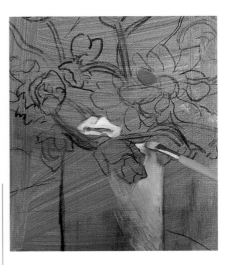

3 The advantage of using a mid-toned background is that the artist is working "up" to the lights and "down" to the darks. This both saves time and adds a particular richness or complexion to the finished work. Here, the lightest tones are painted in.

4 The basic colours of the anemones are painted to establish the colour balance of the group and to create areas of tone. The purple flowers are fairly dominant in tone, but the effect is balanced by the strong area of red and pink, which will jump forward towards the eye.

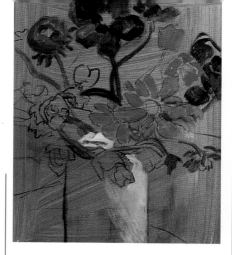

5 The principal colours of the group have been painted in and the main colour balance established.

6 Here, a dark underpainting of the surface has been worked using vigorous "scumbling" brushstrokes. This lively application of paint will give texture and variety of tone to the otherwise plain area of colour.

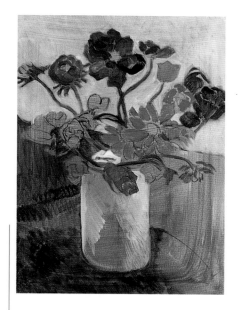

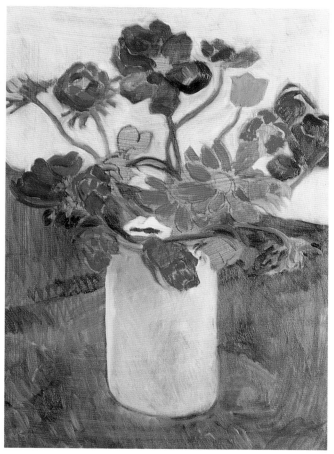

7 The artist paints a thin layer of Naples yellow over the background. Having established the whole colour balance she paints in the smaller flowers and a green-tinted reflection of the tablecloth on the side of the white pot.

8 By painting the purple and red flowers on the left of the group, the artist has created a colour balance in the whole with a trio of darker coloured flowers setting off the brilliance of the reds and purples. Oxide of chromium green is painted around the base of the pot and its form is modelled by dragging the paint lightly from one side to the other with a soft brush, allowing the underpainting to show through.

9 Detail is added with a fine brush, to delineate the flicker of light on stems and the feathery leaves round the flower heads. Modelling the flower heads with darker tones and picking out the flower centres gives them dimension, sets each one against each other and indicates the way they are facing.

10 The palette knife gives a particular texture to oil painting, allowing smooth areas of paint to be applied quickly and creating a rich background for the flowers. This builds up a thin ripple of paint around each flower and smooth patches in the background. Here a brighter yellow is being added to the background.

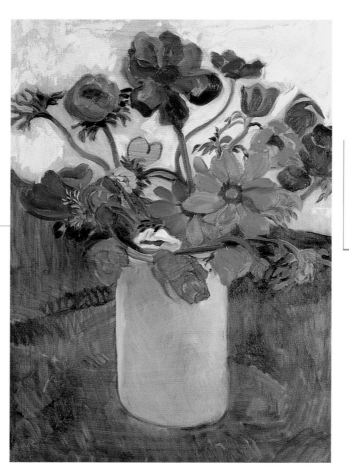

11 At this stage the painter assesses the work. All the components are in place and it is time to stand back and decide what needs to be changed and where most detail is required.

12 More colour is added to the background and flecks stroked onto flowers to denote petals catching the light.

13 A thin brush is used to add detail to the centres of the flowers.

14 Again the palette knife is used to apply large areas of paint with vigorous speed, allowing the underlying colour to shine through. The final green of the cloth gives a lighter note to the base of the composition, but the colour of the two underlying layers adds grain and density to the flat area of colour.

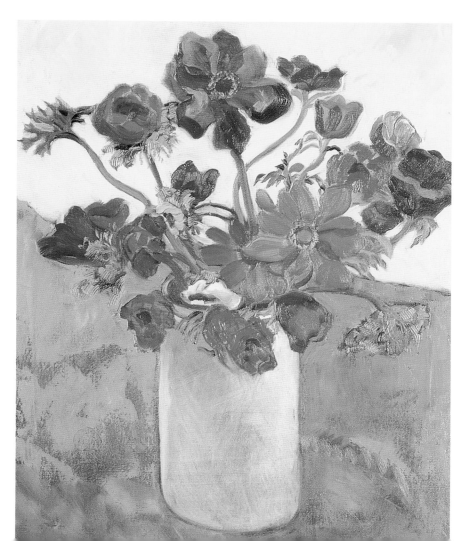

15 The finished painting has an energy that captures the vitality of the flowers. The apparent simplicity of the setting is given depth and dimension by the layers of colour, with underlying tone appearing throughout the work to give harmony to the whole.

A GROUP OF ANEMONES: 2

THIS IS A WATERCOLOUR STUDY OF THE SAME GROUP OF ANEMONES AS IN THE PRECEDING PROJECT. THE COMPOSITION IS SLIGHTLY DIFFERENT AND THE ARTIST'S CONCERN IS TO CAPTURE THE SHAGGY QUALITY OF THE PLANTS AND THEIR HAPHAZARD MANNER OF GROWTH.

BY ELISABETH HARDEN

The colours are permanent magenta, violet alizarin, rose madder, cobalt blue, ultramarine blue, alizarin carmine, alizarin crimson, Naples yellow, raw sienna, raw umber and Hooker's Green.

1 The composition of the group differs slightly from the previous one in a number of ways; the dark cloth has been removed from the table because it was felt to have too strong a tone for the composition and the flowers have been repositioned so that the flow of the stems is more exaggerated.

2 Purples and pinks are notoriously difficult in watercolour, so a number of different shades in these tones were mixed to see if they approximated to the colour balance of the whole.

3 A thumbnail sketch of the whole, to establish basic balance and tone, is transferred lightly to the painting surface – stretched Saunders NOT watercolour paper – and the stem structure sketched in with watery green paint. A pale wash lays in the basic shape of the purple anemones, forming a negative shape around a space for the brilliant pink flower. The wash is very pale at this stage and sharper edges are formed by dropping water into the painted shapes. If there are too many hard edges as a result, they can be softened with a sponge as the painting progresses.

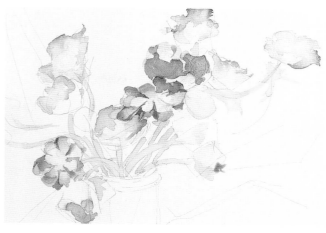

4 More concentrated colour is dropped into the drying paint, tipping the board and using a hairdrier to control the position of the colour. The behaviour of paint depends very much on the dampness of the paper and only experience will ensure confident control.

5 Basic stems and blooms are in place. At this stage it helps to stand back and see where the next shape is needed to give balance to the piece. The flowers seem to be floating in space so they need to be anchored into a structure.

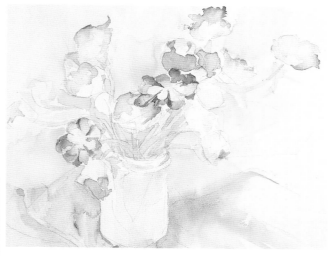

6 Areas of shadow are painted with diluted cobalt blue and the composition starts to come together as a group. Some painters block in this shadow structure at the beginning of the work and it acts as a scaffolding, holding the different components together.

7 A wash of Naples yellow is painted round the whole. This complementary tone to the predominating purple defines the white vase and adds a warmth to the whole. At various points during the drying more colour is flooded in so the soft background is a haze of shades and shapes.

8 The whole group is pale and needs definition. Hooker's green is painted around and between the flowers, giving a sharpness to their outline and throwing them forward in space.

9 Watercolour painting is very much a process of building up layers of colour and modifying tones in relation to each other. More concentrated colour is painted into the flowers and the stems, and the dark interior of the vase is given more definition and weight.

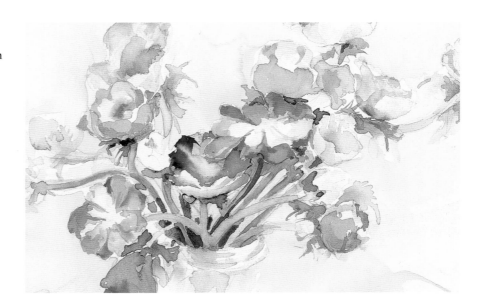

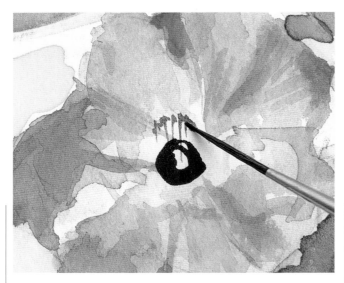

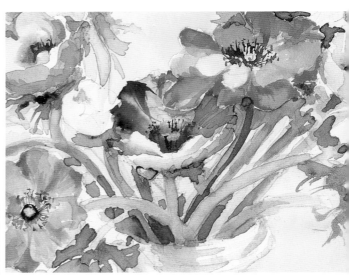

10 Here, the artist concentrates on the heart of the flowers. Often this stage will unexpectedly bring life to the whole painting. A fine rigger brush paints in the dark centres and stamens. It helps to look very closely at the centres; often the petals are a lighter colour than the surround and the stamens grow in a distinctive way that identifies a particular flower.

12 A thicker rigger brush, chosen for its dragging qualities, is used to drop in and pull darker paint into the shaggy shapes surrounding the flowers. The darker green is made by mixing Hooker's green with a touch of alizarin crimson. The flower has been painted very loosely and the artist feels that this ruff of dark leaves is sufficient to establish its identity.

11 The flowers have an identity now and the positioning of the dark centres establishes the direction in which each flower is facing.

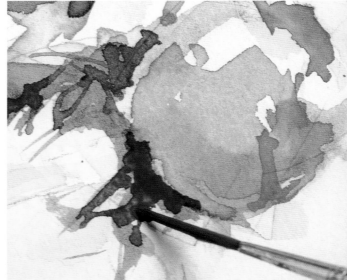

13 The composition still seems to float, so a diagonal of raw umber wash is swept across the composition. Very often, leaving the painting for a period of time will enable you to look with objective eyes and pinpoint the areas that need defining or strengthening.

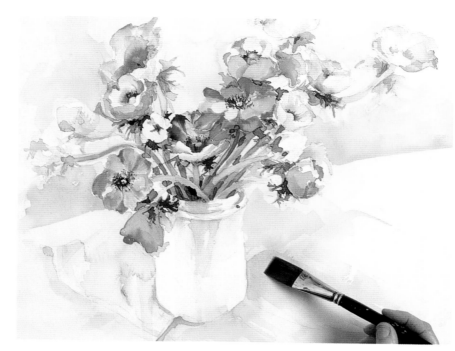

14 The completed painting, which succeeds well in conveying the way in which these flowers seem to reach out from the vase, their stems twisting and bending.

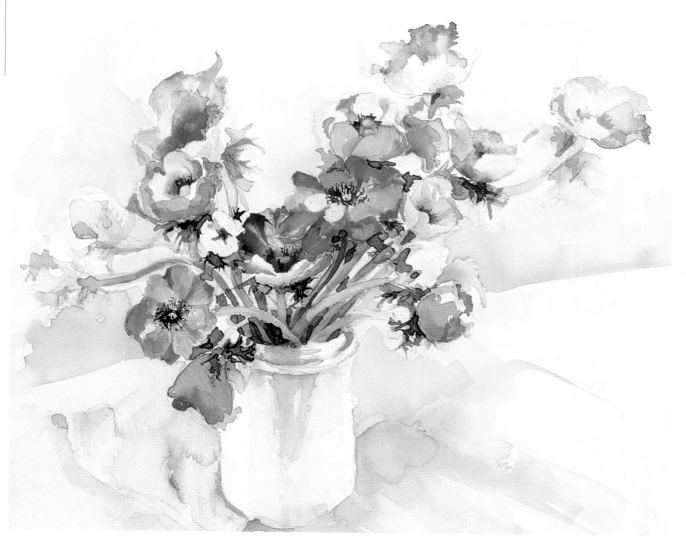

LILIES, ANEMONES AND GLASSCLOTH

IN THIS COMPOSITION SHIRLEY TREVENA HAS ARRANGED A FEW FLOWERS AND HOUSEHOLD OBJECTS IN SUCH A WAY THAT THEIR PATTERN AND DISPOSITION BECOME THE MOST IMPORTANT ELEMENTS IN THE COMPOSITION AND THE SIMPLE OBJECTS THEMSELVES TAKE ON A NEW MEANING. SHE FINDS A VISUAL EXCITEMENT IN SEEING CERTAIN COLOURS TOGETHER AND EXPLORING THE SPATIAL RELATIONSHIP BETWEEN OBJECTS AND SPACES. THE LARGE AREAS OF WHITE PAPER IN THIS COMPOSITION ARE A SIGNIFICANT FEATURE OF THE WHOLE.

The palette is cadmium yellow, sap green, olive green, Winsor green, permanent rose, indigo, purple madder alizarin, sepia, raw sienna and black.

BY SHIRLEY TREVENA

1 Setting up the group can take a considerable amount of time. Each part is carefully placed so that colour, shape, ellipse, line and pattern relate in the jigsaw of composition.

2 The artist uses a combination of watercolour and gouache. Here, strong green paint is dragged into the lines of the leaf with a twig.

3 Cadmium yellow paint is fed into the wet green paint.

4 Further layers of paint are added to create more leaves and the stark outline of the lily petal. A strong purple defines more of this petal and is encouraged to melt into the drying green paint below.

5 The same purple paint is led into the shape of the flower, allowed to merge in some parts and in others used sharply to define the form. At the same time, the flower centre is painted and the petals scraped to create a radiating pattern.

6 The form of the group as a whole now begins to appear.

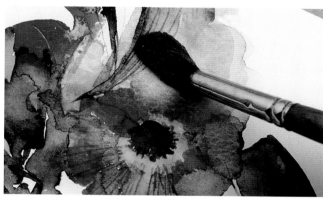

7 Yellow paint is concentrated in the flower centre and allowed to spread into a few of the petals.

8 As the form is built up, leaves are added. A squirrel brush softens shapes, removes paint and blends colour.

9 The lower parts of the painting are now lightly sketched in. The letters on the glasscloth are carefully drawn, and the parts intended to remain white are painted with masking fluid.

10 While the masking fluid is drying, stamens are drawn in the heart of the lily. In some cases the intense colour of the anthers is allowed to flow into the softer green stamens. A pale grey wash adds shadow to the underside of the flower.

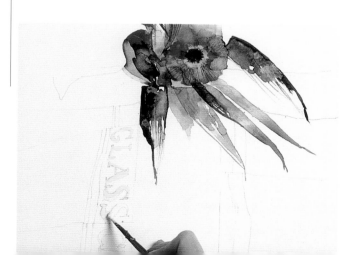

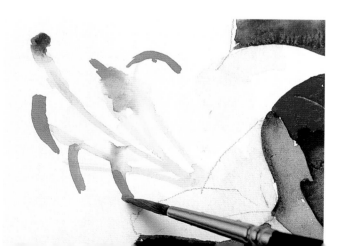

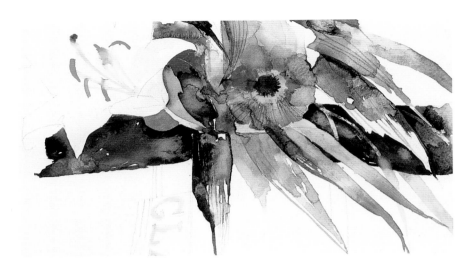

11 An important part of the whole composition is the strong horizontal. A dark sepia wash across the composition throws into relief the oblique thrust of leaves and stems. More leaves are added to emphasise this diagonal.

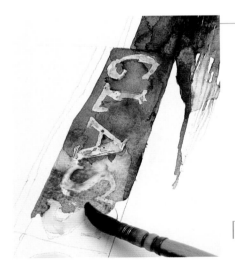

12 An indigo wash is painted over the masked letters to form the stripes of the glasscloth and differing values of tone are used to bring out the ripples and folds of the cloth.

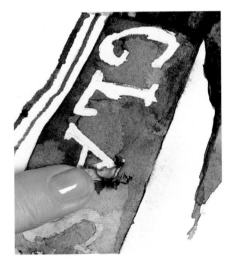

13 The masking fluid is removed by gently rubbing with the finger.

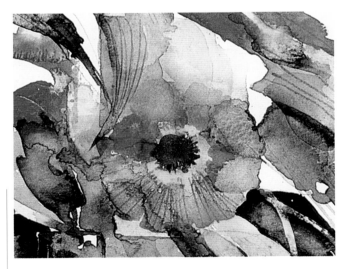

14 Dark paint flicked with a brush adds sharpness to the centre of this anemone.

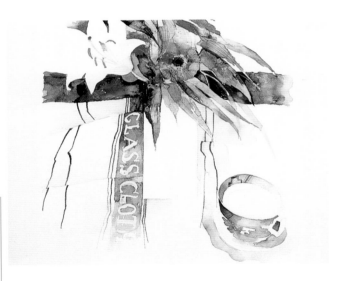

15 Moving from the dense area of activity at the top of the picture, the artist uses indigo paint to shape the cup and saucer, defining only part of its form and using the lines on the glasscloth to tie it into the whole structure.

16 Detailed painting with stronger paints adds pattern and definition to the cup.

18 The finished painting is a wonderful mix of rich colour and shapes of white. The artist has deliberately left the flower container as a blank rectangle, forcing the eye to flicker between the intensely coloured area at the top of the composition and the cup and saucer, and their echoes of colour.

17 When the blue paint is completely dry, a thin sable brush is used to draw the fine decoration, and a thicker squirrel brush floods a wash of raw sienna paint into the cup, carefully manipulating it and adding more colour as necessary.

ANEMONES

THIS DRAWING IS MADE WITH WATER-SOLUBLE PENCILS ON A
GOOD-QUALITY WATERCOLOUR PAPER.

BY HILARY LEIGH

1 Two bunches of anemones
provide the inspiration for this study
which is not intended to be an exact
reproduction.

2 The artist draws an initial outline
using a deep vermilion pencil.

3 The colour is merged with water
applied with a fine brush.

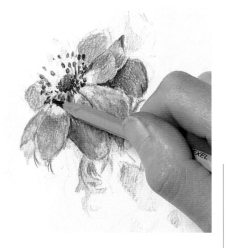

4 Detail at the centre of the flower
is achieved by using a mixture of
dark violet, burnt umber and
burnt carmine.

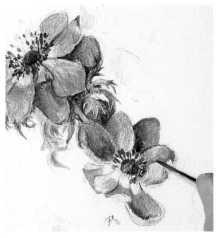

5 Intensity of colour is built up by
applying dry pencil on top of the pre-
washed sections. This dry, wet, dry,
wet technique applies throughout.

6 The pattern of colour is established by introducing mauve flowers between the reds.

7 Fine-cut foliage is worked on, using an initial May green followed by sap, olive, juniper and cedar.

8 Detail is brought out on the central mauve flower using blue violet, light violet and Imperial purple.

9 The artist adds a bud at the top of the drawing, extending the stem to improve the composition.

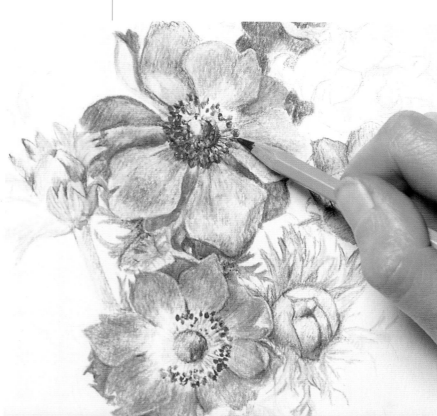

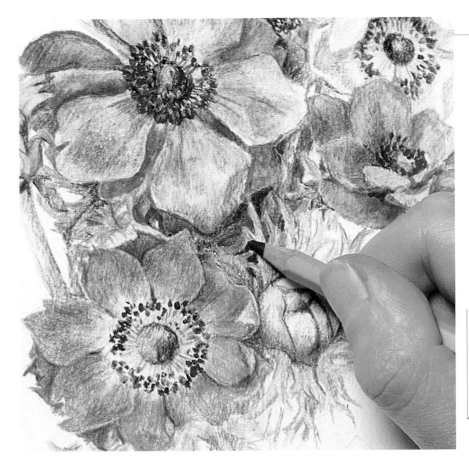

10 Depth is achieved by using an indigo pencil, dipped in water, which gives the darkest tone to the centre of the study.

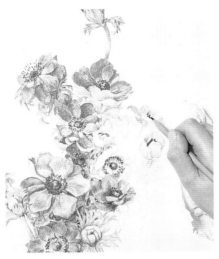

11 The half-moon composition is filled out by adding a semi-profiled flower at top right.

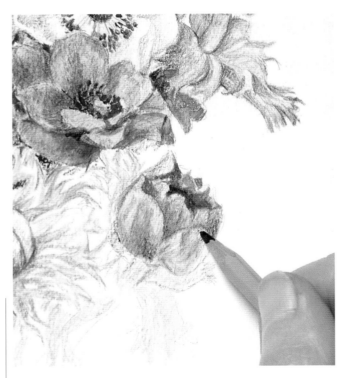

12 The composition is extended further with an opening bud at the bottom right to lead the eye downwards.

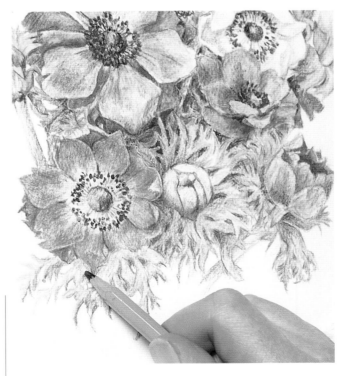

13 Darker tones are added to give stability at the base of the picture.

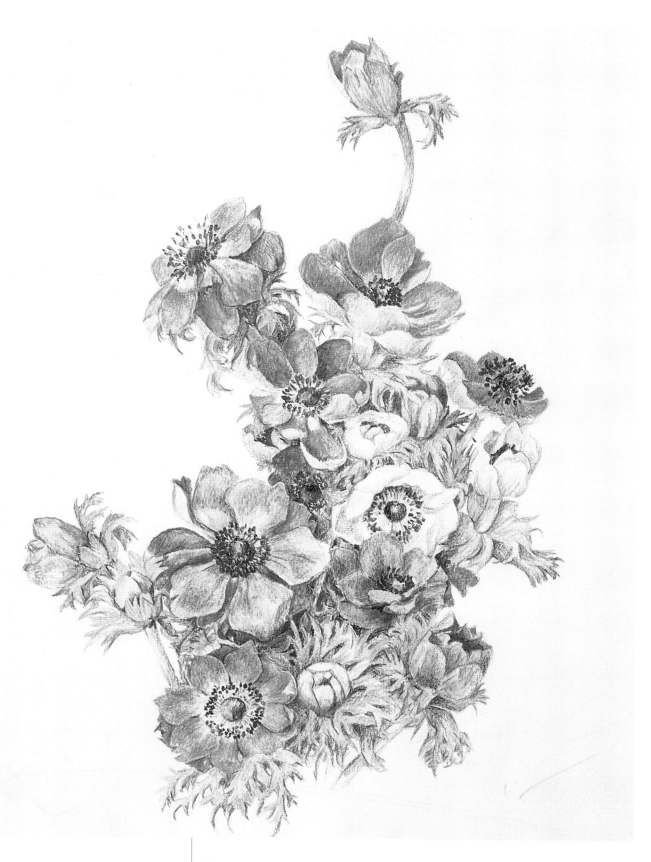

14 Final touches of colour have been added to capture
the glowing colours of the flowers.

IRISES AND HYACINTH

THE RICH BLUES OF THESE FLOWERS ARE IDEAL FOR A
DRAWING USING COLOURED PENCILS ON A SUPPORT OF
NOT WATERCOLOUR PAPER.

BY MARGARET STEVENS

1 Time does not allow all these
beautiful flowers to be portrayed.

2 The artist first makes an outline
drawing of the iris using light
ultramarine. Zinc yellow shading is
added and deep cobalt is used to
shade the petals.

3 A mix of deep cobalt and Prussian
blue is used to contour the petals,
with purple adding the deepest tone.

4 A little carmine supplies the pinkish tinge where
it is needed.

5 Ochre over zinc yellow shades the falls. You will
see that no attempt has yet been made to position
stems or leaves.

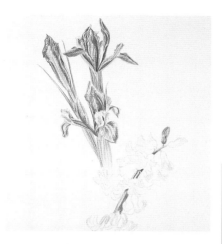

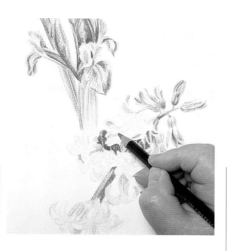

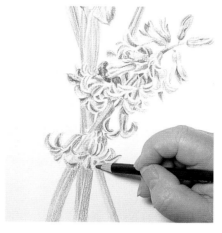

6 The hyacinth is drawn in to cut across the front of the irises. The stem uses an interesting mix of Hooker's green, red violet and deep cobalt.

7 The flowers are worked up using similar tones to the iris, but with less deep blue and more carmine and purple.

8 The stems have been added using a mixture of zinc yellow, moss green and Hooker's green. Now dark touches of detail are added to the hyacinth bells.

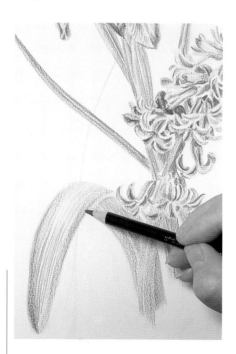

9 The imposing curve of the hyacinth leaf is contoured with slight touches of dark grey.

10 The result is a clean, simple study, with the angular iris balanced by the curvaceous hyacinth.

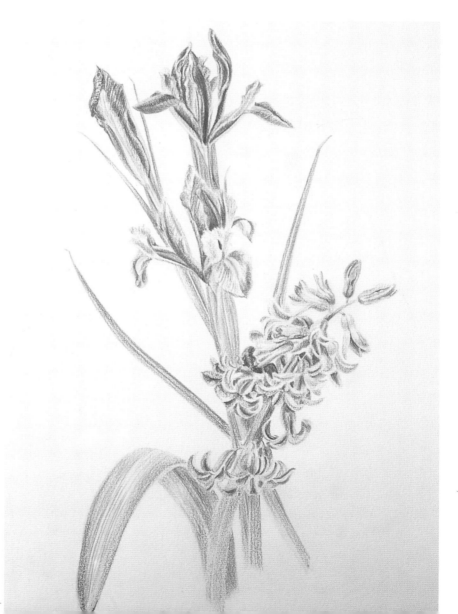

BUILDING THE COMPOSITION

The ideal light for the studio is a diffuse north light. This casts no well-defined shadows and the tones remain constant throughout the day. In a naturally bright studio, you will have the best opportunity to decide about colour.

Alternatively you may be inspired by the effects of sunlight and may be prepared to work fast! It can be exhilarating to try and capture the dappling effect of sunlight on a table. The interplay of shadow can lead the eye and counterbalance the objects themselves.

A vase of flowers on a windowsill, lit from the window behind, can create wonderful contrasts and natural compositions. Exaggerated shadow and silhouetted shapes can enhance the composition, and the subtle interplay of greys and whites can produce satisfying results.

Working in a house or garden with "found still lifes" can be challenging, due to the fleeting nature of sunlight. The dramatic effects of the sun and strong shadow are excellent ways of unifying colour and form. Short sessions of alla prima painting, laying wet paint on wet paint, are one way of achieving sunlight. Returning at the same time each day and working in sunlight requires discipline. Be careful not to inadvertently alter the lighting and composition as the light changes. A typical error would be an inconsistency of the shadow angle cast by objects.

below *Still life with Decoy Ducks.* Oil by Nicholas Verrall. The fleeting nature of sunlight.

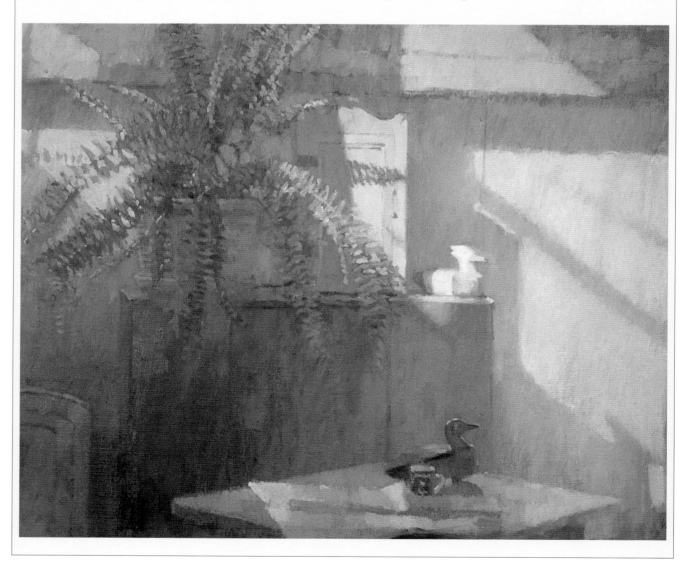

SUMMER HAZE

DEREK DANIELLS CAPTURES A SUNLIT PATIO, USING SOFT PASTELS ON TINTED INGRES PAPER. SUNSHINE DELICATELY REFLECTING OFF THE FLOWERS AND TERRACOTTA POTS BRINGS TO THIS "FOUND STILL LIFE" A WONDERFUL SENSE OF LIGHT, SHADE AND DEPTH.

BY DEREK DANIELLS

The colours are cadmium orange, lemon yellow, Hooker's green medium, Hooker's green light, raw sienna, yellow ochre, indigo, purple, lemon yellow medium, terra verte, pansy violet, Naples yellow, blue green, cobalt light, cobalt medium, crimson lake, reddish purple and silver white.

1 Having carefully mapped out the whole composition, just suggesting the colour, the artist starts to lightly sketch in the negative shapes of the plants and the main plant pots.

2 The pastel drawing is now taking shape and all the groundwork and positioning decisions have been made.

3 In order to create depth and tone, Derek is applying the pastel in small dashes, capturing tiny amounts of colour in the tooth of the paper.

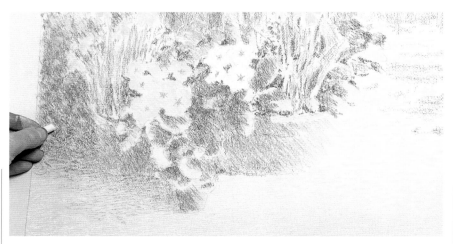

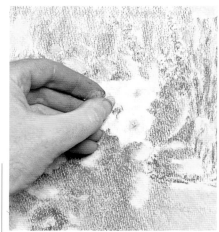

4 The layering ability of pastel allows colours to be placed one on top of another, as demonstrated here, to create the dappled effect of shadow on the background foliage.

5 The colour is carefully judged to keep the delicate contrasts in harmony.

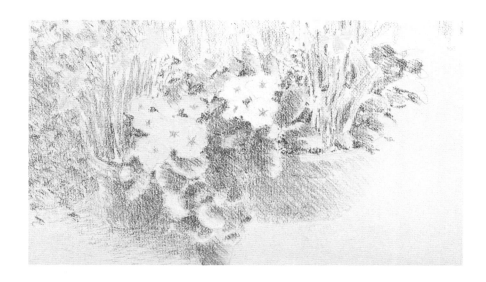

6 The whole picture is gradually building up, strengthening in intensity, at a steady pace.

7 A stippling effect for the sunlit path allows the base colour of the tinted paper to reflect through the lemon yellow and silver white veil of colour.

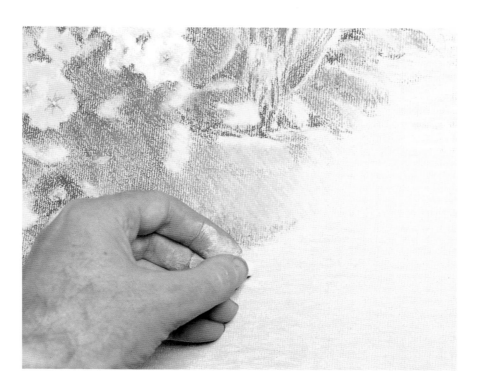

8 The soft transitions of colour that can be attained with pastel are brought to full effect in the completed work.

DAFFODILS

WORKING FROM AN UNDERDRAWING – A SKETCH OF THE COMPOSITION WITH THE TONAL
DIFFERENCES SUGGESTED – ALLOWS YOU TO PAINT WITH MORE CONFIDENCE AND REDUCES THE
RISK OF HAVING TO MAKE CORRECTIONS. THE
UNDERDRAWING BY JEREMY GALTON, FOR A PAINTING IN OILS,
SHOWS HOW THE COMPOSITION IS TRANSFERRED FROM REAL
LIFE ON TO A TWO-DIMENSIONAL SURFACE.

He used: French ultramarine,
Winsor blue, sap green, raw sienna,
raw umber, burnt umber, cadmium
yellow, lemon yellow, Winsor violet
and titanium white.

BY JEREMY GALTON

1 These beautiful spring daffodils
were the inspiration for this still
life in oils.

2 Using a pencil on a ground
washed with raw sienna, the artist
starts the underdrawing in the centre
of the picture with the glass vase and
flower heads.

3 Jeremy uses a ruler to work out
the precise measurement of each
object as seen from his chosen
viewpoint, and then transfers the
measurement to the board.

4 The underdrawing becomes the
foundation for the painting to
follow. Accuracy at this stage is
desirable, although it is important
not to overwork the drawing.

5 Jeremy Galton uses his method of colour matching, painting a scale of colour on a palette knife and selecting the particular hue that is required. Here, the artist is able to judge subtle differences within each petal.

6 The artist's working method here is to paint each component part of the composition, following the underdrawing closely. The flower petals are painted precisely, using a small sable brush.

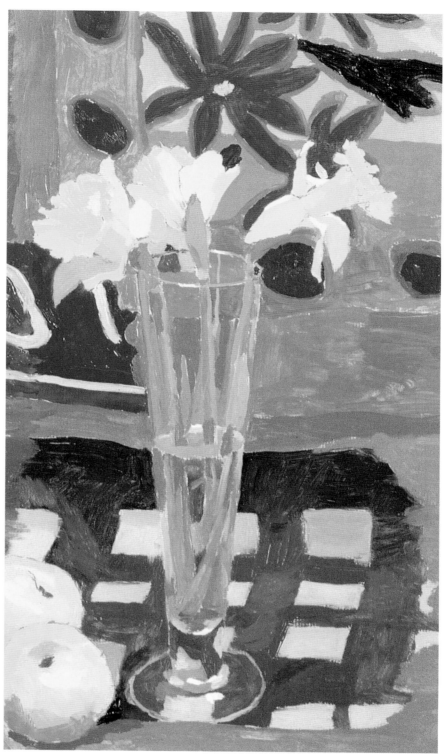

7 A combination of detailed underdrawing and carefully matched colours brings to life this simple composition of garden apples and daffodils.

113

SELECTING A SUBJECT

Still life inspiration can come from any source. The common language of the genre starts with the depiction of familiar objects. Plain is beautiful: fruit and flowers, bowls and pitchers, sitting against a patterned background, an interior, or window.

Consider the symbolic approach to flowers used by Renoir (1851–1919), where the rose was a symbol of feminine beauty, or the Dutch symbolic inclusion of history books, or a glass on its side to remind us of the fleeting nature of things. Still life can include symbols of vanity, the musical instrument; butterflies, expressing the free spirit; a lemon, beautiful to look at, bitter to taste, symbolising a deceptive appearance; red, with its theatrical connotations.

Chrysanthemums are excellent subjects: irregularly shaped flowers with a bright head of linear petals. The appearance of the flower lasts and they tend to stay in one place in the vase! Similarly, daisies have a good strong colour and shape to paint and are a very flexible flower to use, since they last a long time and they present wonderful possibilities for precise brushwork.

Mixtures of flowers can pull together colours in different parts of the painting. A yellow daisy will pick up a tone from a yellow drape, a pattern of petals will reflect a design on a bowl.

Flowers presented in glass vases or unusual pitchers, and combined with fruit, make a favourite subject. They are not, however, the easiest of subjects to paint. Overworking the paint in order to describe a flower's delicate structure is a common problem. Simplify what you are looking at and capture the essence of a flower, as opposed to making a copy. It is worthwhile, however, to study the flowers you are going to paint, for example to discover how many flower heads there are to each stem. An understanding of a particular flower's shape and texture will leave you more informed when it comes to putting brush to canvas.

Achieving good results in painting flowers takes hard work and perseverance, bearing in mind that no two flowers are alike. However, a few disappointments along the way are a small price to pay in learning to paint these rewarding subjects.

The techniques used in the projects include masking, wet-on-wet, spattering and the use of palette and paint knives.

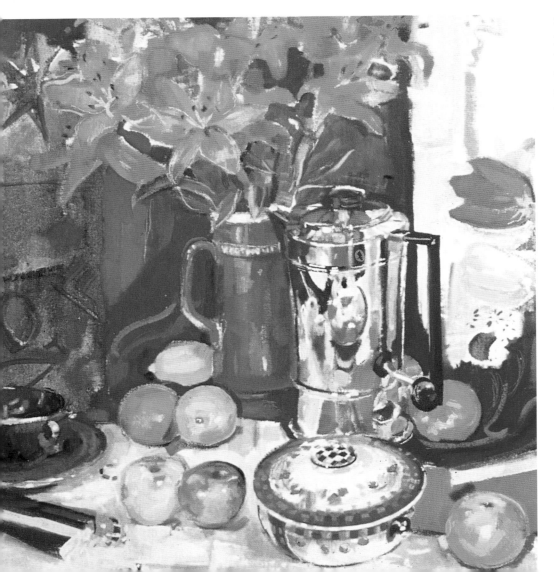

left *The Cherry Pot.* Oil by Peter Graham. Dark objects next to light to create depth and contrast.

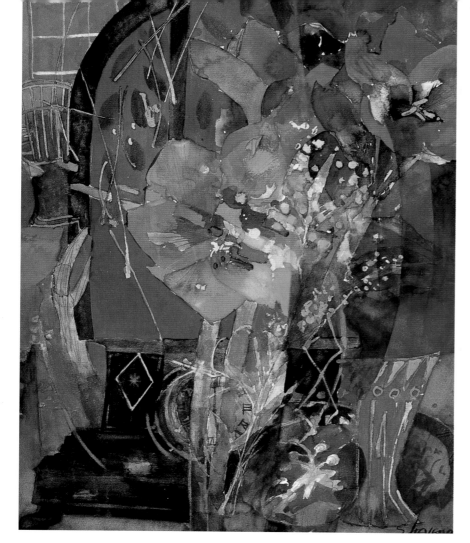

left *Red, Red Amaryllis*. By Shirley Trevena. The excitement of this painting lies partly in its abstract nature – a loose indication of what it portrays, inviting the viewer to explore and imagine.

below *Anemones on Shelf*. By Rosemary Jeanneret. At first glance the three regular pots seem to be the subject of this composition. The eye is then led round the burst of flowing blue anemones to a pinpoint of red and pink at the farthest extremity. Another look at the picture reveals echoes of this brilliant alizarin crimson throughout the composition, in shadows, stems and petal tips.

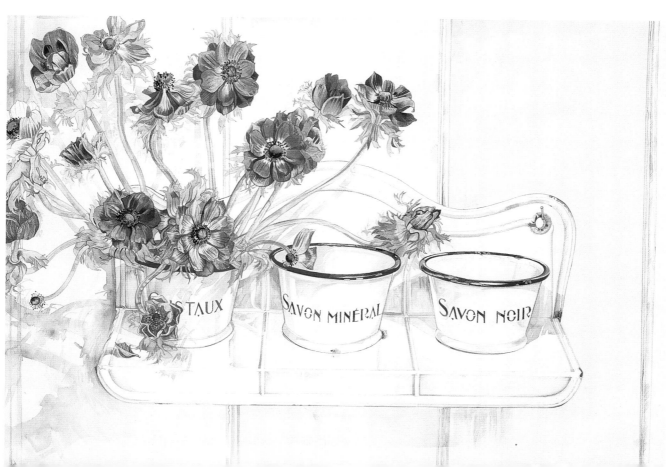

STILL LIFE WITH ORANGES

THE MUTED TONES AND CRISP DETAIL IN THIS UNUSUAL STILL LIFE COMPOSITION IN OILS DRAW VERY MUCH FROM THE DUTCH TRADITION.

BY ARTHUR EASTON

1 Dried flowers, a plain jug, white drapes and oranges might seem an unusual choice for a still life, but Arthur Easton takes advantage of the subtlety of contrast to breathe life into this scene.

The palette is alizarin crimson, burnt sienna, cadmium red, yellow ochre, chrome yellow, titanium white, French ultramarine, viridian and sap green.

2 Arthur uses a small filbert bristle brush to draw out his composition. A mixture of burnt sienna and ultramarine combine to produce a clear, distinct outline.

3 Using a large filbert, the background tones are laid down. The colour is a mixture of titanium white, ultramarine blue and burnt sienna.

4 The jug is the dominant object in the group, and is being built up first in order to anchor the composition.

5 Great care is taken to keep all the contrasts in harmony, since this is a key compositional element to this painting.

6 A rigger sable brush is used to pick out the spindly stems.

7 At this stage, the general form of the composition is complete. The artist can now think about contrasting the solid objects with the fine detail of the dried roses and drapery folds.

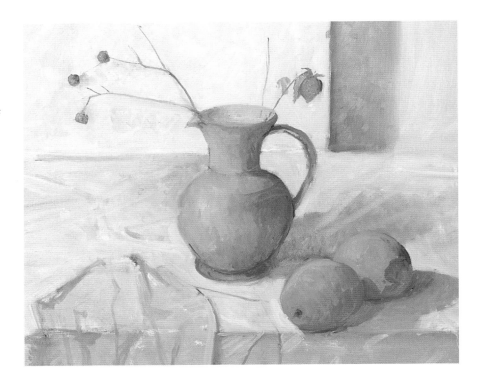

8 The highlight on the white drape in the foreground is painted with a filbert brush.

9 Smaller details like the glint on the neck of the jug are now added.

10 The orange peel is carefully picked out, using a small sable. The textural detail of all the objects plays an important role in keeping the painting lively.

11 The artist now adds final touches to the stark backdrop, taking care not to disturb the subtle balance of contrasts and focal points.

12 In the finished painting you can see the gentle folds and soft shadows of this simple grouping of objects transformed into an exquisitely delicate composition.

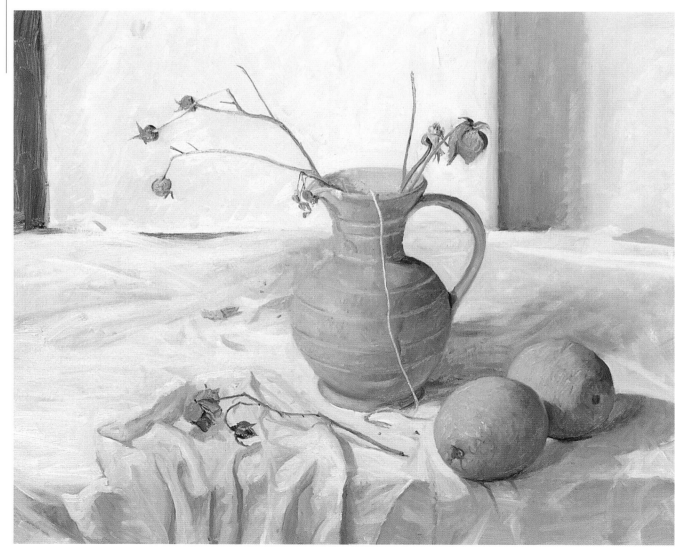

LILIES, TULIPS AND GRASSES

COMBINING CONTRASTING SHAPES, COLOUR AND TEXTURES CAN MAKE A SIMPLE GROUP MORE INTERESTING. IN THIS WATERCOLOUR EXERCISE A FEW FLOWERS, CHOSEN FOR THEIR DIFFERENCES, ARE COMBINED.

The palette on this occasion is Naples yellow, yellow ochre, raw sienna, cadmium yellow, sap green, cadmium orange, cadmium red, Hooker's green, raw umber, and viridian.

BY ELISABETH HARDEN

1 The flowers are arranged to display the different shapes of the plants to best advantage, using the orange flowers as the focus and the darker leaves to give diagonal balance. The lighter and more delicate flowers are arranged to give a freer feel to a fairly conventional composition.

2 A rough drawing is made to establish tones and general rhythms in the composition and this is copied lightly to the working surface – in this case stretched, mediumweight watercolour paper with a NOT surface. The main rhythm of the piece is painted in with very dilute green paint. These lines will either stay as stems or parts of stems, or will disappear under darker paint.

3 The feathery flowers of the cow parsley and flower stamens are blocked out with masking fluid. This allows fast and fluid washes to be used with freedom and avoids having to paint laboriously around very detailed areas.

4 The shape of the lilies is now blocked in with a light cadmium orange wash.

5 A darker cadmium red is dropped into the drying base wash. This building up of colour begins to give form to the petals and definition to the masked-out stamens.

6 The group is still a muddle of shapes and lines, so the artist applies a light wash of Naples yellow round the flowers and vase, and drops a darker ochre in as it dries. Now the form of the whole can be seen and the shape built up.

7 Light sap green with a touch of yellow is used for the paler leaves. Much of the work is done with a flat brush, which is twisted and turned to form the strong shapes of the tulip leaves.

8 A darker green is introduced. This throws the red lilies into relief and defines their shape and colour. It also adds weight to the lower half of the group.

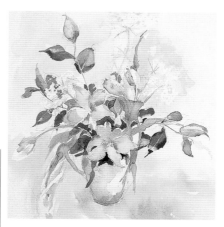

9 Taking an overall view it becomes clear that various areas need weight and definition. The vase is given more substance – white patches are left where the light falls and the reflected colour of the drapery adds weight to the shadows. The tulips are painted wet-on-wet, adding touches of red where the petal tips emerge from the bud, and emphasising the line of the stems, which leads the eye to the left of the composition.

10 The focus of the group is the lilies. A stronger and darker red picks out the areas of more intense colour and shadow to build up their shape.

11 The shadow under the vase gives a weight to the whole and the artist is in a position to make a considered assessment of the composition. The masking fluid is removed and details painted on the cow parsley with a fine rigger brush. The same type of brush adds the thin grasses and pattern on the tulip leaves.

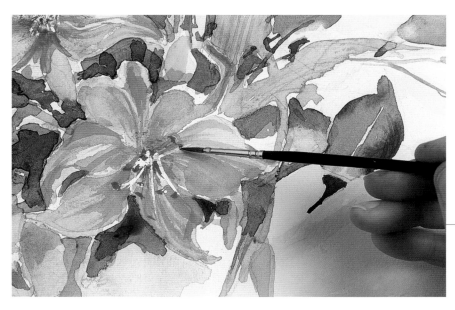

12 The lilies need more colour, some indication of the ridges on the petals and a sharp definition of the distinctive stamens.

13 Critical assessment is a valuable learning process. The rhythm of the piece works well, but possible further improvements would be to give the central area more depth of tone and to anchor the vase of flowers more firmly by increasing the substance and definition of the background.

A BOWL OF ICELANDIC POPPIES

THE PAPERY PETALS AND WANTON GROWTH OF ICELANDIC POPPIES HAVE A PARTICULAR APPEAL FOR AN ARTIST. THEY SEEM TO ENCAPSULATE THE VERY ESSENCE OF LIFE AND MOVEMENT AND THEIR TEXTURE AND SUBTLE COLOURING REWARD DETAILED EXAMINATION. THIS GROUP WAS CHOSEN TO ILLUSTRATE THE DISPOSITION AND CHARACTER OF THE PLANTS AND WAS PAINTED AND DRAWN WITH WATERCOLOUR AND GOUACHE, AND WATERCOLOUR PENCILS.

BY ROSEMARY JEANNERET

1 The poppies are arranged in a glass vase to echo the splay of branching stems and the arrangement is set against a white background to show off the delicacy of the flowers.

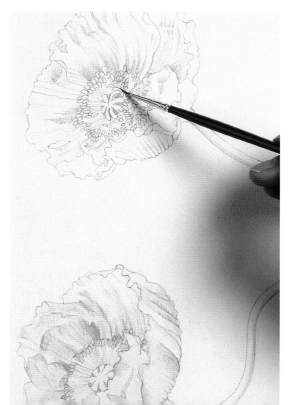

2 A brief sketch is used to plan the general pattern on the paper. The artist then lightly draws the first flower with a fine, hard pencil on Fabriano Artistico paper. Thin washes are painted to build up the delicate tones. While the first flower is drying, the artist starts work on the second flower and, moving from one to the other, builds up with pencil, crayon and wash. The intense concentration on these two flowers is part of this painter's way of working. She builds up a familiarity with the shape and identity, and finds that this establishes a rhythm for the whole composition and that other flowers will then slot easily into place.

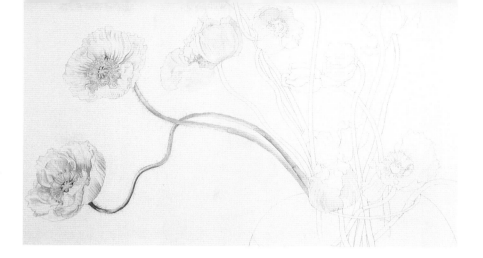

3 The bend of the stems is extraordinary and distinctive. Using thin paint and a medium sable brush she follows their lines back to the vase and then starts to fill in the other plants in relation to these. The whole structure is now sketched in.

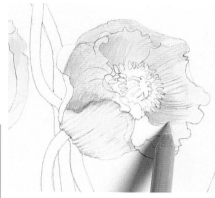

4 Fine brushwork and crayoning picks out the shadow and texture of this stem. The work seems painstaking but the artist works with a fluid rhythm and knows exactly what is needed where.

5 Moving backwards and forwards the flowers are blocked in and built up, the artist paying particular attention to the angle of the head and subtlety of colour. Here you can see the fine texture of the petals being put in with a watercolour pencil.

6 Watersoluble crayon is used to draw the shape of this particularly lovely unfolding bud. Water applied to some areas creates controlled areas of intense colour.

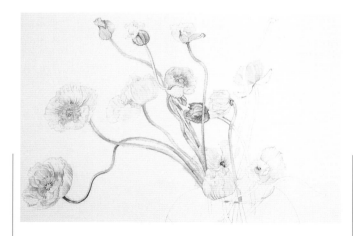

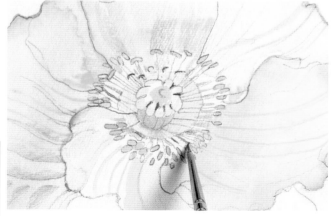

7 The whole composition depends very much on the careful interlacing of stems. When a group of flowers has been completed the background stems are woven into the overall pattern.

8 A fine brush picks out detail in the centre of a flower.

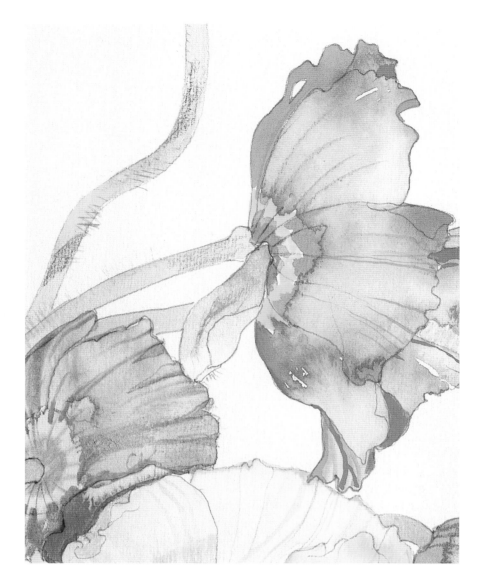

9 Here, the artist is paying particular attention to the join of stem to flower.

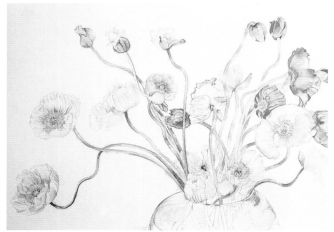

10 The painting of the flowers is completed, but the vase needs to be worked on.

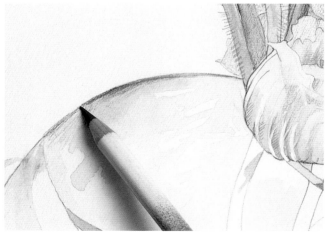

11 Painting glass needs intense concentration. An underlying wash sketches in the delicate patches of shadow, and crayoning sharpens the tone and defines edges.

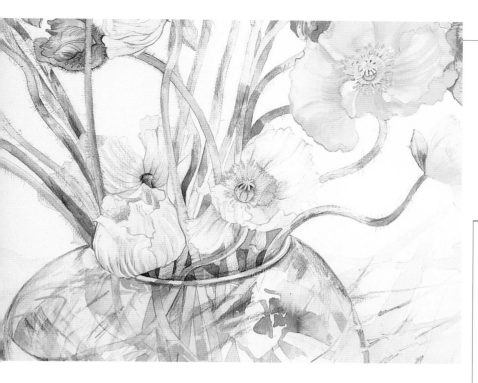

12 The shape of the stems in the vase echoes the spread above, but reflection and deflection create their own abstract pattern, a mesh of unexpected shapes and colours.

13 The painter takes a careful look at the whole and makes adjustments. Some stems are strengthened, and more intense areas of colour built up round the neck of the vase. A web of shadow painted in watercolour echoes the flower shapes and unifies the whole.

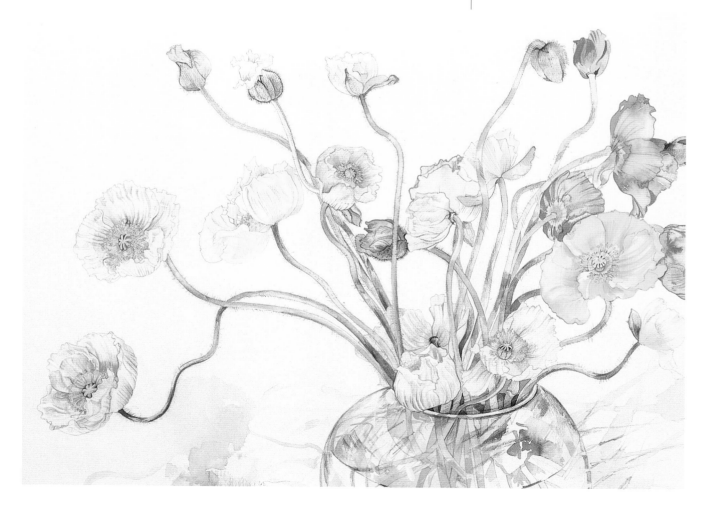

BOUQUET WITH FRUIT

THIS STILL LIFE IN OILS ON BOARD BRINGS LIFE TO THE WHOLE SURFACE OF THE CANVAS. HIGHLY PATTERNED DRAPES, CONTRASTING FRUITS AND CHINA GIVE AN IDEAL OPPORTUNITY TO CREATE A DAZZLING COMBINATION OF STYLE, COLOUR AND CONTENT.

BY PETER GRAHAM

The colours used are lemon yellow hue, Winsor lemon, cadmium yellow, aureolin, Naples yellow, Mars yellow, raw sienna, terra rosa, raw umber, alizarin crimson, cadmium red, cadmium scarlet, permanent rose, cobalt violet, French ultramarine, indigo, cadmium green, Winsor green, Prussian green and titanium white.

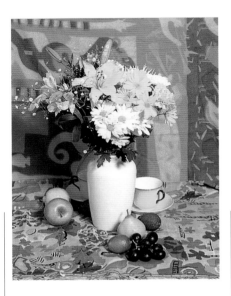

1 This arrangement of objects has been carefully placed to bring out pattern, leading the eye gently around the colours, shapes and forms. Yellow shades in the flowers are reflected in the drapes, cups and lemon, and this is complemented by green shades running through the apples, limes and foliage.

2 Large flats and filberts are used to lay down areas of thinned oil paint. Lemon yellow hue and Mars yellow form the basis for the predominantly warm background.

3 The general colours are blocked in, and key lines and compositional details have been added; for example, the vase and the edges of the cups. This is treated in a very loose manner, which helps give the painting life and vigour from the start.

4 The darker tones are applied, building up the colour gently. Here the green foliage is being painted with swift chisel marks from a flat bristle brush.

5 The negative shapes between flowers are painted, keeping a crisp edge for the petals of the flowers. Prussian green, umber and sienna are used to increase the depth of contrast.

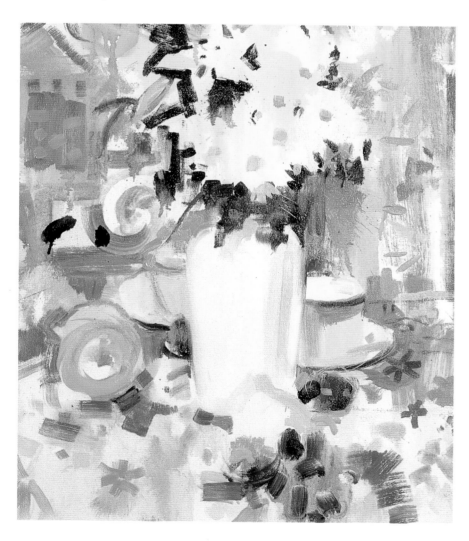

6 The bouquet is outlined using thick, bold brushmarks, and the patterned drape in the foreground has been painted with distinct brushwork over the colour washes of previous stages. The composition is taking shape.

7 The use of a painting knife to draw the edge of the vase is a way of emphasising its shape.

8 A mixture of violet and ultramarine is added to the background pattern to develop depth of colour.

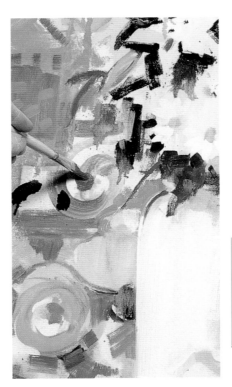

9 The composition is virtually complete. All that remains is the attention to detail.

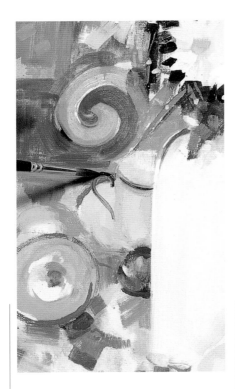

10 A large, round (no. 10) sable is used to pick out the black on the cups. A clean, swift stroke leaves a good line of colour.

11 The gloss on the grapes is achieved, again using a sable, with mixtures of indigo, violet and titanium white. The outline of the grapes is "drawn" carefully with a painting knife.

12 The resulting painting uses colour and pattern to lead the viewer in and around the whole surface.

BLACK VASE AND APPLES

WITH A VIBRANT PALETTE OF OIL COLOURS, PETER GRAHAM CAPTURES THE PATTERN, COLOUR AND CONTRAST OF THIS STILL LIFE ARRANGEMENT.

He uses lemon yellow hue, Winsor lemon, cadmium yellow, aureolin, Naples yellow, terra rosa, raw umber, alizarin crimson, cadmium red, cadmium scarlet, permanent rose, cobalt violet, French ultramarine, indigo, cadmium green, Winsor green, Prussian green and titanium white.

BY PETER GRAHAM

1 A patterned drape with blues and browns frames a composition where delightfully intense colours and the natural shapes of fruit and flowers, with a reflective vase at their centre, provide an exciting subject to paint.

2 Using a large, flat bristle brush (no. 12) and lots of turps, the general colours and shades are loosely blocked in. No great attention is paid to detail at this early stage in the painting.

3 More precise brushmarks are employed to create shapes within the flowers. Violet and terra rosa are used for the darker areas within the composition. Care is taken not to create too strong a contrast between objects at this point.

4 The full spectrum of colour is now roughly painted, giving a good idea of the final composition.

5 A cloth is used to wipe any unwanted paint off the canvas.

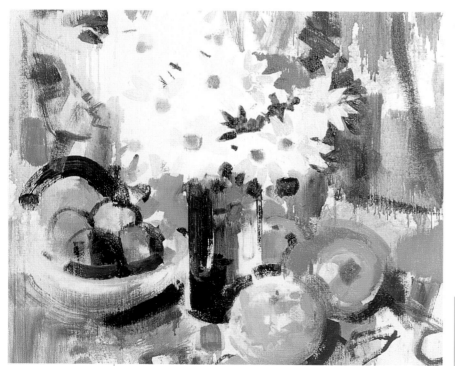

6 The artist starts to tighten up composition and build up colour with slightly thicker paint. Incidental shapes such as the pattern in the foreground are introduced.

7 A painting knife is used to scrape an outline around the apple, revealing the ground colour while defining the round shape of the fruit.

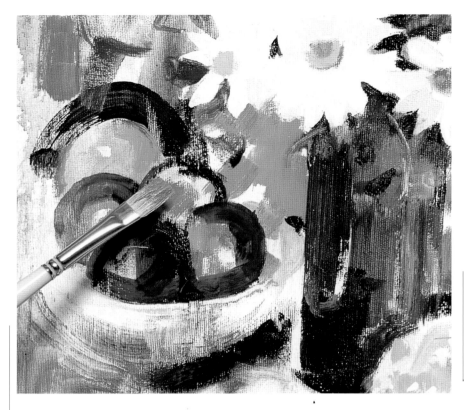

8 At this stage the fruit is suggested by colour rather than by detail.

9 The edge of a flat bristle brush is used to imprint the petal shapes, using a mixture of cobalt violet and titanium white.

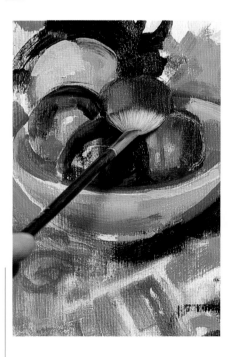

10 Here the artist uses a fan brush to blend the dark tone and light tone together, creating a smooth transition and giving the fruit a three-dimensional feel.

11 The handle of a brush can be useful. Here it has been used to create a texture on the orange cloth, to emphasise and contrast with the polished surface of the apple.

12 The negative shapes between the petals of the flowers are given a very dark colour with indigo and Prussian green to produce a strong contrast.

13 The finished work is a highly coloured composition, with natural tones, and shapes that combine detailed brushwork with looser, more fluid strokes.

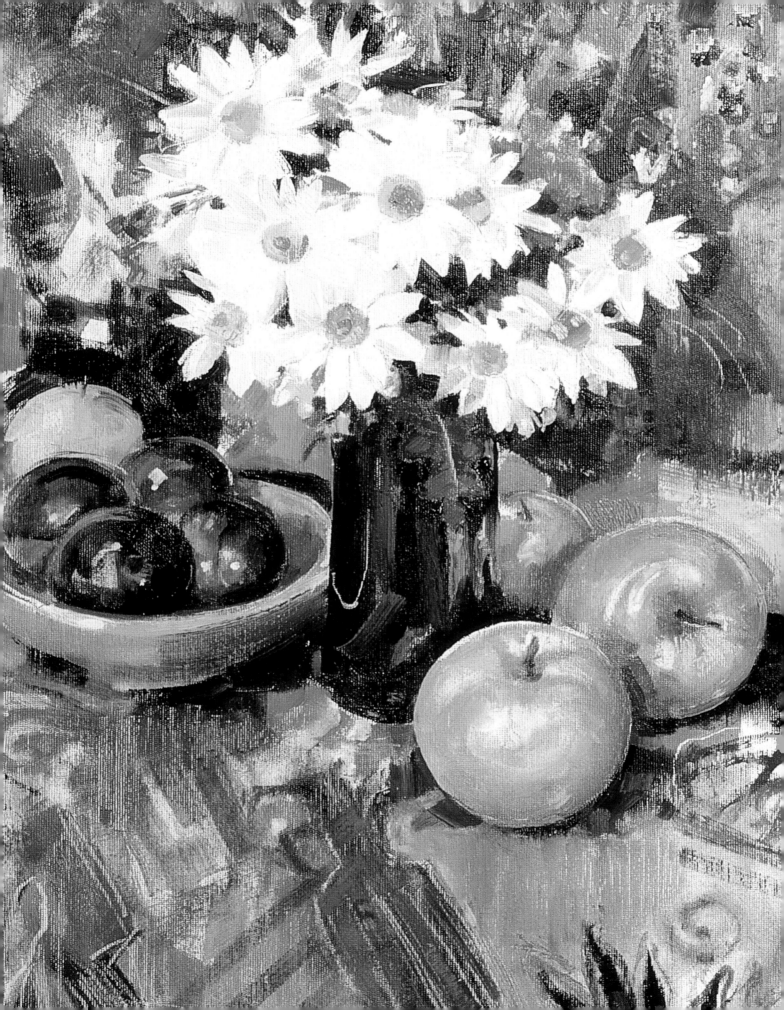

TULIPS

ALISON MILNER GULLAND WORKS VERY FREELY, DRAWING AN IMAGE OUT OF THIS APPARENTLY HAPHAZARD MÊLÉE OF PAINTED TEXTURES AND WORKING INTO THIS IMAGE TO REVEAL ENERGETIC AND LIVELY PLANT FORMS. SHE USES A COMBINATION OF PRINTING INKS, ACRYLIC PAINT, ACRYLIC MEDIUM AND WATERCOLOUR.

BY ALISON MILNER GULLAND

I Brilliant red and yellow tulips are used as a basis for the composition but mainly as a source of reference rather than as a specific subject.

2 An acetate sheet is placed on top of white paper and used as a non-absorbent working surface on which to manipulate the colours. The artist uses printing inks, choosing whatever is appropriate from a wide collection, and manipulates them on the acetate. Diluting the ink with turpentine creates paler pools. Acrylic paint could be manipulated with water in the same way and glass or formica would serve as a surface. A strong, smooth watercolour or printing paper is placed over the pattern of paint, pressed into the surface to move and spread the paint and then gently peeled off.

3 This monoprinting technique can be unpredictable and success depends on experience. The resulting image is left to dry and then considered carefully to discover the flowers within.

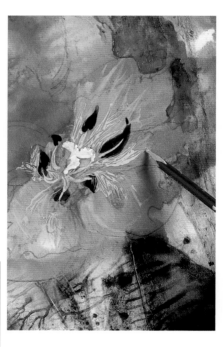

4 Having decided how she is going to use the image, the artist draws a loose structure, using the patterns made by the monoprinted inks to construct the free shapes of the tulips. Using the live flowers as reference, she works into each flower centre with a brush to make strong marks of acrylic paint and employs a pencil to manipulate textures.

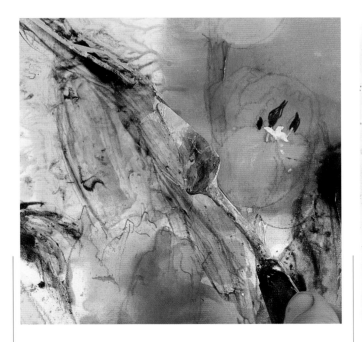

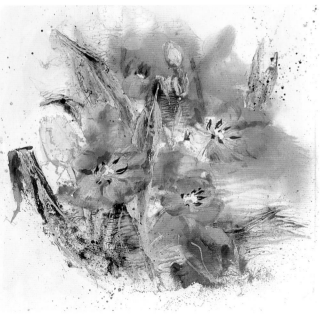

5 Dark leaf shapes are clarified and created with loose brushwork. These are given texture and dimension by manipulating thick opaque paint with a palette knife.

6 The yellow background is extended and the shape of the leaves and the detailed flower centres give a sharpness to the composition.

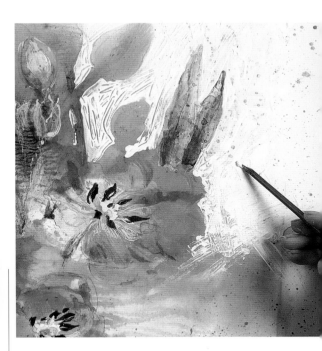

7 Two shades of blue paint are spattered onto the paper with a toothbrush and larger drops are flicked on from a brush.

8 The artist decides at this stage to use a coat of acrylic medium to silhouette some petals and give form to the flowers in the background.

9 The artist then scrapes into the medium to give rhythm to the surface and leave a vigorous basis for further paint.

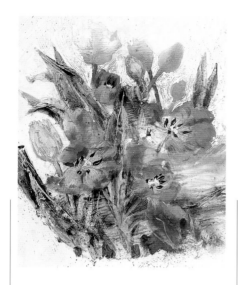

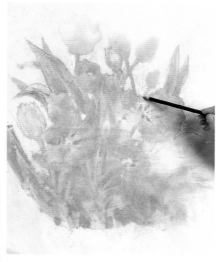

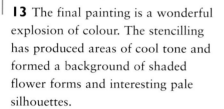

10 The blocking in of certain areas has changed the whole appearance of the composition, defining the fluid shapes of the flowers in the foreground and also revealing a silhouette of shapes behind.

11 The painter decides to cool down certain parts. She traces the outline of the areas she wishes to remain as they are and cuts a stencil.

12 This stencil is taped in position and watercolour paint is sprayed in gentle bursts over the top half of the image with a paint diffuser.

13 The final painting is a wonderful explosion of colour. The stencilling has produced areas of cool tone and formed a background of shaded flower forms and interesting pale silhouettes.

STILL LIFE TABLE

THIS STILL LIFE IN WATERCOLOURS AND GOLD BY JENNY WHEATLEY IS RICH IN COLOUR AND PATTERN AND SHOWS HOW WASHES AND DETAIL CAN COMBINE TO PRODUCE THAT DISTINCTIVE LUMINOUS QUALITY UNIQUE TO WATERCOLOUR.

The materials used are Schmincke Watercolours: Naples yellow, permanent yellow light, Indian yellow, yellow ochre, vermilion, English red light, permanent red deep, brilliant purple, carmine, cerulean blue, cobalt blue, permanent violet, brilliant blue, ultramarine blue, ultramarine violet, opaque green light, May green, green lake deep, brilliant turquoise; and gold metallic powder.

BY JENNY WHEATLEY

1 This ornate arrangement presents wonderful possibilities for exploring colour and contour.

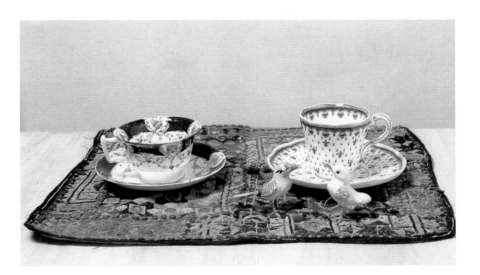

2 The paper is stretched, then the composition is carefully drawn, using pencil line and no shading.

3 Using a wet-on-wet technique and working on a dampened surface, a no. 7 Raphael squirrel mop is used to load on colour with large, generous brushstrokes. All the time, the artist is referring to the objects for tone and colour that relate to the composition.

4 This creates a multicoloured background, which gradually soaks into the paper and merges one colour into the next. The artist works quickly in order to allow this to happen.

5 Now that the background is complete, it is left to dry. Note that areas left white, or with just a hint of yellow, are where the highlights of the painting will eventually fall.

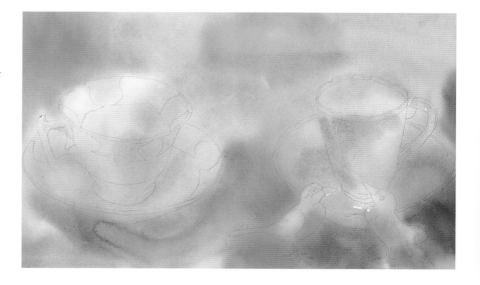

6 The detail is now added, using a no. 6 round sable. Ultramarine blue and violet are used to build up the pattern on the cup.

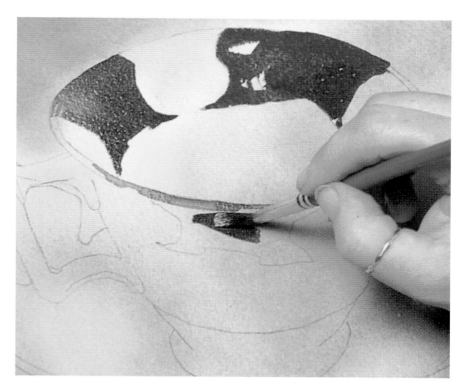

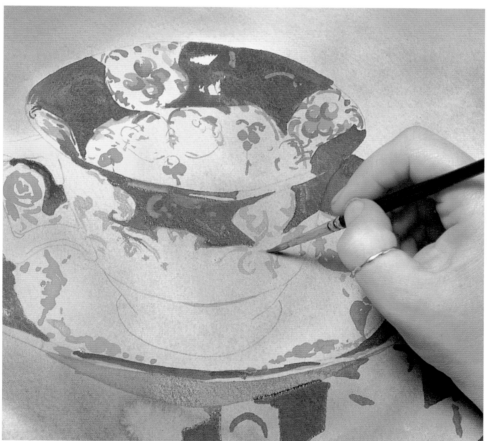

7 Painting one object nearly to a finish allows the artist to gauge the effect of the luminous quality of the underlying washes.

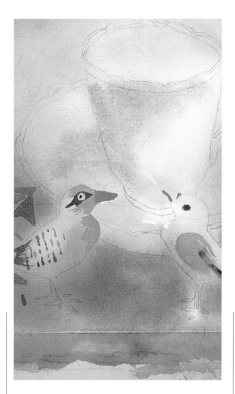

10 The pattern on the cloth is now balanced by the intricately detailed cups.

8 Darker washes are applied, allowing some of the under colour to show through. The random nature of watercolour is brought to full advantage here, especially where the yellow washes sit beautifully, giving the ornamental bird a brilliant glow.

9 The build-up of pattern unifies the composition.

11 As a final touch, gold metallic powder is dabbed on with a soft cloth in order to enhance areas of the painting.

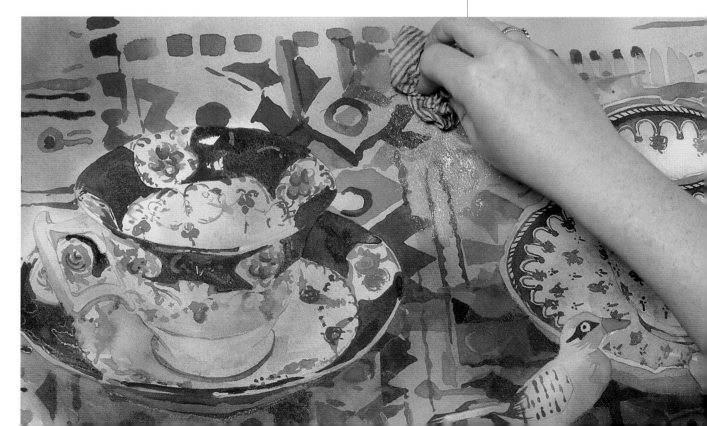

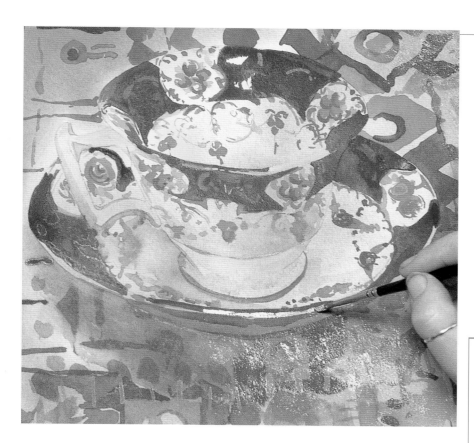

12 Gold is used to pick out the highlights on the edge of the saucer.

13 The finished painting demonstrates how watercolour can produce wonderful effects of reflected light, combined with exquisite pattern and detail.

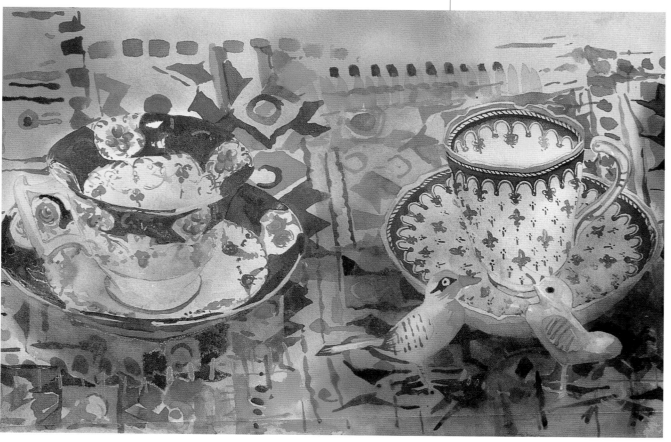

FREE EXPRESSION

A CERTAIN AMOUNT OF NERVOUS APPREHENSION OFTEN ACCOMPANIES THE FIRST
BRUSHSTROKE OF A PAINTING OR THE INITIAL PEN OR PENCIL LINE OF A DRAWING.

Practice with sketching – essentially a direct rather than a contrived response – will help you to achieve spontaneity, freedom and vigour in your work.

Drawing and painting can often be hampered by the necessity of producing finished work, paintings that will work well, accurately recording a new image and perhaps producing something that will stand up to the comments of others. All these requirements place inhibitions upon the artist and stifle and tighten freedom of expression.

Sketching is free from all these constraints and offers a chance to be loose and unrestrained, to explore at will and to exercise the hand and eye, thus developing technical dexterity.

Draw freely, regardless of the result.

Try making fast impressions of a flower group or still life in different media knowing that you will discard them – you can always change your mind if something remarkable emerges. Tape a charcoal stick to the end of a long stick and sketch on the floor or on an easel, smudge the result into a tonal study, strengthening the dark areas and rubbing out the light.

Try also drawing in charcoal or crayon without letting your hand leave the paper and without taking your eye off the subject, not even for a fractional glance. This serves to concentrate the entire attention upon the subject, following the contours and angles without breaking the attention to look at what is happening on the page. The results may surprise you; the maze of lines will reveal unexpected

shapes of great vigour. Assess what is there and see if you can develop it.

Be messy with paint – spread it freely with your fingers or rags; squirt it straight from the tube and mix it around with water or sticks; freedom of expression will add to the vitality you capture from the plant.

The projects that follow are designed to encourage you to work quickly – and confidently – using techniques that encourage freedom of expression.

below Here, strong paper is folded and the edge dipped into thick gouache paint and used to form the sword-like shape of an iris. Shorter pieces of stiff paper manipulate paint into the radiating form of the flower.

right Janet White has employed two techniques here to create a mesh of bamboo foliage. The basic image is drawn lightly and the leaf shapes left by painting a blue background around them, making a negative space. A twig dipped in household bleach adds a further web of lines, which leach the colour and form finer details.

below Preliminary sketches help to assess whether a composition will work. The compositional lines formed by the dresser would normally pull the eye out of the picture, but the dark shades and tonal contrast of the flower group hold the attention of the viewer.

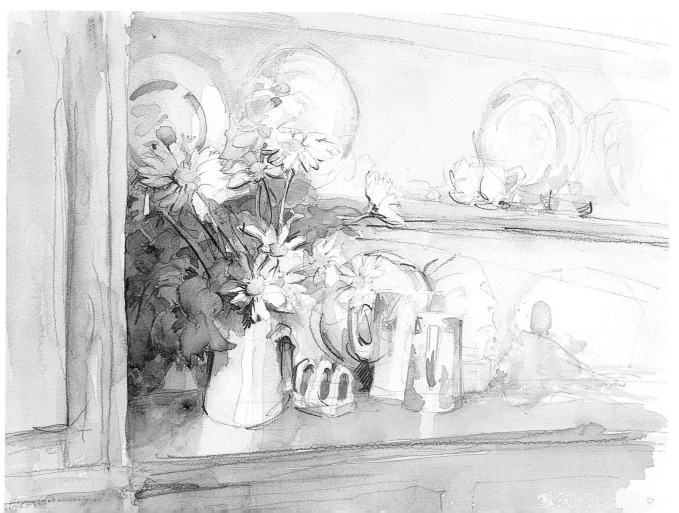

CARNATIONS

WET-ON-WET PAINTING CAN BE A MOST EXHILARATING EXERCISE. COLOUR ADDED TO DAMP WASH HAS A MIND OF ITS OWN, AND THE PAINTER HAS ONLY LIMITED CONTROL. THIS UNPREDICTABILITY IS PART OF THE CHARM, BUT PERSISTENCE IS NEEDED TO WORK THROUGH AND DISCARD SEVERAL FAILURES WHILE WAITING FOR THE MOMENTS OF MAGIC TO APPEAR.

The palette used for this sketch is rose doré, vermilion, alizarin carmine, permanent rose, oxide of chromium, sap green and cobalt green.

BY ELISABETH HARDEN

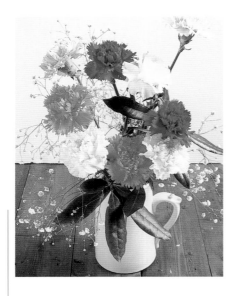

1 Carnations and gypsophila are arranged in a simple group, crowding the flower heads together to give an intensity of colour.

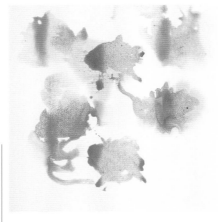

2 Stretched watercolour paper, 300gsm (140lb) with a NOT surface, is dampened with a sponge. Even the sturdiest of papers will buckle after a while. Blobs of paint have been dropped onto the paper and the buckles have caused them to pool. The artist will try and utilise this variation in colour for the tones of the flowers.

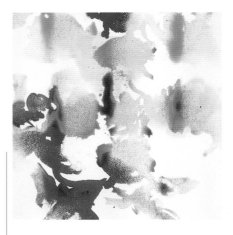

3 A softish green, oxide of chromium, is painted between the flowers. The paper is starting to dry at this point so the paint can be manipulated with a flat-headed brush into shapes of leaves and butted up against the flowers to give definition to the edges.

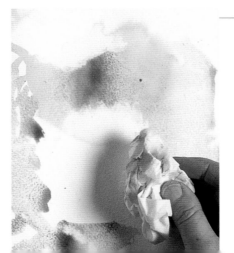

4 Flower shapes are made by removing paint from the semi-dry surface with crumpled tissue. This forms the basic outline of some flowers. At the same time the paints are mixing and merging together to create areas of soft colour.

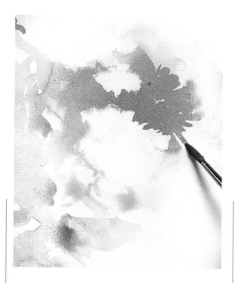

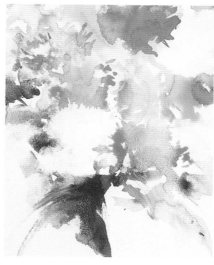

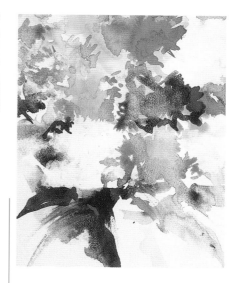

5 The artist paints strong areas of alizarin carmine. Where the paper is dry it will make a crisp edge, forming the petal edges of the pale carnation. On damp patches it will merge to give a soft effect.

6 The spiky nature of the carnations is beginning to emerge. Re-dampening, painting in and removing paint with tissue builds up a loose definition of the plant. Some patches will work better than others and by concentrating on these, the "happy accidents" can be exploited.

7 A pale yellowy green is washed in and pushed with both brush and hairdrier into sharp edges which form the outline of the palest flowers. This is a way of using "negative space" to form the body of the flower. The predominant colour in the two pale carnations in the foreground is a pink frill that forms the edges of the petals. Threads of paints are applied with a fine brush.

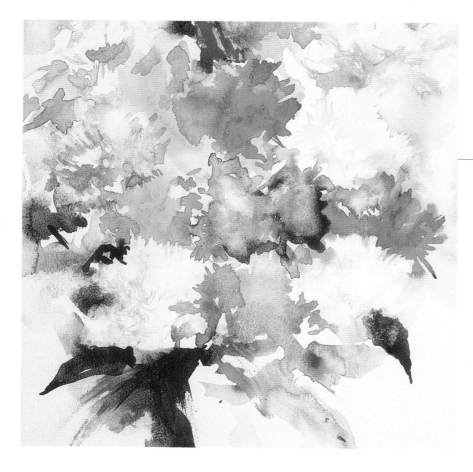

8 A third shade of green, cobalt green, forms the stems and flower calyxes and establishes the rudiments of a jug. A light spatter of white paint gives an indication of the gypsophila. Reassessing the exercise, the artist feels that texture rather than composition has been the more successful outcome. At a second attempt she would avoid the row of three flowers in the foreground, give the jug more substance and spatter a stronger sparkle of white gypsophila with acrylic paint. But, after all, trial and error is part of the painting and sketching process.

MARIGOLDS

THIS DRAWING IN SOFT PASTELS ON INGRES PAPER IS FREELY WORKED AND AIMS TO CATCH THE PROVENÇAL BRILLIANCE OF THE FLOWERS.

BY HILARY LEIGH

1 The vase of marigolds is the basic subject and will be rearranged on paper to produce an interesting composition.

2 The first flowers are positioned using pale cadmium yellow soft pastel.

3 The artist freely sketches in leaves, stems and some detail of the flowers.

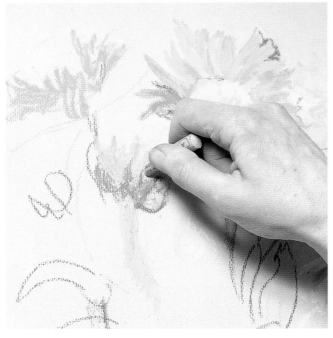

4 Various shades of yellow and orange are used to portray the colour of the petals.

5 The first green is added, with lizard green giving the foundation colour.

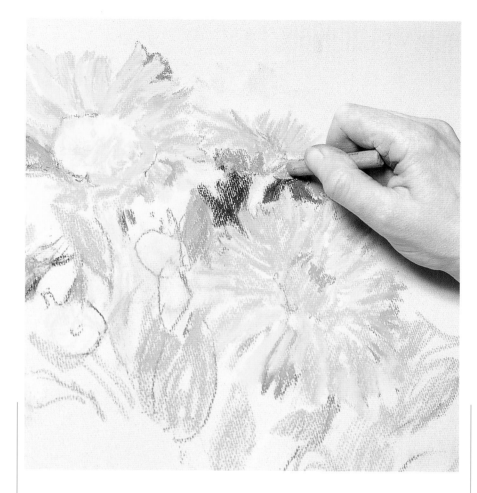

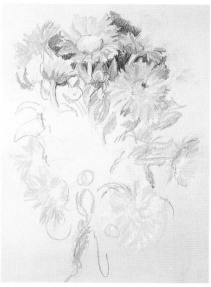

6 Prussian blue has been used to give the deepest tone between the flowers.

7 The overall composition has now taken shape.

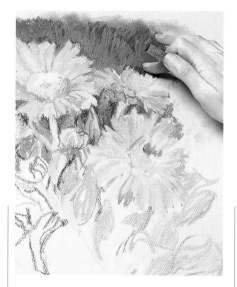

8 The artist uses her fingers to blend Prussian blue and mid-tone purple-blue at the top of the drawing.

9 More work is done on the foliage, using a mix of lizard, sap and olive green.

10 The background is extended, with the purple-blue tone throwing the golden flowers forward.

11 The artist turns her attention to the central cluster of blooms.

12 More background is added and again fingers merge the colours.

13 Detail at the centre of the marigolds is achieved by using brown madder.

14 The finished picture exudes all the warmth and vitality of the Mediterranean.

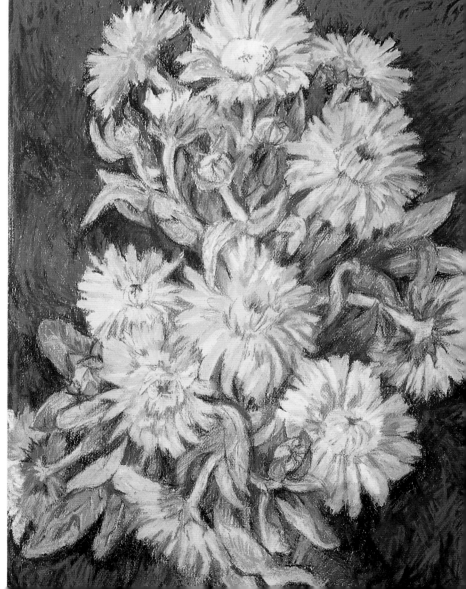

CHRYSANTHEMUMS

THIS PENCIL AND WATERCOLOUR DRAWING ON HAND-MADE NOT PAPER ILLUSTRATES WHAT CAN BE ACCOMPLISHED, RELATIVELY QUICKLY, WITH THIS MEDIUM.

BY HILARY LEIGH

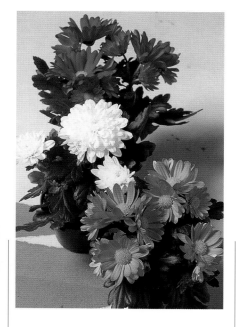

1 Three pots of chrysanthemums are positioned on different levels, to give a pleasing curve of colour.

2 The artist makes short freestyle strokes, using a propelling pencil. The composition is built up using the live material as a guide rather than as the basis for an exact copy.

3 Areas of free crosshatched shading are added to give form and depth overall.

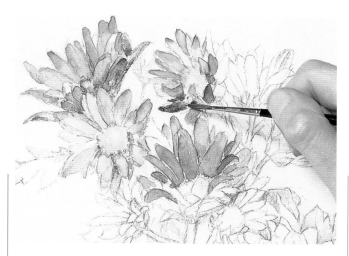

4 The first watercolour washes are applied, again without too much attention to colour-matching the flowers.

5 Chinese white is used with a slight staining of yellow at the centres.

6 You can now see the overall composition building up.

7 Dark green leaves help to project the white flowers.

8 Although freely applied, watercolour washes are built up in the usual dark on light manner.

9 The white paint, being opaque, means that initial detail has been lost and this is now restored by over-shading in pencil.

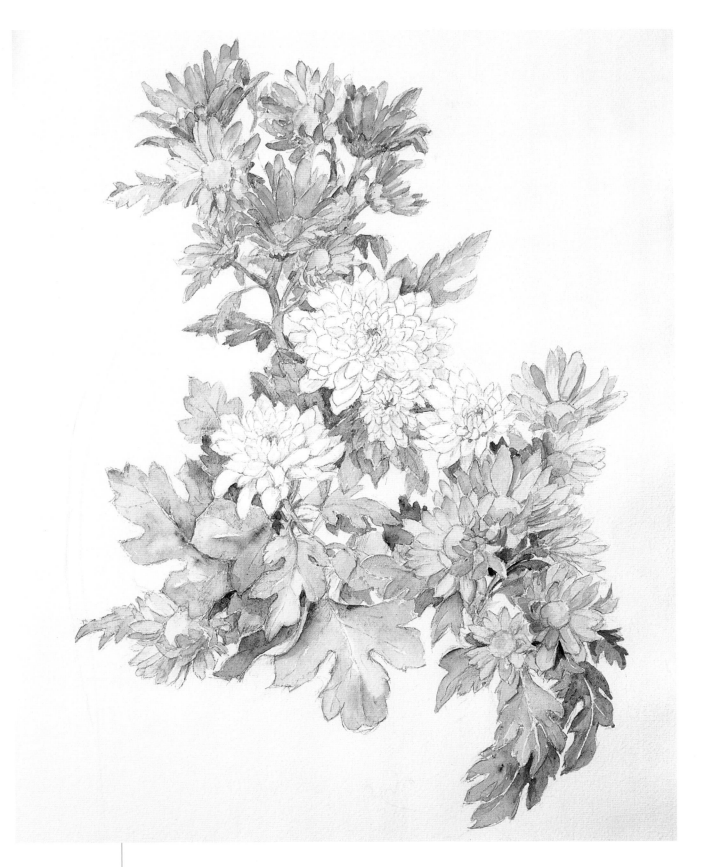

10 The finished study is a rewarding example of a day's work when overall effect, rather than photographic accuracy, is the aim.

THE NUDE AND PORTRAITS

THE PORTRAYAL OF THE HUMAN FIGURE HAS BEEN AN ABIDING CONCERN OF ARTISTS OVER THE CENTURIES. DESPITE THE TREND TOWARDS ABSTRACTION THEIR FASCINATION WITH DEPICTING THE FIGURE, AND WITH PORTRAITURE, HAS NOT DIMINISHED AND BOTH SUBJECTS CONTINUE TO OCCUPY A CENTRAL PLACE IN CONTEMPORARY ART. ALEXANDER POPE'S STATEMENT THAT "THE PROPER STUDY OF MANKIND IS MAN" IS AS TRUE TODAY AS IT WAS FOR EARLIER SOCIETIES.

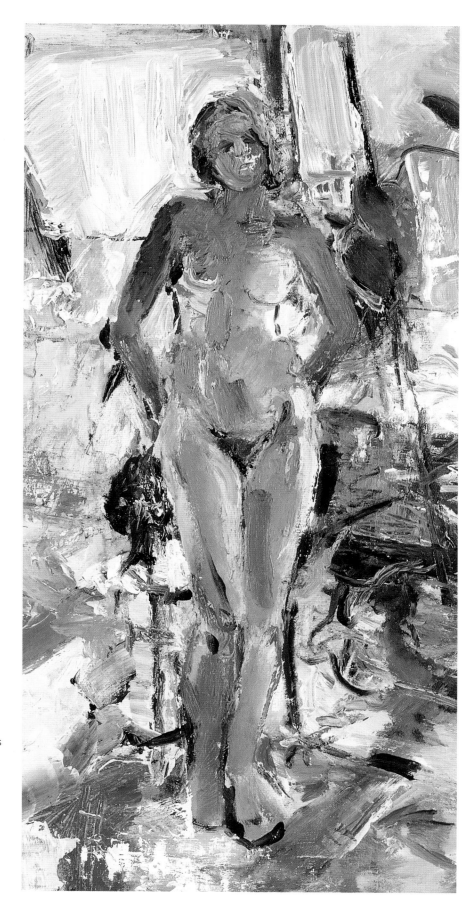

right *Standing nude*. Oil by David Carr. It is broadly painted, and much of the room is done with a palette knife and impasto (paint applied very thickly). A great deal of white was used in the space to give a shimmer of light. The base colour of the figure is raw sienna into which slabs of indigo, alizarin crimson and cadmium red follow the direction of the planes.

ANATOMY

HERE IS AN ABC OF THE FIGURE – 26 IMPORTANT POINTS TO
HELP IN A CONFIDENT AND AUTHORITATIVE APPROACH.

The standing figure shows off the muscles to good advantage. Whatever position the figure takes, these same muscles can be found, either tensed or at rest.

The somewhat complex names of some muscles make sense when analysed. Frequently they describe the progress of the muscle. The *sternomastoid* (a) travels from the sternum (breastbone) to the mastoid process behind the ear. The *rectus femoris* (r) originates in the rectal area and attaches to the end of the femur (thighbone).

Around the head, neck and shoulders the main muscles are the *sternomastoid* (a) and the almost diamond- or trapezoid-shaped *trapezius* (b). The *trapezius* begins at the base of the skull, travels far down the back, attaches itself to the shoulder blades at the side and continues over the shoulders to connect with the collarbone (clavicle) at the front. This muscle gives the characteristic slope to the shoulders.

The *latissimus dorsi* (g) – there is one on each side of the back – laps around the ribs and tucks up

underneath the armpits, attaching to the upper armbone (humerus) at the top. At the front, the large *pectoral muscles* (d) move from the breastbone (sternum) up to the collarbones and out to the upper ends of the arms. The long, flat muscle down the front of the body is known as the *rectus abdominis* (k) and is divided into four main parts, which are more or less clearly seen depending on the muscularity of the person.

The *external obliques* (i) move out from the *rectus abdominis*, around the waist area and up to the *latissimus dorsi*.

below These three drawings of the figure from different positions show all the main muscles of the body.

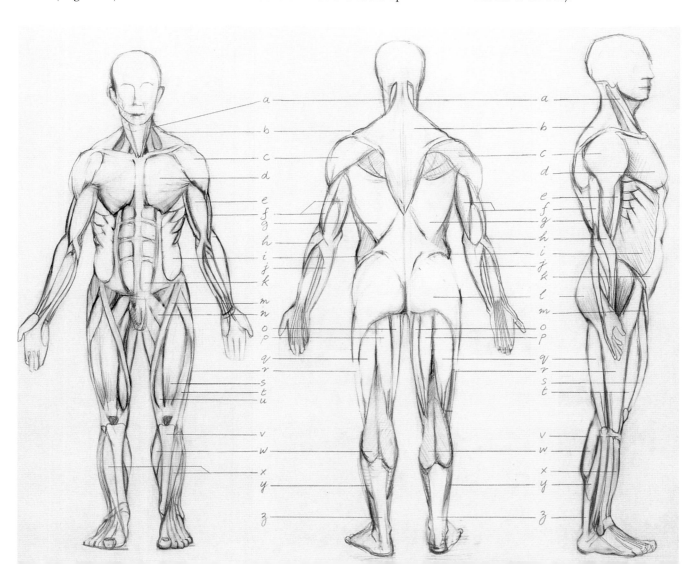

The shape of the shoulders is completed by the *deltoid* (c). Viewed from the side, it is like an inverted triangle (the sign for *delta* in the Greek alphabet is a triangle). It covers the arm joint rather like a raglan sleeve in shape. It moves down the arm and tucks in between the *biceps* (e) and the *triceps* (f).

Much of the characteristic shape of the outside of the lower arm or forearm is created by the *supinator longus* (h) – *supinate* means to turn – together with the long *radial extensor* of the wrist immediately below it. On the inner side are the group of muscles that move the fingers and cause the inner bulge. The outermost of these is the *ulnar flexor* (j) of the wrist, which is seen most clearly from the back.

At the front of the legs the *sartorius* (m), a long thin muscle, travels from the pelvis, in and across the leg, down to the top of the lower leg and attaches to the tibia (main lower-leg or shinbone). It is essential to look for this muscle in defining the leg. The three large muscles – the *rectus femoris* (s), the *outer vastus* (t) and *inner vastus* (u) – although clearly defined, especially when tensed, are really part of one large muscle, which has a common tendon connecting it to the kneecap (patella). On the inner side of the thigh, moving into the pubic area, is a group of muscles known as *adductors* (n).

At the back, the *gluteus maximus* (l) and *gluteus medius* form the buttocks. It is important to note how these muscles are attached by a strong tendon to the *iliotibial band* (r), which flattens the outside of the thigh and travels right down to the top of the *tibia* (v).

The back of the thigh is composed of the three long flexor muscles of the knee – the *biceps* (q) and the grandly named *semimembranosus* (o) and *semitendinous* (p). They originate from the pelvis and are covered at the top by the buttocks. They produce the fullness of the back of the thigh. When the knee is bent they stand out as prominent chords and they are often referred to as hamstrings.

The most pronounced muscle down the front of the lower leg, just at the side of the shin, is the *tibialis anticus* (x) and at the back the calf is made up of two main muscles. The under-lying and flatter one, not unlike a flat fish in form, is aptly called the *soleus* (y) and the predominant muscle is called the *gastrocnemius* (Latin for the belly of a toad). It has two heads, the inside one being lower than the outer. Last, but not least, as it is the largest tendon in the body, the *Achilles tendon* (z) connects the *soleus* and *gastrocnemius* to the heel.

below In this charcoal drawing, the flat planes of the model's torso and limbs can clearly be seen.

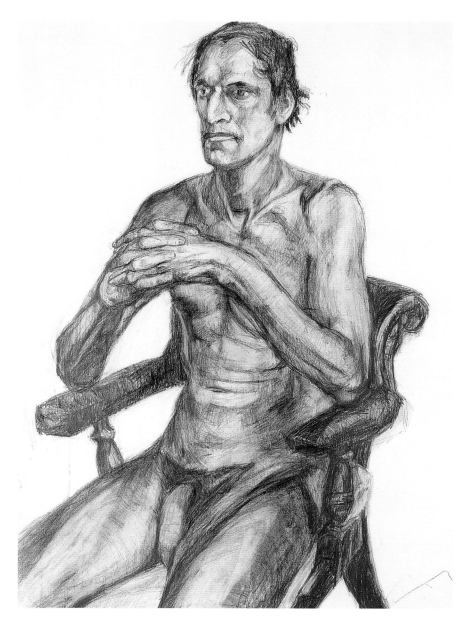

BALANCE AND MOVEMENT

BALANCE AND MOVEMENT ARE TWO SIDES OF THE SAME
COIN. IN REALITY, PERFECT BALANCE IS FLEETING – THE
BODY IS CONSTANTLY MAKING SMALL ADJUSTMENTS TO
"HOLD" ITS BALANCE. BALANCE CAN BE THOUGHT OF AS A PAUSE
IN MOVEMENT.

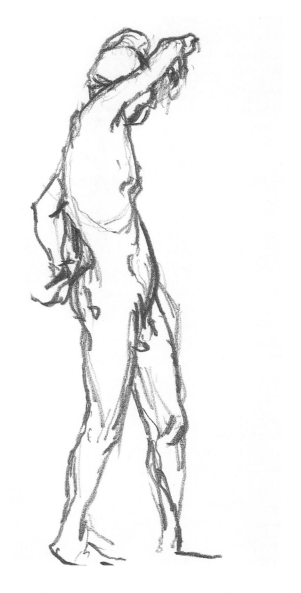

above In this pencil sketch the balance point at the back of the
neck is directly over the leg that is carrying the weight.

above A pencil sketch showing how, even when the body twists
around, the balance point remains over the leg bearing the weight.

The Italian artists gave us the term *contrapposto*, which means counterposing one part of the body against another to maintain a position in balance. For example, when a model stands with almost all her weight on one leg, the shoulders relax and drop down over the side of that leg. They counter the upward thrust of the hip. The head in turn tilts in the opposite direction to the shoulders. Thus protected from falling sideways, the model can hold her pose.

Movement occurs when we overreach our point of balance, whether accidentally or deliberately. It is important to grasp this fact because we must look for the flow of movement and the tension of muscles, even when the most professional of models is posing.

The correct line of balance in a pose must be established for two reasons. First and most obvious is the need to avoid a drawing in which the figure seems to be leaning or tilting. There is, however, a second, more subtle reason. A figure must look well-rooted and balanced if it is to seem to have a firm sense of mass and weight. Without this the drawing, although correct in other ways, will not be truly convincing.

In order to observe and measure balance, we use three points in the body through which we pass an imaginary plumb line. They are, first, from the front, the hollow space between the two clavicles (collarbones) at the pit of the neck; second, for a side profile of the figure, from the ear hole; and finally, for a back view, from the middle of the base of the neck.

If you hold up a pencil vertically in your line of vision from one of these points, the imaginary plumb line will intersect the exact point on the ground where the weight of the body is falling. If, for example, the model has all her weight on one leg, the balance line will run from the balance point down the body to the arch of the foot carrying the weight.

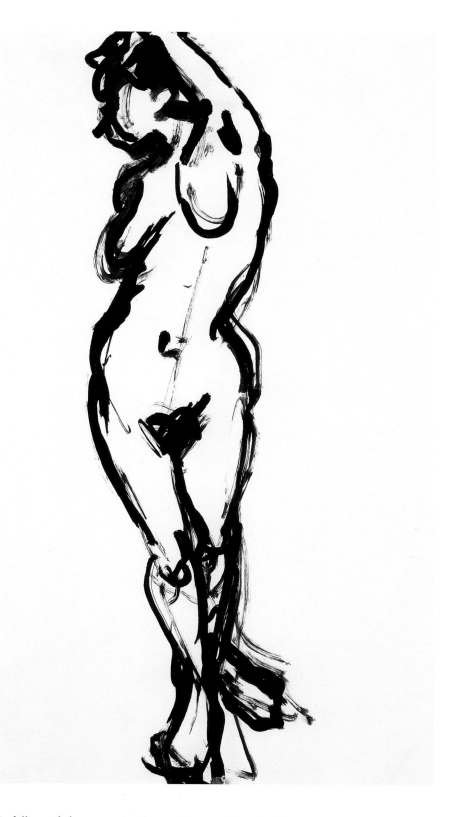

above In this quick brush and ink sketch, the model's body arches out to keep in balance. The balance line runs down from the back of the neck to the arch of the right foot.

BALANCE AND WEIGHT

This series of small watercolours by David Carr explores the problem of balancing the figure and describing the forces at work. Each painting is done from a slightly different angle.

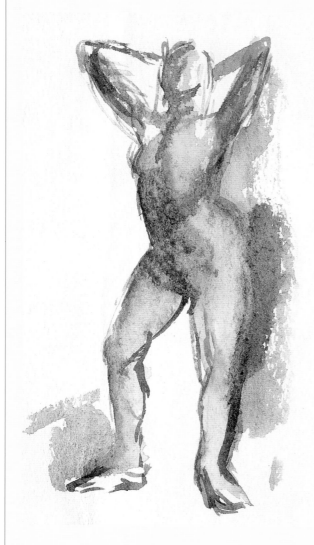

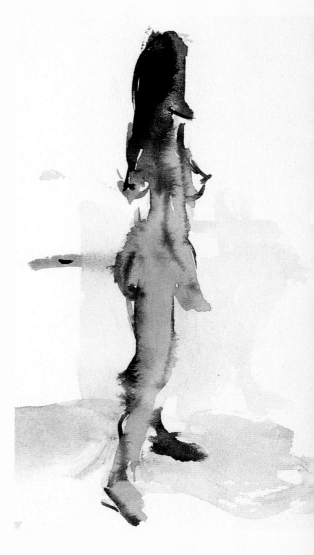

above In this standing nude with the arms raised above the head, the weight is on the left leg, and the enormous change of direction of the waist bears this out. Looking carefully at the watercolour, you will see that the mass of the figure was first established with a warm yellow (aureolin) and the drawing with French ultramarine into the damp paint followed. A brush loaded with ultramarine was taken up the torso with just a touch of alizarin crimson. Three primaries have been used to express the "idea" of standing.

above In this little watercolour, the figure turns and takes the weight off the right leg, transferring it to the left. Again painted with minimal means, a dark violet (French ultramarine and alizarin crimson) was drawn into a warmer wash. Note the slight bleeding of the colour, which helps to give a sense of form.

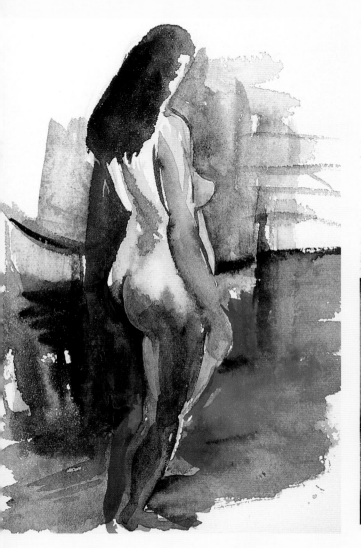

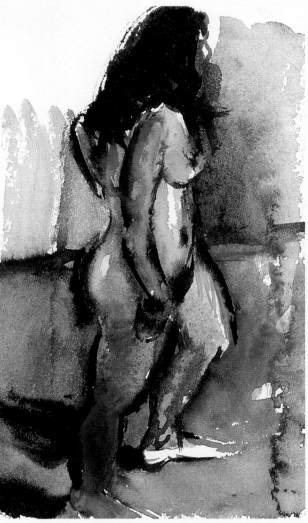

above In this, more of the back was visible. A pale, flat yellow established the shape of the figure. A strong red line was placed down the leg carrying the weight, over which a glaze of French ultramarine put the whole leg in shadow, creating a powerful change of plane at the hip.

above Here, the artist moved around to the front to see more of the stomach and the bent leg. Again, cadmium red was worked into aureolin. Extremely dense lines were painted into that with a mixture of French ultramarine and cadmium red, which gives almost black. This is most noticeable in the hair, but it also helps to give tension to the weight-bearing leg. The cast shadow from the legs helps to give a sense of direction to the plane of the floor.

FINDING THE CORRECT BALANCE FROM THE FRONT

WHEN THE MODEL IS FACING YOU, THE BALANCE LINE IS DRAWN DOWNWARD FROM THE CLAVICLE, THE POINT BETWEEN THE TWO COLLARBONES. IF THE MODEL HAS HER WEIGHT ON ONE LEG, THE BALANCE LINE WILL PASS THROUGH THE ARCH OF THAT FOOT. IF THE WEIGHT IS DIVIDED BETWEEN THE LEGS, THE LINE WILL INTERSECT A POINT BETWEEN THE FEET.

BY DIANA CONSTANCE

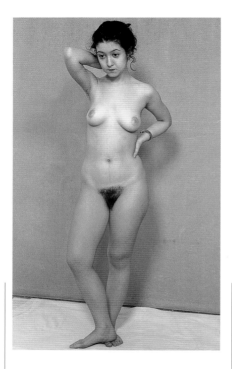

1 The model has been asked to assume a pose with her weight completely on one leg, which is very uncomfortable and can only be held for a few minutes.

2 The vertical balance line is put in first, and then a guideline is drawn across the hips. The weight is on the right leg, causing the hip on that side to be pushed up.

3 A guideline is now drawn across the shoulders and breast, showing the tilt of the shoulders downward over the weight-bearing right hip. The position of the legs is indicated.

4 The counter-thrust of the head and neck are added; these counter movements lock the body into a sustainable balance.

5 The form of the body begins to emerge, firmly held in the right position by the guidelines.

6 An additional felt-tip pen of another colour is used to explore the forms and reinforce the drawing.

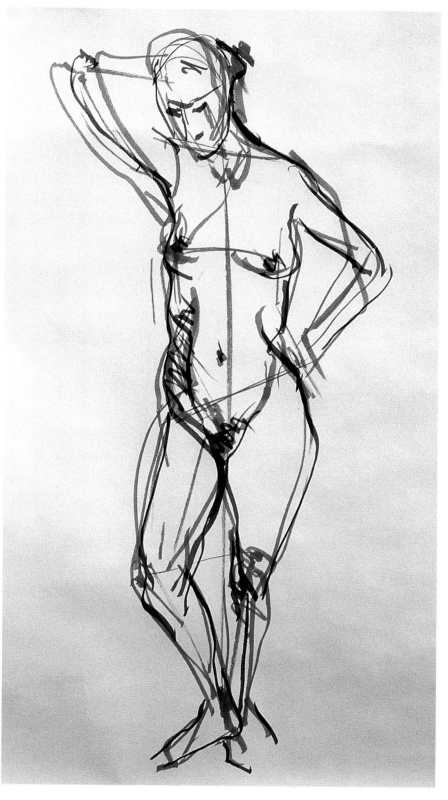

7 This is a quick demonstration to show how the balance of the figure is set out. A non-erasable felt-tip pen would not be used in a normal drawing, where the guidelines would be lightly drawn in.

PROPORTIONS AND MEASUREMENT

IT IS REPUTED THAT PICASSO, IN A BRAVURA DEMONSTRATION OF HIS TALENT, DREW A NUDE, STARTING WITH THE TOE AND CARRYING ON UP THE FIGURE WITHOUT STOPPING. UNFORTUNATELY, THE UNTRAINED EYE FREQUENTLY MISLEADS, SO A SIMPLE OBSERVATION OF THE MODEL HAS TO BE CHECKED AGAINST CAREFUL MEASUREMENT.

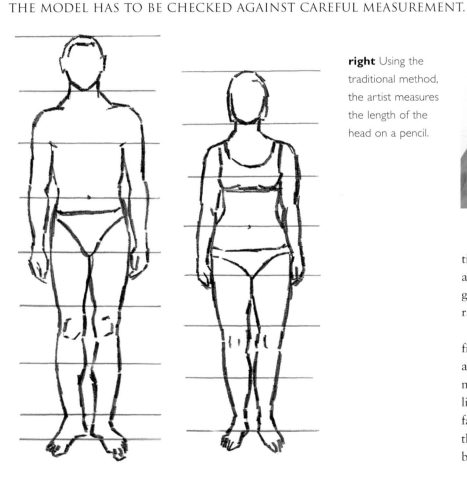

above The typical proportions of an adult male compared to an adult female.

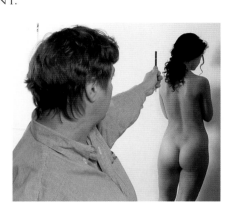

right Using the traditional method, the artist measures the length of the head on a pencil.

We will begin by looking in a generalised way at the proportions of a typical human body. For this a useful unit of measurement is the head-length.

A typical adult male stands about seven-and-a-half head-lengths tall, a female seven head-lengths. Babies and children have larger head-lengths in relation to their bodies. At birth the baby measures about four times its head-length, at five years old, six head-length, at five years old, six times and at nine years old about six-and-a-half times. The head of course grows in size too, but at a slower rate.

Other points worth noting are firstly, that the centre of the body is at the pubic bone, not at the navel as most people think. The elbows are in line with the waist and the fingertips fall level with the lower middle of the thigh. The knee comes midway between heel and hip.

A man's shoulders are about two head-lengths wide, his hips are narrower. In a woman, the shoulders are proportionally less wide and the hips wider than a man's.

Measuring

If you are standing at an easel, put your board and paper at the same level as your eyes. If you have a very large sheet of paper, you must move the drawing board up or down to keep the part of the drawing you are

working on at your eye level. It is always best to stand at an easel so that you can step back from the drawing to see the whole image. If you must use a stool, check for distortions in the lower half of the drawing. Next, whether you are standing or sitting, place yourself where you can see both the model and your paper at the same time without having to look around the side of the drawing board or change your position in any way to see the model. In other words, do not bury yourself behind the board.

The traditional method of measuring the proportions of the body is to hold a pencil vertically, with arm outstretched. Line up the end of the pencil with the top of the model's head and, by moving your thumb on the pencil, mark the length of the head. Keep the measurement on the pencil with your thumb so that you can compare that length to other parts of the body and measure their relationships precisely.

Negative space

The term negative space refers to that area surrounding the figure. Drawing this negative space or marking out this area is one of the best methods of measurement and it is particularly useful when you have a foreshortened pose. By looking at the area outside the model's body, you can measure the parts of the body against the background shapes or against other parts of the figure. So, if the model has her hand on her hip, the shape of the triangle between arm and waist can tell you more about the length of the upper and lower arm than any other method of measurement.

Our observation becomes limited when we fix our gaze on the body alone, and this method of measurement gives us a means of looking at the pose with fresh eyes.

Drawing negative space

Using a soft pencil or charcoal, observe and draw one section of the background or negative space around a portion of the figure. Try to fill in the negative space with your pencil or charcoal without making a complete outline first. Use rapid strokes to make a dark shading. Work on one part of the body at a time. Give yourself enough time to observe carefully – you will need at least 30 minutes for each pose at first. Draw the chair or couch that the model is posing on, leaving the figure as a silhouette. You can now assess the quality of the design that the figure makes on the page, and if you are planning a composition you may now wish to change your position to obtain a view of the model that will give you a more interesting shape.

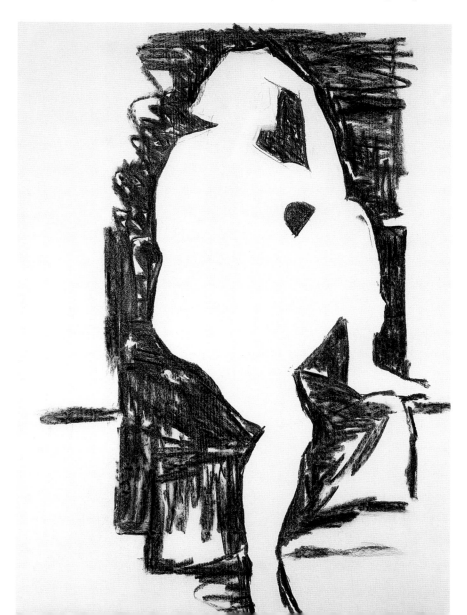

right A charcoal drawing of negative space. The artist slowly works around the space outside the figure and tries to draw only that. The chair and the floor line have been indicated to keep the figure from "floating" in a void.

UNDERSTANDING PERSPECTIVE

THE ITALIAN ARCHITECT FILIPPO BRUNELLESCHI (1377–1446) DEVELOPED THE MATHEMATICAL BASICS OF PERSPECTIVE. HE WAS ABLE TO IMAGINE THE POSSIBILITY OF CHANGING A FLAT, INSUBSTANTIAL PIECE OF PAPER INTO A PALAZZO OR LANDSCAPE OF INFINITE DEPTH.

However, although Brunelleschi is generally credited with starting the obsession with space in western art, the recent discovery of a rare wall-painting, depicting the rape of Persephone, in the Macedonian royal tombs, suggests that Greek painters in the 4th century BC understood and used three-dimensional foreshortening.

Drawing the human body in perspective is vastly more complex than a building or landscape since the structure is constantly changing. In order to draw a foreshortened figure and put it into a composition, we need to understand a few basic rules of perspective.

The floor that you stand on in the studio is what we call the ground plane. If you were outside on flat ground, you could see the ground plane stretching away from you until it reached the horizon. Try holding up a pencil horizontally in front of your eyes. You will notice that this line is exactly on the horizon. So what we refer to as the horizon corresponds exactly with our eye level. If you sit down, the horizon moves down with the level of your eyes; as you stand up, the eye level and the horizon both move upward.

The same thing happens in a studio, but inside a room we are less aware of the horizon and hence of eye level. Check the eye level of the pose. If you are sitting down and the model is lying on a couch, she may be directly at eye level. If, however, you are standing up at an easel, the model will be below eye level. If the person beside you is sitting down and you are standing up at an easel, you will each produce a very different drawing of the same pose.

Determining eye level

Look at the wall or area behind. Keep your head straight and hold your pencil horizontally in front of your eyes – this is your eye level. Note where the pencil is in relation to the model and the wall. If it crosses the figure, they are at eye level; if they are lying down and it is above them, they are below eye level; if the model is sitting on a high stool, the pencil may be on a line below part of them, and they would be partially or wholly above your eye level.

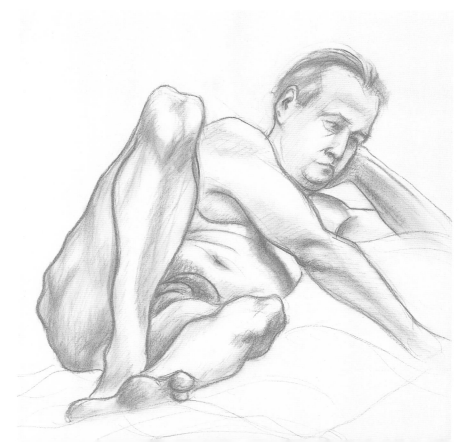

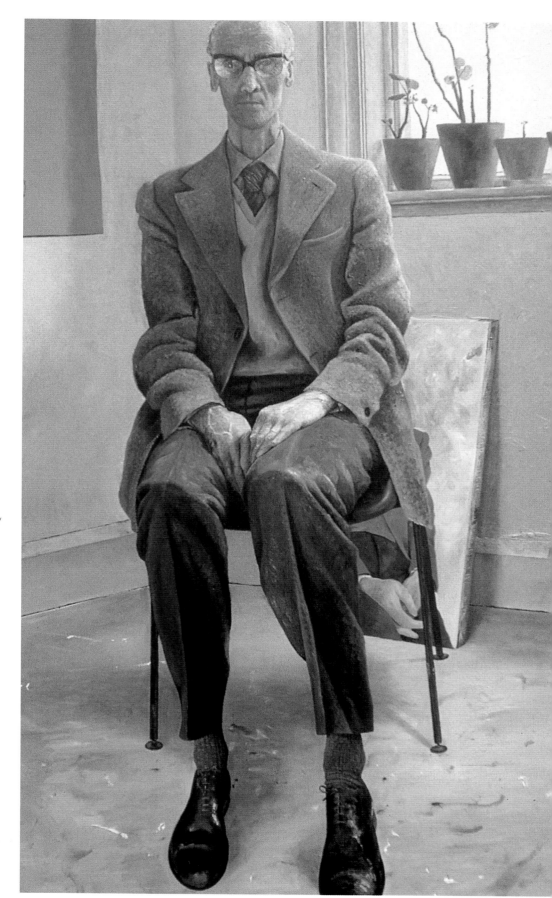

left The illusion of space is created in this drawing by the foot thrusting out towards the viewer. The subtle use of a cast shadow across the abdomen enhances the feeling of light and space.

right *The Reverend Alan Grange*. Oil by Ros Cuthbert. The artist sat quite close to her subject for this portrait. His knees and feet were much closer to her than his head. The result is that his head appears relatively small while his shoes are exaggeratedly large.

MEASURING THE FORESHORTENED FIGURE

THE BODY ASSUMES ODD SHAPES IN A FORESHORTENED POSE. WE TEND TO MISTRUST OUR EYES AND DRAW WHAT WE THINK WE SEE AND NOT WHAT IS ACTUALLY IN FRONT OF US. TO AVOID THIS, THE ARTIST USES CAREFUL MEASUREMENT TO MAKE SURE OF OBJECTIVE OBSERVATION.

Start with the traditional method of measurement. Hold a pencil with outstretched arm, line up the end of the pencil with one part of the model's body and use your thumb to mark the length of that part on the pencil. This will allow you to compare the proportions and distance between the different parts of the body. If you are going to measure their relationships precisely, you must remember to stand in exactly the same spot; any movement will change your angle to the pose and affect the measurements.

You can also use the method of drawing and measuring the negative space around the figure. If the model is lying down, draw the shape of the rug or drapery under her; it is often easier to see the pose from the outside of the figure.

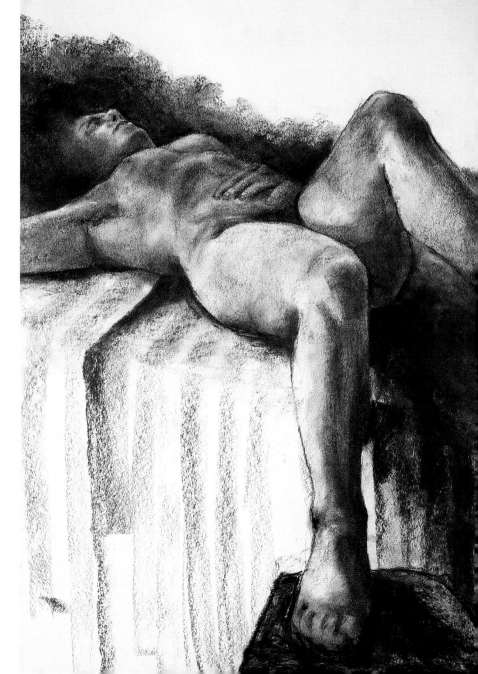

right This effective charcoal drawing was done close up to the model and it has the typical distortion caused by extreme foreshortening.

DRAWING THE FORESHORTENED FIGURE

BEFORE WE CAN DRAW A FORESHORTENED FIGURE AND PUT IT INTO A COMPOSITION, WE NEED TO UNDERSTAND A FEW BASIC RULES OF PERSPECTIVE.

To learn how to draw the figure three-dimensionally, we will begin with geometric shapes that represent the different parts of the body. It is useful to draw a rectangle and cylinder in perspective and to learn how to turn and represent these shapes at different eye levels.

At this stage draw a diagrammatic sketch using the geometric shapes to simplify and clarify the foreshortened pose. Check your observation by looking at the negative space and measuring. There is always the temptation to make a figure that is lying down stand up. This is the result of a mistake with the perspective of the eye level. A part of the body that is closer to you will appear much larger, while the shapes will diminish in size as they recede. The closer you are to the model, the more pronounced this effect will be. It is like taking a photograph with a wide-angle lens: objects close to the lens appear gigantic compared with the other objects. Artists often draw the part of the body that is closest to them with a darker line or in greater detail in order to bring it forward. Exaggerated foreshortening is frequently used to good effect to increase the depth in the picture plane.

A watercolour glaze, wet-on-wet, crosshatching and the use of fingers are featured in the following projects.

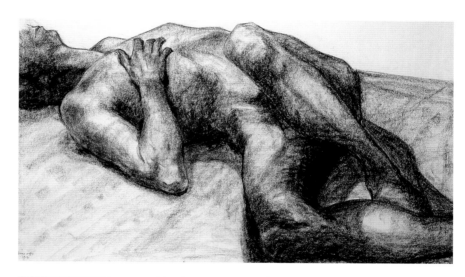

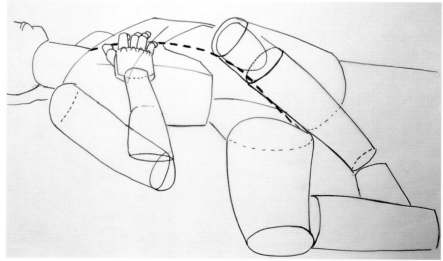

top A charcoal sketch of a figure drawn with a split eye level: the top part of this figure is at eye level, but the leg falls below eye level.

above When a figure is reduced to geometric shapes, we can see how the lower leg is drawn below eye level. The curve of the body comes up onto a flat plane, which is at the artist's eye level.

THE FORESHORTENED FIGURE

A SYSTEMATIC APPROACH IS NECESSARY WHEN DRAWING A FORESHORTENED POSE. WE HAVE A PRECONCEIVED IMAGE OF WHAT THE BODY SHOULD LOOK LIKE. THE DISTORTIONS CAUSED BY FORESHORTENING RUN COUNTER TO THIS NOTION. ALLOW YOURSELF AT LEAST TWICE THE TIME YOU WOULD NEED FOR A NORMAL POSE SO THAT YOU CAN MAKE CAREFUL MEASUREMENTS – AND THEN TRUST THEM.

BY JUSTIN JONES

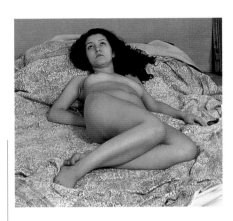

1 The model is posed on the floor so that she can be drawn just below the artist's eye level.

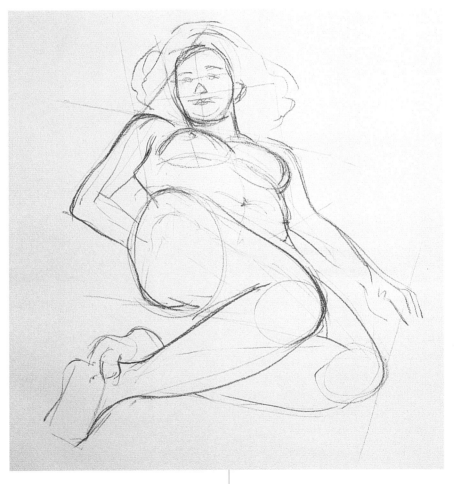

2 The artist has begun by using guidelines to give him the direction of the forms. He is working all over the figure and not concentrating on details.

3 The basic drawing of the model is complete. Note how the important depth of the thigh has been drawn through as a cylinder.

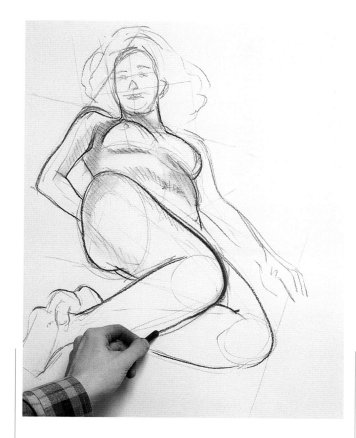

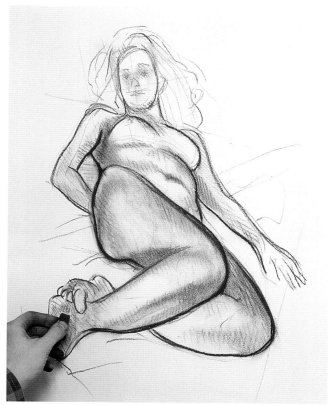

4 The artist uses a conté stick to strengthen the lines of the drawing and begin the modelling.

5 The artist is enhancing the modelling of the figure, working from the limbs in the foreground.

6 Note how the breasts are drawn on the curved surface of the rib cage.

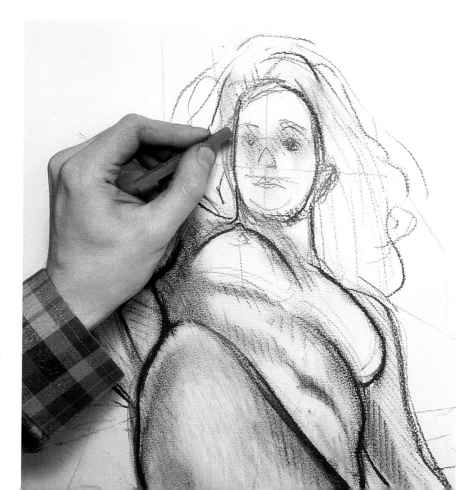

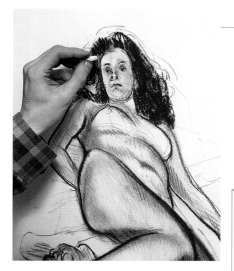

7 The artist finishes the details of the face and the hair at the last stage of the drawing.

8 The completed drawing. You can see how the artist has drawn the size of the forms, which are diminishing as they recede.

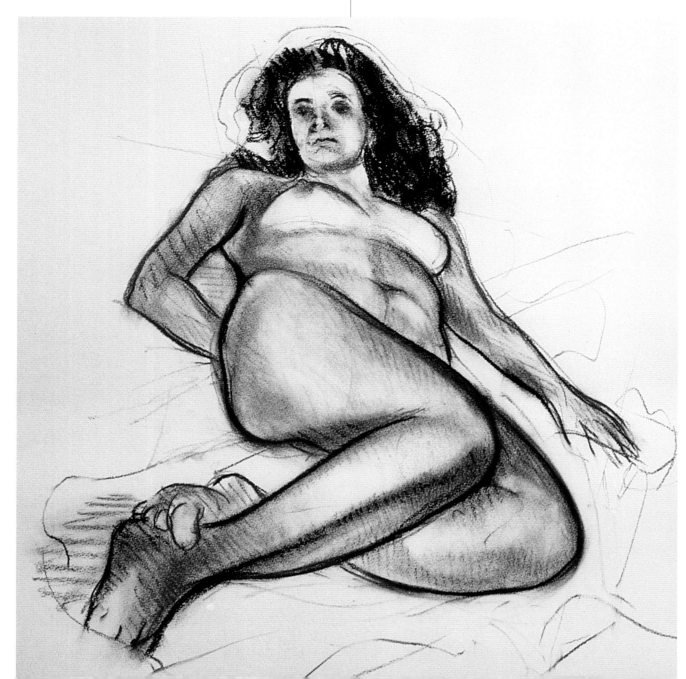

RECLINING FIGURE

THE HARD PASTEL USED IN THIS PROJECT IS CLOSER TO CONTÉ STICKS THAN TO
SOFT PASTEL. IT IS GENERALLY USED ON THE SHARPENED TIP LIKE A COLOURED
PENCIL. IT IS POSSIBLE TO BUILD UP THE FORMS AND COLOURS BY
CROSSHATCHING LINES, AS THIS GRACEFUL DRAWING DEMONSTRATES.

BY VIVIEN TORR

1 The basic drawing is done with the neutral pastel on tinted paper and the light shades are added first.

2 The artist has begun crosshatching warm flesh tones into the light areas of the figure.

3 The figure slowly emerges with the warm colours and appears almost three-dimensional on the page.

4 The completed drawing. The sharp edges and lines of the hard pastel give this drawing a more graphic quality than could be achieved with a soft pastel. Hard pastel can be used on its side, but it tends to flatten the surface of a fine paper very quickly.

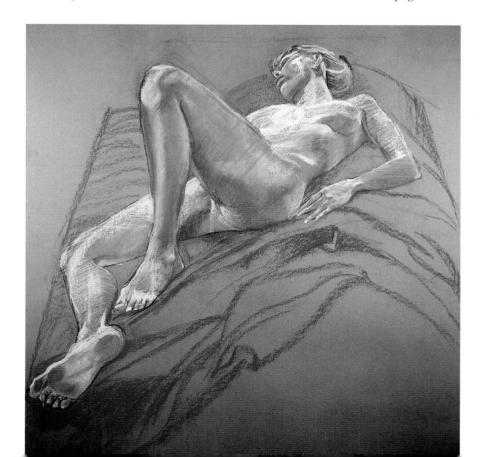

GIRL LYING ON RUGS

IN THIS WATERCOLOUR THE ARTIST IS BUILDING UP A SERIES
OF PLANES WITH THIN DIRECTIONAL STROKES OF COLOUR.
THIS IS PAINTED USING A GLAZE TECHNIQUE AS WELL AS SOME
WET-ON-WET ON 300 GSM (140 LB) – NOT SURFACE PAPER.

The palette for this piece consists
of French ultramarine, cerulean
blue, cobalt green light, cadmium
lemon, cadmium yellow, cadmium
red, alizarin crimson and
ultramarine violet.

BY DAVID CARR

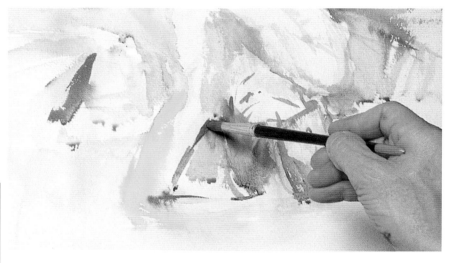

1 The model was positioned on the
floor with the artist standing looking
down on the figure.

3 A much stronger yellow is placed down the side of the torso and the arm. Do
not be afraid of watercolour. It dries paler than it looks when it is first applied.
Cobalt green and French ultramarine are used to begin defining the floor.

4 The floor is developed, and a dilute cadmium red is used to establish the
side plane of the thighs. Some linear work under the thigh and around the hip
defines what was first described by planes.

2 The first marks begin to deal with
the large triangular plane of the
upper chest. The palest dilute
alizarin, cadmium red and cerulean
blue have been used here.

5 Marks follow the direction of the planes felt in the floor. Greater volume is given to the head and body. The planes on the top of the thighs are drawn with line. The painting has been conceived in terms of planes. In other words, the planes were found first so that the position of the contours could be located.

6 The light and transparent marks follow the direction of the planes and the white of the paper has been used as a positive element.

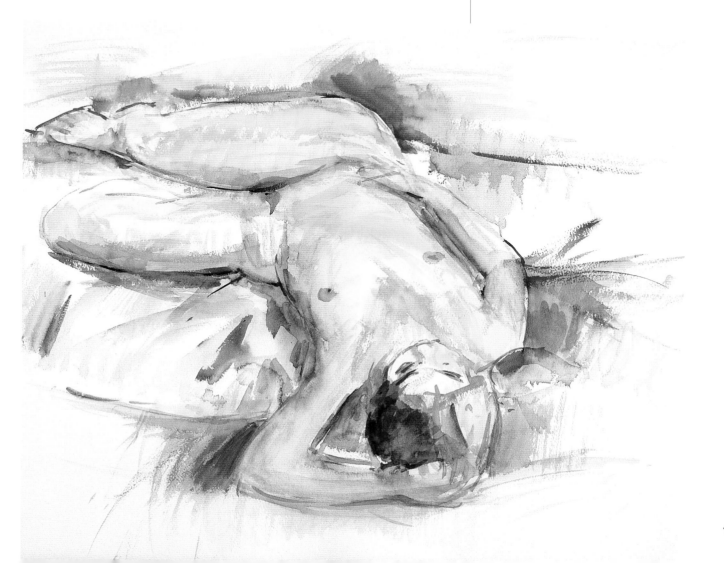

PASTEL TECHNIQUES

Pastel is a very popular medium. The colours themselves are beautiful and they can be used in a great variety of ways. As you work, the pastels almost seem to suggest new ideas to you. Drawings can be built up or changed in a few minutes. Here are just a few of the many techniques you may wish to try.

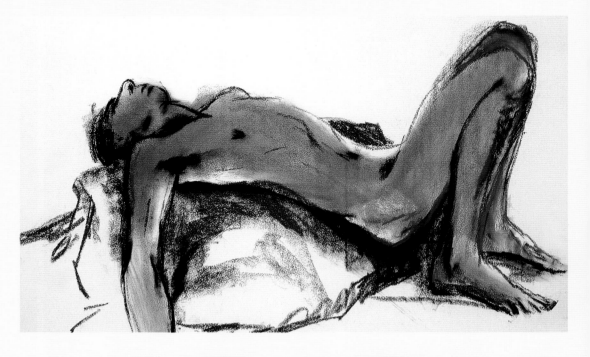

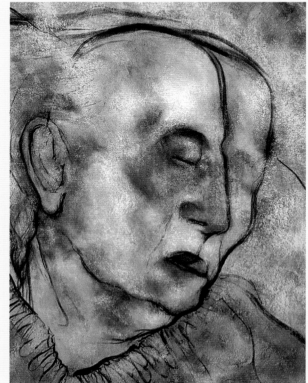

above Only two colours were used for this quick sketch: the black line is soft pastel, not charcoal. The placement of the figure was made by using a conté on its side, then rubbing it, and the drawing was added after the mass was blocked in.

right *Lillian*. In this drawing the white paper has been lightly rubbed with charcoal to give a texture and the drawing of the head has also been done with charcoal. The pastel colour is kept to a minimum to produce this sensitive portrait of an old friend.

opposite Soft pastel on dark grey paper. Using dark paper as a background has the advantage that the light colours and flesh tones stand out easily against it. This artist has used the paper well, creating both a life study and a striking portrait.

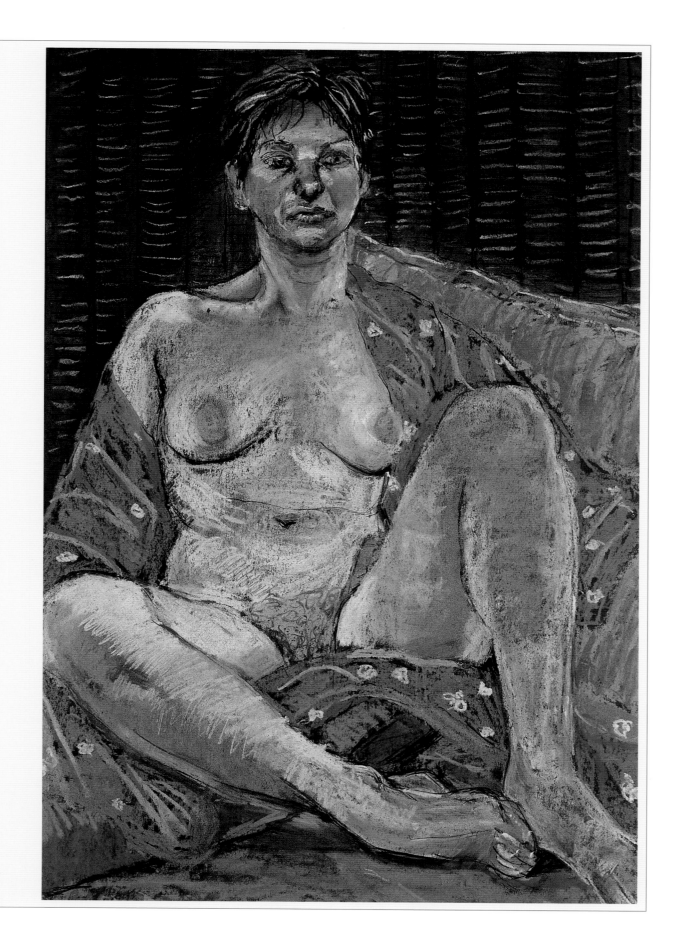

GIRL IN SOFT LIGHT

THE MODEL WAS LYING BELOW THE ARTIST'S EYE LEVEL AND WAS SOFTLY LIT. A SOFT, WARM GREY SHADE OF PASTEL WAS CHOSEN TO BEST EXPRESS THE SUBTLE LIGHT. INGRES PAPER WAS USED FOR ITS FINE TEXTURE, WHICH ALLOWS EVEN BLENDING OF THE PASTEL.

BY DIANA CONSTANCE

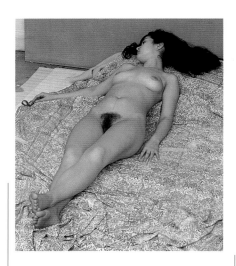

1 The model is lying below eye level. A soft light was achieved by bouncing the light of a "spot" off a white canvas.

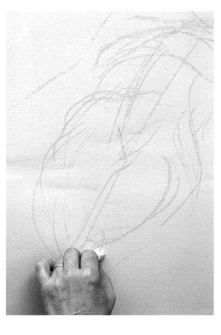

2 A placement drawing is made with a pale pastel. Note the guidelines down the middle of the figure and across the chest, giving direction.

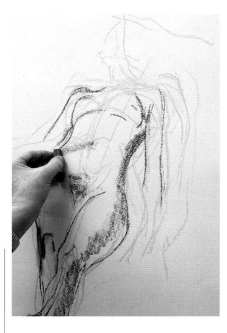

3 Once the placement and adjustments have been made, the darker pastel is added, using both the edge and side of the stick.

4 The thumb is used to begin the blending of the pastel. Some people prefer to use their hands rather than a blending stick.

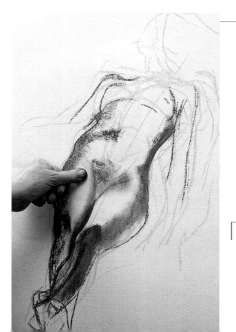

5 Detail of the artist blending the pastel.

6 The hair is drawn up and over the form of the skull and underneath the left side of the face, which defines the shape of the head in the simplest terms.

7 Further modelling of the form is shown here. By using your finger, you can push the pastel into the paper, whereas a blending stick rubs a great deal of it off the paper.

8 A detail of the feet showing the strong modelling.

9 The completed drawing. The guidelines have been erased with fresh bread and the drape has been added so that the model is not left floating.

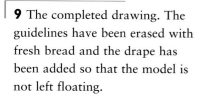

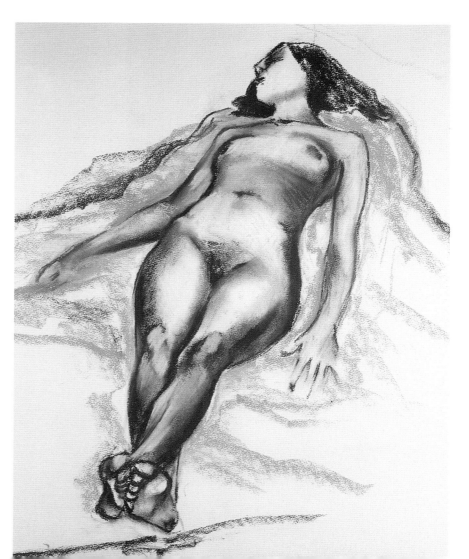

CREATING FORM

ALTHOUGH THE BODY IS COMPOSED OF COMPLICATED, ROUNDED SHAPES, ARTISTS FREQUENTLY REFER TO THE "PLANES" OF A FIGURE.

There are three reasons for this apparent anomaly. First, the artist needs a shorthand method of simplifying and expressing these complex forms. Second, the artist needs to give the figure a strong three-dimensional quality. Third, the use of the plane and angle improves the composition and overcomes the problem of design by providing a contrast to curves and rounded forms in the body. True planes seldom exist in the body; we are looking for an approximation. There is a side of the thigh; a flat of the chest and shoulder blade, and so on. The more angular and flat areas of the body are set against the round and curvaceous parts. The clearer the contrast between the two, the stronger will be the design.

To begin with, you will find it easier to draw or paint the planes of the body when you are using some form of directed light.

When we look at a model, what we actually see is the light being reflected from her body and the area around it. If you change the lighting, you have a different image. The light changes the abstract composition in the pose by making the planes of the body more apparent, casting shadows and highlighting areas that become more important visually. Light also has a profound effect on the mood of the drawing or painting.

An overall flat light is sufficient for a line drawing in which you want to see the contours of the figure clearly. However, in order to model the form, try arranging the light differently. This need not involve great changes – simply turn off some of the lights on

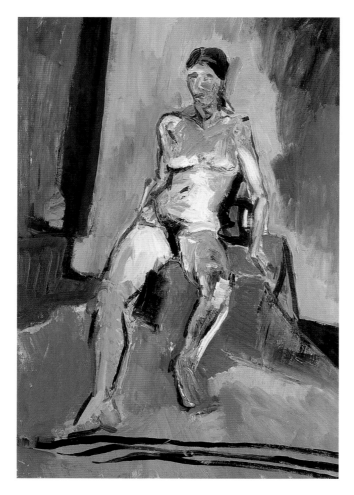

left In the lighter of two oil studies by David Carr, the planes were knocked in rapidly, using multi-directional strokes. A slab of orange described the upper chest and then lighter ochre followed the planes of the stomach and pelvis, and the inside thigh of the extended leg. The structure was brought together by strong lines of blue-black, which cut into the form to emphasise the direction of the planes.

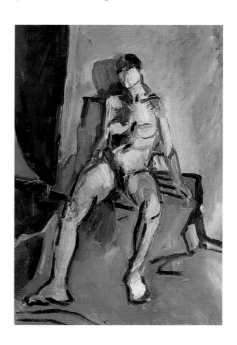

below The darker picture was painted under artificial light, hence the harsh tonal jumps and the clear shadow cast by the figure. The lighter parts of the flesh were painted using the yellow ochre, cadmium red, and white mixed and the darker masses with green and blue-greys. Again, strong lines pulled the form together at the end.

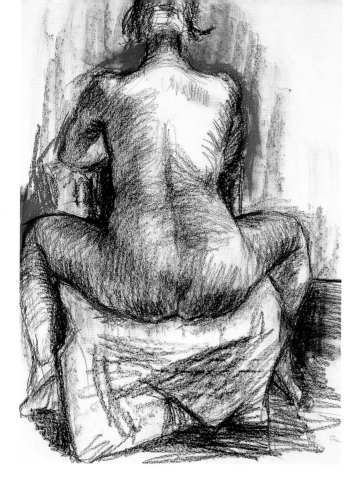

Modelling with light

Modelling tones of light and shadow is a quite different kind of drawing. Line may be regarded as an extension of writing. As we draw, the line envelopes and "describes" the form in a literate and poetic sense, but it stands back from trying to copy nature. When we look for the highlights, middle tones and shadows on a figure, we are striving towards an approximation of nature, "to draw as we see".

Curiously, it is difficult and unnatural to work in this way. In general, people feel happier when they are putting lines around a figure, but sometimes these lines proliferate and become scribble lines or crosshatching. When this happens, the simple line becomes a tone and forms a bridge between the extremes of line and modelling.

Finger-blending, crosshatching, scumbling, and alla prima and wet-on-wet are among the techniques used in the projects.

one side of the room, for example, to give a softer, directed light with shadows. There are advantages to using a dim light: it does not flatten the form, and it enables you to observe the subtle shading of the body for modelling. A harsh light, on the other hand, will change the mood and create strong patterns of light and shade. The long shadows that are cast can be used to create depth in the picture plane.

A simple spotlight is a welcome addition to any studio. It can be directed onto the model to give a strong, dramatic effect, or it can be bounced off a wall or a sheet of canvas to give a soft, reflected light.

Light through line

In an ideal world, the model would always be beautifully lit and your job of modelling the figure would be simple. Unfortunately, the lighting in most studios is more appropriate to a supermarket than a studio for painting and drawing, and it is, therefore, essential to learn how to analyse the volume and shape of the model independent from the light source.

The first step is to appreciate the volume and mass of the body. In trying to recreate the three-dimensional aspect of the form, you will have to decide which part of the figure is receding and which part comes forward to catch the light. Multiple lines are used to make a type of relief map of the body.

The lines will slowly build up and become darker until they exclude all but the strongest high-lights. When the drawing is completed, it will demonstrate how you can show the emergence of light by using line alone.

right In this charcoal drawing, the shadows have been blended.

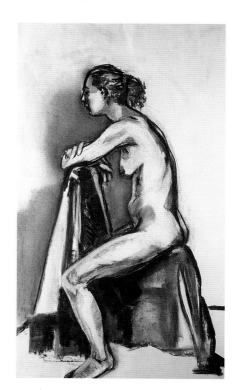

DRAWING THE NUDE WITH LINE

THE DRAWING HAS BEEN DONE WITH A STICK OF HARD BLUE PASTEL. THE ARTIST HAS TO SHARPEN THE STICK WITH A CRAFT KNIFE OR SANDPAPER BLOCK FROM TIME TO TIME, TO KEEP THE LINE FROM THICKENING. THE QUALITY OF THE LINE IS OF PARAMOUNT IMPORTANCE IF THE DRAWING IS TO SUCCEED.

BY JUSTIN JONES

1 The model is posing below the artist's eye level.

2 The artist is drawing directly, without the aid of guidelines, to keep the flow of the line.

BEGINNING A LINE DRAWING

No preliminary sketch is made with line drawings. The essence of the work is the free, loose quality of the line and if you draw over a pencil line with a pen, it loses that freshness. If possible, the quality of the line should not belie the problems of the drawing. Although you will almost inevitably make mistakes, it is better to develop a confident line at the outset instead of being hesitant, which will break up the flow and grace that constitute the "poetry" of the line. Paul Klee (1879–1940) described his drawings "as taking a line for a walk", and this is a valid comparison, for as it travels along the form, the line describes the shape.

There is a good selection of pencils and pens to use for line drawings, and they make a great variety of distinctive lines. It is useful to practise with them before you start so that you develop a feel for what they can do.

You can choose between the smooth line of a pencil and the jagged, dry mark of a bamboo pen. Some artists prefer to use a soft pencil for larger line drawings, because they find the line of a hard pencil is too light on its own. Felt-tip pens are now often used for line drawings, but although they are convenient and quick, unfortunately very few have permanent inks. Before you buy, ask if the colours are fugitive or permanent.

Coloured pencils and pastel pencils are very interesting to use, and they give you the opportunity to use more than one colour in a drawing. There are also various kinds of drawing pen that have an ink cartridge, which makes them very useful.

The paper you use will also make a difference to the drawing. The smoother the paper, the sharper the line you make will be.

3 The basic contours of the figure have been drawn and the long, curving lines of the body have not been interrupted by unnecessary detail.

4 This detail shows how the artist has created volume by drawing the breasts on the curve of the rib cage.

5 The artist draws the soft pillow and cloth under the model's head to give the sense of weight to her body.

6 Here the artist begins to strengthen some of the lines and correct the position of the model's left arm.

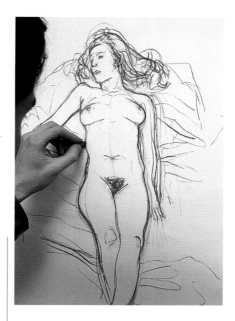

7 Here the details of the head have been drawn in.

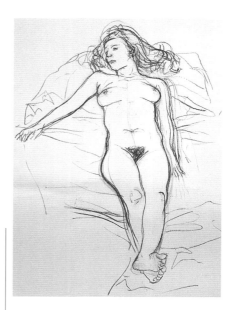

8 The drawing seems complete. However, there is a problem. The top half of the figure is not lying back sufficiently.

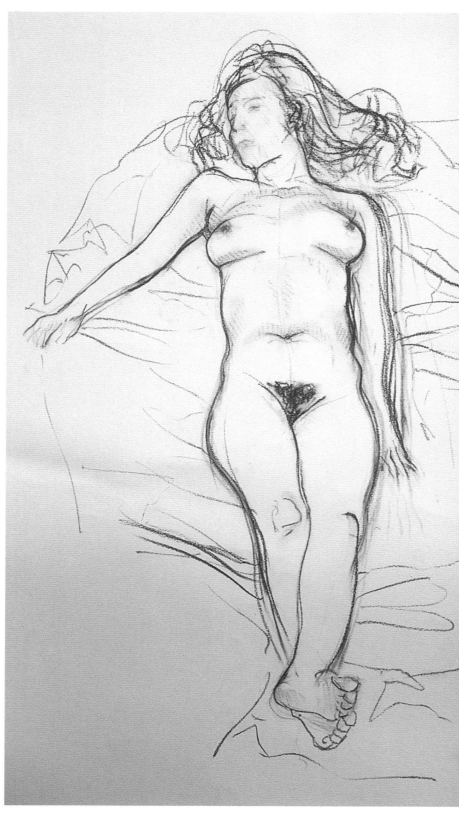

9 The artist blurs the details of the face and smudges a shadow across the upper chest to make it appear to recede. Now the drawing works well.

CREATING THE FORM THROUGH LINE

IN THIS DRAWING OF A SIMPLE POSE, THE TECHNIQUE OF BUILDING UP THE VOLUME AND MASS OF THE BODY USING LINES IS DEMONSTRATED. CHARCOAL WAS USED WITH SOME SOFT PASTEL ADDED TO THE BACKGROUND IN THE EARLY STAGES.

BY DIANA CONSTANCE

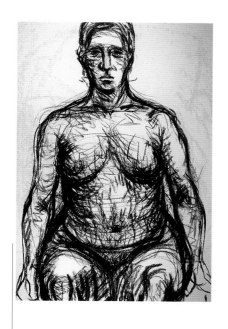

3 A scribble line has been used in the background and on the figure in the shadow areas to deepen the tone. As the lines build up, the feeling of volume increases.

4 The envelopment of the figure by shadow is complete – only the highlights on the form are left. The drawing can be stopped at any point, and the more you continue to add lines, the more the model will slowly disappear into the darkness.

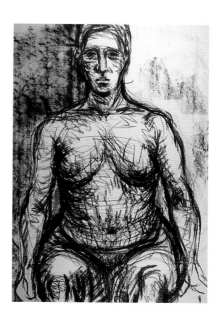

1 The model was asked to take a simple pose. The aim is to use the charcoal line as a sculptor would use a tool, going around the form many times to carve out and refine the directions of each part.

2 Soft pastel has been added to the background to bring out the figure.

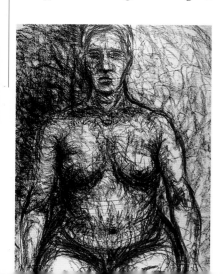

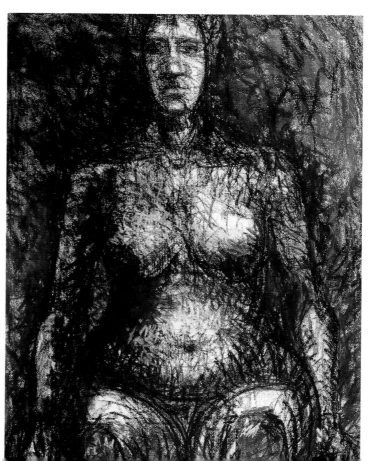

CROSSHATCHING

CROSSHATCHING IS ONE OF THE SIMPLEST WAYS TO PRODUCE A GREY TONE. BY GRADUALLY BUILDING UP A WEB OF FINE LINES, THE ARTIST HAS THE TIME TO CONSIDER CAREFULLY THE SUBTLE EFFECT HE IS CREATING. HE MAY GO BACK TO A DRAWING SEVERAL TIMES, SLOWLY BRINGING OUT A PART OF THE FORM BY STRENGTHENING THE HATCHING AROUND IT.

BY JUSTIN JONES

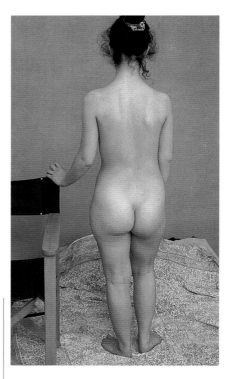

I The model has assumed a simple pose, ideal for crosshatching. Unfortunately, a standing pose cannot be held for a long time.

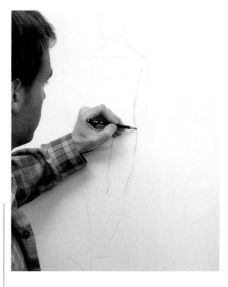

2 The artist begins with a contour drawing.

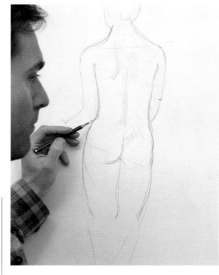

3 The most interesting part of the pose is the swing of movement through the back and hips, so the artist is concentrating on this part.

4 In this detail you can see how the lines are drawn to enhance the roundness of the forms.

5 The artist works over the whole figure to complete the overall modelling.

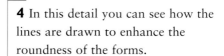

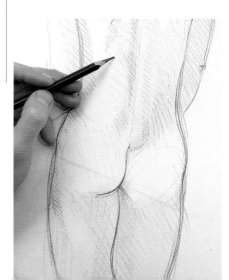

6 At this stage some of the details are being brought out by another layer of crosshatching.

7 You can see how the tone deepens as each new layer of line is added.

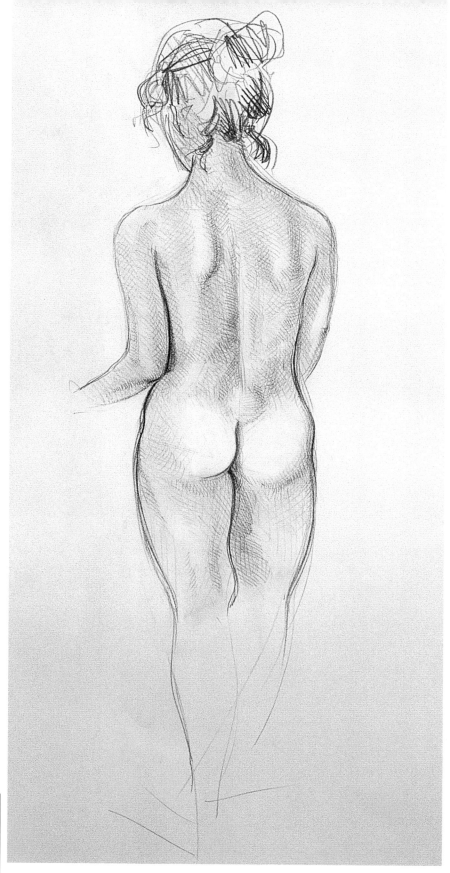

8 The details of the hair have been added at this last stage. The looseness of the line the artist has used for the hair contrasts pleasingly with the controlled crosshatching used for the body.

GIRL LYING DOWN:1

THIS PROJECT DEMONSTRATES ONE OF THE BASIC TECHNIQUES OF MODELLING THE FORM. CHARCOAL IS USED, ON BOTH THE END AND SIDE. A SIMPLE POSE GIVES THE BEST RESULT. IN THIS CASE THE MODEL IS LYING BELOW THE ARTIST'S EYE LEVEL, AND THERE IS A PROFUSION OF TUMBLING CURVES THROUGH HIPS AND LEGS WHICH GIVE THE POSE A QUIET AND RELAXED MOOD.

BY VANESSA WHINNEY

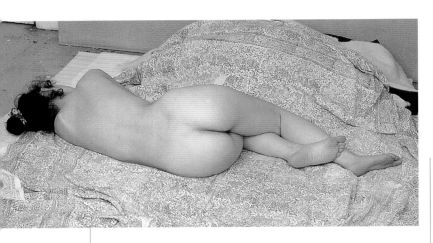

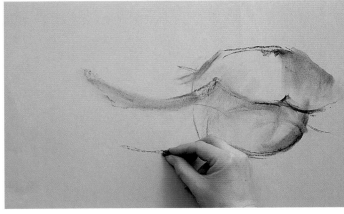

1 There is a flat light on the model. The artist will have to use a bit of imagination with the modelling to avoid an insipid drawing.

2 The basic curving movements are put in lightly. Since the key to the pose is in the back and hips, the artist has rightly started at this point.

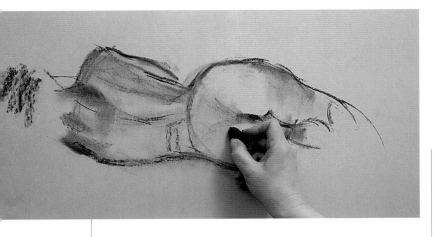

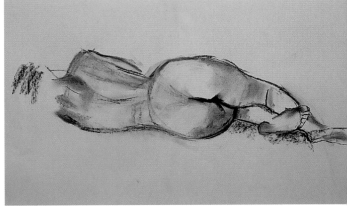

3 The side of the charcoal is being used to put in the broad planes on the figure.

4 The basic drawing is in place; the artist has worked across the entire figure without becoming involved with the details.

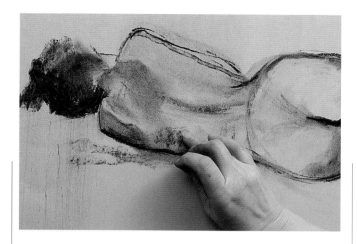

5 The rough charcoal is being lightly blended with the finger.

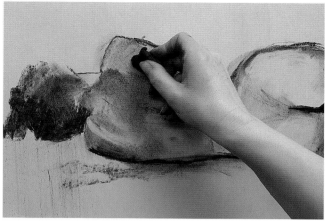

6 The tones and lines are being strengthened where needed.

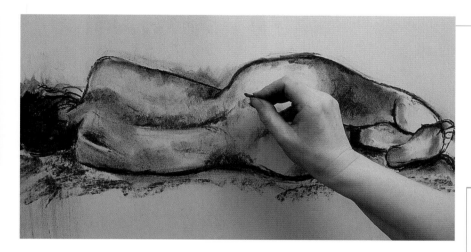

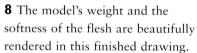

7 The sharp detail is being drawn in with charcoal pencil.

8 The model's weight and the softness of the flesh are beautifully rendered in this finished drawing.

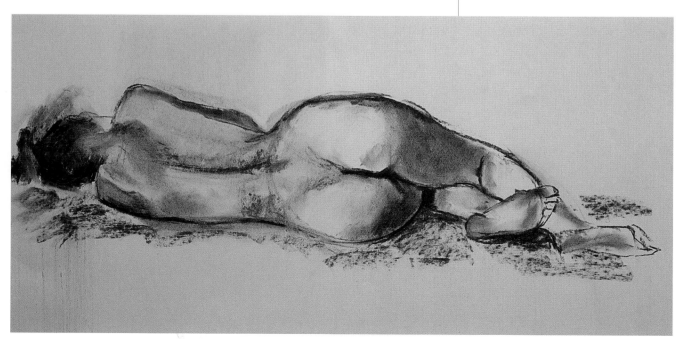

GIRL LYING DOWN:2

CROSSHATCHING IN BLUE AND RED COLOURED PENCILS GIVES THIS SKETCH ADDITIONAL DEPTH AND WARMTH. THE LINES MOVE LOOSELY, GLANCING OFF AND THEN TUCKING AROUND AND BEHIND THE FORMS. THE DRAWING HAS A LYRICAL QUALITY ENHANCED BY THE MERGING OF THE RED AND BLUE LINES INTO A PALE VIOLET HUE.

BY JUSTIN JONES

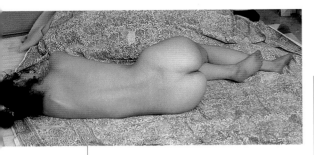

I The model is lying below the artist's eye level.

2 The artist does a loose placement sketch of the entire body using the blue pencil.

3 The red pencil is used with the blue in the crosshatching.

4 The faint overall effect can now be seen.

5 As the artist adds more lines, the form slowly begins to emerge. This type of crosshatching work takes at least one or two hours to complete.

6 The drawing of the torso is now complete. The artist has concentrated on this area because it is the centre of interest in the drawing.

7 The blue pencil is used for the darker tone to define the bottom plane of the foot.

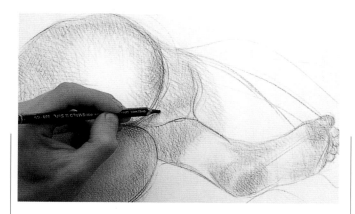

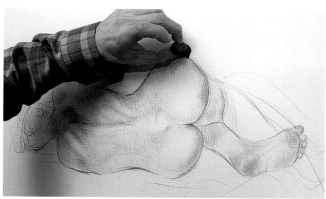

8 Using the blue pencil exclusively for the crosshatching will make the leg appear to go back in space.

9 The drawing is being "cleaned up" with a kneaded eraser.

10 The completed work, though if the artist had additional time and wished to, he could continue the crosshatching even further.

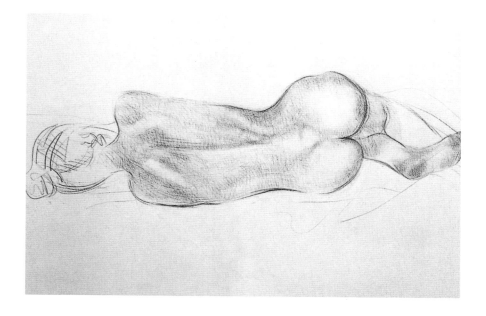

STANDING FIGURE

SOMETIMES BY LIMITING THE NUMBER OF COLOURS YOU USE, A MORE STRIKING EFFECT CAN BE ACHIEVED. THIS DRAWING IS A MONOCHROME IN WHICH TWO SHADES OF YELLOW OCHRE HAVE BEEN USED. THE DESIRED EFFECT WAS TO CREATE THE SKETCH JUST BY DRAWING THE SHADOWS AND LIGHT ON THE BODY WITHOUT USING A LINE.

BY DIANA CONSTANCE

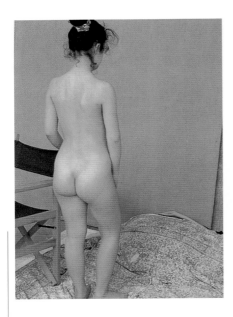

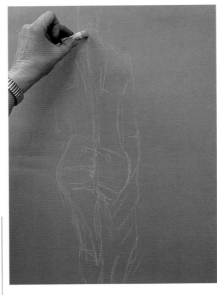

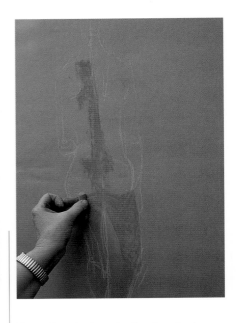

I The model has assumed a standing pose with most of her weight on the left leg. For this long standing pose, the model was given a chair to hold on to.

2 A simple drawing is completed first using a neutral grey pastel on the tinted paper which has been selected.

3 With a darker shade, the shadow areas are drawn in, starting with the twist of the spine.

4 The shadow areas are complete and the darkest shade is added to emphasise the movement through spine and hips.

5 Using a very soft pastel, barely touching the surface of the paper, the light shades on the form start to be worked.

6 The basic pattern of light and shadow is now established all over the body.

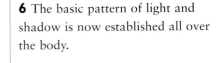

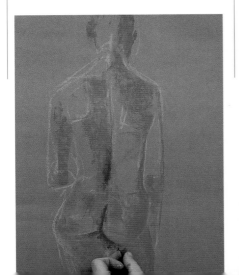

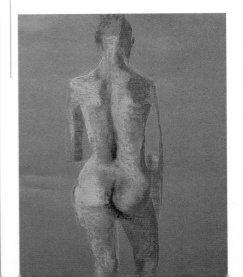

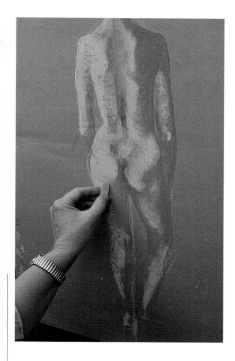

7 A detail showing how the light pastel is worked on top of and into the darker shade. They are being allowed to blend slightly, using fingers to rub them together.

8 Here the artist is sharpening up the shades and defining the planes of the body more clearly.

9 The final touches to the modelling are added to balance out the figure.

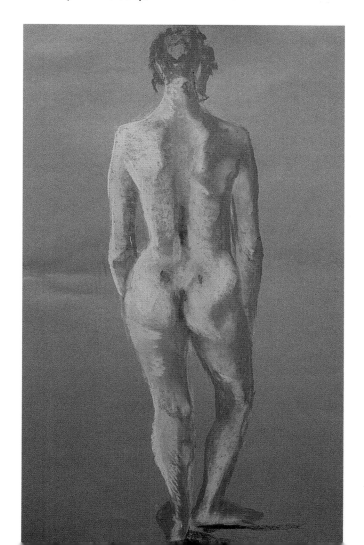

10 The completed sketch. You can see how the balance of the figure falls from the back of her neck to a point directly between her two feet. The chair has been omitted because it would have destroyed the simplicity of the drawing. You can now see how the figure rises from the paper, using nothing more than two shades of pastel.

PRELIMINARY STUDIES

The importance of making preliminary studies before you start work on a painting cannot be overstressed. Time and effort spent thinking things out at this stage saves much frustration later on. Painting oneself into trouble takes seconds; painting oneself out of it can take hours.

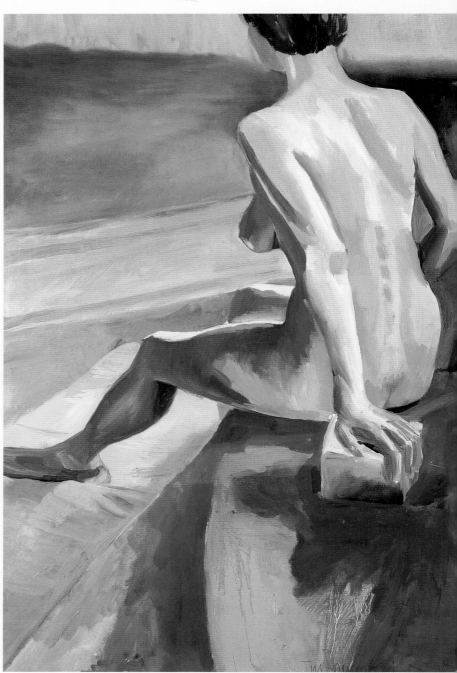

above The artist, Jill Mumford, used a sketchbook to make a small gouache colour study before starting her painting of the back of a seated nude. She decided to place the figure high on the page, and to make something of the large space in the foreground; it occupies almost half the picture. A clear, simple statement has established a composition with due regard for the distribution of shapes around the seated figure.

above In the finished picture, done in oils, we feel that we are very close to the figure. The head has been cropped and the foot just squeezes into the picture space. The artist has extended the dark tone of the thigh down the whole leg and exploited the slabs of light falling on the back, floor and bed and the silhouette of the leg, thigh and breast.

above For the figure seated in the chair, Jill Mumford worked out the relationship of the figure to the floor, wall and chair in broad terms. The composition was worked out in more or less primary colours in oils and the forms were seen in simplified terms.

above In the finished picture, in oils, the flesh tones and colours are more subtly modulated from warm to cool. The figure sits satisfactorily in the chair. The dramatic light on the figure clearly comes from a second window to the left, out of the picture.

RECLINING WOMAN 1

THIS SMALL ALLA PRIMA OIL STUDY WAS PAINTED

IN LESS THAN AN HOUR.

The artist used a restricted palette of yellow ochre, cadmium red light, alizarin crimson, French ultramarine and titanium white. She is working on board primed with white acrylic, using no. 5 and no. 8 filbert hoghair brushes.

BY JOY STEWART

1 The model in a reclining position as seen by the artist.

2 Without any preliminary charcoal drawing, the artist lays in the figure in terms of mass using a mixture of yellow ochre and cadmium red.

3 She begins to draw into this with alizarin crimson and French ultramarine.

4 The wall is established and boundary lines and points around the form hold the figure in place.

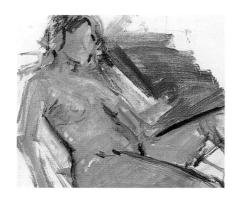

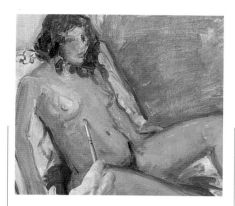

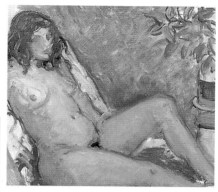

5 Using white, the artist begins to give the form more volume and to work some blue into the ochre flesh paint to define the darker parts of the form.

6 Using the same palette, the artist works into the fabric on the wall and the bed. The plant pot and the plant are painted in simply, introducing an additional lemon yellow mixed with ultramarine.

7 The volume of the figure is strengthened as the artist works wet into wet with light ochre, pinks from the alizarin and purples from mixing ultramarine and alizarin.

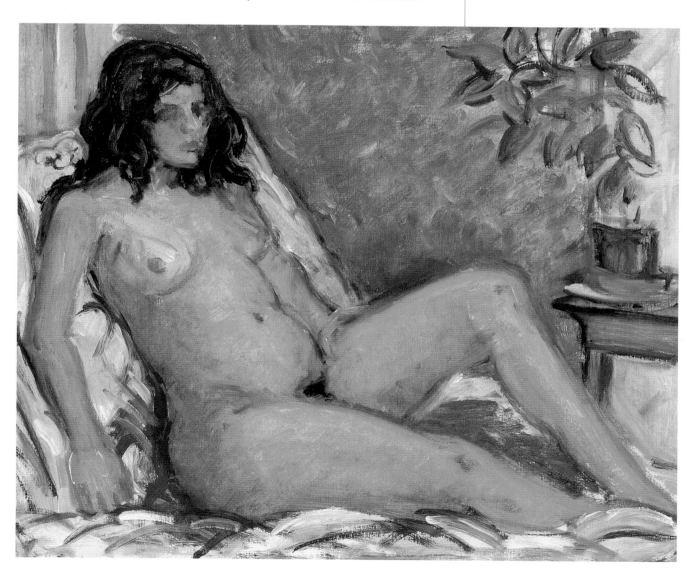

RECLINING WOMAN: 2

THIS OIL PAINTING OF THE SAME POSE FROM A DIFFERENT

ANGLE ILLUSTRATES THE PRINCIPLE OF

WORKING FROM LEAN TO FAT.

The artist is using much the same palette as in the preceding project, with an additional light red, viridian green, burnt umber and a mineral violet. She likes to use a painting medium made from about two-thirds turps to one-third oil.

BY SUSAN CARTER

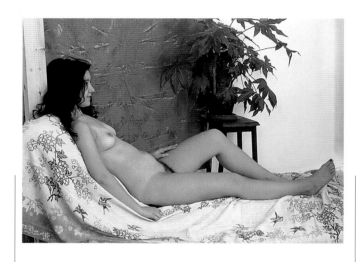

1 The model in pose.

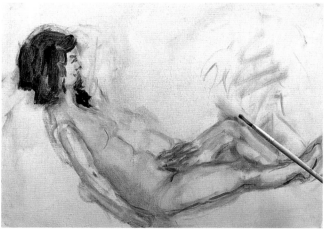

2 The initial drawing has been done with paint thinned with plenty of medium. The artist soon sets about laying down thin masses of colour over the whole canvas.

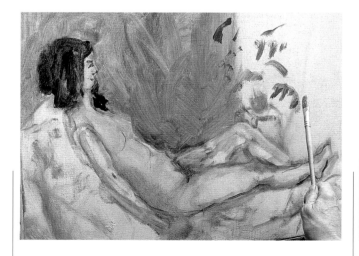

3 The aim is to develop the picture as a whole.

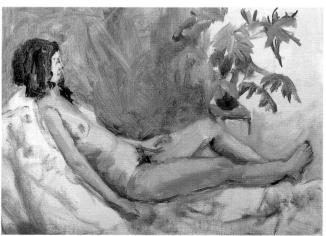

4 The artist paints the flesh using light red, yellow ochre and white, and draws into it using blues and umber.

5 It is important to keep moving around the canvas, adjusting each part to preserve a credible sense of light throughout. Touches of warmth are introduced into the cloth.

6 By continual attention to the whole picture surface, the artist has attained a sense of completeness rather than finish.

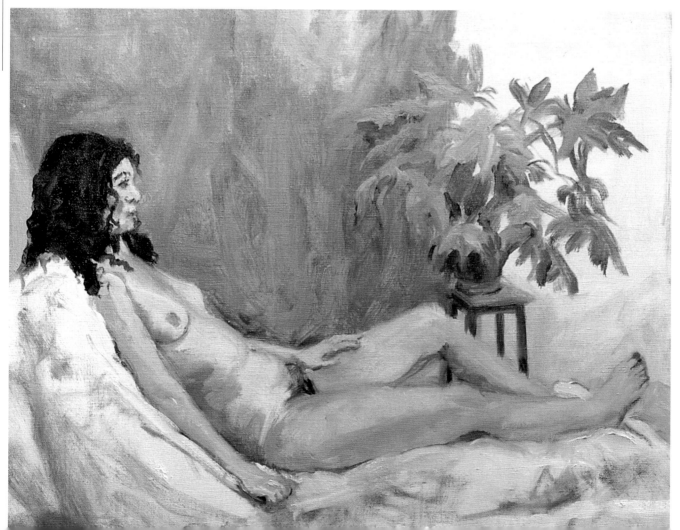

WOMAN BY A WINDOW

THE ARTIST'S AIM IN THIS PROJECT WAS TO SEE THINGS BROADLY AND SIMPLY –
AND WATERCOLOUR IS AN IDEAL MEDIUM FOR THIS. IN EXPLOITING THE
IMMEDIATE AND DIRECT QUALITIES OF THE MEDIUM, DETAIL IS SUBORDINATED
TO A FEELING FOR THE WHOLE.

The artist is using a restricted
palette of French ultramarine,
permanent green, Vandyck brown,
cadmium yellow and cadmium red.
The paper is a warm buff colour
and the artist is using a no. 2 brush
and small pieces of tissue.

BY KAY GALLWEY

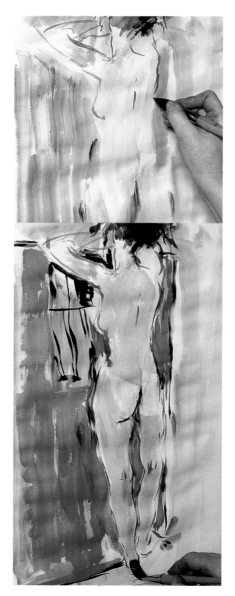

1 A thin wash of light orange
(mixed from cadmium red and
yellow) is laid down for the figure
and a stronger cadmium red is used
for the cloth against which the figure
is standing. Some strokes of
ultramarine into the wet paint
surface give the slightest suggestion
of form. The forms are softened with
a tissue. A tissue can also be used to
remove excess moisture.

2 One or two marks in Vandyck
brown are placed to define the edges
of the form.

3 It is only at this stage that the
artist begins to draw the form with
any definition, using line. Prior to
this she was only concerned with the
main masses of the composition.
Both ultramarine and brown are
used in the drawing.

4 Using tissue, the artist is able to control the amount of bleeding and achieve just the right softness of line she requires.

5 The light washes of blue on the legs define the shadow well and throw up the hips and buttocks into the light.

6 Right at the end of the painting the artist introduces pattern into the drapery and carpet, and into the foliage outside.

7 The final picture, which is the result of less than 30 minutes' work, is a simple, satisfactory statement about the figure and its relationship to the room.

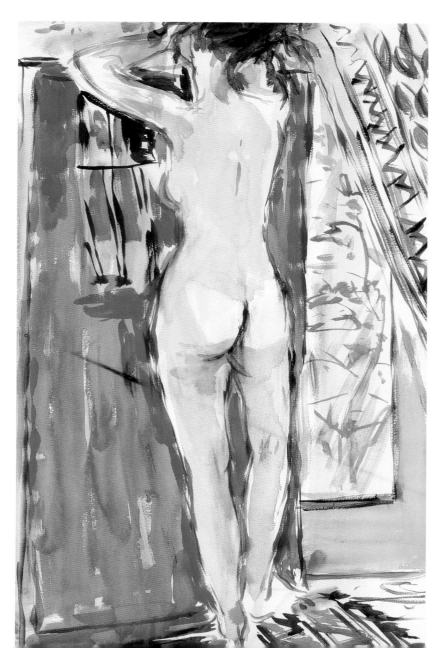

SEATED WOMAN

IN THIS PROJECT FORM IS BUILT UP USING A RESTRICTED PALETTE OF YELLOW OCHRE, CADMIUM RED LIGHT, ALIZARIN CRIMSON, FRENCH ULTRAMARINE AND TITANIUM WHITE, PLUS AN OCCASIONAL COOLER LEMON YELLOW.

BY JOY STEWART

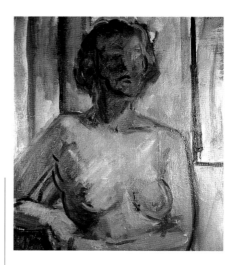

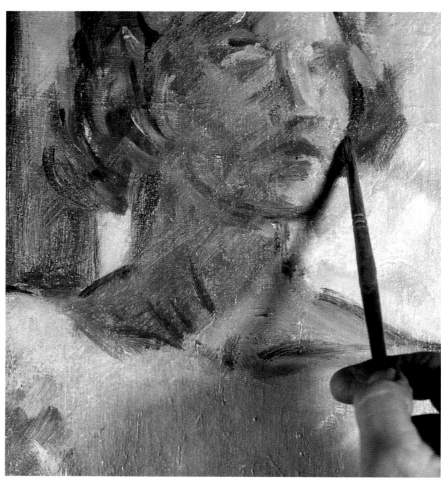

1 Initially the figure is massed in with thin alizarin crimson, into which are worked mixtures of cadmium red, yellow ochre and white.

2 This is drawn into with lines of pure ultramarine and alizarin crimson.

3 The form is built up, establishing the strong light plane of the torso with more yellow ochre and red, and placing accents of light yellow ochre on the breast. The darker areas are built up with a light scumble of ultramarine, which is particularly effective around the side of the face. Some reflected light is observed on the breast and is picked out with ultramarine and white. A strong form has been achieved with great economy of means. The light works well. There is some very fluid drawing around the arms, and the clear, directional brushwork in the torso makes for a convincing study.

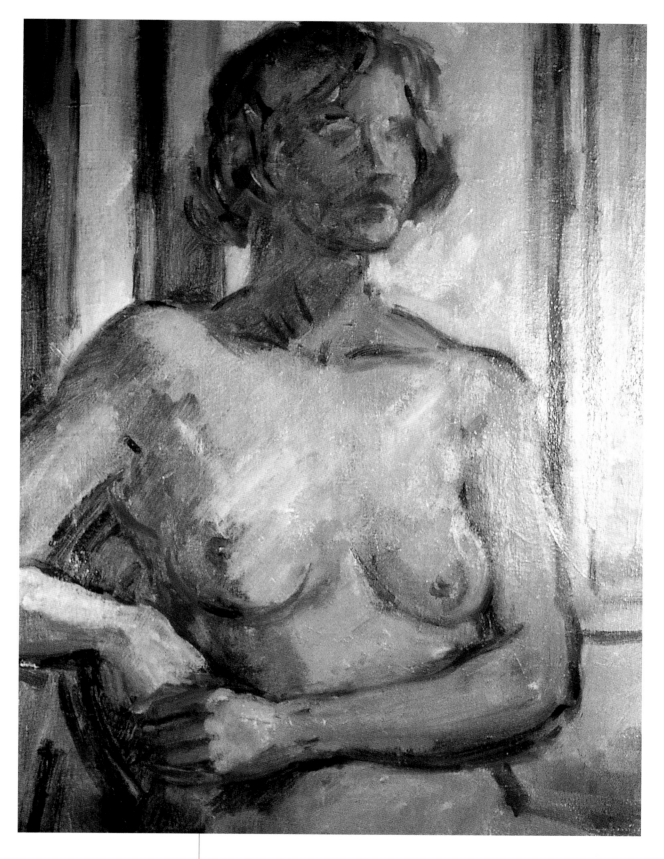

4 A solid and imposing result, using
a restricted palette.

COMPOSITION AND CONTEXT

IT IS DIFFICULT TO IMAGINE HOW PROFOUNDLY THE COMPOSITION OF A PICTURE AFFECTS ITS SUBJECT. WHEN WE FOCUS ON AN INDIVIDUAL WE ARE SCARCELY AWARE OF THE OTHER INFORMATION OUR EYES AND MIND ARE RECORDING AND ASSESSING IN THE GENERAL SCENE.

When we put a figure in context we are putting into the drawing or painting different elements that will enhance and throw light upon its meaning. In a sense, we are weaving a story about the person. This is not the same as composition, although composition comes into it.

Looking at the work of good photographers can be a help, for they develop a keen eye for composition and context. Light can play an important part in a composition – a dark, heavy atmosphere will say something quite different from a sunlit room. A vast, open studio has a different feel from a claustrophobic room. The type of furnishings or lack of them will say something else. Before you begin on a work, decide what you want to say in it – think of the "storyline" – then you can begin to choose the type of lighting that would be suitable. If you cannot change the existing light in the studio or room, you can invent a different type of light.

While context is always a part of a composition, a composition may not put the figure in context. Some compositions are pure divisions of space, made of tone colour or decorative pattern, and with little or no content in themselves. Most drawings and paintings live in the twilight zone between the two, the basic composition being of paramount importance, although there are some contextual elements in it. The golden rule seems to be that context is optional, but a good composition mandatory.

Composition is the arrangement of shapes that are composed of colour, tone, line, or texture. The paper you are working on is a shape and that shape is an important part of the whole composition.

A successful, lively composition demands the careful balancing of all the elements, although the elements

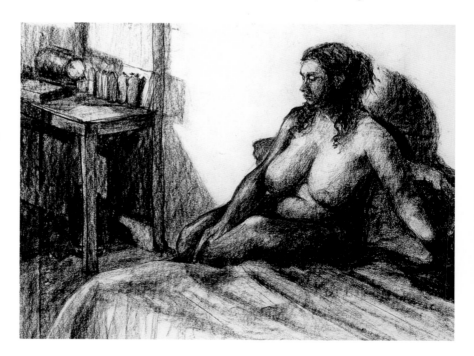

above This is more than a charcoal drawing of a nude seated on a bed. The harsh light casts a shadow on the wall and obscures part of the figure. The small dresser and unmade bed add to the gloom and suggest a run-down furnished room. The charcoal has been used on the side and not blended, adding a coarse texture that reinforces the message and puts the figure in context.

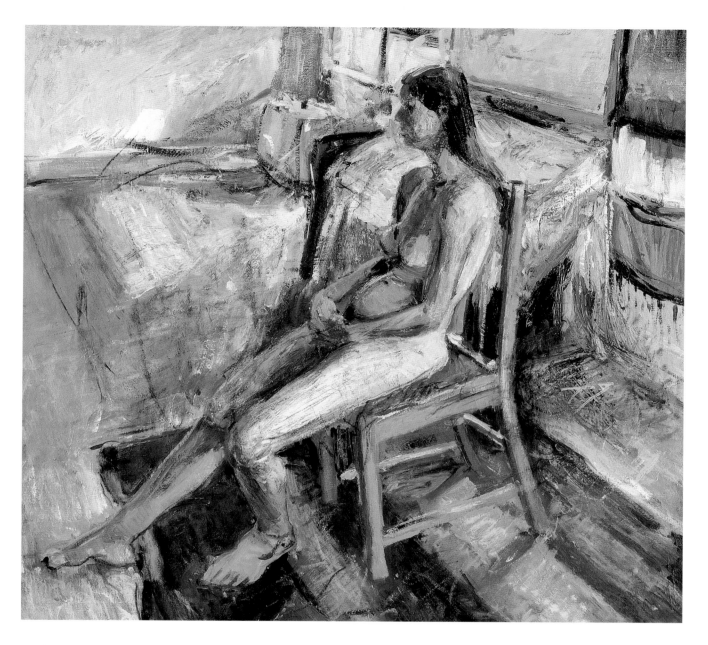

or shapes must not be too static or the composition will be boring. There are two types of symmetry in design. Static symmetry is when the sizes of the shapes are equally divisible – in proportion to the numbers 2–4–6, for example. Dynamic symmetry occurs when the shapes are never equal or evenly divisible, but are in proportion to the numbers 3–5–8, for example. Random forms and scale are the rule in nature, and the more variety you introduce in the shapes you use, the more interesting the

composition will become. Remember that the relationship between the sizes is all-important.

Compositions also need a centre of interest, but this is seldom placed right in the middle of the work. Instead, it is almost always off-centred to create movement and tension. Of course, there is always a danger of going too far and this is what makes composition a "balancing act".

Good composition can make an extremely dull subject vitally

above The large studio space was exploited here in this oil painting of a seated figure.

interesting, while a successful drawing or painting in context will leave the viewer thinking about the person in the work and not just about a figure in a composition.

The projects that follow demonstrate the techniques involved in creating a successful composition.

SEATED FIGURE

CHARCOAL AND PASTEL ARE BOTH DRY-STICK MEDIA AND,
AS SUCH, WORK WELL TOGETHER. CHARCOAL IS FREQUENTLY
USED FOR THE PRELIMINARY SKETCH. IN THIS CASE, THE
ARTIST HAS EXTENDED THE IDEA AND USED CHARCOAL AS
A BASE TONE FOR THE DRAWING.

BY DIANA CONSTANCE

1 The paper has been rubbed with a block of soft charcoal and a quick sketch is made. Charcoal sticks are too heavy for this work.

2 A composition begins to emerge. The diagonal line leads the eye to the second figure.

3 The first very soft pastel is gently layered over the charcoal. Hard pastel would push away or mix with the charcoal underneath.

LAYERING PASTEL

For layering, you will need soft pastels and charcoal pencil and some watercolour paper.

For a large composition use charcoal pencil for the basic drawing of the figure and the overall composition. Use the same thin sticks to put in light crosshatching in all the areas that are in shadow. This method will mean that the tonal structure of the composition is planned before the colour is added. It is particularly important with pastels to have a clear plan of the light and dark areas of the composition at the first stage of any work. Pastel colours are light and seductive and it is quite easy to lose the bass notes and be left with a shallow piece that lacks structure.

Next, select a few colours and, with the flat side of the pastel, loosely put in the basic blocks of colour that you plan to use. Repeat the colours in small areas in different parts of the drawing to "tie" it together. Pastel mixes well with charcoal. Light blue or cool green in shadows mixes with the charcoal and makes a subtle blend.

Now that you have the basic structure, you can work into the drawing by loose hatching in colour or by using the side of the pastel to continue to build the volume of the forms. Allow plenty of time and keep building up a tapestry of colour that allows the layers underneath to show through. Avoid fixing until the drawing is finished.

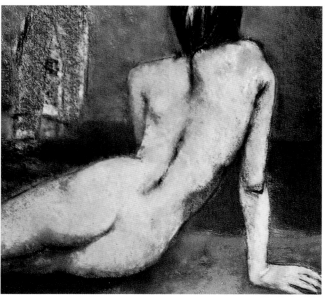

4 More pastel is added and the shadows take on a silvery colour as pastel and charcoal merge.

5 With the charcoal providing a dark base, note that the pastel colour can become richer.

6 The finished work.

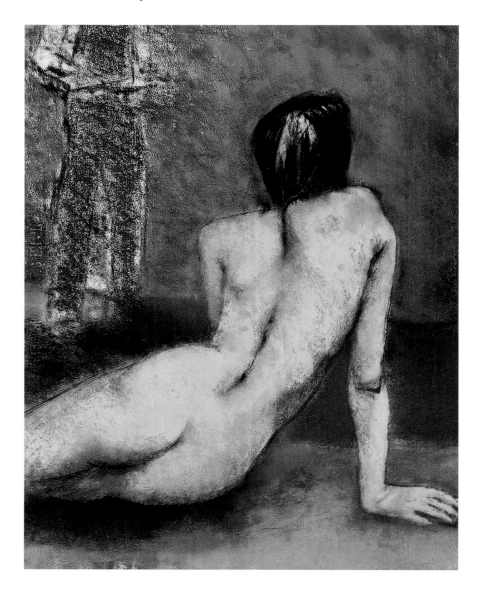

GIRL SEATED SIDEWAYS

THE COMPOSITIONS OF THE FOLLOWING TWO OIL STUDIES
ARE IN CONTEXTS AND IN BOTH THE ARTIST'S AIM IS TO
KEEP THINGS SIMPLE.

The palette is French ultramarine,
cerulean blue, viridian green,
cadmium lemon, cadmium yellow,
cadmium red, alizarin crimson and
titanium white, initially thinned
with turps. The brushes are a no. 5
filbert and a no. 2 round hog-hair.

BY DAVID CARR

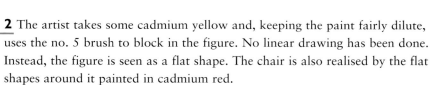

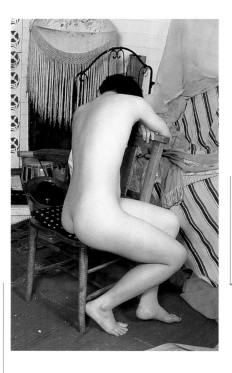

2 The artist takes some cadmium yellow and, keeping the paint fairly dilute,
uses the no. 5 brush to block in the figure. No linear drawing has been done.
Instead, the figure is seen as a flat shape. The chair is also realised by the flat
shapes around it painted in cadmium red.

I The model is seated sideways with
her arms on the back of the chair.
The artist is working on 25 x
27.5cm (10 x 11in) board.

3 Further shapes are placed around
the figure using ultramarine and
alizarin. The whole painting takes
on the appearance of a flat, jigsaw
puzzle arrangement of interlocking
shapes. At this point some
simplified form is introduced on
the figure using cadmium yellow
mixed with white.

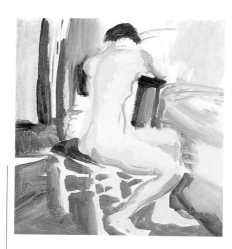

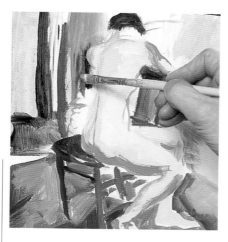

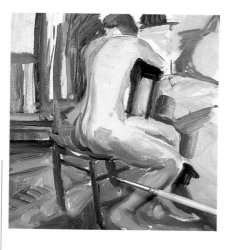

4 Some of the darker tones of the figure are now established using very light touches of light green and blue painted into the wet yellow paint. Note that the defining line down the front of the figure is put in after the main shape of the figure has been established. It was not drawn first and filled in.

5 Depth is now given to the space around the figure through variations in tone, and some of the warmer shadows on the figure, notably under the thigh, are painted in.

6 The space is pushed back and pulled forward using cool and warm colours. Ultramarine is painted into the crimson carpet, and shapes adjacent to the figure are defined. The result is a clear, simple statement.

7 Every part of the picture surface has been made to work, and the figure, simply conceived, occupies a credible space.

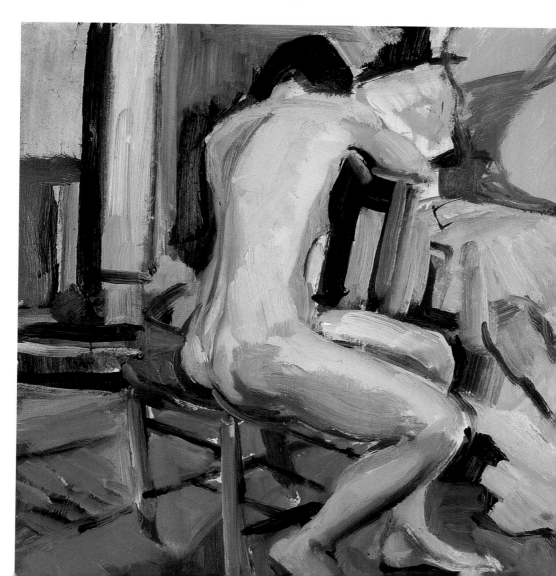

GIRL ON ARM OF CHAIR

THIS IS A SLIGHTLY LESS SUCCESSFUL ATTEMPT THAN THE PRECEDING EXAMPLE. NONETHELESS, IT APTLY ILLUSTRATES THE ARTIST'S INTENTION. THE LENGTH OF THE VERTICAL POSE SUGGESTS A DIFFERENT-SHAPED BOARD IS REQUIRED.

BY DAVID CARR

2 Notice again the simple, direct approach of lightly massing in the figure and space with thin paint.

1 The model is half-seated sideways on the arm of the chair.

3 The artist gradually develops the shapes around the figure. The axis of the shoulders, breast and pelvis is well felt. Note how the picture evolves through a combination of line and mass and not through an initial line drawing, subsequently filled in. It is useful to think in terms of an interlocking jigsaw puzzle of shapes.

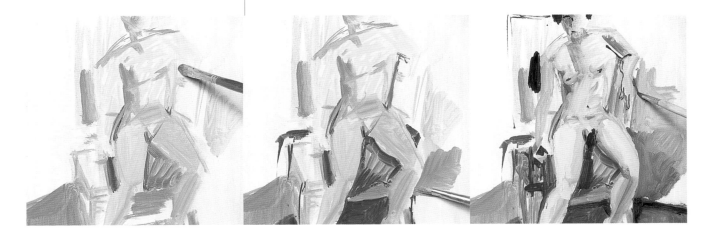

4 Into these simple areas the painter now draws with a fine brush. The figure's right side and left arm are carefully described by the shapes around them.

5 The no. 5 filbert is used again to work back into the figure more broadly. Here much of the cool lemon colour of the flesh is stated.

6 The space around the figure is now more thoroughly blocked in and unified.

7 Stronger defining lines are painted boldly around the legs of the figure and the seat of the chair. The head and shoulders are resolved, and although some of the top of the head and the lower foot are lost, this is a useful preparatory study that could lead to a more finished painting.

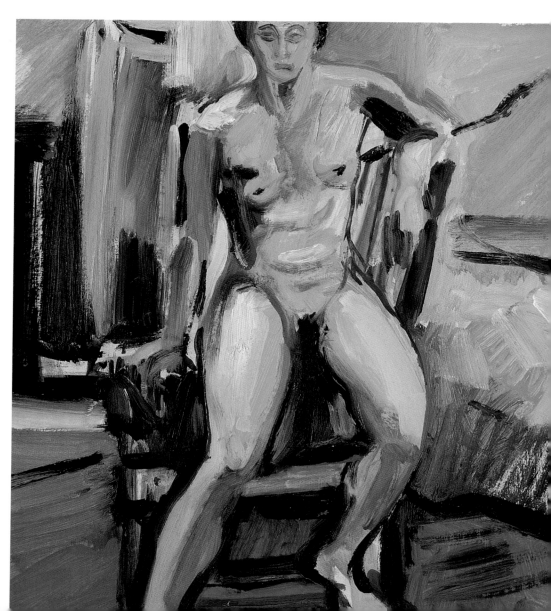

DARK-HAIRED WOMAN IN CHAIR

THIS PROJECT IS A STUDY IN OILS WHICH DEMONSTRATES THE USE OF A SPACE FRAME AND THE VALUE OF PREPARATORY STUDIES. THESE ARE AN INVALUABLE AID IN COMPOSING A PICTURE. HOWEVER SMALL, THEY HELP IN MAKING CHOICES AND IN FAMILIARISING ONESELF WITH THE SUBJECT. IT IS IMPORTANT THAT THE STUDIES AND THE BOARD OR CANVAS ON WHICH THE FINAL PICTURE IS PAINTED SHOULD HAVE THE SAME PROPORTIONS. THE PROCESS FOR MATCHING THE PROPORTIONS OF THE PAINTING BOARD AND THOSE OF THE PAPER USED FOR THE PRELIMINARY STUDIES IS QUITE SIMPLE.

BY DAVID CARR

I The model is in position.

2 A space frame is a useful compositional device. It may be adequate to cut a rectangle out of the middle of a piece of card and hold it up to the subject, but this restricts the shape of the picture. A more flexible device can be made with two L-shaped pieces of card, which can be moved against each other to form a rectangle of varying proportions.

3 In this case the board was slightly smaller than the large piece of paper and the artist has placed the board against the paper and drawn a line along the bottom. He then draws in the diagonals on the paper. Any two lines drawn from two neighbouring sides, and at right angles to them, that meet on the diagonal form a smaller rectangle that has exactly the same proportions as the larger one. (If the canvas is very large, a piece of paper is placed on the corner of the canvas and, using a long stick, the diagonal of the canvas is drawn across the paper.) The board is also shown squared up for the subsequent enlargement of a small study.

The palette is French ultramarine, cobalt blue, viridian green, cadmium lemon, cadmium yellow, cadmium red, alizarin crimson and titanium white. The brushes are no. 5 and no. 8 filberts, and a no. 3 round hog-hair. The study was painted on board prepared with a commercial white ground.

4 Having cut out one of the small paper rectangles, which now has the same proportions as the board, the artist begins to make a simple drawing of the figure. Having used the L-shaped pieces of card, he decides to let the figure fill the space and he is making the study accordingly.

5 He makes a further study and manages to lose the head. Consequently he rejects this and decides he will probably use the first drawing.

6 He now squares up the small drawing using the same number of squares as on the larger board and begins to transfer the drawing very simply using charcoal.

7 He then fixes the drawing.

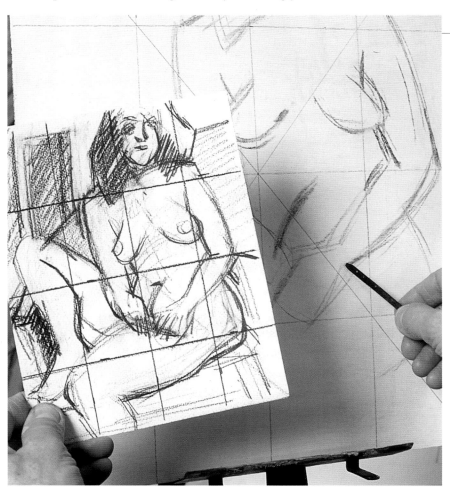

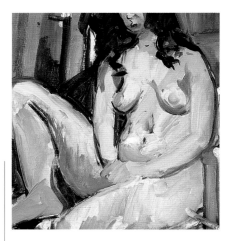

8 Looking at the model again, he begins to paint the flesh tones using a mixture of cadmium red and yellow. He draws the chair cushion in ultramarine and defines some of the form using the same colour.

9 His aim is to establish everything firmly and simply. He works colour into the flesh and paints strong defining lines into the form. The shapes around the figure are developed.

10 The figure is fully established, but sits rather squarely in the chair. The flesh has been painted simply with basic yellows and pinks. The artist now works into this with neutral colours based on blue and green and redraws the figure.

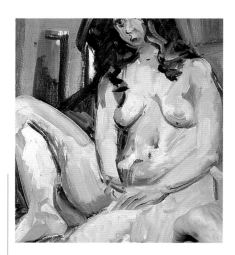

11 Grey-blue is worked into the stomach and under the model's right thigh, and slabs of paint push this leg back diagonally towards the chair back. The hair and face are defined more fully.

12 The point of this whole exercise is to make sure that the artist is in charge of the painting process right from the beginning to the end.

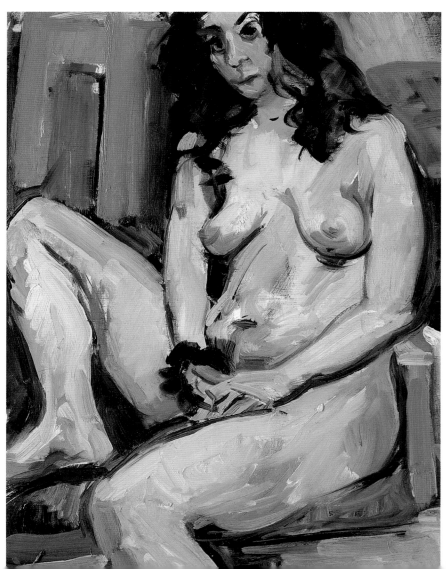

WOMAN SITTING BY A WINDOW

THIS PAINTING DEMONSTRATES HOW A WATERCOLOUR CAN BE BUILT UP WITH LAYERS OF LIGHT WASHES AND HOW QUITE LARGE CHANGES CAN BE MADE DURING ITS DEVELOPMENT.

The palette is Prussian blue, French ultramarine, viridian green, lemon yellow, cadmium yellow mid, cadmium red, permanent rose and alizarin crimson. The brushes used are nos. 10 and 12 sable nylon mix, a no. 3 sable and a 3.75cm (1.5in) flat wash brush. A small natural sponge and blotting paper are also used.

BY SHARON FINMARK

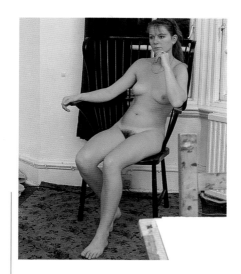

1 The model posed in front of the window.

3 The artist establishes the shapes around the figure using a neutral colour (viridian and rose mixed). Complementaries mixed together always produce interesting neutral tints. Try mixing various reds and greens, blues and oranges, lemons and violets.

4 The chair and the window behind the model are established lightly and viridian green has been used to describe the cooler shadow on the model's left arm and to define the form of the thighs.

2 Using a no. 12 brush and keeping the colour very thin, the artist uses a dilute mixture of cadmium yellow and permanent rose, and with a combination of line and mass begins to establish the figure. Washes should be kept very light and delicate to allow a gradual build-up of colour and form.

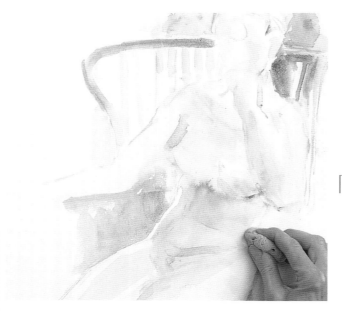

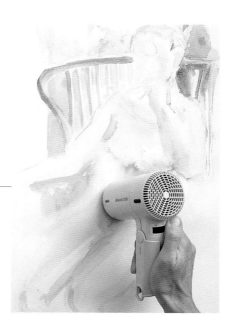

6 In order to control this, she takes a small hairdrier and quickly dries the areas she is changing.

5 Now we can see how quite important and necessary changes can be made. The artist feels that the marks down the side of the figure are too strong and impinge too much on the form. The form is defined too strongly in general. She is unhappy also about the position of the figure in the chair and wishes to move it – quite drastic modifications. Taking a small sponge dipped in clear water, she wets the surface and sponges off the colour on each side of the figure.

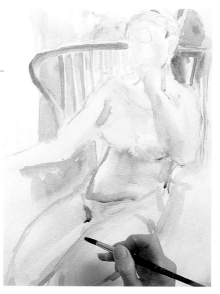

7 Now she can redraw the figure using French ultramarine and crimson.

8 She begins to establish the lower legs and the shape of the chair, and uses some cadmium yellow to bring out the warmth of the chair seat.

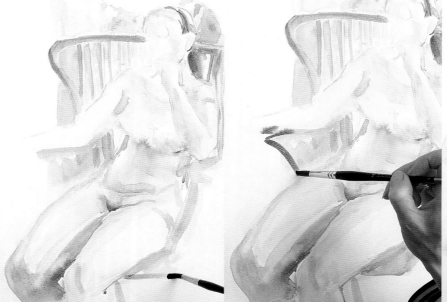

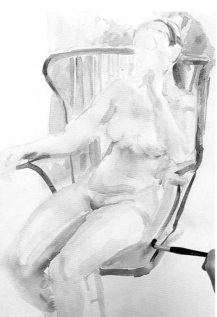

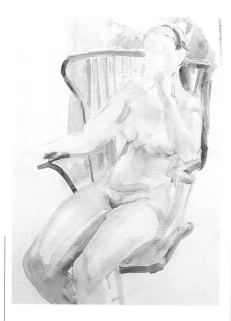

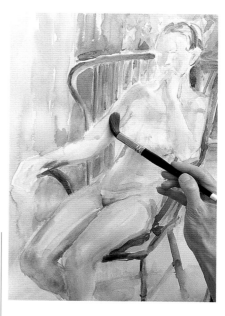

9 Note how in the whole scheme of things the lemons and cadmium are acting against the violets and blues.

10 Using a 3.75cm (1.5in) flat wash brush, the artist begins to lay in the wall and the curtain.

11 Using a large sable mix brush, she lays in the figure more strongly, glazing transparent orange over the completely dry layers beneath.

12 Here we see she has warmed up the whole figure, as she felt it had become too violet. Note, too, the strong glaze of green along the figure's left thigh, which acts effectively against this warmth.

13 She is unhappy about the strength of the red patch beneath the breast and takes a brush with clear water to dampen this area and blot it out.

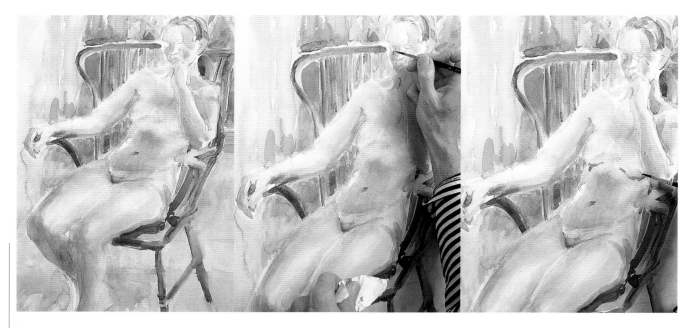

14 The paint has been removed and, with blotting paper in one hand, she takes a fine sable brush and begins to define the face and the breasts.

15 Finally she strengthens the wall behind the figure with a further glaze and emphasises the form of the stomach, introducing some green under the breasts.

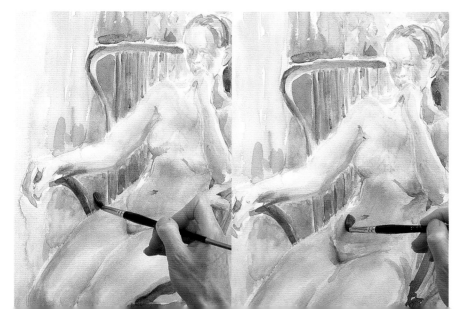

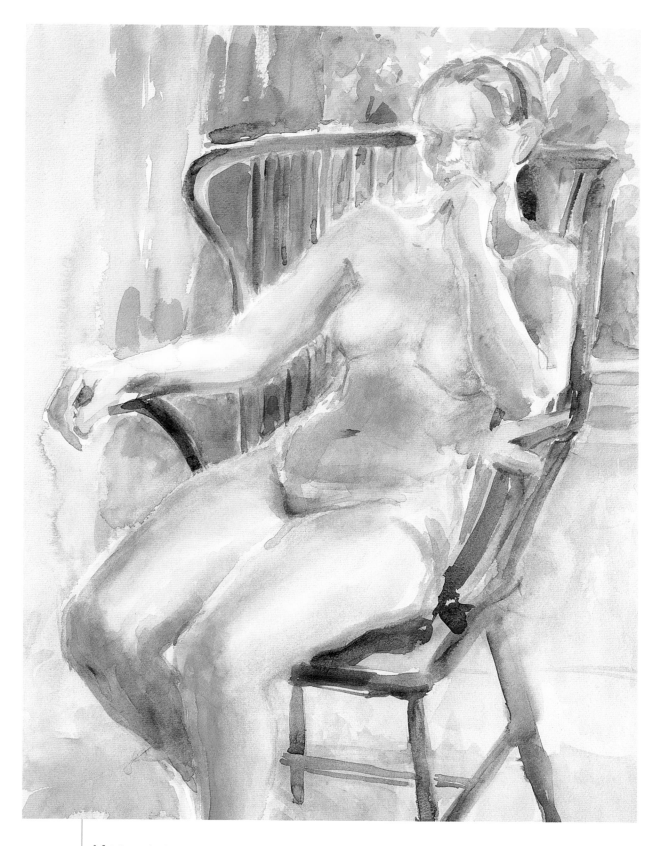

16 This whole process shows how to build up a watercolour slowly. Let the layers of paint dry thoroughly if you are going to apply a glaze over the top. It is possible by dampening, sponging and blotting to make quite drastic changes to your work.

KURUMI

FOR HIS PORTRAIT OF KURUMI, IN ACRYLIC ON PAPER, DAVID CHOOSES A PALETTE COMPOSED OF STRONGLY CONTRASTING COLOURS AND SHADES WITH WHICH HE INTEGRATES HIS SUBJECT WITH HER SURROUNDINGS.

The colours are parchment (greenish cream), unbleached titanium (slightly pinky cream), raw sienna, cadmium yellow, cadmium red, cadmium red deep, quinacridone red, burnt umber, cerulean blue hue and turquoise green.

BY DAVID CUTHBERT

1 David covers the paper with a layer of cerulean blue hue. He then proceeds to draw in the composition using cadmium red.

2 The next step is to block in the major colour areas. He chooses unmixed colours, straight from the tube, intending to overpaint and adjust later. Here he is applying turquoise green.

3 At this stage all the main colours are blocked in and the composition is established, with colours in the surroundings relating to those on the figure. Colours used are raw sienna, burnt umber and quinacridone red.

4 Next, David begins to explore the hands and face using unbleached titanium.

5 He then turns his attention to the orange drape. As this is so close to the face it will affect the skin tones; it will also enliven the adjacent blues. David uses a mixture of cadmium yellow and cadmium red.

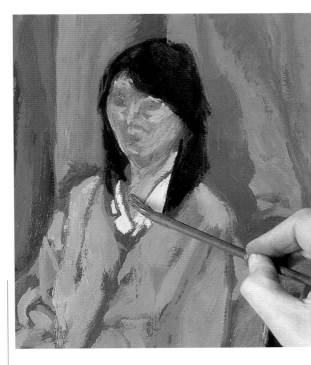

6 Having lightened and defined the top left corner with a thin layer of burnt umber and parchment, and added more of the flesh tint to the face, David now applies cadmium red deep to the drape on the floor.

7 The coat is given a lighter layer of blue mixed with turquoise green and parchment.

8 Kurumi's face receives a glaze of raw sienna.

221

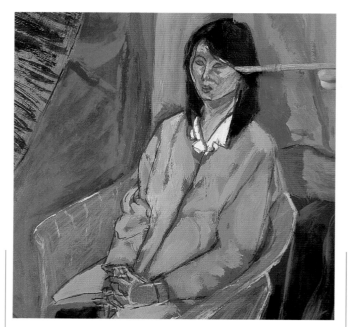

9 The likeness is then redrawn using thinned-down cadmium red deep.

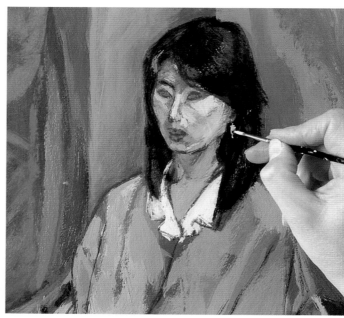

10 Highlights on the face and the earring are added with parchment.

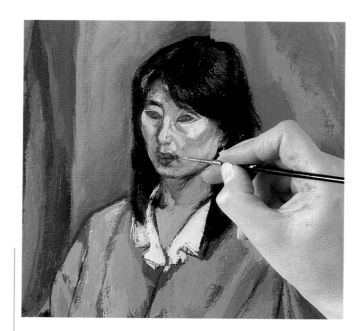

11 Shadows are touched in using raw sienna mixed with a tiny amount of burnt umber.

12 The chair is developed next, using raw sienna and parchment. The trousers and shoes are painted using mixtures of burnt umber, cadmium red and unbleached titanium. Here and there the original red underpainting is strengthened. Finally, David paints in the hands using unbleached titanium, raw sienna and cadmium red.

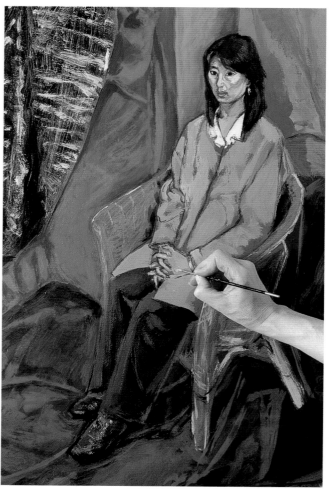

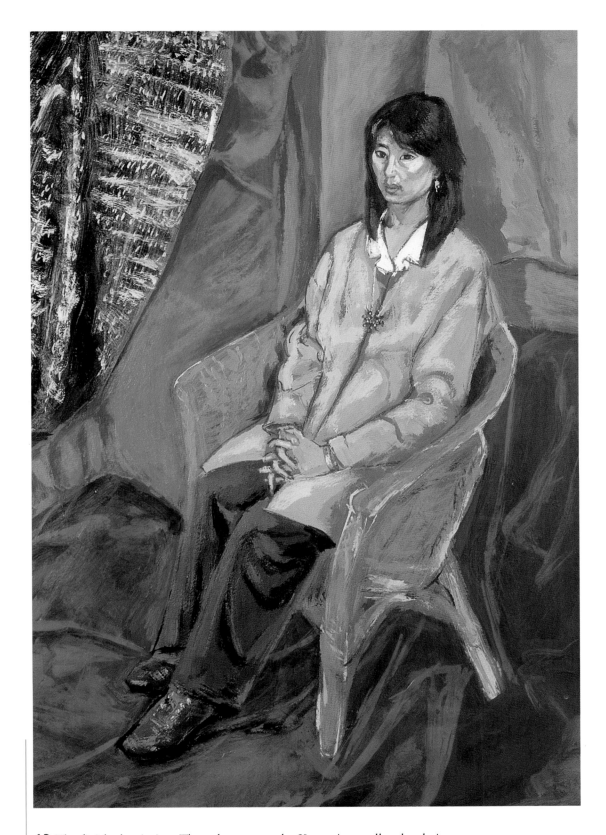

13 The finished painting. The colours worn by Kurumi as well as her hair and flesh colours are all repeated elsewhere in the composition. The strong reds and oranges are allowed to leak into the linework on the figure. Warm/cool and light/dark contrasts are beautifully balanced.

WOMAN SEATED BY RED SCREEN

THE MODEL IS SEATED AGAINST VERY BRIGHT
FABRICS TO GIVE THE ARTIST FULL PLAY WITH
COLOUR.

Only a few colours have been used
and the palette comprises French
ultramarine, cerulean blue,
cadmium lemon, cadmium yellow
deep, cadmium red, alizarin
crimson and ivory black. It is
painted on white primed canvas
tacked to a board.

BY KAY GALLWEY

1 The model is seen here surrounded
by strong primary colours.

2 Three slabs of colour are put
down – the stripe of ultramarine
along the top, part of the red screen
and cadmium yellow for the body.
Using a rag dipped in turps, the
artist moves the paint around on
the canvas.

3 With ivory black she lays in the
hair and begins to draw the face,
neck and arms, working into the wet
yellow paint and letting them mix.

4 More of the body is drawn with black and cadmium yellow deep.

5 The artist works stronger black lines into the hair and has drawn some of the figure in ultramarine. Much stronger, purer colour is now applied – a powerful red around the head.

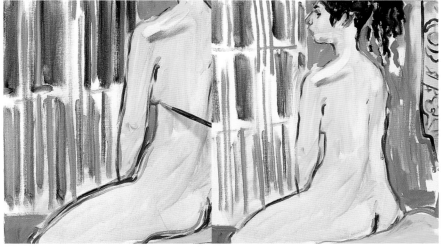

7 At this point she introduces some fluorescent day-glo paint into the picture to make things really go with a zing. With a no. 5 round bristle brush, she draws multiple contour lines around the form in bright red and green.

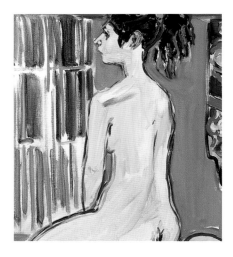

6 The artist extends the red into the cloth to the left of the figure. Then, taking a rag dipped in turps and a mixture of alizarin crimson and ultramarine, she daubs in the fabric.

8 She uses some of this colour in the face and places some strong accents of a fluorescent blue in the hair, at the same time completing the patterned cloth on the right.

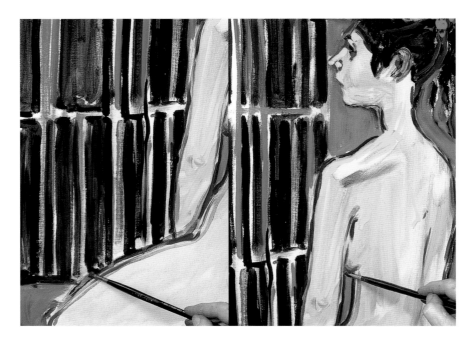

9 The artist makes the cloth darker and continues to modify the contour with a darker line of deep violet. She paints a lot more lemon yellow, cadmium yellow deep and light cerulean blue into the flesh of the head, neck and body.

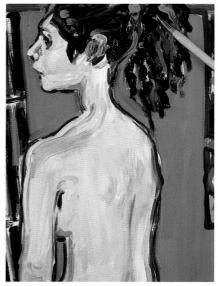

10 Finally, she works some pure bright green and ultramarine into the head to produce a very jazzy painting.

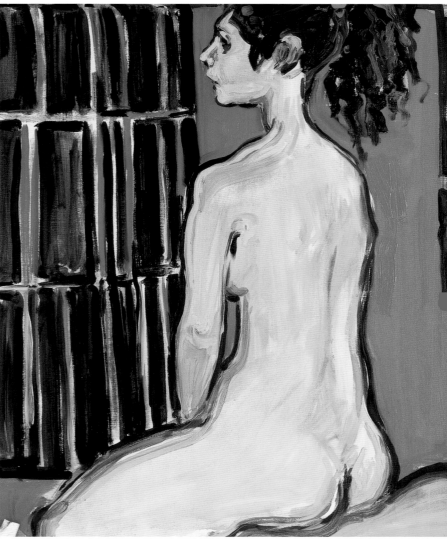

11 Strong, bold colour and rapid execution are the keynotes of this vibrant study.

LAURA

IN THIS PORTRAIT OF LAURA, IN ACRYLIC ON PAPER, DAVID SHOWS HOW TO WORK BOLDLY WITH ACRYLICS, PUTTING ONE LAYER OF COLOUR OVER ANOTHER, CORRECTING WHERE NECESSARY AND ACHIEVING AN ENERGETIC AND FRESH FINISH.

He used titanium white, parchment (greenish cream), raw sienna, lemon yellow, neutral grey (mid grey), cerulean blue hue, manganese blue hue ultramarine blue, bright violet, deep violet, quinacridone red, reddish brown, Hooker's green deep hue and turquoise green.

BY DAVID CUTHBERT

1 First of all, David draws in the composition using cerulean blue thinned with water. He works broadly and confidently, knowing that mistakes can be overpainted.

2 He reaffirms the drawing with reddish brown red hue.

3 Then he begins to work in the main colour areas around the figure. Here he is using permanent Hooker's green, deep hue and titanium white.

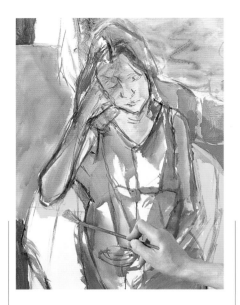

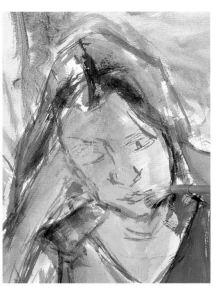

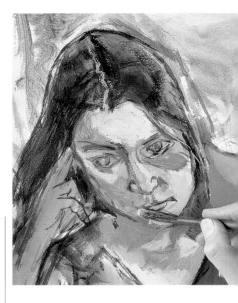

4 The head and arms are filled in with dilute quinacridone red and a bright lemon yellow is chosen for the chair. The paper is now almost covered with a thin layer of paint.

5 Next, David brushes a thin layer of lemon yellow over the red face and arms.

6 The shadows on the face are explored using semi-opaque deep violet over reddish brown and the drawing strengthened by emphasising the tonal contrast between the pale face and the dark hair.

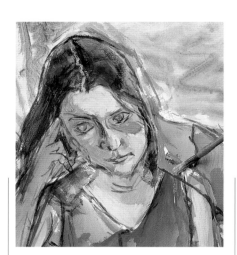

7 Here, the shoulder line is being corrected.

8 For the eyes, David uses permanent Hooker's green deep hue, unmixed for the darkest parts, and mixed with parchment for the lighter tints on top of deep violet and reddish brown. For the white of the eyes he uses deep violet and a mixture of parchment and turquoise green.

9 Shadows on the dress are blocked in with ultramarine blue on top of a thin underpainting of manganese blue hue.

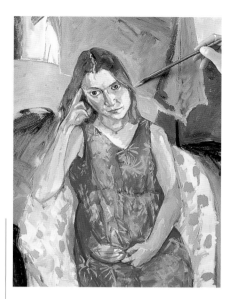

10 At this stage the composition, colour harmonies and likeness are well established.

11 The pattern on the dress goes in next, with a mixture of neutral grey and raw sienna.

12 Adjustments to the background involve toning down the violet drape with a green made by mixing permanent Hooker's green deep hue with parchment.

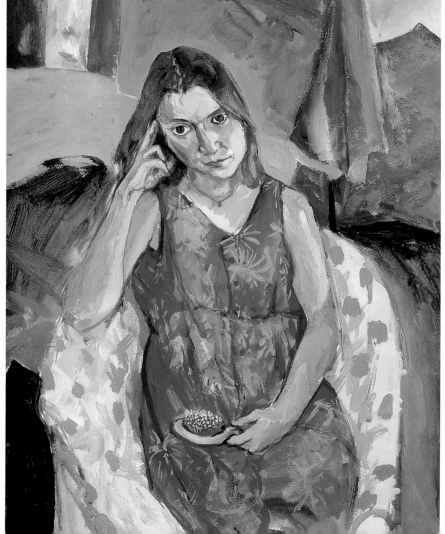

13 The hairbrush is completed last, the final touch of titanium white being applied with the tip of the brush.

14 The finished painting.

SKIN COLOUR AND TONE

PAINT MANUFACTURERS HAVE PRODUCED A COLOUR THAT SHOULD BE AVOIDED AT ALL COSTS. ITS NAME IS "FLESH PINK" AND IT IS SOMETIMES CALLED "FLESH TINT".

Its appearance is more akin to that of a cosmetic or dermatological cream and it has no use whatsoever in rendering the luminosity of human skin. In the wide spectrum of skin colours, from the whitest of northern skins to the blackest of African skins, from Middle Eastern hues to the porcelain tones of the Far East, nowhere is this colour found except in the circus.

Many different factors are at work creating skin colour and tone. Not only is skin colour affected by the ambient light, but very much by the surrounding colours, and particularly clothing. Its variety results from racial origin, and degree of exposure to the sun and weather. It varies from one part of the body to another.

Ruddier skin is caused by the closeness of the blood vessels and capillaries to the skin's surface. In very pale-skinned people, the blue veins can sometimes be observed just below the surface.

There is a great variety of cool and warm skin colours and tones and it is important to use warm and cool colours to the full when painting. Warm primaries include cadmium yellow, cadmium red and French ultramarine, and cool primaries lemon yellow, alizarin crimson and cobalt blue. Earth colours, used

below In Victor Willis's painting Indian red and yellow ochre mixed with flake white were used for the overall skin tone.

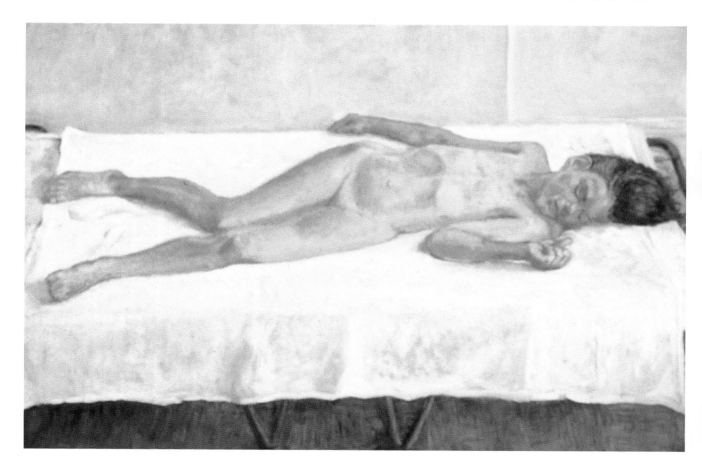

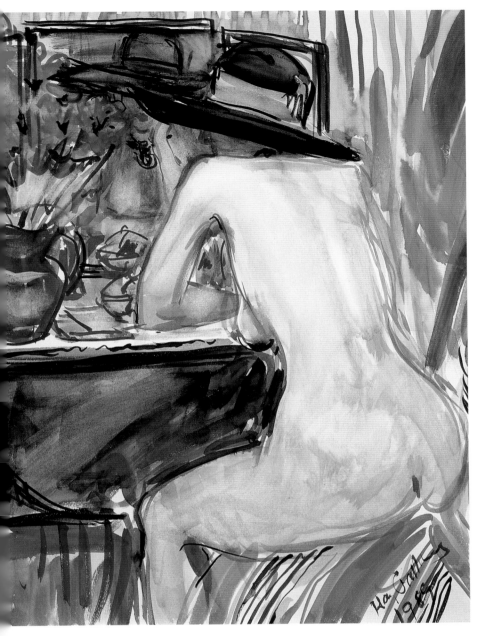

above *Rosemary*. Oil by Jane Percival. This study shows how the flesh tint was laid on and the likeness obtained by drawing with a darker shade which also works as a half tone. Colours used were white, yellow ochre, raw sienna and cadmium red.

left Kay Gallwey uses large brushes to modulate warm yellows to cooler pinks, defining and redefining the form with sepia.

carefully, are important. These should include yellow ochre, raw sienna, raw umber and light red.

Careful use of warm and cool colours is a help in modelling the form, as cool colours tend to recede and warmer colours to come forward. It is also necessary to expect the interaction of complementaries to give a sense of light on and in the skin. Glazing darker colours over light and vice versa can give a real sense of luminosity. The scumbling of

darker paint over light, allowing just a little of the underlying colour to show through, gives a sense of light on the shadows. Renaissance artists frequently used a cool underpainting of green, grey or violet, over which they placed warm complementary colours. Very early Italian paintings often display this green appearance where the upper layers of paint have worn away.

If you are painting in sunlight or warm artificial light you will need to

adjust your palette. Some artificial light is cold but domestic lighting is generally warm. Thus the flesh tints will appear warmer and you may feel the need of a dab of lemon yellow or Naples yellow. Beware of overdoing it – too much yellow can result in a case of jaundice!

The projects that follow show the range of colours that can be used to portray different skin tones and a variety of techniques including oil glaze and impasto.

GIRL LEANING ON PILLOWS

THIS OIL PAINTING RELIES MAINLY ON THE DELICATE CONTRAST OF YELLOW AND PALE LILACS, PINKS, MUTED GREEN, WARMER YELLOWS AND COOL BLUES.

The palette is French ultramarine, cerulean blue, viridian green, oxide of chromium, cadmium lemon, cadmium yellow mid, cadmium red and alizarin crimson, thinned with turpentine. The brushes used are a no. 5, no. 8 square, a no. 8 round bristle and a large, round, long-handled hog-hair.

BY KAY GALLWEY

1 The model was seated against a number of cushions.

2 The study was painted on a canvas with a warm cream ground. The artist does the preliminary drawing with a fine brush and alizarin crimson. With a rag, she works crimson behind the figure and cerulean blue around it, and begins to paint into the figure with cadmium yellow.

3 She supports her arm with a mahlstick rested on the canvas at one end and begins to define the head with violet (alizarin and ultramarine) using the large hair brush. She introduces much stronger accents into the drapery and a striking crimson pink at the figure's shoulder.

4 The artist takes great care with the axes of the body. There must be a strong sense of the model's right arm bearing the weight and pushing up at the shoulder. She places a clear line at the "hinge" there. She continues to develop the drapery as it will be crucial in creating the rhythmical and fluid contour of the figure. She works more light, warm yellow paint into the body and cooler paint above the breast.

5 She builds up the colour in the face and begins to introduce some delicate complementary green to the forehead, around the neck and under the elbow. The green used is oxide of chromium mixed with white.

6 She begins to develop the form of the figure further by painting into the shadows. She has wiped away some of the paint with rags and in the detail the cream ground can be seen clearly. It is, in fact, being used here as a colour in the painting. Toned grounds such as this can have a unifying effect within a picture.

7 With the most delicate touches of dull green and violet, she defines the face. Note the accent of slightly stronger green near the hairline. It is just strong enough to act effectively with the pink of the model's cheek.

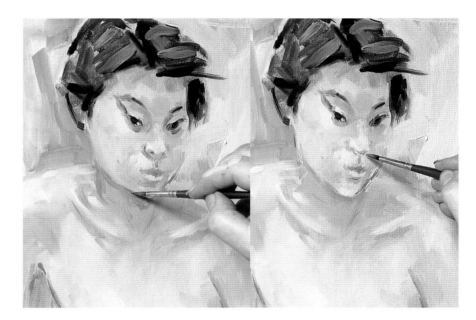

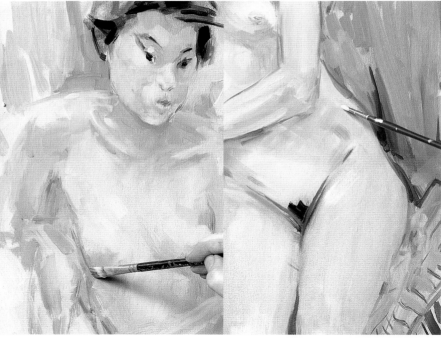

8 Refining work takes place on the body, building up a sense of luminous skin. Subtly modulated strokes of pink and lilac grey play against the predominantly pale yellow flesh.

9 A strong highlight is placed on the shoulder to give an added sense of pressure at this point.

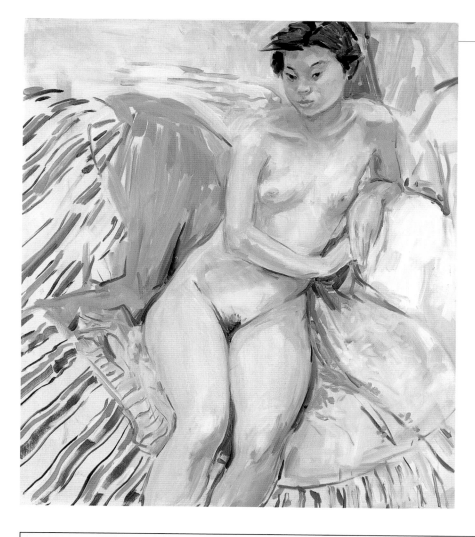

10 The volume of the pink sheet behind the figure becomes more solid, separating the figure from the busy striped cloth on the right. The turquoise cloth is enlivened with touches of pure orange. The drawing of the hand and arm is completed. The feeling of light has been skilfully created by a carefully balanced use of complementaries: delicate green against pink, lilac against yellow and the warmer yellow against blue.

STRONG COLOUR AND THICK PAINT

In this large oil painting of a reclining figure, by David Carr, much stronger colour has been used. It is 1.5 x 1.2m (5 x 4ft) on canvas. The initial layers of paint were laid in flat with plenty of turps and were worked into with thick paint of tube consistency. Very little mixing was done on the palette and many different strokes and swirls of paint were applied with both brush and fingers. The palette is a fairly simple one of titanium white, two blues (French ultramarine and cerulean blue), two yellows (cadmium lemon and cadmium yellow mid), two reds (cadmium red and alizarin crimson) and viridian green. Blacks have been made with a mixture of alizarin, French ultramarine and viridian green.

The flesh is treated more simply than the highly textured paint surface of the drapery. A light cadmium yellow and red mixture has had a variety of colours scrubbed into it – warmer reds on the lower leg tucked under the body, warmer yellow on the stomach and cooler lilac and violet touches on the thighs, breasts and face.

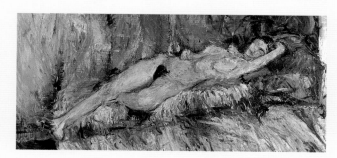

left This whole painting has a tapestry-like feeling, with strands of colour weaving together to give a sense of light.

SEATED MAN

THE ARTIST WORKED FROM DRAWINGS FOR THIS PROJECT AND MADE COLOUR NOTES TO AID HIS MEMORY. IT IS IMPORTANT TO ASK THE QUESTIONS: "CAN I PAINT FROM THIS DRAWING? DOES IT TELL ME ENOUGH ABOUT THE SUBJECT?" THIS CONCENTRATES THE MIND AND HELPS YOU TO MAKE CLEAR, INFORMATIVE DRAWINGS.

The palette to be used for this painting was French ultramarine, viridian green, yellow ochre, raw sienna, cadmium red, alizarin crimson and titanium white.

BY DAVID CARR

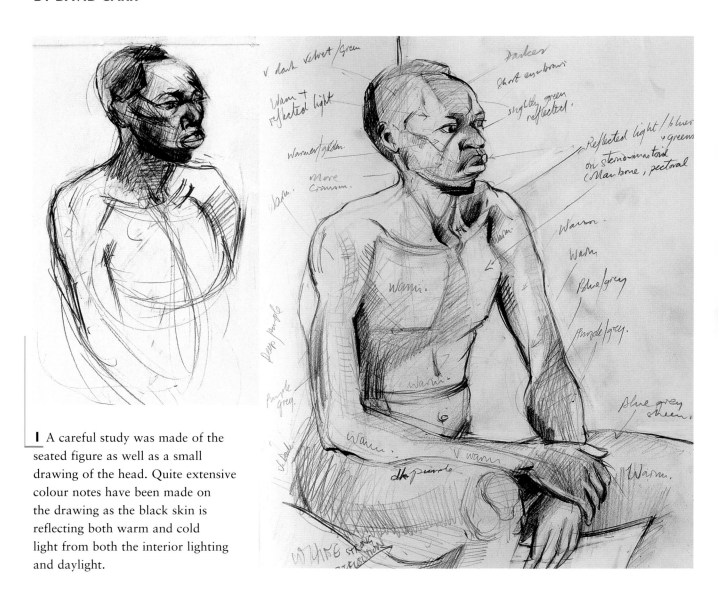

1 A careful study was made of the seated figure as well as a small drawing of the head. Quite extensive colour notes have been made on the drawing as the black skin is reflecting both warm and cold light from both the interior lighting and daylight.

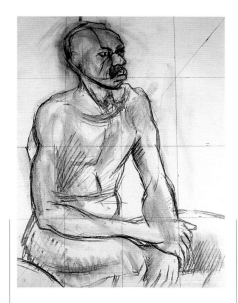

2 Having been as clear as possible about the planes in the figure, the artist squares up the drawing (with squared-up tracing paper) and transfers it in charcoal to a larger board with the same proportions.

3 The figure is washed in with raw sienna and then a heavier layer of cadmium red and raw sienna. Grey-violet (mixed from alizarin crimson, French ultramarine and raw sienna) is rubbed in for darker tones.

4 All this is blended together with titanium white, and a little viridian green is introduced into the chest.

5 The artist constantly refers to the colour notes on his drawing.

6 Much more work is done around the figure: the artist concentrates on the volume of the head, working wet-on-wet, adjusting and balancing the warm and cold light and deciding what is reflected light and what is body colour. He begins to pull it together with some yellow ochre, and a pale green reflection on the chest is established.

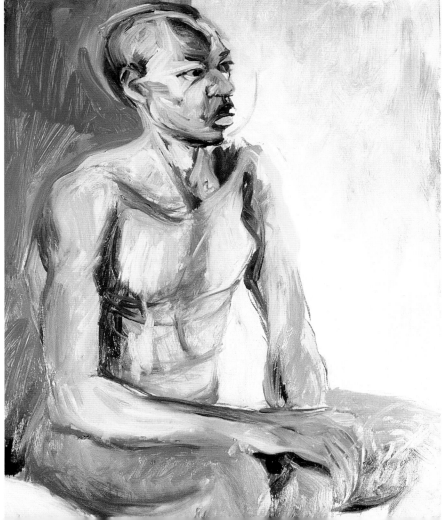

237

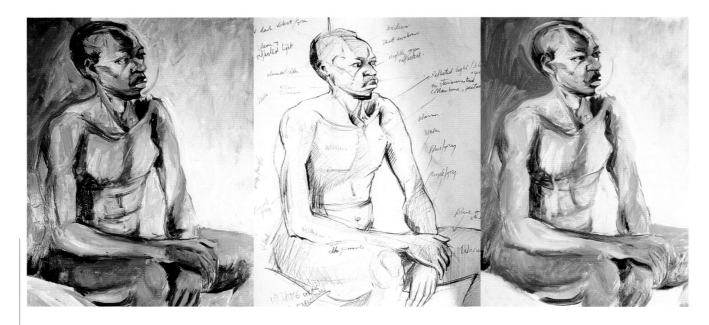

7 By constant reference to the drawing, the artist is gradually able to resolve the structure of the head, neck and shoulders, and build up the colour in the body.

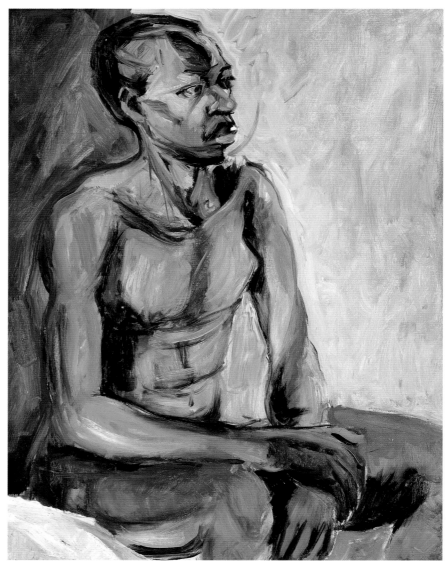

8 Practice in these techniques can enable you to make finished pictures of subjects where you have only limited time for direct study.

ANGUS

DAVID USES A WARM NEUTRAL
TINTED PAPER WHICH
PROVIDES A TONED GROUND
FOR THE PASTEL COLOURS.
HERE AND THERE THE PAPER
COLOUR SHOWS THROUGH,
UNIFYING AND ENLIVENING
THE COLOURS DRAWN
OVER IT.

He uses vermilion, pale flesh tint, brown madder, red oxide, yellowish orange, yellow ochre, dark pink, dark maroon, very dark mauve, bright purple, dark cool grey, greenish grey, terre vert, dark greenish blue, bright turquoise, Hooker's green, dark blue violet, dark olive green, viridian, charcoal, black and creamy white.

BY DAVID CUTHBERT

1 Using vermilion, David begins by drawing in the outlines.

2 He establishes some values on the face, using pale flesh tint, brown madder and dark maroon. Then he works on the background adjacent to the face using white.

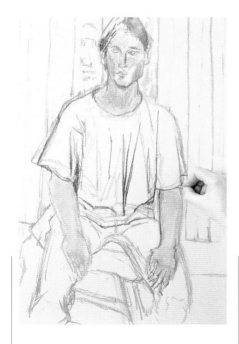

3 Having explored the flesh tints of the arms and hands using red oxide and pale flesh tint, David reaffirms the drawing with Hooker's green.

4 The T-shirt is blocked in next using dark cool grey.

5 Before proceeding too far David begins work on the background, using vermilion, greenish grey, terre vert, black and a creamy white.

6 At this stage the composition and distribution of tones and colours is clearly mapped out.

7 The T-shirt now receives a layer of dark greenish blue and dark blue violet, and touches of very dark mauve and touches of viridian.

8 The face is modelled using red oxide and blended greens and greys – Hooker's green, dark olive green, terre vert and earth. Also touches of bright purple.

9 The eyes receive touches of charcoal to give a soft dark line.

10 The trousers are worked in with strokes of bright turquoise, bright purple and white. The hands and arms receive yellowish orange, dark pink, yellow ochre and terre vert.

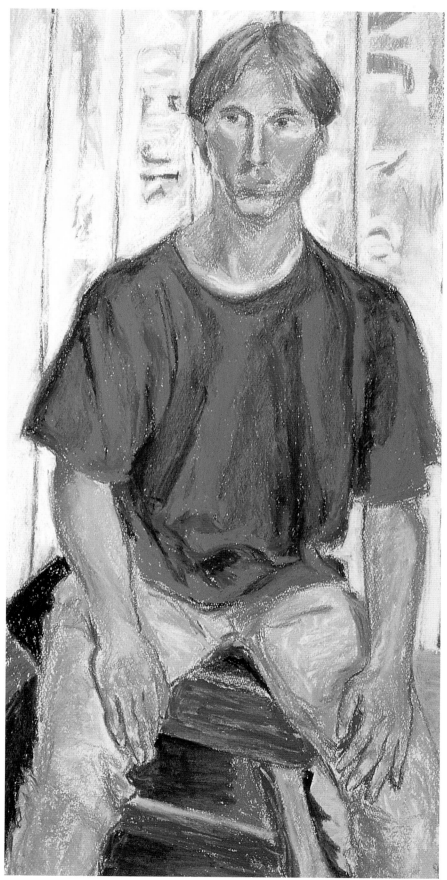

11 The completed picture.

YOUNG MAN LEANING ON WINDOWSILL

PLANNING IS IMPORTANT. THE FIGURE WAS SEATED ON A STOOL AGAINST A PURPLE VELVET CLOTH. THE ARTIST DECIDED TO WORK FROM THE HEAD AND TORSO AND TO FILL THE PICTURE FRAME WITH THE SUBJECT. HE WAS INTERESTED IN EXPLOITING THE DRAMATIC LIGHT CONTRASTS OF THE FLESH AND THE VELVET. AN OIL GLAZE TECHNIQUE IS PARTICULARLY SUITED TO SUCH DRAMATIC TONAL DIFFERENCES.

The palette used is raw umber, cadmium yellow, cadmium red, alizarin crimson, rose madder, Winsor violet and titanium white.

BY MICHAEL CHAITOW

1 The model in position.

2 Working on a white ground, the artist draws in the basic shapes of the figure in charcoal. He has decided to use a water-based medium, gouache, for the underpainting in order to speed up the process. This is perfectly legitimate as normally he would have to wait for each layer of paint to dry thoroughly. The water-based underpainting will act in exactly the same way as an oil-based one would. If acrylic paint rather than gouache is used, it must be kept very dilute. He adds a small amount of acrylic white to the shoulder. He then fixes the drawing.

242

3 He now begins to strengthen the drawing, giving the figure much greater mass by pushing the charcoal around using both a cloth and his fingers. He uses a putty eraser to pick out some of the form.

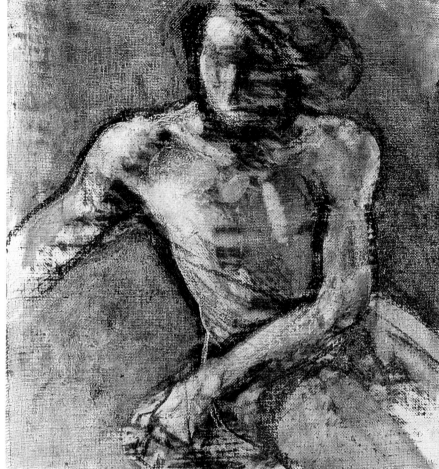

4 The figure and its surrounding space are now well established and developed with charcoal, black and white conté and white acrylic.

5 The artist clarifies the edge of the arm further with black acrylic. We can see how simply but subtly the form has been drawn.

6 Now the glaze is applied. The glazing medium used here is made up as follows: one part stand oil, one part damar varnish, one part genuine turpentine. The pigment in this case is a mixture of alizarin crimson, raw umber and violet. The artist based this choice partly on the mood of the pose and sitter and partly on the deep violet velvet cloth behind the figure. The glaze is applied evenly across the picture using a 3.75cm (1.5in) brush.

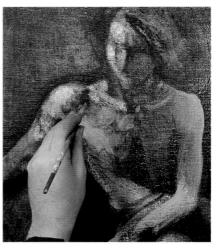

7 Taking a cotton rag, he rediscovers the forms of the figure by gently wiping away the glaze. He constantly refers to the model while doing this as adjustments of form can still be made. We can now see the charcoal drawing and underpainting.

8 Using a flesh tone mixed from cadmium red, cadmium yellow, and white, he begins to paint some of the lighter flesh tones with a thin impasto.

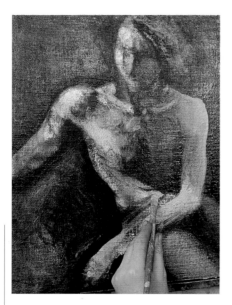

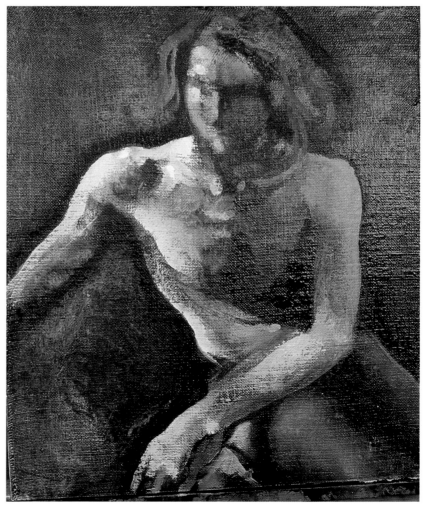

9 The artist uses stronger cadmium red and yellow to paint the warmth around the stomach and he establishes highlights on the right shoulder, chest, waist and wrist.

10 He blends the paint around the model's head and places warmer accents on the forehead and left arm and hand.

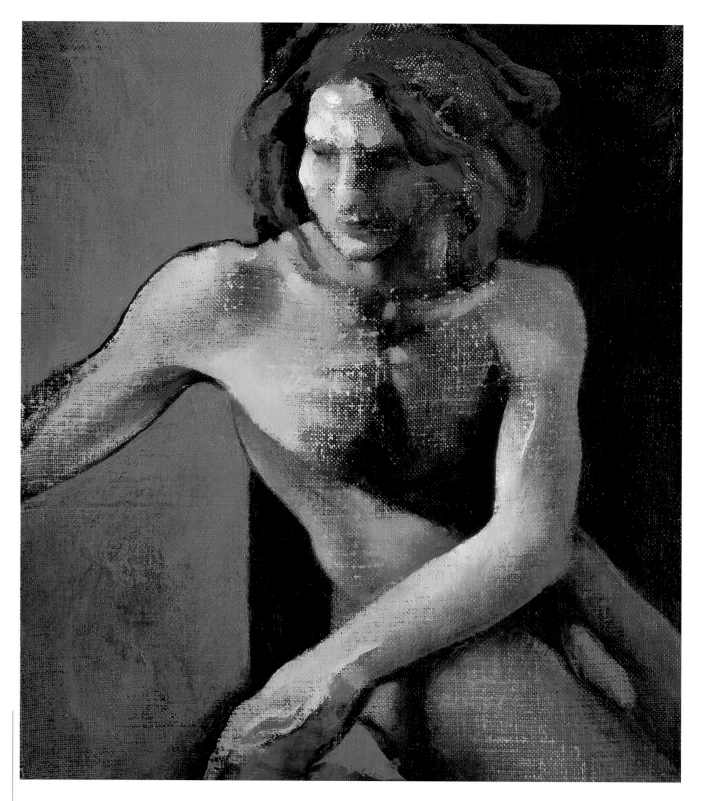

11 The final stage is painted at a later sitting, once the painting has had time to dry. He gives the painting an all-over glaze, using a mixture of rose madder and raw umber, and wipes this off with a cotton rag to find the form. He continues to lay in opaque flesh tones. He develops the face and hair further and makes a small alteration to the cloth on the side of the head.

JAZ

IN THIS OIL PAINTING ON BOARD IT IS INTERESTING TO SEE HOW BLUE AND GREEN ARE USED IN AN OTHERWISE WARM-TONED COMPLEXION.

The palette is titanium white, monestial turquoise, magenta, lemon yellow, cadmium orange, Indian red, cadmium red, Mars violet, cobalt green, cerulean blue, ivory black and sepia.

BY ROS CUTHBERT

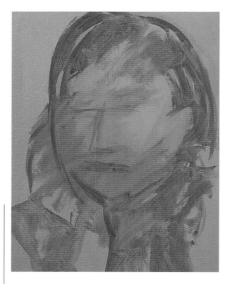

1 The imprimatura – a word used to describe the tinting of a white ground prior to painting – is in two layers, cadmium scarlet followed by a mixture of white and raw umber. The artist begins the underpainting with magenta thinned with turpentine, blocking in the head and hand boldly to establish the composition.

2 Adding monestial turquoise to the magenta, she blocks in dark areas and establishes a likeness. The paint is kept thin so that she can move it around easily

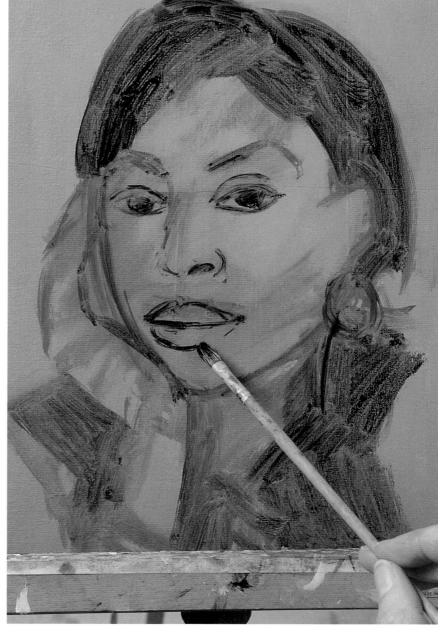

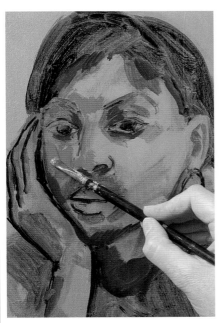

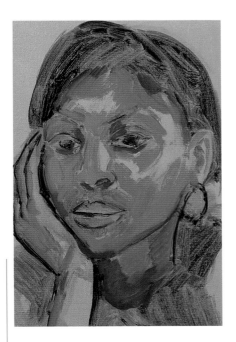

3 With a mixture of white, cobalt green and cadmium orange, she blocks in the half tones next.

4 Then she mixes a flesh tint using cadmium orange, cobalt green, Indian red and white.

5 At this stage the flesh tint is blocked in but the underpainting is still visible.

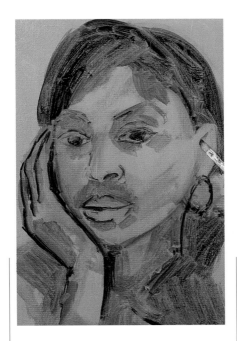

7 The upper lip is darkened with a mixture of Mars violet and sepia.

8 Highlights are added next using cobalt green and white, with the addition of cerulean blue on the cheek bone and nose and the upper and lower lip.

6 The artist blocks in the background with a mixture of cadmium orange and cadmium red and strengthens the hair, eyes and eyebrows with sepia.

9 The eyes are developed using Indian red on the iris and cerulean blue and white for the whites.

10 Highlights are added with titanium white warmed up with a little lemon yellow.

11 Using ivory black and sepia, the fringe is pulled forward over the forehead and the hair is completed.

12 Finally, a few textural details are added to the jumper with sepia, black and white, and the picture is complete.

THE HEAD

DRAWING THE HEAD AND THE STUDY OF PORTRAITURE BOTH BEGIN WITH AN UNDERSTANDING OF THE BALANCE AND MOVEMENT OF THE COMPLETE FIGURE.

Every segment or part of the body is a reflection of the whole person and this is particularly the case with the head.

The head has a great deal of mobility. It rests like a globe on the atlas vertebra at the top of the cervical vertebrae of the upper spine. This beautifully designed bone allows the head to rotate easily back and forth and from side to side. It is one of the most flexible joints in the body. A great many muscles are required to hold the head in position, but the most obvious and important to the artist are the two sternomastoid muscles, which are connected just behind the ears. They wrap around the sides of the neck and join onto the breastbone and the clavicle or collarbone at the front. These are powerful muscles and are clearly visible in both men and women. They are used for turning the head and they give a graceful curve or diagonal line to the neck, which it is important for the artist to express.

The neck and head should always be seen and drawn together. Find and follow the direction of movement up through the spine and the shoulders.

Look at the whole pose to find the balance and movement. Note the position of the shoulders, then come up through the neck to find the right angle for the perch of the head.

The cranium or skull is, on average, as deep as the face is long. The jaw is connected by ligaments to the upper part of the skull and is important to

remember this if a model is resting her head on her hand. The entire lower part of the face will be pushed out of alignment by the thrust of weight on the hand and arm. If you draw this correctly, you will give a convincing feeling of the weight of the head.

above In this sensitive pencil sketch of the head, note how the features wrap over and around the curve of the face.

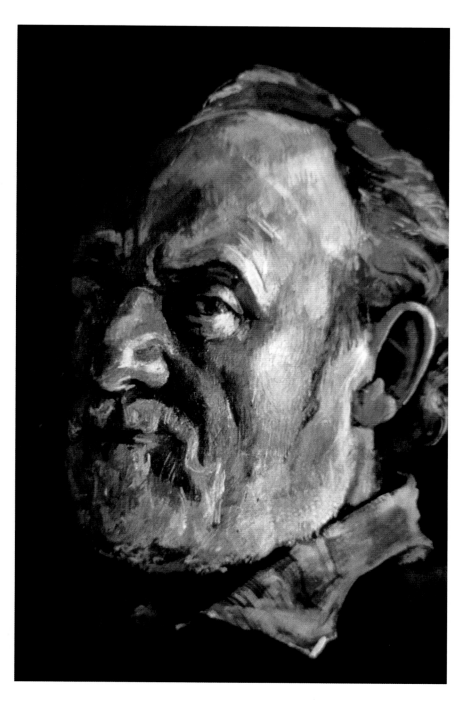

above In this self-portrait in oils by the painter John Arnold there is a terrific sense of the volume of the skull, and the hair and beard have a structure that follows the form of the head and the facial muscles. A build-up of planes has been preserved throughout.

Drawing the head

As long as the model's head is straight and at your eye level, it is quite easy to draw. Unfortunately, it is seldom held in this manner. So before you start work, consider three points. First, is the head under, above, or level with your eye level? Second, which way is the head tilting? Because the head is heavy, the angle of the tilt is bound to increase with time. Allow a few minutes for the model to settle into the pose. Third, how much of the face are you seeing – full front, profile, or more likely somewhere between the two?

If you have a three-quarter view, determine exactly where the line of the middle of the face is and how much is foreshortened on the far side. The slightest change in position by yourself or the model will change this angle, so try to mark the position on the sheet with guidelines and hold to it, making any small adjustments by moving yourself as the model drifts out of the original alignment.

Once you have determined the position of the head, the next step is to draw a line for the middle of the face and light guidelines to place the features. The lines should wrap around the curved surface of the face or head and be parallel to each other. The ears of the average person line up with the top of the eye socket and the bottom of the nose. The angle or slant of the ear follows the line of the jaw, which it is behind. To achieve a likeness, measure the triangles formed by the eyes and the bottom of the nose, mouth and chin. This gives the shape of that particular face.

FORESHORTENED HEAD

THERE ARE TWO IMPORTANT THINGS TO REMEMBER ABOUT THE HEAD. FIRST, WE SELDOM HOLD OUR HEAD STRAIGHT SINCE THE HEAD IS HEAVY AND IS CONNECTED TO THE SPINAL COLUMN BY THE ATLAS VERTEBRA, WHICH, AS ITS NAME IMPLIES, ALLOWS THE HEAD TO MOVE EASILY IN ALMOST ANY DIRECTION. THE SECOND POINT IS THAT NO SINGLE PLANE IN THE HEAD IS FLAT, PARTICULARLY THE CURVING SURFACE OF THE FACE. THE HEAD IS AN ELUSIVE FORM TO CAPTURE ACCURATELY.

BY DIANA CONSTANCE

1 The head is begun with a light sketch, placing guidelines around the head so that you can position the features on the curving surfaces. Always draw an imaginary line going down the middle of the face to line up the features.

2 The modelling and details of the features are added gradually, following the guidelines.

3 The drawing is completed and you can see how the size of the chin, which is close to the viewer, is larger than the forehead which diminishes as it goes back. The two mastoid muscles are shown as they wrap around the neck from behind the ear and join up at the clavicle.

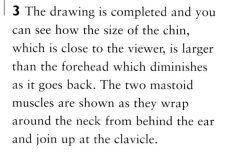

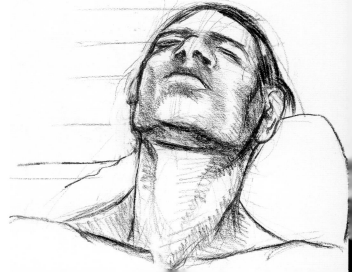

BARBARA

KEEPING THE PAINT THIN AND WORKING ON A WHITE GROUND,
ROS CUTHBERT AIMED FOR LUMINOSITY AND A FRESH APPROACH
IN THIS STUDY OF BARBARA. SHE WORKED IN OILS ON CANVAS-
COVERED BOARD.

The colours used are titanium
white, lemon yellow, raw sienna,
carmine, cadmium red, burnt
sienna, viridian, raw umber and
cobalt blue.

BY ROS CUTHBERT

1 The artist chose a white ground.
First, she decides on the size and
position of the head, using viridian
thinned with turpentine.

2 Then she explores the likeness and
develops some modelling. She uses a
mix of raw umber and burnt sienna
and continues to work very thinly.

3 She brushes in a background
colour of raw sienna and then begins
applying the flesh tint, mixed with
titanium white, cadmium red and a
touch of raw sienna and cobalt blue.

253

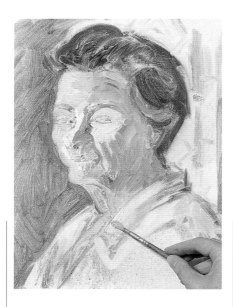

4 Still working broadly, she adjusts the half-tones using some of the flesh tint and adding more raw sienna and cobalt blue.

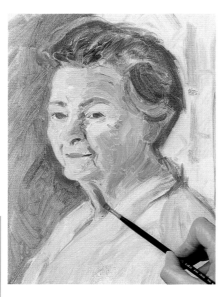

5 The features are strengthened and the expression caught using mixes of raw umber, carmine, cadmium red, cobalt blue and white.

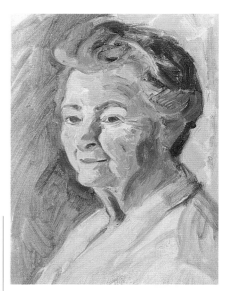

6 At this stage the likeness and the modelling are established but the treatment is still very rough.

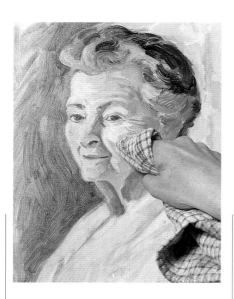

7 The artist further defines contours and establishes form adding a small amount of lemon yellow, cobalt blue and carmine to some of the half-tone areas and using a rag from time to time as well as a brush to blend and make corrections.

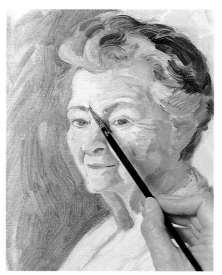

8 Lighter values are now added to the flesh tint using white, cadmium red and lemon yellow. The cheeks and chin have been warmed by the addition of a little carmine.

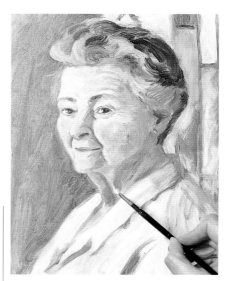

9 The ear is touched in using a mixture of raw umber, cobalt blue and cadmium red. Cheek and neck are further developed and white highlights are added to the eyes.

10 Using raw umber and burnt sienna, the artist deepens the background around the pale hair, face and blouse, and adds a final touch of light on the ear.

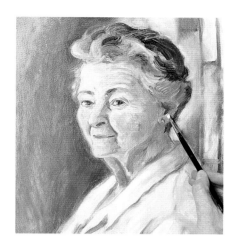

11 The final picture.

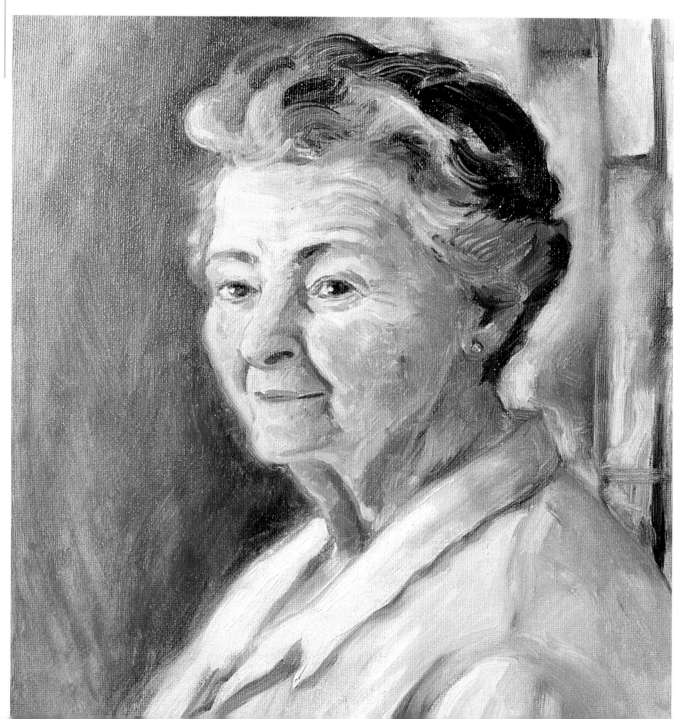

DOMENICO

DOMENICO'S LONG HAIR AND HIS SHORT BEARD WERE AN INTERESTING
CHALLENGE. ROS CUTHBERT HAD TO IMITATE THE HAIR GROWTH WITH HER
WET BRUSHMARKS, USING LONG FAST STROKES FOR THE HAIR AND SHORT, DEFT
MARKS FOR BEARD AND MOUSTACHE, BLENDING BEARD COLOUR AND FLESH
TINTS TOGETHER WHERE THE HAIR GROWTH WAS THIN.

She worked in oils on board and
used titanium white, lemon yellow,
raw sienna, raw umber, cadmium
red, magenta, Indian red, turquoise
(pthalocyanine), cerulean blue,
cobalt blue and Mars violet.

BY ROS CUTHBERT

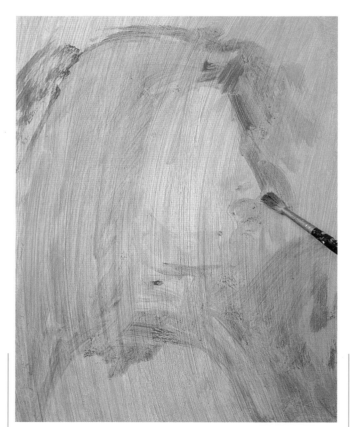 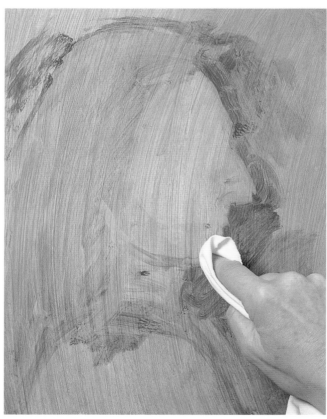

I The imprimatura is a mixture of titanium white and
raw umber applied several weeks previously. The artist
begins the portrait with cerulean blue thinned with
turpentine, working broadly to establish the composition.

2 She keeps the paint thin while
adjusting the underpainting.

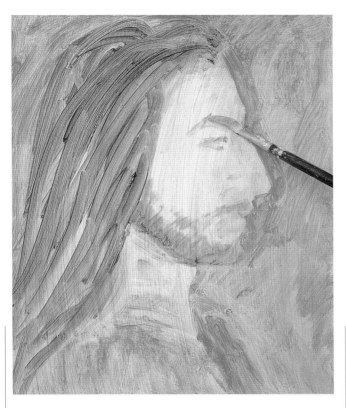

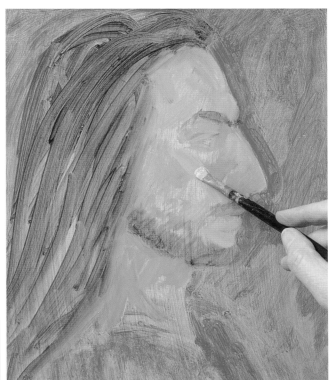

3 Using raw umber and a little Indian red, she establishes the likeness and blocks in the hair and beard.

4 The flesh tint – a mixture of titanium white, cadmium red and cobalt blue – is applied next.

5 She roughly blocks in the dark areas of beard and eyebrow and more fully models the eye. Then she paints in the background using turquoise and white, making small adjustments to the profile as she goes.

6 The head is modelled using mixtures of white, cadmium red and cerulean, with an occasional small dab of lemon yellow.

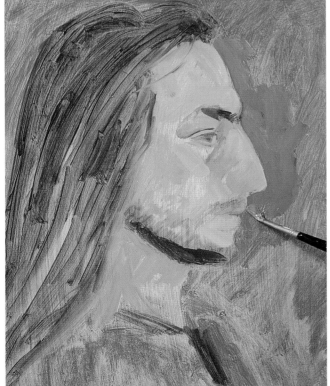

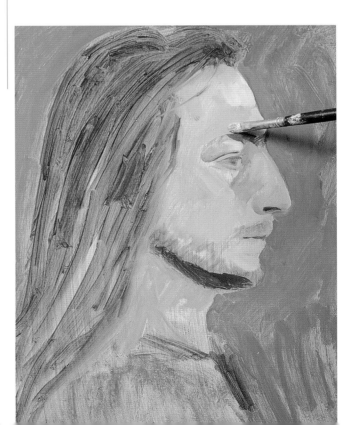

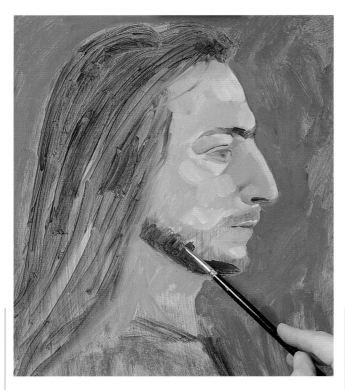

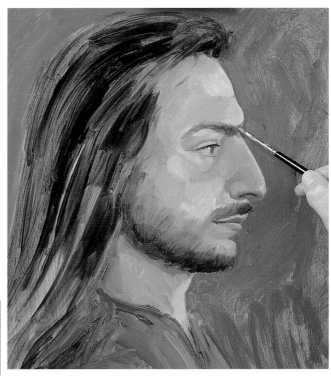

7 The artist darkens the beard with a mixture of raw umber and Mars violet and begins to blend together the flesh tints and shorter beard growth. In the shadow areas under the beard and close to the hairline, cobalt blue is added to the flesh tint.

8 Areas such as the thin hair growth between the eyebrows need careful observation and delicate treatment.

9 She adds darker values to the hair using mixes of monestial turquoise, raw umber, raw sienna and Indian red. For the shirt she uses first a dark, then a pale cobalt blue. She models the forms using variations of flesh tint, and blends adjacent values.

10 Another subtle area is the hairline. Here, the artist blends forehead into hair using the flesh tint plus raw umber.

11 Paler tints are added to the hair next. A mixture of white, lemon yellow and raw umber indicates lighter hair growth, while white, cobalt blue and raw umber mixed together suggest highlights.

12 Finally a highlight of magenta mixed with white is added to the flesh tint in a band down the front of the face, close to the profile.

13 The finished painting.

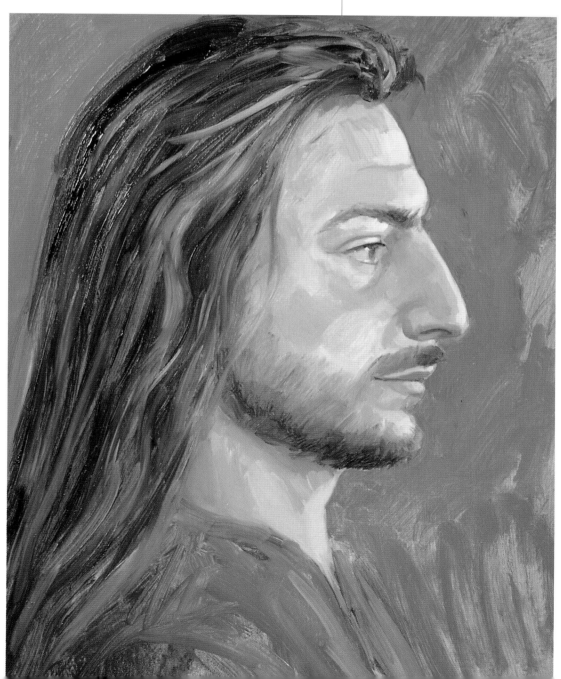

INGRID

IN THIS WATERCOLOUR PAINTING MAX CAPTURES INGRID'S
PALE HAIR AND COMPLEXION BY USING VERY DELICATE WASHES
AND MAKING THE WHITE COLD PRESSED PAPER
DO SOME OF THE WORK.

The colours are aureolin, cadmium
orange, cadmium red, carmine,
Winsor violet, cerulean blue,
ultramarine, emerald green,
and viridian.

BY ROBERT MAXWELL WOOD

1 Max began by doing two fast
studies which took just a few
minutes each.

2 He starts by drawing in the
likeness with a 3B pencil. Then he
proceeds to paint in very dilute
washes, using aureolin for the hair
and a mixture of Winsor violet and
carmine for the flesh tints.

3 The shadow on the neck is added
with a mixture of aureolin and
viridian. Throughout the painting
Max works with a no. 7 sable brush.

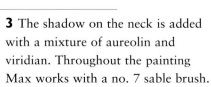

4 He uses a mix of ultramarine and cerulean blue for the eyes, working around the highlights. Then he deepens the flesh tints with Winsor violet and cerulean on the nose and chin and around the eye sockets.

5 Max touches in the eyebrows with a mixture of cadmium orange and emerald green.

6 The lips are deepened with a wash of Winsor violet and carmine, cooled and darkened for the mouth line with violet and ultramarine.

7 The hair is now developed using strokes of orange mixed with emerald in varying proportions and with a few light touches of very dilute viridian. The shadows around the temples are a mix of violet and orange. The eyes receive a deeper wash of ultramarine dulled with orange.

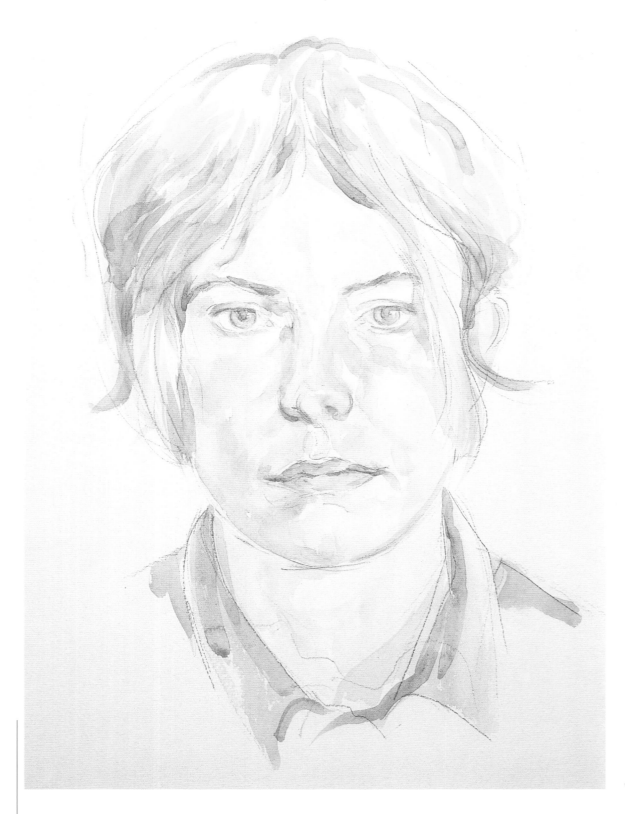

8 The hair is shaded next using a mixture of ultramarine, violet and orange.
One or two touches of a flesh tint, mixed with carmine and orange, are added
along the line of the jaw and down the shadowed side of the face. Finally, a
pale wash of cadmium red is applied to the skin above the upper lip.

PORTRAIT HEAD

IT IS IMPORTANT TO FEEL THE VOLUME OF THE SKULL UNDER THE SKIN AND TO SEE THAT THE HAIR FOLLOWS THIS VOLUME AND IS NOT ADDED AS IF IT IS A WIG. IT IS SOMETIMES A GOOD IDEA TO ASK A FEMALE SITTER TO PUT HER HAIR UP SO YOU CAN OBSERVE THE BASE OF THE SKULL AT THE BACK MORE CLEARLY.

The palette for this was French ultramarine, cobalt blue, cerulean blue, cobalt green, viridian green, raw umber, cadmium lemon, cadmium yellow, yellow ochre, cadmium red, alizarin crimson and titanium white.
The brushes used were no. 8 filbert, no. 3 round hog-hair and no. 8 sable-nylon mix. It was painted on canvas primed with an egg tempera ground.

BY DAVID CARR

1 The model in position with the light coming from the left.

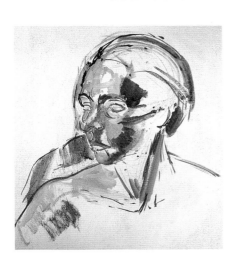

2 The initial drawing was done very lightly using a minimum amount of charcoal and mainly with a very dilute mixture of raw umber and ultramarine. The lighter parts of the face, head and shoulder were established with a mixture of cadmium yellow, cadmium red and yellow ochre plus white. The ultramarine, raw umber and cadmium red were used to define the darker parts. The artist was very aware of the volume of the skull and its height at the back beneath the hair. The sternomastoid has been very clearly painted in, as has the zygomatic arch leading from the cheek to the ear.

3 Cobalt blue and green, viridian green, cadmium lemon and alizarin crimson were being used. To paint the wall behind the figure, the artist used largely viridian and cobalt blue with some white and yellow ochre.

4 The back of the chair has been defined. These slabs of colour will be important in establishing the profile. Note the continued attention to the underlying form.

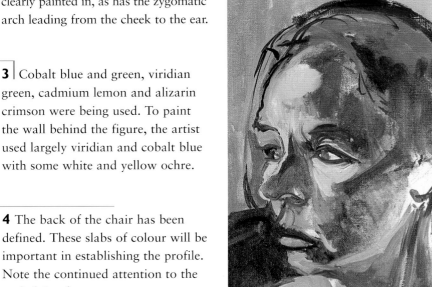

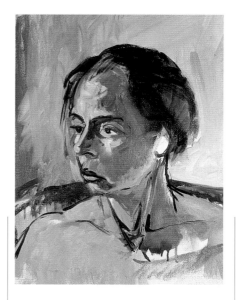

5 The trapezius muscle has now been established and therefore the shoulders, and the structure of the neck has been further clarified, showing that the throat comes out between the sternomastoid muscles. The hair should always follow the form of the skull.

6 The chair and wall have been further defined. The artist drew into the head with an ultramarine/raw umber mixture, constructing the eye more clearly and defining the hair travelling around the head.

7 The artist was aware of some reflected light from the body under the model's chin.

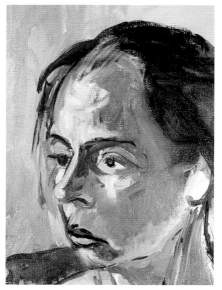

8 The artist noted a rhythm of shadow down the forehead, cheek and neck, and, in establishing this, flattened the face too much and lost some of its volume. The actual likeness has gone to an extent.

9 Note in the detail, however, that the planes around the eye and down the side of the nose have been developed. The forehead needs to be broader and the cheekbone should be redefined. The chin is also weak.

10 This reworking has been done using a light flesh tone of cadmium yellow and cadmium red with white and some yellow ochre. The way the hair flows around the head has been emphasised. Lips and chin are fuller.

11 Adjustments have also been made to the head and neck, and the artist has built up the planes on the shoulders and upper chest using the same flesh tones, but modulated with a little ultramarine and alizarin crimson.

12 Some warmth has been introduced into the nostril to bring the nose around, and a light plane has been introduced just under the eye to bring the lower lid around the eyeball. It is important that eyelids follow the volume of the eyeball underneath. A light blue-grey has been used to establish the whites of the eyes. The use of pure white should be avoided as it is usually tonally too sharp.

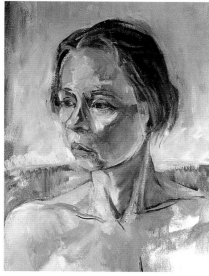

13 Some violet in the wall behind the head and neck helps to give the flesh a sense of light by reacting with the yellow. The green (both the dark patch on the left and the light green-yellow under the violet) acts against the warmer areas of red in the figure.

14 The picture underwent several changes and at one point was almost lost. The successful outcome shows the importance of constant reference to structure in rescuing form.

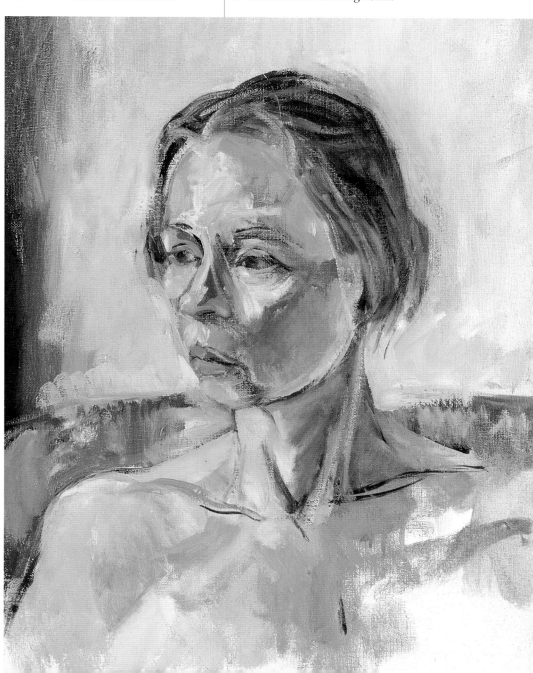

HANDS AND FEET

THE COMPLEX ANATOMICAL MAKE-UP OF HANDS AND FEET MAKE
DRAWING AND PAINTING THESE EXTREMITIES CHALLENGING,
BUT A BASIC UNDERSTANDING OF THEIR STRUCTURES GOES A
LONG WAY TOWARDS SUCCESSFUL REPRESENTATION.

left *The Reverend Derek Warlock –
Archbishop of Liverpool (England)*. Oil by
Helen Elwes. Understated shading gives
the sitter's hands an ethereal mood.

of the hand is very seldom straight or
flat. When the arm and hand are
relaxed and hanging freely, you can
see a long, curving line running
through the wrist down to the tips of
the fingers. The thumb also curls
around and rests facing the palm.

Details of hands

Fingernails are roughly oval and
curve both around the finger and
(much more subtly) along its length.
When painting, note the highlights
that may be present. However, such
details should always be seen within

below *Last of the Snow*. Oil by Ros
Cuthbert. Knuckles, and the soft shine on
fingernails, are indicated very simply so as
not to detract from the purity of line.

The hand is fan-shaped, its bones
radiating out from the bones of
the wrists. Each finger has four bones
– the phalanges – and the thumb has
three. The first bones, the meta-
carpals, are enclosed within the palm
or main body of the hand, and the
first joints of those bones are our

knuckles. It is important to remember
that the finger bones actually start at
the wrist. Often the hand is drawn as
a stiff block, with only the fingers
gripping or moving. This movement
should, in fact, be one piece, with the
whole hand bending or curving in
line with the fingers. The palm or top

the context of the whole hand, and indeed the whole pose, if they are not to become annoying distractions. Shadows between fingers tend to be reddish, sometimes with reflected light bouncing back into them from the adjacent finger.

Do not neglect the wrist, if it is visible, with its many small bones. It is often these linking areas, such as ankles, wrists and necks, which are considered less important and thus do not receive sufficient attention. In fact, they are crucial to the posture of your sitter and you neglect them at your peril.

above Conté drawing of a man's hand.

above The position of the forms is drawn first without the details.

above The completed conté drawing with fine crosshatching lines to model the forms.

The feet

The foot is at least one head in length. The ankle joint permits movement freely forwards and backwards, with a limited rotation in the joint. The foot and the ankle are not symmetrical. From the front, the foot resembles an uneven triangle with the top cut off, sloping down on its outer side. The curve of the arch is visible only on the inner side of the foot. Put a wet foot on a piece of brown paper to form a footprint and you will clearly see the flat outer edge, the arch and the curve of the toes. The heel bone protrudes from the back, and the strong Achilles tendon connects to the top of the calcaneus or heel bone.

The ankle is formed by the ends of the tibia, the large shinbone, and the delicate fibula. These bones straddle

top Conté drawings of the ankle joint. The bones of the lower leg, the tibia and fibia, tightly straddle the top of the foot. The inner bone of the ankle is higher than the outer.

right A conté drawing of the foot clearly showing the shape of the arch.

the top of the foot and form the hinge joint. The large bulge on the inner ankle is the side of the tibia; it is higher than the fibula on the outer side. A good way to remember this is that the lower ankle bone is on the sloping, outer side of the foot.

Drawing your own foot with the help of a long mirror is good practice and will save expensive model fees.

Techniques used in the following projects include scumbling.

A PAIR OF HANDS

THE MORE PRACTICE YOU HAVE AT DRAWING AND PAINTING HANDS AND FEET, THE BETTER. YOU'LL HAVE NO SHORTAGE OF SITTERS IF YOU USE A MIRROR, AND CONTINUAL STUDY WILL BE REPAID HANDSOMELY. THIS STUDY WAS DONE IN OILS.

The palette included French ultramarine, viridian green, cadmium lemon, yellow ochre, alizarin crimson and titanium white.

BY DAVID CARR

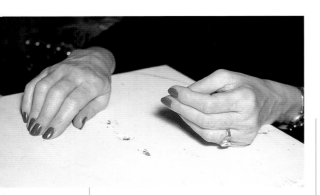

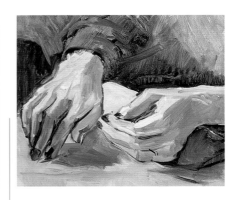

1 The model's hands were placed so that the light source clearly illuminated the individual planes.

2 In this study the hand is established very simply in terms of planes. The fingers are treated as a series of hinged planes. The colours used are yellow ochre and white, ultramarine and alizarin crimson. Some viridian is used for the table.

3 The second hand is included and the table top painted more warmly. The plane at the wrist is made clear, and smaller planes within the fingers are defined with smaller brushstrokes. Cooler colour is laid into the darker areas of skin.

4 The basic aim is to see the hands as hinged planar forms and to realise their structure clearly and boldly in this way.

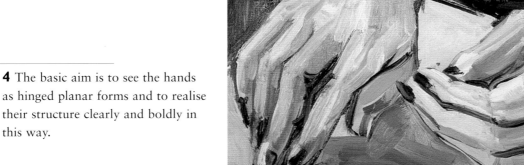

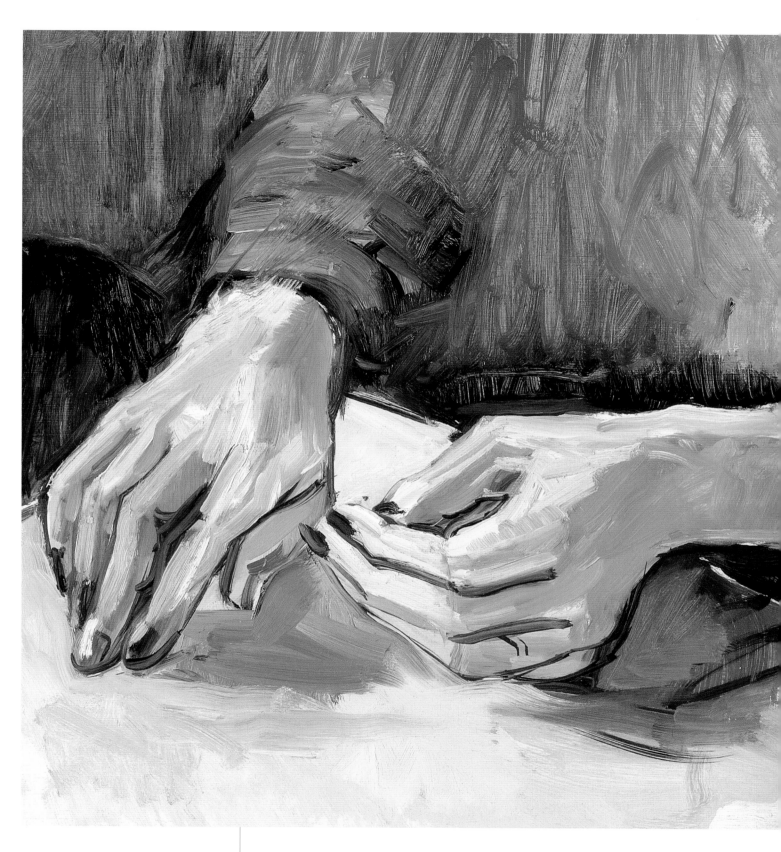

5 This basic alla prima study sees the brushwork following the directions of the form.

A PAIR OF FEET

HERE, THE ARTIST DECIDED
TO USE A MUCH THINNER
PAINT THAN IN THE
PRECEDING STUDY, AND ALSO
A DIFFERENT PALETTE.

BY DAVID CARR

The colours used here are French ultramarine, viridian green, yellow ochre, raw sienna, cadmium red and titanium white.

2 Some raw sienna with the slightest touch of ultramarine is scumbled over the yellow ochre for the darker tones. To preserve a clear change of tone at the ridge of the foot, white is added to yellow ochre to make the light planes clearer still.

I The outside of the form is drawn very simply in charcoal and then the silhouette of the form is washed in with dilute yellow ochre. Try to be aware of the difference between the plane on the top of the foot and that of the side. All other areas are washed in at this stage.

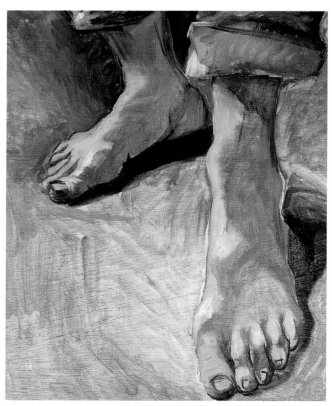

3 The darkest parts of the feet, around the toes and heel and on the leg, have a further layer of ultramarine and sienna scumbled over them. Finally, some linear drawing is done around the toes. The technique of lightly scumbling darker, cooler paint over warmer, lighter paint, allowing some of the warmer paint to show through, gives a good sense of light on the flesh.

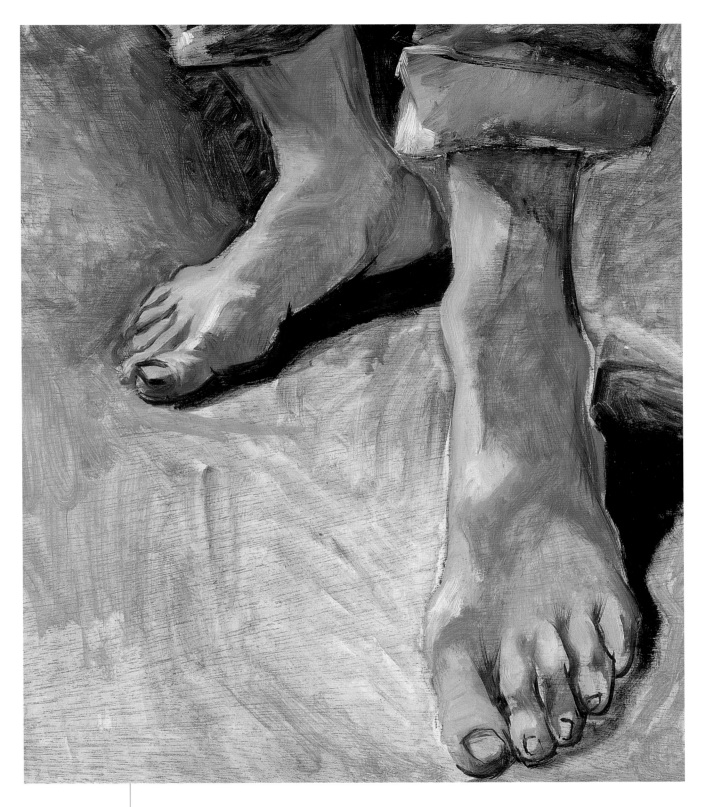

4 Note the strong sense of directional light from left to right, which just catches the leg of the jeans and casts a shadow over the ankle.

CHANGING AN UNSATISFACTORY DRAWING

"IF YOU ARE GOING TO DECIDE TO BECOME A PAINTER, YOU HAVE GOT TO DECIDE THAT YOU ARE NOT GOING TO BE AFRAID OF MAKING A FOOL OF YOURSELF." (FRANCIS BACON). ROTTEN DRAWINGS ARE FREQUENTLY LESS UPSETTING TO PROFESSIONAL PAINTERS THAN TO THE AMATEUR. THEY ARE CONSIDERED AS ONE OF THE RISKS OF THE JOB.

BY DIANA CONSTANCE

1 The original drawing was wooden and lifeless, and the tones were completely disconnected.

2 The artist is erasing the drawing with a piece of tissue.

3 Here the artist is beginning to redraw.

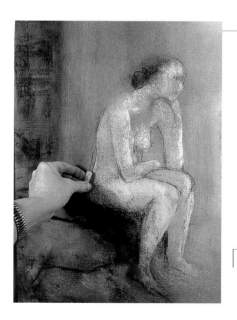

4 The light tones have been added.

5 The composition has been simplified with the light source established at the fire.

272

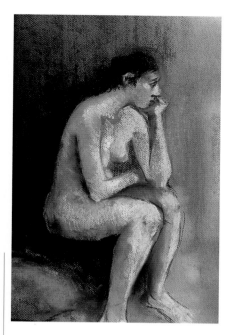

6 The figure has been completely
refined, with much more emphasis
on the modelling.

7 A light tone is being added to the
drapery, and the light coming from
the fire has been emphasised.

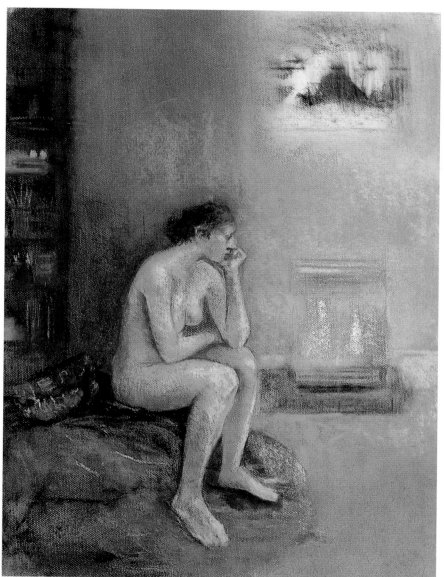

8 The completed drawing bears little resemblance to the original. The centre
of interest and light source are clearly established with the negative space in
the composition now framing the model instead of distracting attention from
her, as it was in the original.

LANDSCAPES

LANDSCAPE PAINTING IS ONE OF THE
MOST FASCINATING AND ENDURING
SUBJECTS FOR PAINTERS, AND ONE
THAT HAS INSPIRED ALL THE GREAT
ARTISTS. THE CHALLENGE IS TO
CAPTURE THE EVER-CHANGING
EFFECTS OF LIGHT ON THE OBJECTS
THAT MAKE UP THE NATURAL WORLD;
AND TO DEPICT THE DRAMATIC
DIFFERENCES THE SEASONS CAN
BRING TO A FAMILIAR SCENE AS
AUTUMN TINTS DISAPPEAR BENEATH A
BLANKET OF SNOW, OR DRIVING RAIN
REDUCES A SPECTACULAR VIEW TO A
FEW INDISTINCT SHAPES.

RIGHT *Cornfields and Roses.* Oil by
Timothy Easton. This is a tour de force of
landscape painting. His delicate, sure
brushwork combines with an unerring
sense of tone and colour which results in
an immensely accomplished picture.

SKETCHING

SKETCHES ARE THE PRINCIPAL REFERENCE SOURCE FOR THE LANDSCAPE PAINTER. THE SKETCHBOOK IS THE ARTIST'S PERSONAL VISUAL DICTIONARY, CONTAINING EVERYTHING THAT MIGHT BE USED IN LATER WORKS, FROM THUMBNAIL STUDIES OF LEAVES AND GRASSES TO COMPOSITIONAL DRAWINGS IN PREPARATION FOR LARGE-SCALE PAINTINGS.

Sketching is also a pleasure in itself. Every painter has experienced the urge to make a quick visual statement when confronted by a superb view or an intriguing object, a scene that demands to be drawn on the spot and with whatever materials are on hand. Quite apart from compiling your own visual handbook, sketching is vital to the artist's personal creative development. It is like a private sanctuary where experiments can be made and ideas explored, free from public scrutiny. The dedicated artist always carries a sketchbook or notebook with him wherever he goes. A small ring-bound sketchbook is ideal for the purpose as it slips easily into a coat pocket or a small bag.

A phenomenon associated with sketching is that the sketch often appears more natural and satisfying than the finished painting made from it. This is because we are stimulated by the first sight of the scene and make the drawing without preconception. We are also in an unconcerned, relaxed state of mind, enabling us to work quickly, without self-conscious thought about quality or "getting it right".

Of course, you can work in any medium to produce a sketch. The quick drawing that we have been discussing is probably best done with

above A quick pen sketch by the author sitting on the quayside. A fountain pen was used for the line drawing and then smeared and spread with a piece of damp cloth to create tone and to soften the line.

a pencil or pen, but colour can be used as well. If you decide to make a day of it, it might be worth taking a small box of watercolours or some water-soluble pencils, even oils or acrylics and a portable easel.

Many "plein air" artists, including some of the Impressionists, have the practice of sketching in the whole picture loosely in thinned colour. They finish the painting with thicker, more brilliant colour in their studio with the support of sketches and studies.

above *Houses by a Canal.* Watercolour by Ted Gould. This study is an example of the line and wash technique. The line drawing was made first using a 2B pencil. Only the basic shapes of the houses and canal bank were indicated lightly. Watercolour was then washed in over the line.

Water-soluble pencils and felt-tip pens are very handy tools for doing quick colour and tonal sketches. You need a small covered water container and a brush to dissolve the colour and spread the tone.

Sketching with a brush dipped in paint or ink can produce delightful effects. Rembrandt and Constable were masters in its use, when they wanted to catch the effects of large, contrasting areas of light and dark. If you are prepared to carry the necessary equipment – brushes, a palette, some paint and cloths – it is possible to produce dramatic tonal drawings quite quickly.

top right This charcoal sketch was executed in under 10 minutes.

right A soft pencil was used for this drawing.

below Fishing boats on the beach at Hastings were the Inspiration for this rapid pen sketch.

COMPOSITION

COMPOSITION IS THE DIFFERENCE BETWEEN MAKING A SKETCH AND
CREATING A PICTURE, BRINGING ORDER TO APPARENT CHAOS.

For your first landscape choose a view that is interesting without being too complex, one that contains both verticals (trees, buildings) and horizontals (fields, pathways, etc.) Angled lines – diagonals – add a sense of movement to a picture. They also function as a visual link between one part of a painting and another.

The balance of light and dark is a very important consideration. The dark or shadow areas of a picture set off the light, brightly coloured areas.

The one emphasises the other and creates a sense of depth and contrast.

Some painters find it essential to create a clear focal point, or centre of interest; others prefer to see their work as an overall pattern of shapes and colours, sometimes called an architectural composition.

Finally, perspective is the means by which the artist can create the illusion of depth in a painting. It is an important aid to the landscape painter, although it should not be

allowed to displace the principles of good composition.

The techniques featured in the projects include scumbling, masking, glazing, wet-on-wet, sponging, spattering and using a palette knife.

below Strong parallel diagonals emphasise the slope of the hillside in this gouache study. The counterchange between light and dark areas creates a pattern which is bisected by the curving tree trunks going off the top of the picture plane.

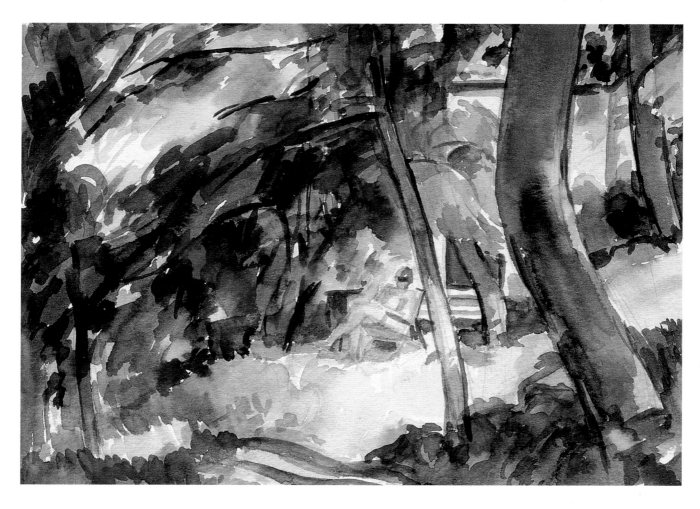

PERSPECTIVE AND LANDCAPES

If you stand looking out through an upstairs window, the point directly in line with your vision is the eye level. The window frame in front of you is your canvas or picture plane. In single-point perspective, the point on the eye level, straight ahead is the vanishing point, where all lines parallel to your line of vision will converge. This is known as linear perspective.

Aerial perspective concerns colour and tone, and is governed by the effects of light and atmosphere.

We realise that hills and trees in the far distance are indistinct and light in tone, whereas a tree that is close up in the foreground is sharply focused with rich, contrasting colour.

The four main situations in which the painter will need to have a knowledge of perspective are illustrated below. They are: one-point (high and low eye levels), two-point and three-point perspective. Note what a radical difference the position of the eye level makes to the same scene.

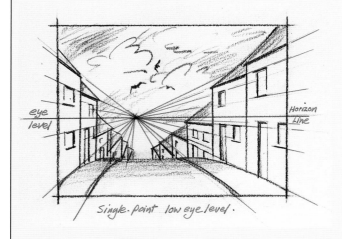

above Single-point, low eye level.

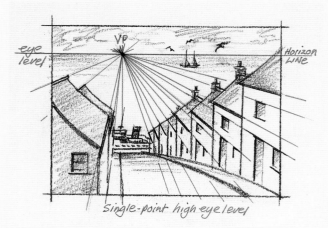

above Single-point, high eye level.

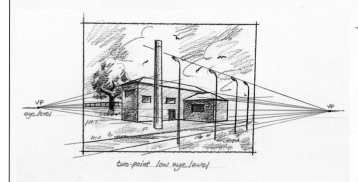

above Two-point, low eye level.

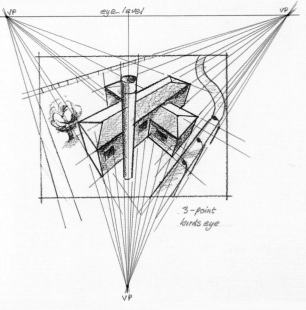

right Three-point, bird's-eye level.

HARVEST, NEAR DATCHWORTH, HERTFORDSHIRE

ENID FAIRHEAD IS FROM THE TRADITION OF EN PLEIN AIR PAINTERS. SHE SEARCHES FOR HER MOTIFS AND, WHEN SHE HAS FOUND INSPIRATION, WORKS DIRECTLY ON THE SPOT AND WITHOUT PRELIMINARY STUDIES OR DRAWINGS. SHE WRITES, "I AM FORTUNATE TO LIVE IN THE MIDST OF LOVELY ENGLISH COUNTRYSIDE – THE SOURCE OF MY INSPIRATION AS A LANDSCAPE PAINTER. VISUALLY, ONE OF THE MOST EXCITING TIMES FOR ME IS THE HARVEST – SEAS OF VIBRANT TAWNY GOLDS, BLEACHED GRASSES AND BRIGHT GREENS GIVING WAY TO BLUE PURPLE AND BRONZED GREENS."

BY ENID FAIRHEAD

The colours used are titanium white, lemon yellow, cadmium yellow, yellow ochre, raw sienna, cadmium orange, light red, alizarin crimson and ultramarine. Use brush nos. 5, 6 and 7 bristle filberts and a no.4 pointed sable. The support is Masonite primed with three coats of acrylic white primer.

1 A quick charcoal sketch of the scene.

2 The ground is prepared with a wash of light red diluted with turpentine.

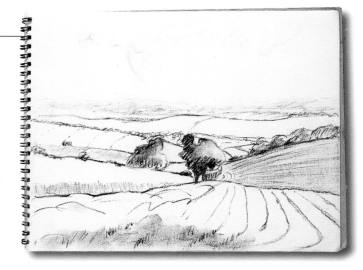

What fascinates the artist about this painting is the way the lines of wheat and stubble converge at the trees in the middle distance. This makes for a natural focal point, which she places slightly off-centre. She is intimately concerned with light and its effects on colour, which change according to the time of day.

Enid normally prefers to work on a coloured ground, because this provides a key for colour and tonal unity at the start. She uses well-diluted paint to apply glazes across the picture, gradually using her paint more thickly with each glaze. She never completely covers the preceding layer, but allows tints of translucent colour beneath to remain and contribute to the overall subtlety.

3 Drawing the main lines of the composition with thinned raw sienna. A no. 4 filbert bristle brush is used.

4 Patches of ultramarine, with white and a little crimson, are worked into the sky with a no. 6 flat-bristle brush. Yellow ochre, cadmium orange, raw sienna and light red are brushed into the fields, using turpentine only.

5 The artist occasionally rubs in colour with a rag to spread the tones more quickly.

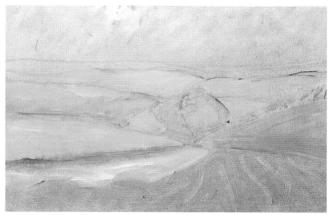

6 The first glaze of warm tints is complete.

7 Ultramarine and raw sienna are mixed to make a cool green to mark the trees. The horizon line is indicated with a mix of ultramarine and lemon yellow, then rubbed down with a cloth.

8 Thicker glazes are now being used, following the "fat over lean" principle. Furrow lines are drawn into the mid-distance field with a pointed sable brush dipped in turpentine.

9 A no. 4 bristle brush is well loaded to paint a mix of thick yellow ochre and white for the bright grain tops.

10 The corn stubble lines are drawn in. The artist uses the edge of a flat bristle brush.

11 A no. 2 pointed bristle brush is employed to touch in the tractor with a mixture of cadmium orange and light red.

12 A mix of thick pale yellow is applied to the tops of the wheat, increasing contrast and introducing more texture.

13 The painting is almost finished and the artist decides that some final touches of blue and pink are needed in the sky.

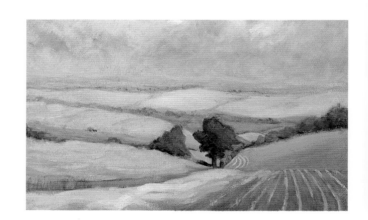

14 More touches of violet and blue are scumbled in the distant horizon to add more atmospheric perspective.

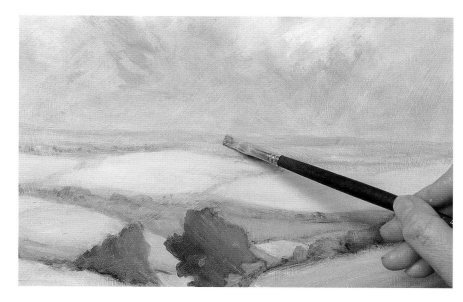

15 The finished painting.

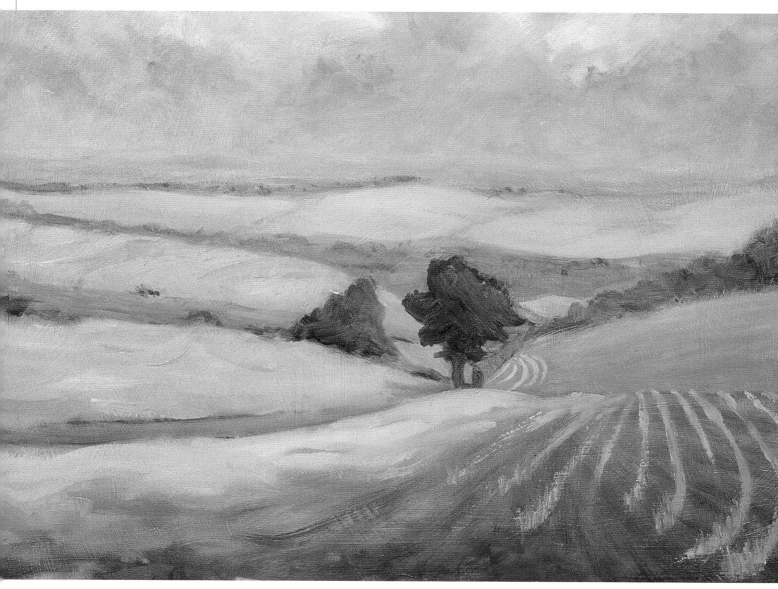

ABBEY VIEW

THE TITLE, ABBEY VIEW, IS ALSO THE NAME OF THE HIGH-RISE BUILDING WHERE THE MURAL NOW HANGS AND IS THE RAISON D'ÊTRE OF THE PICTURE.

BY TED GOULD

The colours used are Venetian red, cadmium red, cadmium yellow medium, lemon yellow, yellow ochre, oxide of chronium green, cobalt blue, cerulean blue, blue violet, black and titanium white. The support is canvas board. The brushes are nos. 2, 5, 6 and 8 filbert bristle, no. 2 pointed sable and no. 4 flat sable.

From the top of the tower it is just possible to see the tower of St. Albans Abbey projecting above a line of trees, about 8 miles distant. It was obviously not feasible to work so far away from the subject, so the artist made a trip to St. Albans to seek out a much closer position. He discovered that the view across the lake in front of the abbey is quite delightful and offered all the elements for colour and composition that he could desire. He immediately sat down to make a watercolour study and also take some photographs. The next task was to return to his studio and collect everything that would be necessary for at least two days' painting outdoors.

The mural is now installed in the foyer of a development in Watford, Hertfordshire.

1 Photograph of St. Albans Abbey seen across the lake.

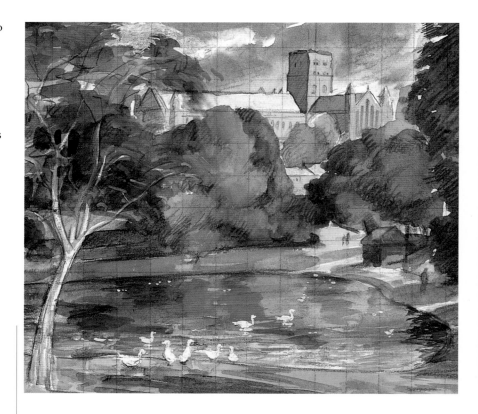

2 Watercolour study done on the spot.

3 Travelling to the painting location.

4 Before unpacking and setting up the easel, etc., Ted Gould uses a viewfinder to survey the scene and find the best position.

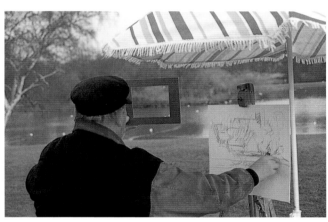

6 The artist continues to draw. A sun umbrella is up, shading the white support from strong sunlight.

5 Set up and making a start. The picture is drawn with charcoal, and the viewfinder is used to find the positions and directions of the main composition lines.

7 The palette and a detachable palette rest. The solvent containers are detachable from the palette, but Ted Gould keeps them close to the colour. One contains pure turpentine, the other a linseed oil and turpentine mix.

8 The first washes of colour being applied: cerulean blue with a little white for the sky, cadmium yellow and violet for the screen of autumn trees. The artist is using a no. 7 filbert bristle brush.

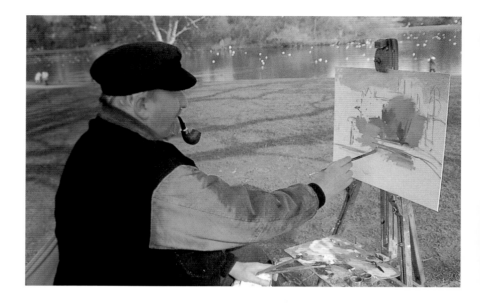

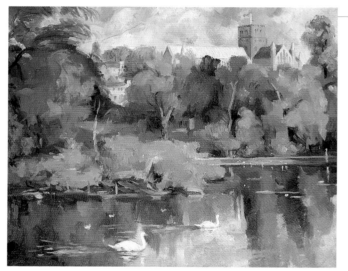

9 The completed painting. Separate studies were made of the swans, which were added later in the studio. The painting has been done in exactly the same proportion as the intended mural – that is, it is exactly the same shape, but much smaller.

The next stage is to "scale up" the painting to the same size as the larger mural. The support for the mural is cotton canvas, stretched over a wood frame and primed with acrylic white. The size of the mural is 1.8 x 2.1m (6 x 7ft).

Scaling up was achieved by drawing a grid of squares onto tracing paper and laying this over the painting. Exactly the same number of squares was drawn onto the mural support using charcoal. It was then possible to draw the basic composition onto the mural support, using the squares overlaying the painting as reference points.

10 Detail of the mural.

11 The finished mural painting.

ROCKS ON THE ATLANTIC COAST

THE ARTIST DISCOVERED THIS BEAUTIFUL STRETCH OF COASTLINE DURING ONE OF HER VISITS TO SOUTH AFRICA. AT THE TIME SHE WAS NOT PRIMARILY CONCERNED WITH A PAINTING LOCATION, BUT WITH FINDING A SUITABLE SWIMMING SPOT FOR HERSELF AND HER FAMILY. HOWEVER, WHEN SHE HAPPENED UPON THIS SERIES OF INLETS ON THE CAPE PENINSULA, SHE WAS INSPIRED BY WHAT SHE SAW AND SET OFF IMMEDIATELY TO EXPLORE THE WHOLE AREA FOR THE MOST INTERESTING VIEWS.

BY HAZEL SOAN

The Cape Peninsula is on the Atlantic seaboard. It consists of a series of inlets interspersed with boulders and rocky outcrops, incised by coves of almost pure white sand. Much of this coastline is backed by high cliffs and a ridge of mountains in the background. A strong contrast is made between the rocks, piled up in many strange configurations and the smooth planes of sand cutting between them. This is the visual inspiration for the picture.

Hazel Soan uses a variety of watercolour techniques in this painting; wet-on-wet, wet-on-dry, glazing, masking, sponging and waxing. She works intuitively, preferring to keep all her options open as the work progresses. As can be seen from this project, she starts simply and broadly. A few light pencil marks are made to indicate key points in the composition and then light washes of colour are added to establish the tonal areas. These are then textured and further washes are laid in a build-up to the finale.

The colours she used are yellow ochre, alizarin crimson, Prussian blue, scarlet lake and French ultramarine. Brushes are a selection of pointed sables. The support is 535gsm Saunders watercolour paper, unstretched. Other materials include a natural sponge, masking fluid and candle wax.

1 The main composition lines have been sketched in lightly with an HB pencil. Masking fluid is applied to the sketch to preserve the highlight areas all around the picture. A no. 3 pointed sable brush is used.

3 A broad wash of diluted yellow ochre covers most of the paper, except for the sky. This provides a warm key to the picture. A no. 14 pointed sable is used for this.

2 Candle wax is gently rubbed onto selected areas – particularly the rocks – to produce texture as the colour washes are applied.

4 The sky area has been dampened with clean water and diluted Prussian blue "touched in" to blend with the still-wet yellow ochre.

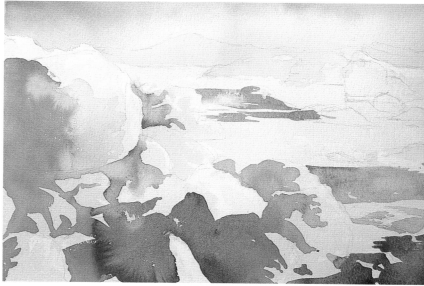

5 The blue has been brought down into the foreground rocks. Wax has been applied to the edge of the rock and yellow ochre is being washed over. The effect is to give a rough edge to the changing planes of colour.

6 A little alizarin crimson has been added to the Prussian blue to create warmer cast shadows in the rocks.

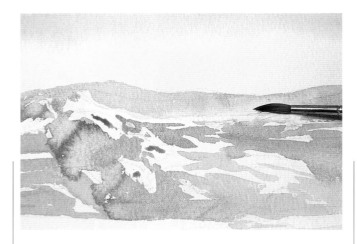

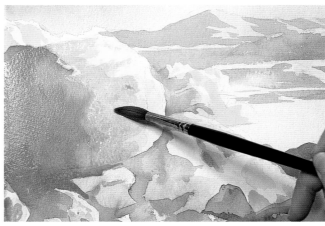

7 The blue and violet areas are completed by "soaking off" some colour towards the base of the mountains, thereby creating a misty effect.

8 A glaze of slightly thicker yellow ochre over the rocks, makes them warmer and defines their shape. "Spots" of alizarin crimson are dropped into the wet paint.

9 Deeper colour is "dropped" into wet areas producing a "little explosion" effect. Wax is drawn into the rocks to protect previous washes and increase the textured effect. Alizarin crimson, yellow ochre and Prussian blue are used.

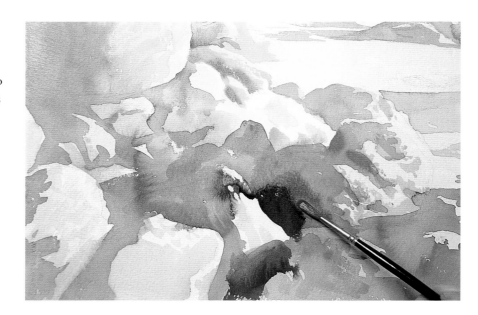

10 A variety of techniques are now employed in painting the rocks – wet-on-wet, wet-on-dry and wax. Darker tones of scarlet and blue are added to stress shape and colour.

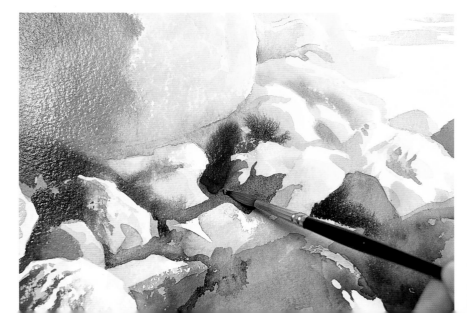

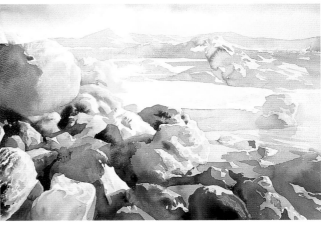

11 The broad washes are now completed and the masking fluid is being removed with a kneaded eraser.

12 The complete picture so far.

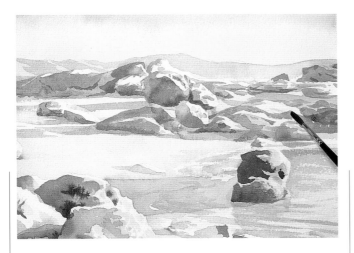

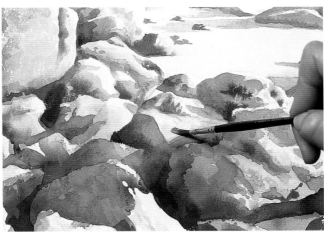

13 Yellow ochre and Prussian blue are mixed to apply small wet-on-dry washes to the mountains and the rocks in the middle distance.

14 The artist has decided to modify a portion of the picture by taking out one of the rocks. Using a sable brush and clean water, she soaks off the colour until it is almost obliterated and then retouches the area to leave it like the rest of the beach.

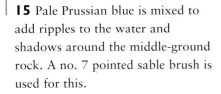

15 Pale Prussian blue is mixed to add ripples to the water and shadows around the middle-ground rock. A no. 7 pointed sable brush is used for this.

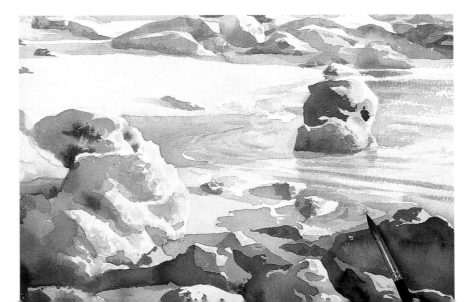

16 A natural sponge dipped in a mixture of Prussian blue and alizarin crimson is dabbed onto the foreground rocks in order to add surface texture.

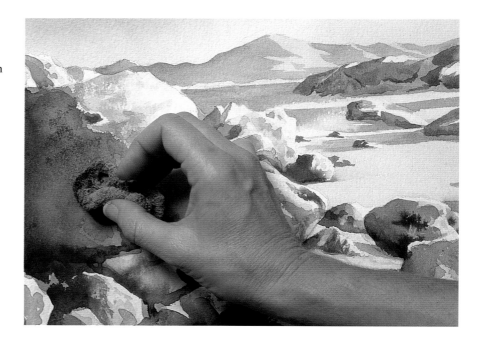

17 The finished painting.

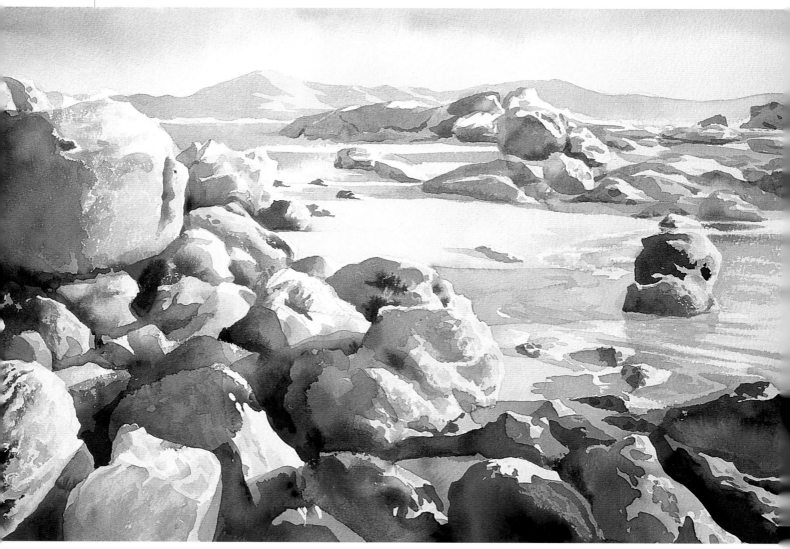

OLD FISHGUARD, PEMBROKESHIRE

MIKE BERNARD IS ABSORBED BY THE TACTILE EXPERIENCE OF WORKING WITH A VARIETY OF MATERIALS. HIS MAIN CONCERNS ARE WITH THE PICTURE SURFACE AND THE TEXTURES HE PRODUCES. HE DELIGHTS IN THE DISCOVERY OF UNEXPECTED EFFECTS OBTAINED BY THE RANDOM USE OF MATERIALS AND GAINS SATISFACTION WHEN A "HAPPY ACCIDENT" OCCURS.

The materials he uses include orange, blue and black inks, orange, pink, violet, pale green, blue and brown pastels, and white acrylic and acrylic matte medium. The support is 190gsm Hot Pressed watercolour paper.

BY MIKE BERNARD

He prefers not to have detailed references of the subject or to work on location, because too much visual information inhibits his creative response to the subject. For this painting, his only reference is the outline pencil sketch of the harbour and a photograph providing a glimpse of the scene.

His materials are chosen for their variety, offering the possibility for the unexpected to happen. Nevertheless, this is still a "controlled" process. The artist is aware of the nature of these ingredients and what is likely to happen when they are combined.

The painting process begins with rough cut-outs of different papers mounted on the support. Waterproof inks are then applied and allowed to run into each other to form other colours and textures. Successive layers of ink, paper and paint are created, eventually producing the rich, dense final picture.

1 The artist is much more concerned with luminous colour, surface texture and good formal structure than with straightforward representation, so he prefers the simplest of reference material. In this case it consists of a line sketch and a photograph providing some detail of the foreground boat.

2 Strips of paper, some cut, others torn from tissue paper, newsprint, envelopes, etc., are assembled on the support.

3 The papers are then arranged to divide the picture surface into broad areas of colour and texture, simulating the light conditions of the harbour scene.

4 After the papers have been mounted with acrylic medium, the support is painted with clean water to soak the surface and prepare it for washes of coloured inks.

5 Marine blue ink is applied to the damp surface with a broad bristle brush, which allows rivulets of colour to form.

6 While the blue ink is still wet, orange ink is applied, blended with the blue, and allowed to run.

7 The painting is allowed to dry before deciding what to do next.

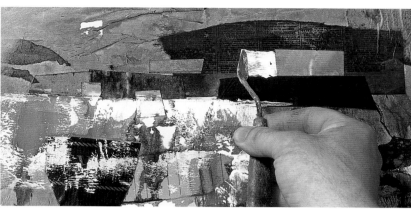

8 White acrylic paint is rolled on in patches, creating areas of texture and allowing the colours beneath to show through.

9 A small palette knife is used to apply white accents to represent some of the house façades and the small boats lining the quay.

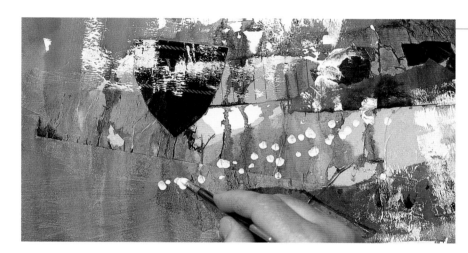

10 White highlights are scumbled on with a synthetic sable brush, adding more texture and simulating bright reflections on the water.

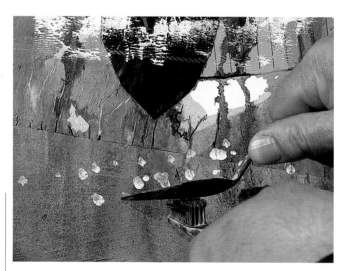

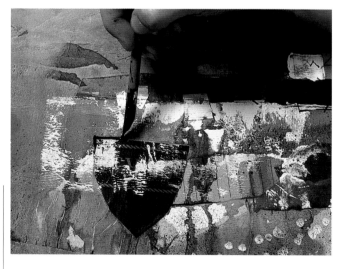

11 Orange ink is spattered onto the background by dragging the palette knife across the bristles of a toothbrush loaded with colour.

12 A dipping pen is used with black ink to introduce line into the buildings and boat shapes. The artist uses both steel-nib and cut-bamboo pens.

13 Some spattered black ink has also been applied, reinforcing the lines and creating more texture.

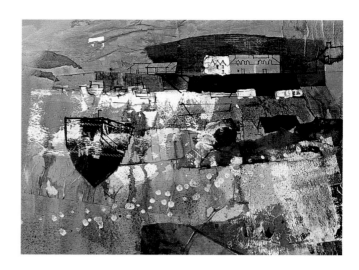

14 To create more depth and richness, the artist has decided to apply additional washes of blue and orange to the background and harbour areas. This also introduces more tonal harmony. A 2.5cm (1in) flat bristle brush is used.

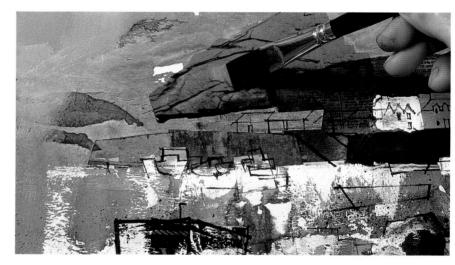

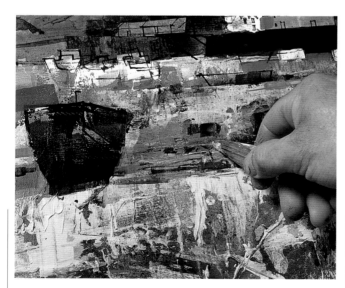

15 Scraping away colour with the tip of the palette knife. This exposes layers of colour beneath and creates linear texture.

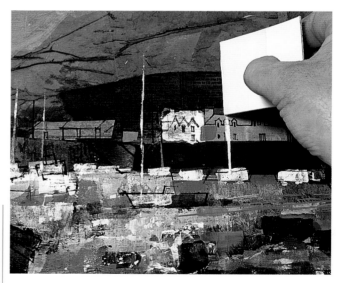

16 Thin cardboard dipped in acrylic white paint, and used edge on, is ideal for indicating the boat masts.

17 More patches of white texture are created by using the piece of cardboard flat.

18 Touches of pastel, usually the complementary colour of the colour beneath, are added to create "sparkle" and richness on the surface.

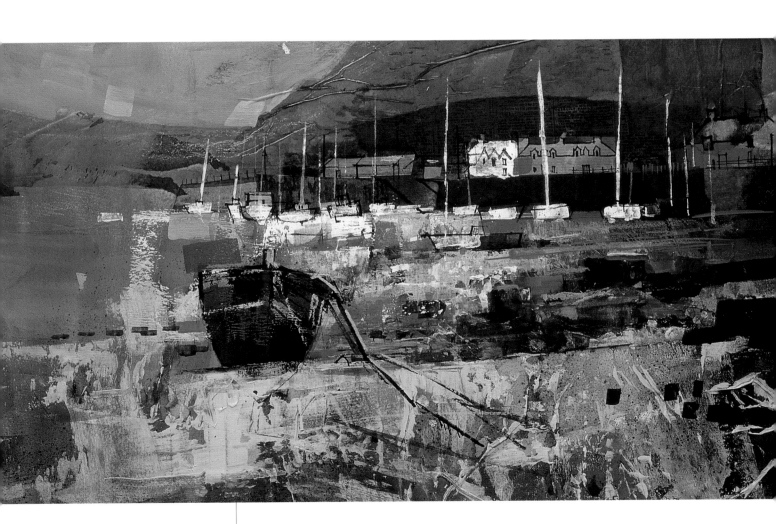

19 The finished painting.

USING PHOTOGRAPHS

SINCE THE RENAISSANCE, ARTISTS HAVE SHOWN A CURIOSITY ABOUT TECHNICAL SCIENTIFIC AND MEDICAL DISCOVERIES SUCH AS THE CAMERA OBSCURA, A KNOWLEDGE OF ANATOMY, MATHEMATICAL PERSPECTIVE AND COLOUR THEORIES, AND HAVE MADE USE OF THEM IN THEIR WORK.

above and right This photograph of the river at Salisbury was taken with the aim of making an oil painting of the scene. The pencil study made from the photograph compresses the image into a more compact, vertical composition. It also functions as a tonal analysis of the subject.

This accounts for many of the changes in style which have happened over the centuries. Ever since photography was invented artists have made use of it. In one sense it freed them from illusionistic painting and in another it provided them with extra means.

Photography, therefore, which was originally seen as the usurper of representational art, is now widely used as a valuable means of obtaining source material for painters. The Photo-realists actually copy photographs at very large size in minute detail.

The use of the camera as an aid to painting is still the subject of debate. Some artists feel that photography is a different medium altogether and that its use by painters leads to mere copying and the loss of drawing skills.

For many, however, the issue is not one of right or wrong, but whether a photograph is appropriate or helpful. The photograph has been used by artists for almost a hundred years and it is probable that if photography had been invented in Leonardo da Vinci's lifetime he would have used it. Vermeer did, as we all know, use an

early forerunner, the camera obscura. But this by itself was not responsible for enabling him to produce such marvellous paintings. He still had to compose them and paint them.

Any medium that a painter uses or borrows from has its own intrinsic qualities which can change the character of the work. Edgar Degas, the Impressionist painter, made extensive use of the photograph which opened up new possibilities in composition for him.

One advantage of the modern camera loaded with high-speed film is that it is now possible to record

forms in motion: the running figure, a racehorse, etc.

For the landscape painter a photograph provides a quick accurate record of nature – and the view captured on film can later be amended to create the desired composition. The skilful use of the camera can provide a very useful reference source of complex details that would take hours to draw.

As the following projects show, the photograph is almost as indispensable to the modern travelling artist as the traditional sketchbook. The techniques they use include scratching, scumbling, impasto, dry-brush and glazing.

above and below Ted Gould discovered this scene while looking for subjects to paint. Two overlapping photographs were taken to act as reference for the oil painting below.

BOY MEETS OCEAN

THE BOY IS THE ARTIST'S SON JONATHAN. THIS OIL PAINTING IS NOT THE RESULT OF HOURS SPENT ON LOCATION WORKING IN FRONT OF THE SUBJECT. ALTHOUGH IT IS HARD TO BELIEVE THAT A PICTURE SO FULL OF LIGHT, COLOUR AND ATMOSPHERE WAS NOT PAINTED ON THE SPOT, IT WAS ACTUALLY DONE FROM START TO FINISH IN THE STUDIO.

The colours are magenta, alizarin crimson, Prussian blue, Payne's grey, burnt and raw umber, yellow ochre, cadmium red, cadmium yellow, cadmium orange, chrome green, chrome green deep, cerulean blue, lemon yellow and Indian yellow. The brushes are bristle brushes nos. 4 to 10 and the support is primed canvas.

BY KENNETH SWAIN

The idea for the painting came several weeks after the event when Ken saw a photograph taken while he was introducing his son to the water. This grey, monochrome image was enough to activate the colour sensations that had been stored in his mind through observation.

There are no preliminary studies or drawings. The artist has launched directly into the full-size painting, making a simple charcoal sketch first and then applying patches of dry colour into the sky and water. The colour areas are rubbed down, repainted and generally modified until they approximate to the image in his mind. In fact, there are only two main stages to this work. The first, as described above, continues using dryish colour, until all the forms are balanced against each other across the entire painting. The second stage is impasto. The artist employs a palette knife, a penknife and a small bristle brush to apply modelling and texture to the underpainting.

1 This monochrome photograph was the only reference for the picture.

2 The artist begins with a light charcoal drawing outlining the main colour and tonal areas. A touch of diluted flesh colour is used to position the figure. No base colour has been applied, because the intention is to use high-key, pure colour throughout this painting.

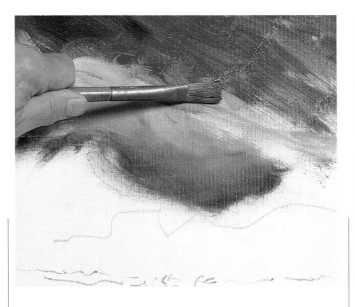

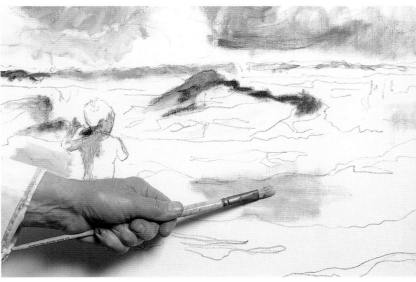

3 The colour of the sky will set the key for the entire picture. Washes of Prussian blue broken with a little white and black are brushed in, using a no. 10 flat-bristle brush.

4 Pinkish tints are added near the horizon line. The Prussian blue is used in the sea, reflecting the colour of the sky and then broken with lemon yellow to produce a translucent green. The colour is used thin and "rubbed" into the white canvas.

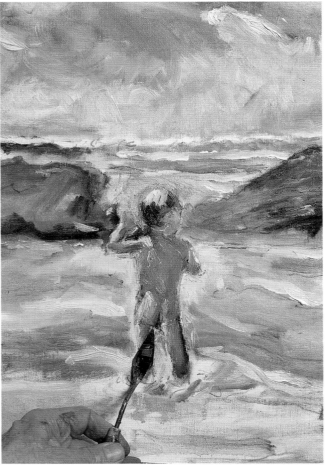

5 Patches of diluted colour are now placed all around the painting following the principle that a picture should look somewhat finished at every stage. Yellow ochre, crimson, cadmium red and burnt umber are added to the palette. They are mixed and still used *thinly* to establish the waves and rock shapes. Bristle brushe sizes 4 and 10 are used. The artist uses a cloth to rub down certain areas.

6 From now on, the palette knife is brought into use to apply thick colour, which is then "scratched and scraped" back with the tip of a penknife. The child's figure represents the focal point of the painting, so the artist builds up the colour here first. Similar warm tints of yellow ochre and red are then "found" in the rocks, reflections and the sky.

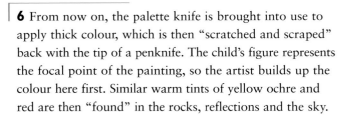

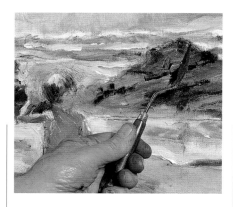 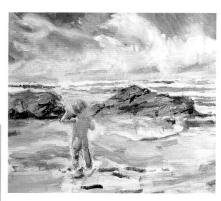

7 Mixing darker tones of Prussian blue and burnt umber. The rock forms are stressed and divided into sharper planes of colour.

8 The sky area has been modulated with thicker paint using tones of pink, blue and yellow. The child's torso is more finely washed with warm tints of orange.

9 White is worked into the sea forms and to the surf, to soften and "feather" the colour. A no. 4 round bristle brush is used with a palette knife to create texture.

10 The penknife is again being employed to scratch through the impasto and expose the colours beneath.

11 Adding more tones of pure colour. Chrome orange is used here with the palette knife to create the skin tones reflected in the water. Burnt umber is worked into the child's figure and the rocks to stress form. Colours are now used straight from the tube without first being mixed or diluted.

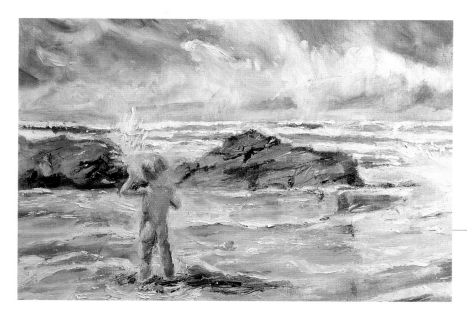

12 The picture is nearly finished and it is time to take stock and decide where the final touches and alterations should be made.

13 A little more impasto white, occasionally broken with tints of blue, green and pink, is applied to increase the sense of atmosphere and light.

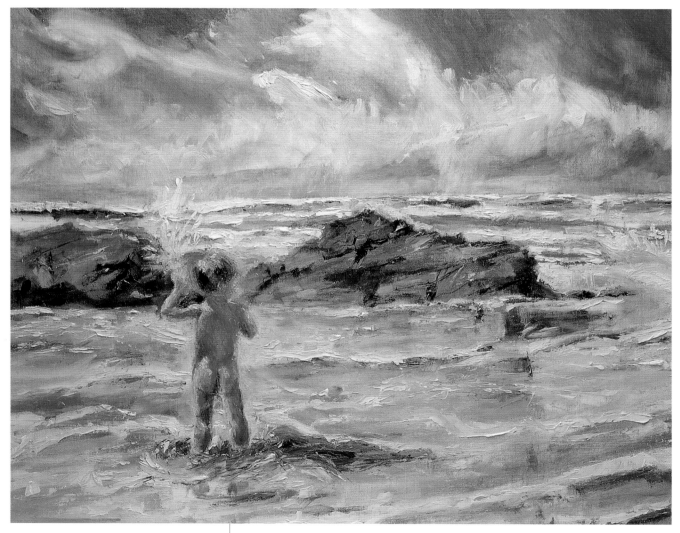

14 The finished painting.

FISHING BOATS

THIS STUDY OF FISHING BOATS IN A PORTUGUESE HARBOUR IS
THE RESULT OF A BRIEF VISIT TO A LITTLE HARBOUR IN THE
ALGARVE REGION. THE FISHERMEN WERE REPAIRING THEIR
NETS IN PREPARATION FOR THE NEXT DAY AND THEY WERE ALL
BUSY IN THEIR BRIGHTLY COLOURED BOATS.

The materials he used are
watercolour board (NOT), a flat
sable brush, household bleach,
black fountain-pen ink, a dipping
pen, white conté pencil, cotton-
wool swabs and a child-safe
container for the bleach.

BY TED GOULD

Standing on the dock, the artist
took some photographs before
moving on to the next stop on the
journey. When he saw the prints later,
he was reminded of the vibrating
image of reflected light and decided
to make a bleach drawing to attempt
to re-create the sensation.

**Note: Bleach is caustic and must be
kept well away from children. Do not
allow any skin contact. Also, do not
use sable or bristle brushes with
bleach as it will quickly rot the hairs.**

1 The photograph that provided the
reference for the drawing.

3 Starting with a cotton-wool swab
dipped in bleach, the light areas are
etched back. Only a little bleach is
used at first – because if the swab is
too heavily loaded, it will clean the
ink off right down to the surface of
the board.

2 Watercolour board is covered with
a good wash of ink using a flat sable
brush. When this has dried
thoroughly, the composition is
sketched in with conté pencil.

4 The swab is used all over the light
areas, gradually applying more
bleach to increase the contrast
between light and dark.

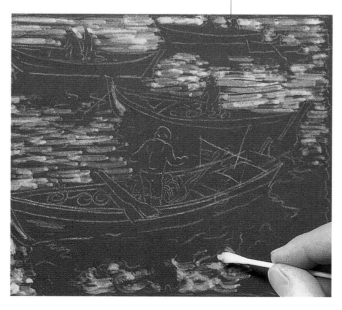

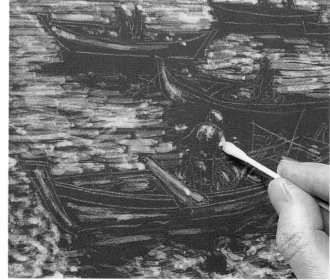

5 A pen dipped in bleach is used to draw in the details and highlights.

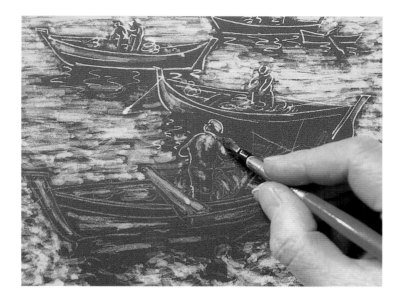

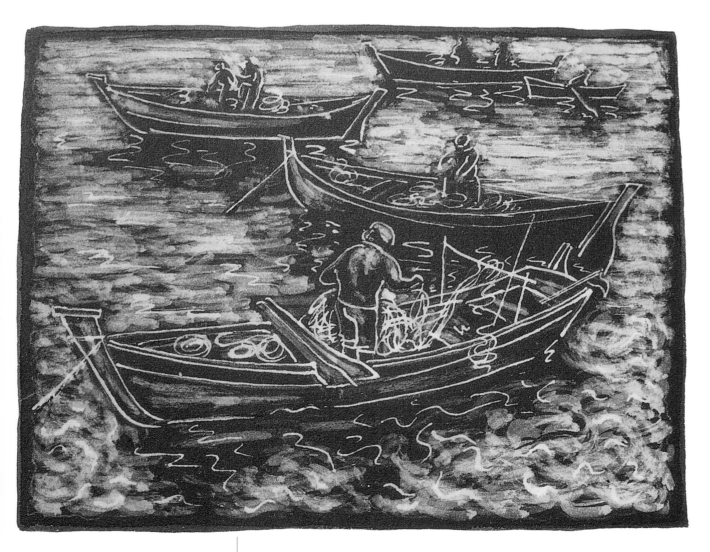

6 The finished picture.

OASIS IN TUNISIA

A SIMPLE POSTCARD WHICH DROPPED THROUGH TED GOULD'S MAIL BOX ONE MORNING IS THE BASIS FOR THIS PICTURE. THE DISTINCTIVE SHAPES OF THE PALM TREES STANDING VERTICALLY ON THE RIPPLED SAND DUNES MAKE THEM A "NATURAL" FOR THE GOUACHE LIFT TECHNIQUE.

BY TED GOULD

He decided to use coloured gouache to evoke the atmosphere of the desert. As can be seen, the gouache lift technique produces a similar effect to that achieved by a lino or wood cut. However, it is much quicker than either of those two methods, but, of course, you end up with just one original, whereas with lino or wood, you can make dozens of prints.

Three colours are used – cerulean blue, yellow ochre and violet – and waterproof Indian ink. The support is NOT surface watercolour board. Do not use a smooth surface paper or board because you will find that the textures are disappointing. The brushes used are nos. 4 and 8 pointed sables and a no. 8 flat synthetic sable.

I The postcard that inspired the picture.

2 A light pencil drawing is made onto the board. This defines the areas of light and dark and indicates the areas for painting in the gouache. Do not draw the lines too heavily; otherwise, they may be visible in the finished painting.

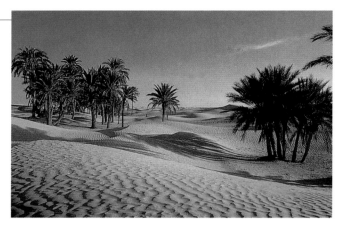

3 Full-strength colour has been applied straight from the tube. Note that these colours will be lighter in tone when "washed off". Those areas where no ink is to penetrate have been painted thickly. The edges and some other parts have been dry-brushed for texture. Remember that those parts left white will be black in the final picture. The paint should be left to dry completely. A no. 4 pointed sable brush was used.

4 The entire painting is now covered with an even layer of waterproof black ink, using a no. 8 pointed sable. The brush is well loaded with ink, which is applied as quickly as possible to avoid disturbing the gouache beneath. The ink layer must be left to dry completely before "washing off".

5 The final "washing off" stage is best done under a slow-running cold tap. The gouache slowly dissolves and lifts the ink off the painted areas. This process is assisted by gently rubbing with a large sable brush until all the surface gouache has been removed.

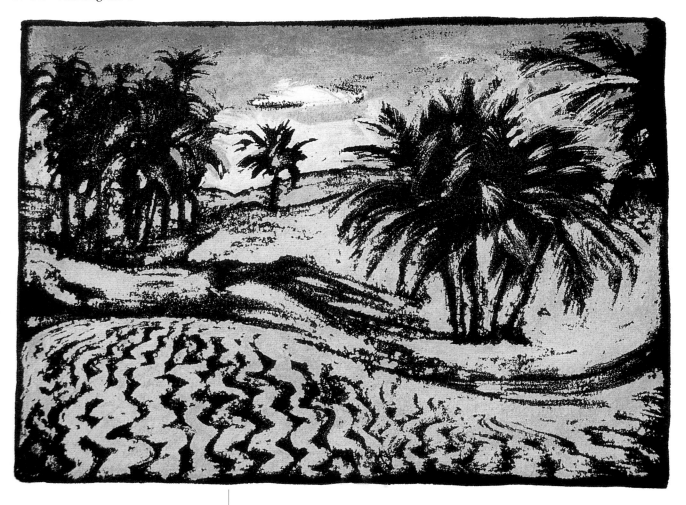

6 The finished picture.

TREES AT STE. FOY (BORDEAUX REGION)

GERRY BAPTIST LIKES TO TRAVEL, PARTICULARLY IN THE WARM MEDITERRANEAN CLIMATE – THE COOL GREENS AND DARK GREYS OF THE ENGLISH LANDSCAPE ARE NOT FOR HIM. HE ACKNOWLEDGES THE INFLUENCE OF THE FAUVISTS ON HIS COLOUR, BUT THE EXPRESSIVE POWER OF THIS ACRYLIC PAINTING CONTAINS ECHOES OF THE GERMAN "BLAUE REITER" GROUP.

BY GERRY BAPTIST

A quick comparison of the painting with its reference demonstrates the fact that the photograph has been used as little more than a starting point for the picture. The scene was originally glimpsed from a car window as the artist was travelling through the area, resulting in the photograph below.

Before starting the final painting, various studies are made exploring different colour schemes. These are important in the process of translating the greens and greys in the photograph to the bright sensuous colours used in the picture.

The artist likes to establish bright, contrasting base colours for his pictures. They function as the colour key for the entire work. In this painting there are three complementary base colours. He then draws the main forms and lines of the composition and expands the shapes with thicker paint. Further planes of colour are then applied, usually complementaries of the colours beneath them.

More glazes are overlaid as the picture grows and changes, often leaving some of the underlying colours "exposed". In addition to

The colours are chrome yellow, chrome orange, chrome green, violet, emerald, pthalo green, pthalo blue, cerulean blue, acra red, magenta and black paints and matte gel medium. The brushes are size nos. 8 and 14 hog bristles and no. 8 synthetic sable. The support is fine cotton canvas that has been primed with gesso.

glazing, he "feathers" some of the layers one into the other to create gently receding or advancing planes. The picture is "finished" when he feels that he cannot add anything more and the work appears to have its own independent existence.

1 The reference photograph which provides the starting point for the painting.

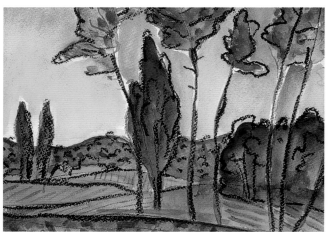

2 A preliminary study for the picture.

3 A base painting is prepared indicating broad horizontal areas of colour, which the artist will continually modify throughout the painting. Emerald green, chrome orange, acra red, magenta, chrome green yellow, pthalo blue and cerulean blue, are mixed and applied with a no. 14 bristle brush.

4 The base painting is complete and left to dry.

5 The foreground trees are brushed in with green, changing to violet mixed with white and red for the right-hand tree in the middle distance.

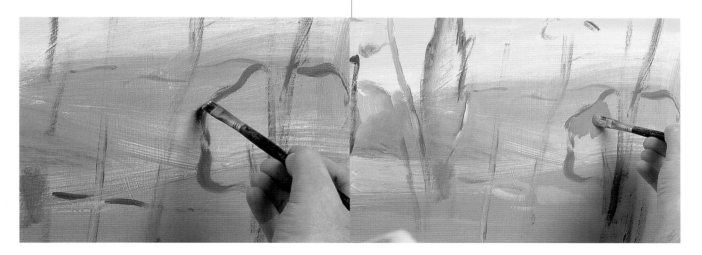

6 More dryish colour has been brushed into the sky background and trees, which are worked alternately. Yellow, white and cerulean blue are the principal colours used for this.

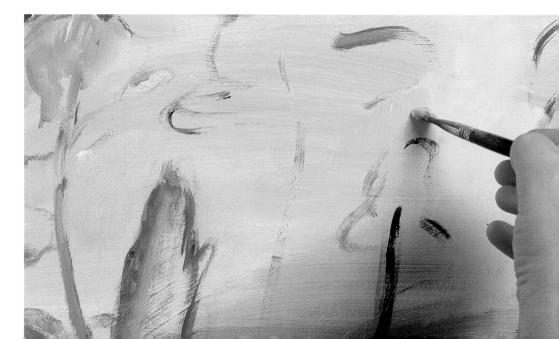

7 *Detail* Green tones are added to the foliage, contrasting with the violet in the trees behind.

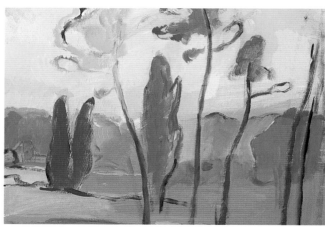

8 More green is brushed into the foreground against the complementary pink. The whole picture is assessed by the artist at this stage.

9 Thicker pink is dry-brushed onto blue, producing a violet fringe to the form. Matte gel medium is added to the colours at this stage to thicken them.

10 Some yellow is dry-brushed and then feathered over the pink form. The artist moves from one area to another applying complementaries over previous colours.

11 This picture shows how the painting has changed by continually working different colours over the top of previous glazes. The paint is thick but dry, so that it can be scumbled onto the surface and feathered.

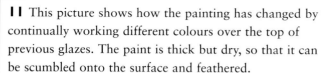

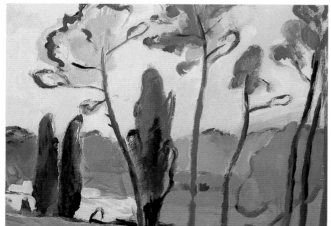

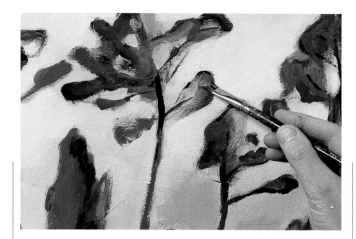

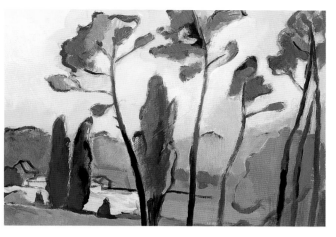

12 Forms in the foreground tree are built up with a blue and blue-green mix to pull them into the foreground. A no. 8 bristle brush is still being used.

13 The picture is nearly finished. More pale yellow has been brushed into the sky and, the tree foliage has been modulated with a little more pink and yellow.

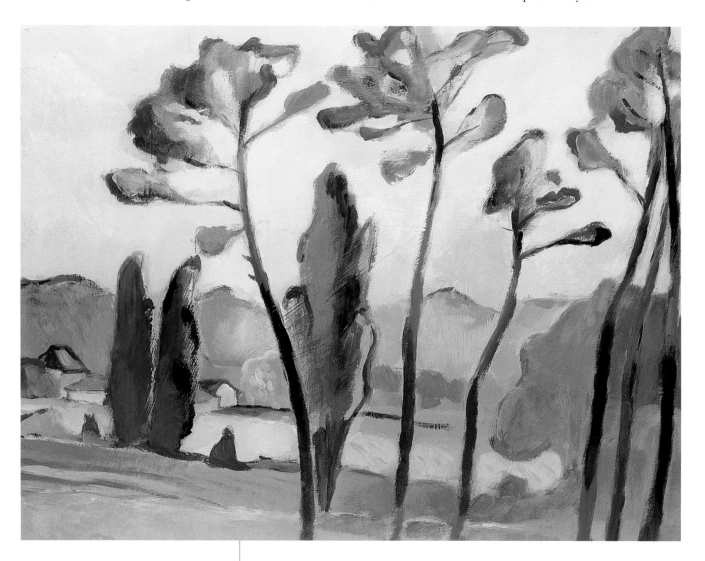

14 The finished painting.

COLOUR AND LIGHT

COLOUR AND LIGHT ARE INSEPARABLE ELEMENTS IN ALL PAINTING. WE CANNOT SEE COLOUR WITHOUT LIGHT AND THE COLOUR OF LIGHT ITSELF AFFECTS ALL THE LOCAL COLOURS IN OUR FIELD OF VISION.

Painters always strive to reproduce the effect of light on colour in the landscape. Only an approximation can be achieved with paint, which, after all, is simply only a pigment suspended in a binder. The colours in a scene on a wintry, misty day will generally be at the cool end of the spectrum. On a clear, sunny day the same scene will be dominated by colours towards the warm end.

Neutral colours have the effect of creating unity, and adopting a limited palette of colours close together on the spectrum is an aid to achieving a unity of the whole picture. A complementary colour can be used to create a bright focal point in a painting, while complementaries outlined or separated by a neutral colour can create a vibrant painting full of light. The dark areas of

below Oil study employing a warm palette: Venetian red, orange, cadmium yellow and chrome green.

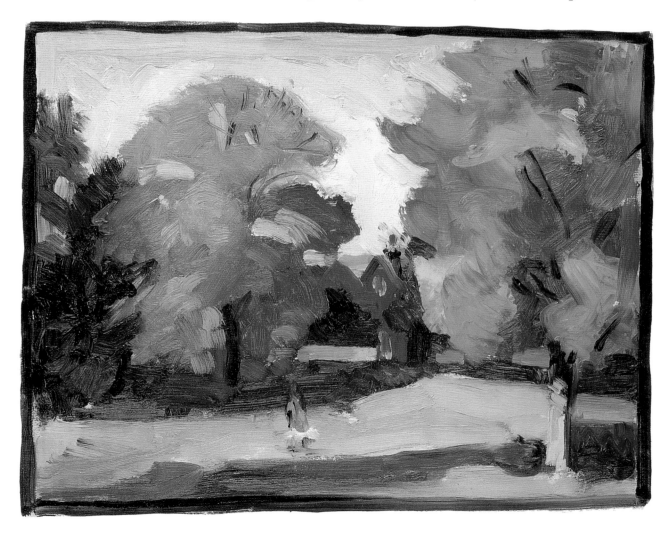

shadows and shade create contrasts with lighter ones.

A peculiarity of landscape painting, and an essential consideration for the artist, is the effect on colour caused by the atmosphere, which will make a radical difference to the colour and tone of an object. For example, a house near the horizon will appear light and greyish, almost disappearing on a misty day, by comparison with a similar building in the foreground.

Light itself can elicit an emotional response. A bright sunny day with clear blue skies induces a sense of joy, happiness and peace whereas a dull, overcast, cold day usually suggests menace, often even despair and a sense of isolation.

The techniques featured in the projects that follow include dry-brush, stippling, scrumbling, glazes, wet-on-wet and using a palette knife.

above *West Herts College.* Gouache by Ted Gould. This makes use of the primary colours blended together in washes of diluted colour. A neutral grey with black lines encloses the central forms to make something of a frame for the composition.

below Smooth washes of colour in this seascape by Robert Tilling give an impression of great space and depth. A limited palette of three or four colours has been used with strong tonal contrasts providing the visual interest.

The colours are cerulean blue, sky blue, cobalt blue, ultramarine blue, pale violet, turquoise blue, pink, orange, red, lemon yellow, chrome green, oxide green deep, purple and black pastels, and pink, orange and green flourescent pastels. The support used is 200gsm NOT tinted cover paper.

BY KAY GALLWEY

GARDEN LANDSCAPE

KAY GALLWEY DOES NOT USE THE TRADITIONAL PASTEL PAINTER'S METHOD OF "LAYERING". THAT IS TO SAY THAT SHE DOES NOT "BLOCK IN" AREAS OF COLOUR AND THEN WORK OVER AND INTO THEM. SHE PREFERS BOLD STROKES OF COLOUR, USING THE THIN EDGE OF THE PASTEL. FOR HER IT IS ESSENTIAL TO STAY IN TOUCH WITH THE GROUND, NEVER ENTIRELY COVERING IT.

This picture, vibrant with colour and movement, was not done on location, but was produced from a magazine cut-out that took the artist's eye. No preliminary studies were made – the painting is entirely spontaneous and executed on the spot. The artist works fast, continually standing well back from the painting, so that she can assess the progress of the whole. Long strokes of colour appear right across the picture to start with. She does not "dally" in any particular area and when changing to another colour continues to use it, finding the right places for it all over the picture.

The work progresses by adding more lines, occasionally smudging an area to prevent it from becoming dominant, introducing a pink here to add richness and a more neutral violet there to unify areas of colour. Finally, Kay puts in some touches of fluorescent pastel.

PARKING LOT TO PARADISE

Beth Chatto describes how she transformed the car park of her Essex nursery into a gravel garden for all seasons *Photographs by Steven Wooster*

1 A spread from a garden magazine was the inspiration for the painting.

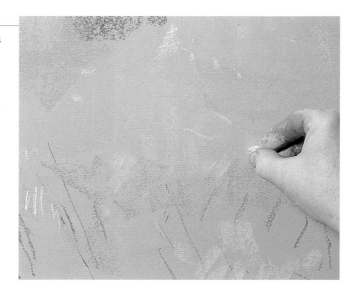

2 The artist does not start with a neutral base drawing. She launches straight into the picture, placing patches and flicks of colour right across the surface.

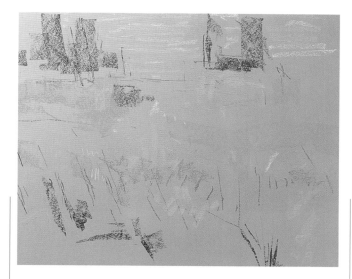

3 Broad strokes of yellow with the pastel held lengthways indicate the field and sunlit foliage.

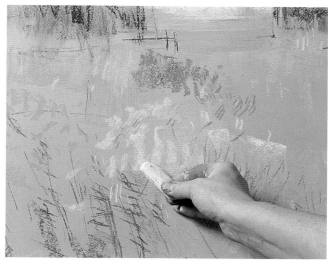

4 Light green is applied in rapid strokes around the painting, changing to a complementary pink and light blue.

5 Touches of white are added to keep the colour key light.

6 Strokes of dark green are added to some areas in shadow, gradually increasing the contrast with the light pinks and blues of the flowers.

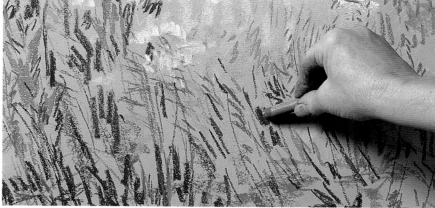

7 Black is employed here to provide a link between the surrounding contrasting tones.

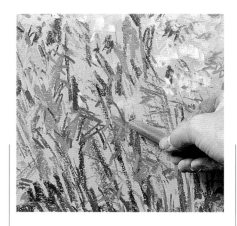

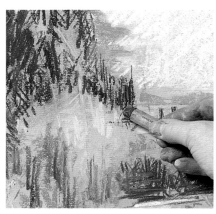

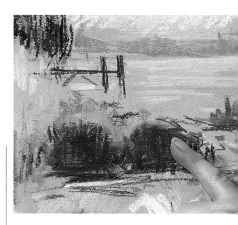

8 More pink is applied to the flowers progressively, making the picture more dense and saturated with colour. Note that the artist never completely covers the background paper with solid colour.

9 Dark blue is added to the green of the foliage to increase contrast with the yellow bushes in front.

10 Gently rubbing the pastel in the background bushes softens the forms and adds to the sense of atmospheric perspective.

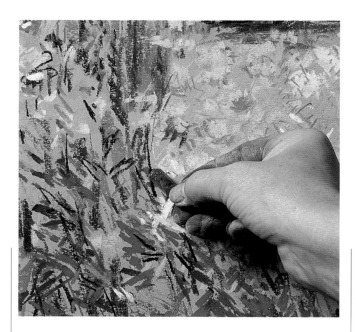

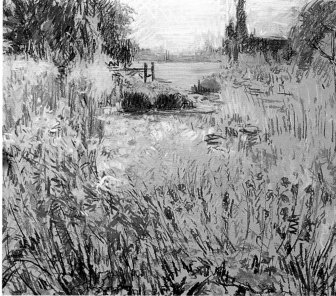

11 To increase the contrast between foreground and background, dark violet is applied between the bright tones. This also has the effect of creating more spatial depth to the picture surface.

12 Touches of fluorescent pastel have been placed in the flowers and foreground foliage. This gives the picture a little more "sparkle". The painting is nearly complete and the artist considers the finishing touches.

13 A few more strokes of blue to the central part of the painting and some touches of violet create more spatial depth.

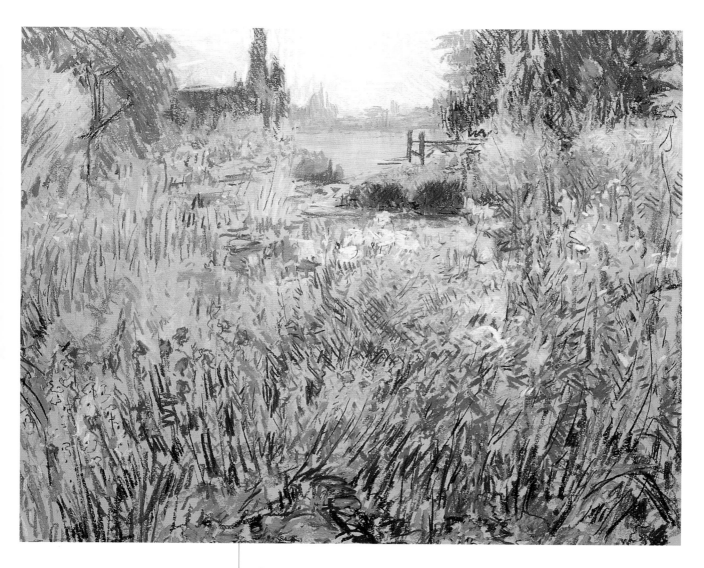

14 The finished painting.

WHERE THE WATERS CROSS

THIS OIL PAINTING IS OF A VIEW ACROSS A POND ATTACHED TO A MOAT SURROUNDING A COUNTRY FARMHOUSE. THERE ARE TWO ISLANDS TO THE LEFT AND RIGHT, AND THE SUN RISES ON THE LEFT OF THE COMPOSITION, CREATING SOME INTERESTING SHADOWS AND HIGHLIGHTS THAT HELP GIVE DISTANCE ACROSS THE WATER.

BY TIMOTHY EASTON

During the warm summer months of the year, there is usually a degree of certainty that successive days will be fine enough for a painting to progress outside. The artist finds that he can work on a number of canvases during a day, so the first session will start at 6.00 a.m., progress to 10.00 a.m., and the next will begin at 10.15 a.m., going on to the lunch break. This pattern can continue until 10.00 p.m. The paintings will be returned to for as many days as needed to complete each one. The canvas used here is double primed on linen, which is washed over with a medium-tone wash of colour.

The colours used are titanium white, cadmium lemon, yellow ochre, Indian yellow, burnt sienna, burnt umber, cadmium red, permanent magenta, permanent sap green, olive green, cobalt blue, cerulean blue and French ultra-marine. Brushes are hog-hair sizes 1–5, preferably filberts. Sable brushes are the finest quality no. 7 (Winsor & Newton) short handled.

1 The initial view.

2 In the nuttery on the left-hand island is a flowering cherry tree and it was anticipated that the picture would incorporate this, as well as the blossom that would come out a week later when the cherry blossom was over.

3 The canvas is covered with a base colour of thinned olive-green paint that allows both light and dark tones and colour to register against a middle-toned colour. *This base colour must be totally dry before work begins.* The composition is then drawn in with a sable brush using thinned olive-green paint.

4 Some broader areas of colour are blocked in using a no. 3 hog-hair brush to give some idea of the balance of light and dark areas. No medium is used on the house and sky areas, but the colour used on the water areas has been thinned out with turpentine.

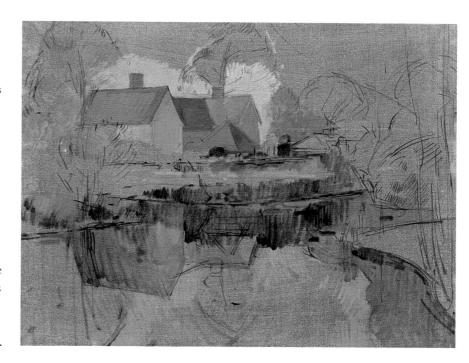

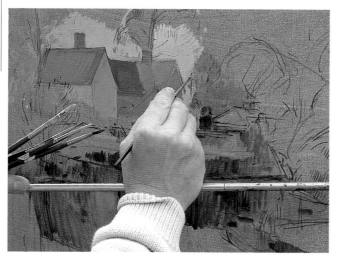

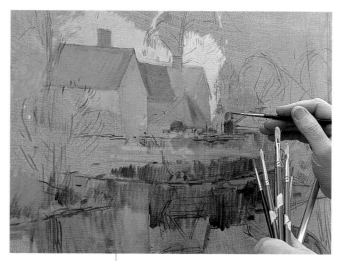

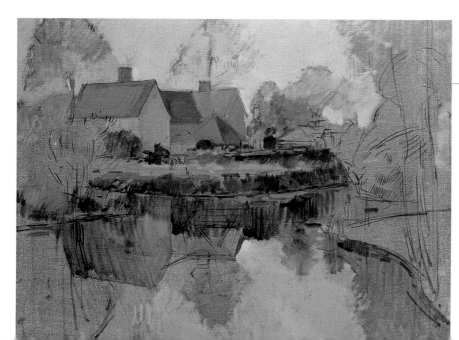

5 The garden gateway is drawn in using a fine no. 2 sable brush and a mahlstick to steady the hand.

6 The sky and water areas are further established to give an overall impression of the light and dark masses. The sky is dry-brushed with some additional olive-green lines to suggest the form of the main tree branches.

7 The middle tone of the house roof reflected in the water is established using a no. 3 filbert hog-hair brush.

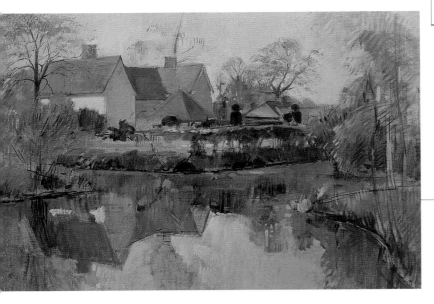

8 The colours along the top edge of the palette. Start with the light colours on the left: yellows through to ochres, then to the reds: mid-way next to cadmium red are the complementary colours of sap and olive green, continuing on to blues. The colours below these are initially premixed using a palette knife. These two rows take up half the palette, leaving the other part free to be used for additional mixing as work progresses.

9 After one and a half hours' work, with the early morning sun creating strong contrasts in light and shade, the light areas are heightened to contrast with those in shadow.

10 The sky is further reworked using dry colour and into this the blossom of the flowering cherry tree is worked up using small dry dabs over the middle-tone areas of paint below. This detail shows the suggestion of the branches and leaves of the middle tree in the composition.

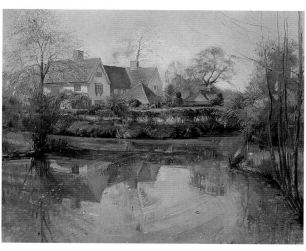

11 Adjustments are made to the colour and proportions of the house, and the windows are added. There is a further reworking of the roof and blossom.

12 The light across the lawn showing between the gaps in the hedge is further heightened. and the water is also reworked, for greater contrast.

13 Having broadly established the tone, colour and contrast required, some smaller details are painted in using fine sable brushes.

14 Hog-hair brushes are used to define the water reflections.

15 A wind was driving the petals across the pond. The water is disturbed and the arching of the petals helps to lead the eye across the pond from the bottom left-hand corner towards the bend in the moat.

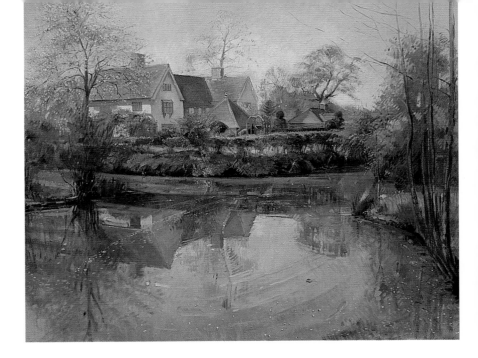

16 More raking light is introduced into the part of the moat coming from the left, behind the nut trees and cherry.

17 The cherry blossom has now gone, but the may tree has fully flowered on the right side. The may blossom is added between young trees on the small island to the left of the picture. The chance arrival of the white duck offers a small detail in the foreground. Working on a picture over several days, with changing moods in the weather, means there are always incidents the artist can take advantage of. These "happenings" add interest to the composition. A painting done from a photograph captures only one moment in time, whereas a painting completed outdoors evolves over some time.

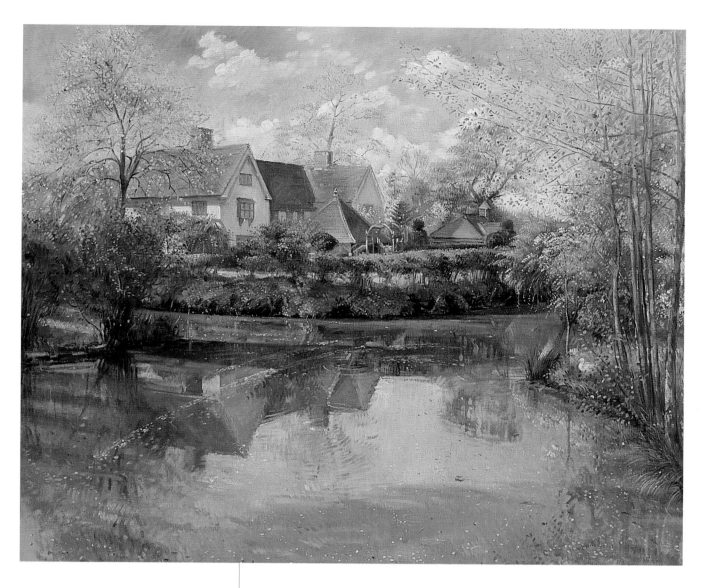

18 The finished picture. The top of the sky has been strengthened once more with a darker blue and some clouds introduced to reflect something of the light wind movement expressed in the arching petals on the surface of the pond.

OLIVE TREES WITH DONKEY

THE IDEA FOR THIS OIL PAINTING CAME AS THE RESULT OF A SHORT TRIP TO CRETE DURING EARLY SUMMER. THE ARTIST HAD A SMALL SKETCHBOOK WITH SOME TUBES OF GOUACHE, AND HIS CAMERA, AND CAME ACROSS AN AREA OF THE ISLAND THAT WAS GIVEN OVER TO GRAIN FIELDS AND OLIVE TREES, INTERSPERSED WITH THE OCCASIONAL MELON GROVE. HERE AND THERE, HE COULD SEE A DONKEY SHELTERING FROM THE MIDDAY SUN. THE SCENE WAS MADE EVEN MORE ATTRACTIVE BY A RANGE OF MOUNTAINS RUNNING BEHIND THE FIELDS AND PARALLEL TO THE HORIZON. HE SAT DOWN RIGHT AWAY TO MAKE A QUICK STUDY AND TO TAKE SOME PHOTOGRAPHS.

The colours are cerulean blue, ultramarine blue, mauve, Indian red, chrome green or light oxide green, Winsor yellow, yellow ochre, titanium white and lamp black. The brushes are no. 3 and 5 hog bristles, flat and filbert. The support is primed canvas board.

BY TED GOULD

There are two dominant colour complementaries running throughout this landscape: yellow and blue/green, which create something of a counterchange pattern. The whole is held together by the bright cerulean blue of the sky and the blue/violet of the mountains.

After the underpainting is completed, areas of thicker, more textural paint are applied using a knife. The term palette knife properly applies to those with long handles used for mixing paint on the palette. Painting knives have short broad blades with "cranked" handles to keep the hand out of the wet paint. They feel flexible and springy and produce a variety of effects, always wonderfully spontaneous and bold.

There is almost a sense of modelling the paint onto the canvas. Light is reflected off the strokes and textures, keeping the surface lively.

Dragging the knife at an angle with firm pressure spreads the paint in a transparent layer with thick "edges", rather in the manner of spreading soft butter on bread. Using the point with short, sharp patting movements produces a raised texture of points. Fine lines can be drawn while simultaneously turning the knife to score through the surface layers in a sgraffito effect.

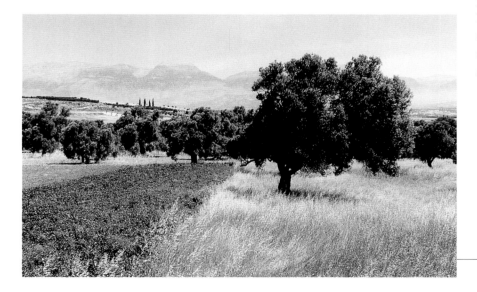

1 A photograph of the area.

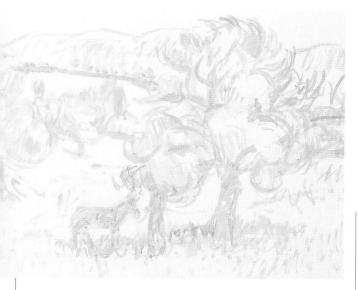

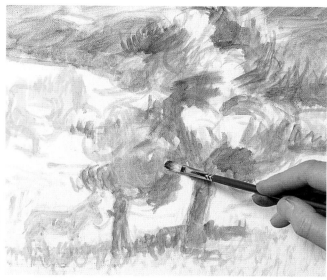

2 A base drawing in charcoal and yellow ochre diluted with turpentine is the first stage. This places the shapes in space and indicates the main composition lines.

3 Beginning the underpainting. The intention is to paint the entire picture with thinly diluted paint first, then when dry, to work over the top using palette knives. Starting at the top with cerulean blue, mauve and chrome green, the sky, mountains and foreground tree are brushed in lightly. A no. 5 filbert bristle brush is used.

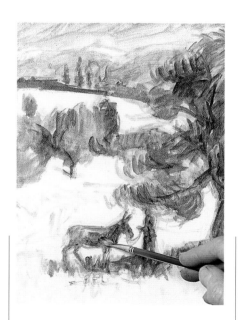

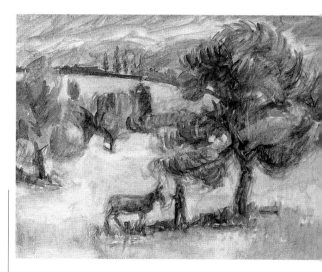

4 The figure and donkey are brushed in using a mix of mauve and yellow. Parts of the drawing are lost during this process and then restored by drawing back with ultramarine and mauve.

5 Yellow ochre and Indian yellow are mixed for the grain fields, which are painted as a flat wash. A no. 5 filbert bristle brush is used.

6 The underpainting is complete. A soft cloth has been used to rub down wet areas and spread the colour. The painting is left to dry over the next few hours.

7 The palette knife painting is begun by mixing cerulean blue with a little white and a touch of linseed oil, working broadly across the sky using a large pointed knife.

8 The mountains are indicated with mauve and ultramarine added to the cerulean. This is broken with white and a touch of yellow ochre toward the base, which creates a heat-haze effect.

9 Tree foliage is painted with a mix of chrome green and ultramarine, keeping the knife well loaded with colour and changing the angle continually to create texture.

10 The tip and edge of the knife are employed to put in the cypress trees in the background.

11 A good thick mix of yellow ochre, Indian red and a touch of mauve is applied to the grain fields. The knife is turned regularly and used to scratch and scrape back to reveal the underpainting.

12 Modulating the colours in the middle ground.

13 Black is added to the deep shadow areas such as tree branches. Final touches of Indian red and mauve are mixed to add texture to the grasses and shadow areas under the trees.

14 A small pointed palette knife is used to model the foreground tree foliage and to create texture.

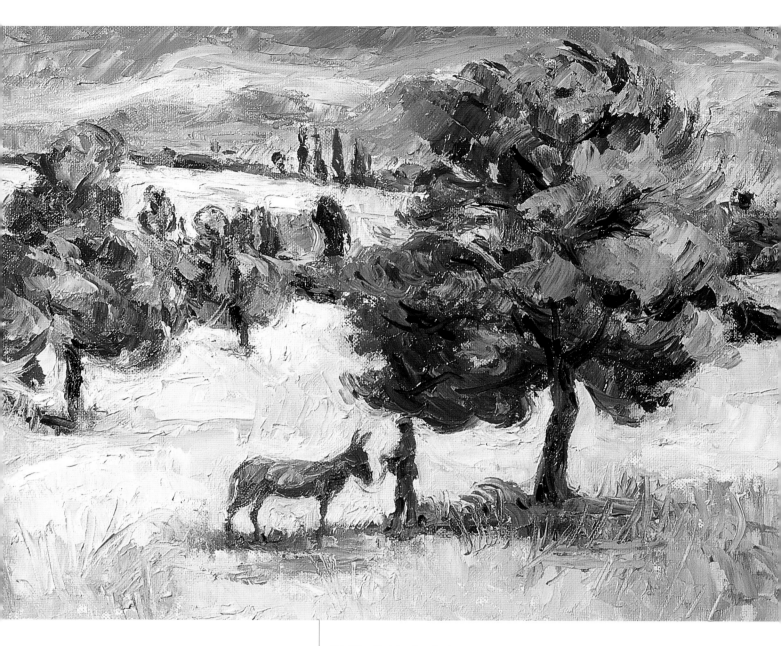

15 The finished painting.

MT. ASPIRING

MARK TOPHAM HAS CHOSEN ONE OF THE CLASSIC LANDSCAPE SCENES FOR THIS GOUACHE PROJECT. MOUNTAINS FRAMED BY TREES WITH A BROAD RIVER MEANDERING BETWEEN VERDANT HILLS MAKE FOR A CHALLENGING SUBJECT. THE SNOW-CAPPED MOUNTAINS AND SANDBANKS CONTRAST SHARPLY WITH THE SHADOWS IN THE DARK GREEN WATER.

The colours are permanent white, cadmium yellow, cadmium orange, raw umber, burnt sienna, burnt umber, azure blue, French ultramarine, indigo, viridian and spectrum violet and acrylising medium. The brushes are squirrel hair brush, no. 7 synthetic sable and no. 7 pointed sable. The support is 300gsm NOT watercolour paper.

The artist has a precise approach to his work. He takes time before starting to do a visual analysis of the subject. He makes mental notes of the light and dark areas and the warm and cool colours he will need. He then indicates these areas on the support using a soft pencil. Choosing from a large range of colours, he assembles those he will need. Mark prefers to work with a greater number of pure colours, rather than mixing from a limited selection. His experience has given him the ability to work with and control more colours than would be recommended for a beginner in landscape painting.

The painting proceeds initially with diluted washes, leaving the very lightest areas white, until he has completed a delicate underpainting of the whole picture. He uses fairly small brushstrokes, varying the tints as he goes. The process is then one of a gradual build-up of thicker paint, culminating in touches of white for highlights. He uses both the wet-on-wet and dry-brush techniques, with some stipple and blotting for texture.

1 The painting is an interpretation of this photograph.

2 A base drawing of the main forms in this composition has been made using a 6B pencil. The sky is being washed in with a diluted mix of cerulean blue, ultramarine blue and monastial blue. The paper has been slightly dampened and the artist is pulling the wash down with a squirrel hair brush.

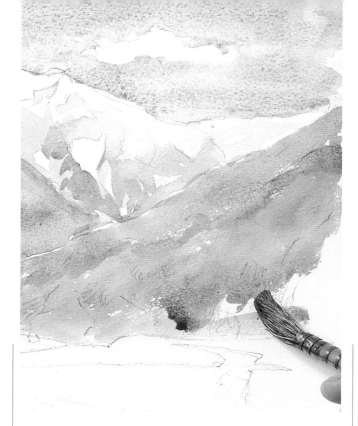

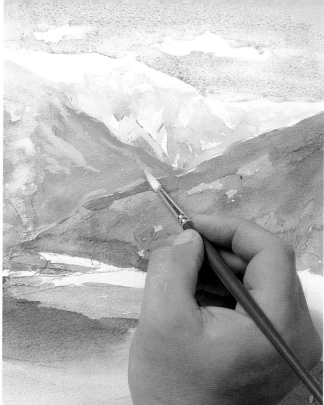

3 *Detail* Changing to a no. 7 synthetic sable brush, patches of colour have been placed in the mountains using diluted pale violet. Green mixed with yellow ochre is being brushed into the middle-ground hills down to the shore line with the squirrel brush.

4 Thinned washes of blue with a little green are mixed for the water tones. Violet is added for the shadow areas. The artist has returned to the mountains, working with orange, white, burnt umber and violet. The hills are lightened with white to create aerial perspective. This is done with a no. 7 pointed sable brush.

5 The first glazes are finished. Thicker paint will now be used mixed with some acrylising medium to give body to the colour.

6 The sky has been reworked with blue and white to define the clouds. Darker shades of viridian green and raw sienna are mixed to paint the tree in shadow. More shades of dark green, blue and raw sienna are used to finish the tree.

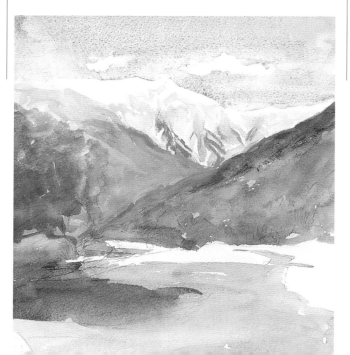

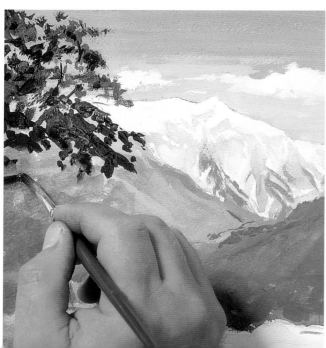

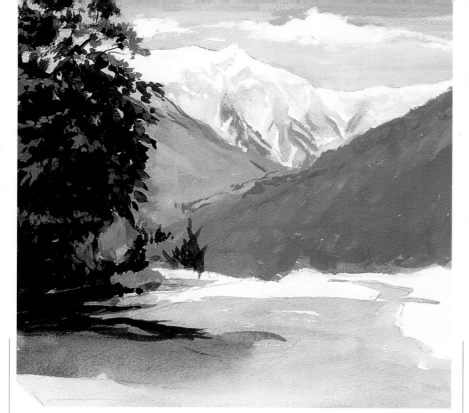

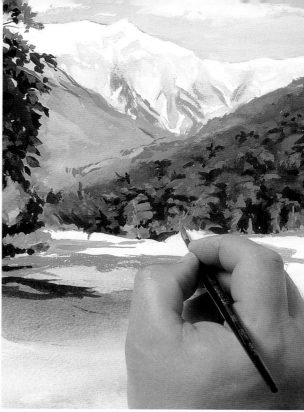

7 The picture looks one-sided at the moment – darker tones must be carried over to the middle hill on the right.

8 Texture in the right-hand hill is being applied with a no. 7 pointed sable brush. This is "feathered off" towards the horizon.

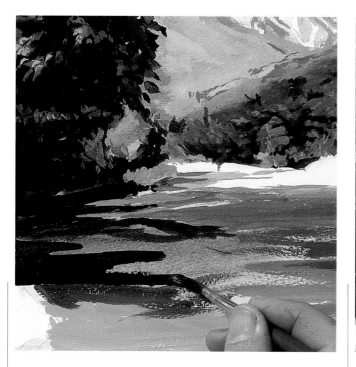

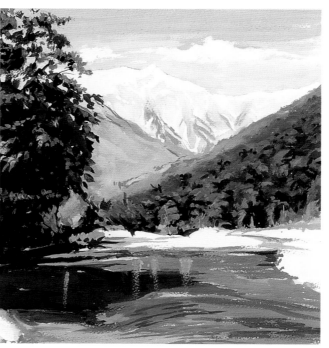

9 Still using the no. 7 sable brush, with a mix of green, blue and raw sienna, the shadows and ripples are painted on the river.

10 Dryish colour, a mix of light grey, has been brushed into the water to create reflections.

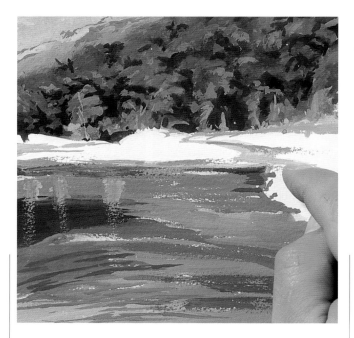

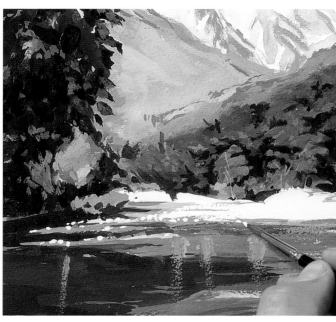

11 Now some light grey is dragged across the snow and rocks with the finger.

12 White with a little pink, used thickly, is applied to the banks and to suggest snow floating in the water. Some white is scumbled onto the foreground to indicate ripples.

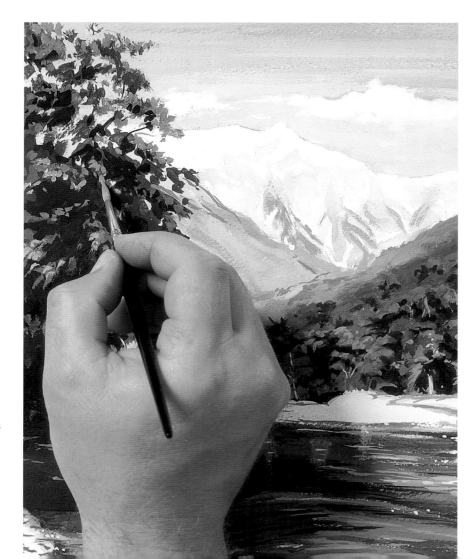

13 Final touches for highlights are added to the tree, and the painting is finished now.

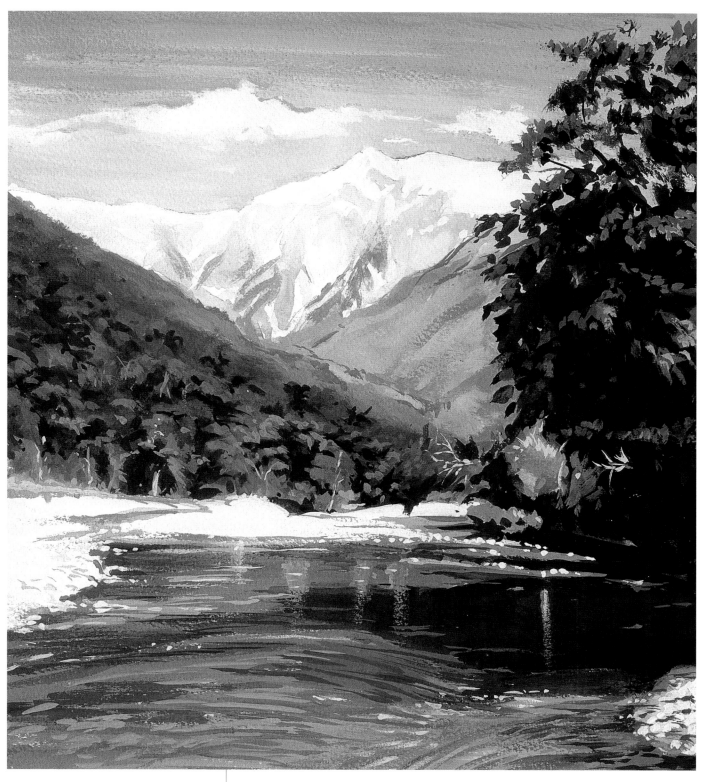

14 The painting represents a
beautiful study of the cool
atmospheric effects of this region.

PRESENTATION AND CARE OF WORKS

ART SHOULD REVIVE THE SPIRIT AND

INSTIL EMOTIONS. IT SHOULD

INVIGORATE AND ENTERTAIN.

PAINTINGS AND DRAWINGS CAN

SPEAK QUIETLY BUT SAY GREAT

THINGS. PRESENTATION AND

FRAMING PLAY AN IMPORTANT PART

IN CREATING AND ENHANCING THE

IMPACT OF A WORK OF ART.

FRAMING

MANY ARTISTS FEEL THAT ONCE THE PAINTING IS COMPLETE, THE FRAME IS AN
AFTERTHOUGHT. YOU MUST FORGET THIS MYTH, ESPECIALLY IF YOU ARE
THINKING OF ENTERING WORK FOR AN ART CONTEST OR EXHIBITION.

A well-made and well-designed frame can enhance and exemplify your work to a degree that would surprise even the most imaginative person. The type of mount and moulding should be in empathy with the painting itself. It should complement without calling attention to itself.

When selecting mouldings or mounts, the expertise of your framer comes into play. Of course, it is possible to make your own frames and put effort into staining and colouring them, but finding a sympathetic framer will benefit you greatly. When you are working with paint or pastel, time spent at the easel is the best way to use your energies and to take on the job of frame maker as well as painter will give you an uphill struggle.

When mounting work (see page 339), it makes sense to use a mount that is at least 7.5cm (3in) wide and to use off-white shades of mounting board. Mounts and/or washes over different coloured mounting boards can pull out certain colours that are within your composition.

The fascinating techniques involved in preparing frames, each style a craft in itself, take time to master. A good frame maker is like gold dust, so it is worth looking at a number of framers to find one whose work you like. Keep your eyes open for framers who specialise in producing exclusive designs and decoration.

The choice of decorated mouldings is vast: period frames, such as Italian mouldings, richly decorated with engraving and sgraffito effects, swept mouldings, flat mouldings, or reverse mouldings. Frames that are hand coloured are more expensive, but the results can be worth it.

The delicate nature of watercolour demands a refined and sympathetic style of mount and frame. A traditional method of presenting watercolour paintings is to have a wide mount incorporating line and wash decoration.

Double-thickness mounts are also excellent for giving more depth to the painting itself. The advantage of double mounts is that the window effect of the mount is strengthened,

above The colour of the frame is important to the final presentation of your work. The grey of this frame brings out the grey of the cottage enhancing the other colours within the painting.

above *Lilies in a Blue Vase.* Oil by Jeremy
Galton. The use of the small wooden slip
gives a sense of depth to this framed
work.

right The use of gold leaf in this frame enhances the depth and quality of the drawing.

allowing more depth to be created under the glass.

Remember always to use acid-free papers and boards.

Gilt frames are very expensive, but the use of gold and silver leaf in frame-making can achieve really tremendous results. There are cheaper alternatives, such as metal leaf in silver and gold, which give a similar glint to a frame. Remember that the picture frame has to fit in with the environment in which the painting will eventually hang, so think about this carefully. A painting is often reframed by a new owner, who wants it to fit in with the decorative style of a particular room or interior.

When framing oil paintings, the use of a small wooden or canvas slip is popular. This has a similar effect to that of a mount. It separates the canvas from the frame and gives a sense of depth to the framed work.

The glass used for framing is normally 2 mm (1/8in) thick. Some artists prefer to glaze oil paintings. This physically protects the surface from any damage and the effects of the environment, but oils do not really need glass to look their best.

PRESENTATION

WHEN PUTTING WORKS ON A WALL, THINK ABOUT ARRANGING THEM IN
GROUPS AND INTEGRATING THEM WITH THEIR SURROUNDINGS.

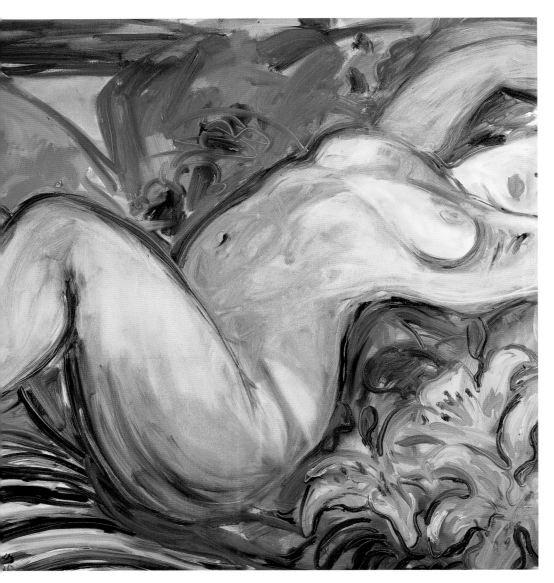

above A dramatic painting, such as this large and energetic reclining nude in oils by Kay Gallwey, should take centre stage within a room.

Pick out styles of frame that reflect architectural features and use the edges of a piece of furniture to guide you in selecting appropriate widths for a painting that could be hung above: for example, match up the sides of a sideboard with a painting. It is a good idea to hang work with the centre of the picture at eye level.

There are basically two ways of hanging paintings, an ordered symmetrical fashion or an informal fashion. Geometric ordered arrangements could mean a series of pictures all lined up level at the tops, with a standard gap between each, or hung in a square format with all outside edges in line. This system of hanging works best when the pictures are all the same size. A column of pictures will accentuate the height of a room and a horizontal run of pictures will give a room more width.

When deciding how to hang an unusually shaped canvas or when filling narrow walls, an informal approach is useful. Experiment to find the most appealing arrangement. Large pictures need room to breathe, smaller ones hang well in clusters.

Avoid hanging work above a central heating radiator. Rising heat can dry out and warp a frame or damage a painting. In general, paintings should not be hung where they will be in direct sunlight.

MOUNTING YOUR WORK

THERE ARE TWO REASONS FOR MOUNTING YOUR WORK. FIRST, IF IT IS FRAMED, THE PAPER MUST BE KEPT AWAY FROM THE GLASS TO AVOID CONDENSATION MARKS FORMING ON THE DRAWING OR PAINTING. SECOND, MOUNTING WILL HELP TO PROTECT YOUR WORK.

left This charcoal drawing of giraffes is mounted on a simple card mount, which confines and defines the space it occupies.

A window mat (see overleaf) is not only an attractive and professional way to present your work, but it will also keep it in excellent condition.

You may choose to have your work professionally mounted, but if you do it yourself all you need is a mat knife and a steel ruler. If you plan to do quite a lot of mounting, you may want to consider investing in a bevel-edged ruler with a rubber base to stop it from slipping, which makes the job safer and easier. Be sure to change the blade in the knife frequently to keep it cutting cleanly. Use masking tape to anchor the mat board to a table that you have protected with cardboard. If you want a window mat, cut two boards the same size. The first will be used for the window mat, the other for the back board. On the first board, cut out a shape that is slightly smaller than your drawing. Position the window board over the back board. Slide the drawing or painting between the two, taking care not to smudge it, and move it into position so that it is framed by the window. Hold the work in place with small pieces of masking tape. The two boards are attached at the top with a tape hinge so that they can be opened to gain access to the drawing.

Whatever type of mat you use, remember to use an acid-free board if you want it to remain white and not leave a ring around your drawing.

CUTTING A WINDOW MAT

AS A STUDENT, ONE OF THE FIRST THINGS DIANA CONSTANCE WAS TAUGHT WAS HOW TO CUT A MAT AND TO PRESENT HER WORK PROPERLY. ALTHOUGH SHE OBJECTED AT THE TIME TO THIS ADDITIONAL WORK, SHE QUICKLY LEARNED THE VALUE OF THE PROFESSIONAL DISCIPLINE.

1 These are the basic tools you will need. The mat board, mat knife, steel ruler, masking tape and double-sided tape.

2 Measure and draw the lines for the window mat.

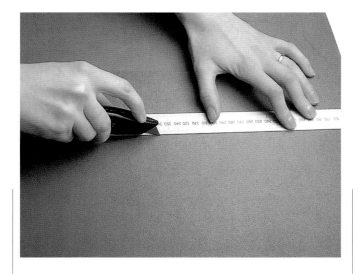

3 Cut the window mat. This type of ruler is adequate, but heavier steel rulers with rubber bases are safer.

4 Lift out the cut-out from the window board. Save this piece of board; it may serve for a smaller drawing.

5 Tape the drawing or painting in position on the window mat. If it is a pastel or other delicate, easily smudged medium, it should be laid face-down on tracing paper to keep it from smudging.

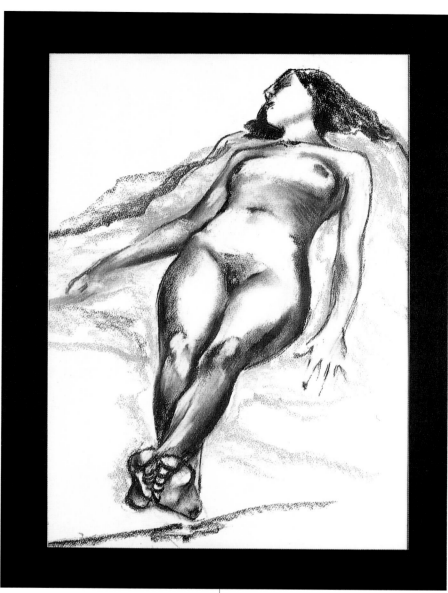

6 Attach the back board to the window mat with double-sided tape.

7 The finished drawing in its mat. Tracing paper can be put over this if it is to be stored away.

STORING YOUR WORK

FRAMED PAINTINGS AND DRAWINGS, WHEN NOT ON DISPLAY, TAKE UP A REMARKABLE
AMOUNT OF SPACE AND ARE EASILY DAMAGED IF THEY ARE NOT WELL PROTECTED.

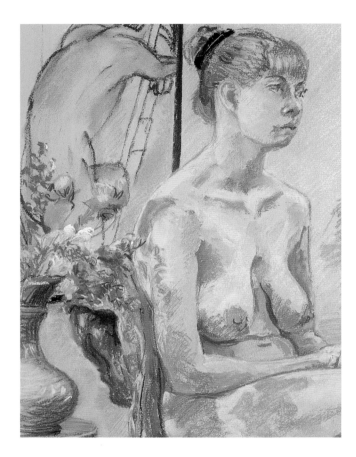

above Pastel drawings, such as this, should always be covered
with light tracing paper to prevent smudging.

It is a good idea to cover them with bubble wrap if you are planning to store them for a while, as this both protects and insulates them. Store your work in a dry part of the house, which has a more or less constant temperature and not much traffic! This prevents the warping of frame stretchers, as well as the development of mould, and accidental damage. A garage is not a suitable spot, especially in the winter.

You can always tell an artist's house because they hang their own work everywhere. They take up any wall space and there is the added advantage that the greater public gets to look at them!

Drawings in charcoal, conté and pastels should be covered with either light tracing paper or with tissue paper. Tracing paper lies flat and does not pick up the medium. Try to avoid rolling your work. If it is at all possible, keep it flat in a drawer or in a portfolio.

PHOTOGRAPHING YOUR WORK

BEFORE YOU PUT YOUR DRAWING BEHIND GLASS, YOU MAY WISH TO PHOTOGRAPH IT.

If you plan to submit work for schools or for exhibitions, it is wise to adopt the habit of taking slides and other photographs before framing, because once the glass is in position, the reflections will make photography difficult. If you can work outdoors in daylight, the task will be straightforward. For indoor photography, the best method is to use a tripod and two photographic flood-lamps with film that is colour-corrected for tungsten light. Flash can also be used, but experimentation is essential. If you stand too close, the work will be bleached out; if you are too far away, the white paper will look murky.

CARING FOR DRAWINGS

THE CARING ACTUALLY STARTS BEFORE YOU BEGIN WORK,

WITH THE SELECTION OF PAPER.

Cheap paper's useful in the beginning when you want to be as free as possible to experiment without worrying about the cost of paper. As you improve, however, you will want your work to be permanent. This means avoiding papers made with wood pulp – that is, newsprint, construction paper, lining paper, or brown wrapping paper. If a paper is not acid-free, it will eventually yellow or turn brown.

Many felt-tip pens are made with fugitive inks, which fade very quickly and coloured tissue paper is not suitable for collage for the same reason. Charcoal, conté and pastel are all permanent, but they should be sprayed with a good-quality fixative. Many artists dislike fixing pastel because the light colours are slightly "pushed back" by the damp spray, but a light fixative can be used to protect both drawing and the mat board. When a framed pastel drawing is moved, the pastel dust can drift down onto, and soil the bottom of, the mat board. This is particularly galling when work has been sent for exhibition. Always use a good-quality artist's fixative.

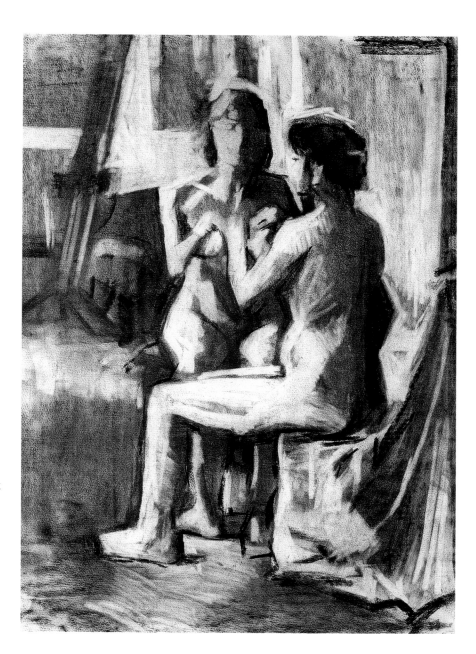

above Charcoal drawings, like this one, should always be sprayed with a fixative.

SELLING YOUR WORK

SELLING A WORK IS A REWARDING EXPERIENCE FOR AN ARTIST.

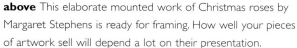

above This elaborate mounted work of Christmas roses by Margaret Stephens is ready for framing. How well your pieces of artwork sell will depend a lot on their presentation.

above This study of snowdrops, also by Margaret Stephens, is best displayed in an oval window mount. It is important to take time and care with the final presentation of your work if you want it to sell.

Greetings card companies provide an opening for many artists to sell their work. However, the standard of work required is extremely high and you might expect quite a few rejections before having any work accepted. If you have ambitions in this or any similar field it is important to get to know the market. That means, in the case of greetings cards for example, looking at those in the shops and deciding which are compatible to your style. Never send unsolicited artwork without this preliminary enquiry. You may choose to publish your own

work, as cards or even prints, particularly if you have knowledge of a sales outlet – always easier if you live in a tourist area. This is quite an expensive step to take and care is needed to find the right printer and to check out other examples of their work. Nothing is more disappointing than to see your good artwork reproduced badly. Remember also that the actual profit on the exercise may well be tied up in the last prints or cards, the earlier sales simply recouping your costs.

Whatever your ambitions, you can be assured of many hours of

relaxation and pleasure when it comes to painting and drawing your favorite subjects whether it be flowers, still life, nudes, portraits or landscapes.

GLOSSARY

Alla Prima A technique of painting in which only one layer of paint is applied to a surface to complete a painting.

Binder The fixative with which powdered colour is mixed.

Body colour Pigments such as gouache that have been rendered opaque by the addition of a white substance like chalk.

Botanical drawing The realistic and accurate method of illustrating plants that combines both their scientific and aesthetic qualities.

Cold Pressed paper see NOT

Collage A work put together from assembled fragments.

Complementary colours Colours that lie opposite each other on the colour wheel and have the effect of enhancing their opposite.

Composition The arrangement of the subject matter in a way that is harmonious and pleasing to the eye.

Contour A method of drawing where you look exclusively at the model/object without reference to the paper at all.

Contrapposto Counterposing one part of the body against another to maintain a position in balance.

Contre-jour Painting against the light.

Counterchange A technique for leading the viewer to the focal points, involving placing dark objects next to light and vice versa.

Cross-hatching A method of shading in which successive layers of pen or pencil strokes are applied at right angles to each other.

Dicotyledon A flowering plant with two embryonic seed leaves, such as members of the daisy family. See also monocotyledon.

Drypoint A method of engraving that does not require the use of acid.

Egg tempera A water-based medium that uses the binding properties of egg yolk to complete the mixture of pigment.

Fat Possessing a high proportion of oil to pigment.

Felt-tip pen An inexpensive, disposable marker, available in a wide range of colours, not necessarily lightfast.

Fibre-tip pen A disposable pen with fine grade tip, ideal for an even width line.

Fixative Made from synthetic resin, fixative can be used to seal pastel or charcoal drawing. It can be toxic and should be used outdoors.

Foreshortening A perspective term applied when one is representing an oblique object to one's line of vision.

Form The appearance of the subject matter – its line, contour and so on.

Fugitive Applied to dyes and paints which are short lived in intensity, especially in sunlight.

Glaze Transparent film of pigment over a lighter surface or over another.

Gouache An opaque medium in which the coloured pigment is mixed with white or body colour.

Graffito Lines produced by scratching the pigmented surface to reveal another.

Graphite The mineral used in the manufacture of "lead" pencils, which are either made of pure graphite or graphite and clay.

Gum arabic Hardened sap of acacia trees, used as a binder and to thicken paint and add gloss.

Hatching Shading by means of a single layer of pen or pencil lines.

Highlight The point on an object that reflects the greatest amount of light.

Hot Pressed paper Paper that has been hot pressed and the surface "ironed", so that the fibres have been smoothed down.

Impasto Paint applied thickly, so that brush and palette knife marks are evident.

Indian ink A black, permanent ink, usually with a shellac base.

Lean Paint containing little oil in proportion to pigment.

Local colour The inherent colour hue of an object.

Luminosity The effect of light appearing to come from a surface.

Mapping pen A dipping pen with a fine metal nib.

Medium Substance mixed with pigment to make paint; and with acrylic and oil to ease manipulation.

Mixed media Any painting or drawing technique that employs several materials – e.g., ink, watercolour and pastel.

Monocotyledon A plant that bears only one seed leaf – e.g., those of the lily or onion families.

Negative space The space round an object, which can be used as an entity in composition.

NOT Paper that is not Hot Pressed, also known as Cold Pressed. Rough paper acquires its surface by being pressed between a blanket. Cold pressing is applied to rough paper and flattens the surface texture.

Oil pastels Pastels in which the pigment is bound with waxes.

Perspective The way in which the effect of distance is represented graphically.

Picotee The finely coloured edge found on the petals of some bi-colour flowers – e.g., some carnations.

Picture plane The defined surface area being painted.

Pigment A colour that is solid, as opposed to a dye, which will stain only when mixed with another substance.

Plasticiser A substance, usually glycerine, added to watercolour paint to improve its brushing and soluble qualities.

Precipitation The grainy effect produced when pigment separates from the medium.

Propelling pencil An automatic or clutch pencil with renewable leads, graded in the normal manner from hard to soft.

Resist Using materials which protect a surface from the action of paint; paper, masking tape and masking fluid all fulfil this purpose.

Sanguine A mixture of iron oxide and chalk that was used to give the red colour often used as a drawing medium with charcoal and white chalk. Now available in conte crayons.

Saturation The strongest possible concentration of pigment.

Scratching or scoring Lines etched into a paint surface with the tip of a palette knife or the handle of a paint brush.

Scumbling To drag or dab thick paint onto the support.

Sgraffito To scrape away paint. A method used to define objects within a painting.

Shading The means by which a three-dimensional appearance is given to a two-dimensional drawing; the application of light and dark tones.

Silverpoint Silver wire used to make a drawing on specially prepared paper.

Spatial depth This is created by changing the tones of colour on receding planes.

Splattering A method of sending droplets of paint over a painting with either an old toothbrush or a flat hog bristle.

Sponging The application of paint with a natural sponge (preferably) to produce a textured surface.

Stippling A method of shading that uses dots instead of lines.

Support The paper, board or canvas and so forth, on which the drawing or painting is made.

Technical pen A pen with a fine tubular metal nib which gives fine lines of constant thickness. The ink is supplied from an independent cartridge.

Texture The term used when the artist conveys the "feel" of the subject, not just its form and colour, but a furry leaf or a velvety petal.

Tint A colour either diluted or mixed with white.

Tone The variation in colour, lightness or darkness of a subject.

Tonking Clearing an area overloaded with paint without disturbing the underlying structure. This is achieved by placing newsprint over the overloaded area and slowly pulling away.

Tooth The texture of the paper surface that allows pigment (particularly pastels) to "bite" and settle with varying density.

Underdrawing A sketch of the composition with pencil, conté, or charcoal that suggests tonal differences.

Unified colours Colours close together in the spectrum.

Wash An application of watercolour paint, often diluted to the lightest tone, as a preliminary stain, on which subsequent, often more detailed work will be executed.

Water-soluble pencil Coloured pencils that can be used with water to give a watercolour effect.

INDEX

CREDITS

About the contributing authors

Still Life

Peter Graham is one of Britain's most gifted and distinctive modern colourists. He graduated from Glasgow School of Art in 1980 after which he trained as a film editor and worked for the BBC for five years before starting to paint professionally in 1986. During a British Council-sponsored residency in Singapore, he produced a collection of fluently drawn and beautifully composed works, enhancing his reputation as a flamboyant painter of colour and form.

Painting Flowers

Elisabeth Harden studied History of Art and English at Edinburgh University and worked as a picture researcher for several years. She works principally in watercolour but enjoys using other techniques like etching and lithograph. She divides her time between painting, writing and teaching.

Drawing Flowers

Margaret Stevens specialises in botanical and other realistic studies. She is a founder member of the Society of Botanical Artists and exhibits widely both in the UK and overseas. Her work is in numerous private collections worldwide and features in the collection of the Hunt Institute for Botanical Documentation in Pittsburgh. She holds numerous Royal Horticultural Society Medals including the prestigious Gold Medal.

Portraits

Rosalind Cuthbert attended the Central School of Art and Design in London and the Royal College of Art. Her work is exhibited widely and is held in public collections, including the National Portrait Gallery in London.

Drawing the Nude

Diana Constance was born in New York City where she won a scholarship for the Art Students' League. She later continued her studies at the University of New Mexico. Her work is frequently exhibited and is held in a number of major collections,

Painting the Nude

David Carr studied at the Slade School of Fine Art where he won the Tonks Drawing Prize. He was awarded a David Murray Scholarship by the Royal Academy and the Boise Scholarship by University College, London, and he also spent some time at the British School in Rome.

His works are in public and private collections throughout Europe, the USA and Japan.

Painting Landscapes

Ted Gould studied at Harrogate College of Art and Design, London. He has exhibited widely since the 1960s, and has published work in several books. He is a regular contributor to the Artists and Illustrators magazine.

The Publishers would like to thank the authors for their contribution to *The Encyclopedia of Art Techniques.*

PICTURE CREDITS

John Arnold (p.251); Gerry Baptist (p.58 above left, p.308-311); Mike Bernard (p.293-297); Jane Bond (p.7); David Carr (p.37, 38 bottom, 60, 155, 160-161, 174-15, 180, 208-209, 210-211, 212-214, 236-238, 263-265, 268-269, 270-271); David Cuthbert (p.220-223, 227-229, 239-241); Rosalind Cuthbert (p.220-223, 227-229, 239-241); Michael Chaitow (p.242-245); Diana Constance (p.162-163, 178-179, 185, 192-193, 206-207, 252, 272-273); Derek Daniells (p.109-111); Arthur Easton (p.116-119); Timothy Easton (p.318-323); Helen Elwes (p.266 above left); Enid Fairhead (p.52 middle, p.280-283); Sharon Finmark (p.215-219); Kay Gallwey (p.2, 200-201, 224-226, 231 left, 232-235, 314-317, 338); Jeremy Galton (p.112-113, 336); Ted Gould (p.42-43, 276 right, 284-287, 299, 304-305, 306-307, 313 above, 324-328); Peter Graham (p.67, 86, 114, 128-131, 132-135); Elisabeth Harden (p.22-24, 87-89, 94-97, 120-123, 146-147); Pat Hares (p.33); Rosemary Jeanerette (p.85 right, 124-127); Justin Jones (p.170-172, 182-184,186-187,190-191); Hilary Leigh (p.51 middle, 75-77, 102-105, 148-150, 151-153); Robert Maxwell Wood (p.260-262); James McDonald (p.63); Steve McQueen (p.46); Sue Merrikin (p.85 left); Alison Milner Gulland (p.136-138); Jill Mumford (p.194-195); David Napp (p.48); Faith O'Reilly (p.40-41, 90); Valerie Oxley (p.51); Jeni Sharpsone (p.85); Hazel Soan (p.288-292); Margaret Stephens (p.344); Norma Stephenson (p.31); Joy Stewart (p.196-197, 202-203); Philip Sutton (p.84), Kenneth Swain (p.300); Shirley Trevena (p.62, 98-101, 115 left); Robert Tilling (p.313); Mark Topham (p.329-333); Vivien Torr (p.173); Jenny Wheatley (p.139-143); Vanessa Whinney (p.188-189); Janet White (p.145 right and bottom); Shirley Williams (p.49); Nicholas Verrall (p.108).